MW00860993

Jim Henson's™
FRAGGLE ROCK™

THE ULTIMATE VISUAL HISTORY

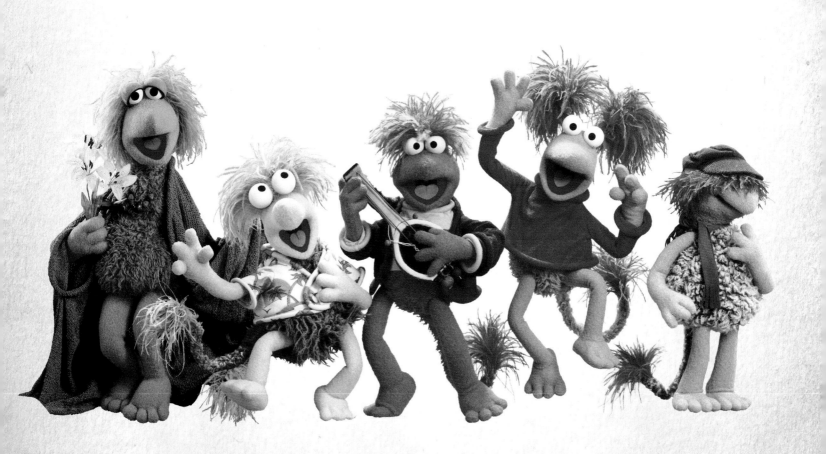

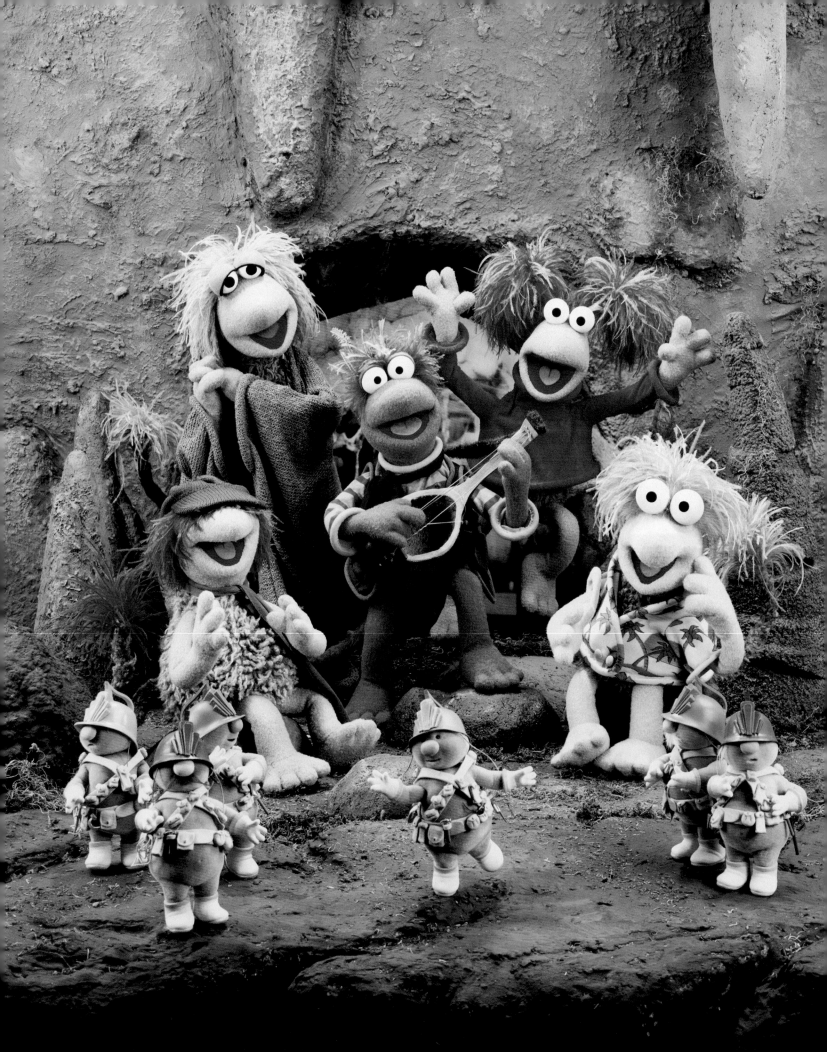

THE ULTIMATE VISUAL HISTORY

WRITTEN BY

JODY REVENSON AND NOEL MURRAY

FOREWORD BY

NEIL PATRICK HARRIS

SPECIAL CONTRIBUTIONS BY

JOCELYN STEVENSON

INSIGHT
EDITIONS

San Rafael • Los Angeles • London

CONTENTS

FOREWORD
BY NEIL PATRICK HARRIS

RIGHT AROUND THE TIME *FRAGGLE ROCK* PREMIERED, I wrote the first (and only) fan letter I would ever write. It was to Jim Henson. The letter was a simple handwritten note in big print on a piece of loose-leaf paper that I tore out of a binder. I don't know the exact wording of the letter, but am sure it read something like "Dear Mr. Henson, I like your shows and puppets, especially *Fraggle Rock*. Thank you for making them make me laugh. You are the best. Sincerely, Neil." I was never the best speller, but meant every word of the letter with all my heart.

I have been a fan of Jim Henson's work for as long as I can remember. I was literally born into it. Like many children my age at the time, I was learning life's earliest lessons from the characters of *Sesame Street* before I could make it across the living room without spilling my bowl of cereal. And once Big Bird and I had mastered my ABCs, I was more than ready for the fun of *The Muppet Show*. Gonzo was my favorite, but, then again, I always did identify with characters who are repeatedly shot out of a cannon. The point is, I was a child when these shows became popular, and they shaped my imagination.

But by the time *Fraggle Rock* came around, I was dead set on becoming a teenager and convinced I was too old for children's puppet shows. Or at least I thought I should feel that way. At an age when I found myself trading in so many of my favorite childhood things for more grown-up pursuits (like dirt bikes and rebelling and illegal fireworks),

the Fraggles remained. Despite the tugs of adolescence (or maybe because of them), there I was every week, planted in front of the TV and waiting eagerly for these brightly colored underground dwellers to sing their way into another episode.

At first, I kept my love of the show a secret. It was fine for my theater friends to know I still liked puppets, but letting everyone else in on the secret was more risk than my preteen self-esteem could handle. But then I noticed something amazing going on in the halls of my school. Everyone else seemed to love the Fraggles as much as I did. And not just other students in my grade, but the teachers, the principal's elderly secretary, the janitor and his six-year-old daughter, whom he brought to work with him, and even the juniors and seniors. I didn't think about why this was significant at the time. I was just relieved to know that I loved something that everyone else loved, and that was enough. In fact, it wasn't until much later on, while searching for the series on DVD as an adult and finding it odd that it was filed in the "children's section," that I realized why the show was so mesmerizing to me as a teen.

Fraggle Rock isn't a children's show at all. It's an adult show that children can follow. Jim Henson's Fraggles relay complex adult themes, but these are executed in the context of a children's world. In this way, both adults and children can relate and find meaning. As a teen precariously balanced between these two worlds, this duality was what made the show so special to me and what made it endlessly watchable and relatable. Now, as an adult and artist, I love this daring coordination. It's fascinating, layered, and holds endless intrigue.

Whenever I think about the show, an iconic scene from the episode titled "Marooned" comes to mind. I can't help it. I just find this episode so moving. During the show, Red and Boober confront their mortality after being trapped underground without oxygen. The scene can't be more than a minute and a half long, and yet it conveys so much in that short period of

PAGE 1 The Fraggle Five: Mokey, Wembley, Gobo, Red, and Boober.

PAGE 2 Publicity photo of Boober, Mokey, Gobo, Red, and Wembley, accompanied by Doozers.

PAGE 5 Uncle Travelling Matt, Gobo's adventurous relative.

ABOVE Character concept of what would become a Fraggle, drawn by Michael K. Frith during the brainstorming sessions held in the Downshire Hill house in Hampstead, July 1981.

BOTTOM LEFT Fraggle aficionado Neil Patrick Harris.

OPPOSITE Jim Henson surrounded by the Fraggle Five.

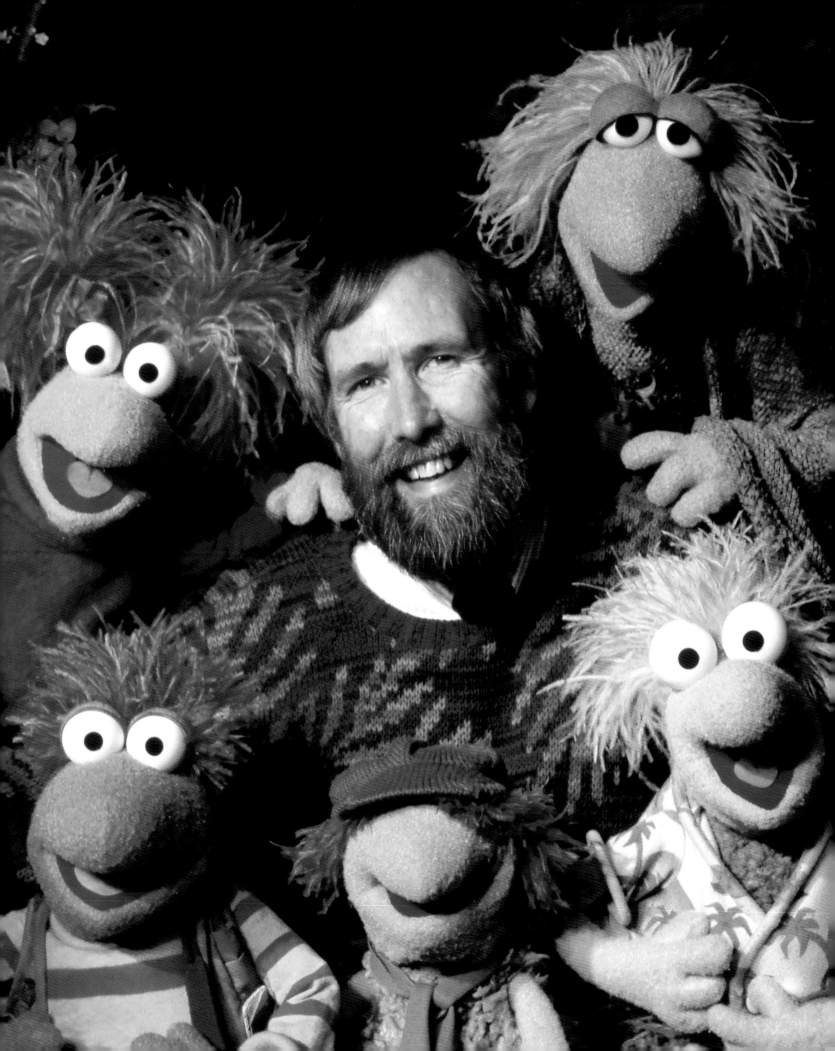

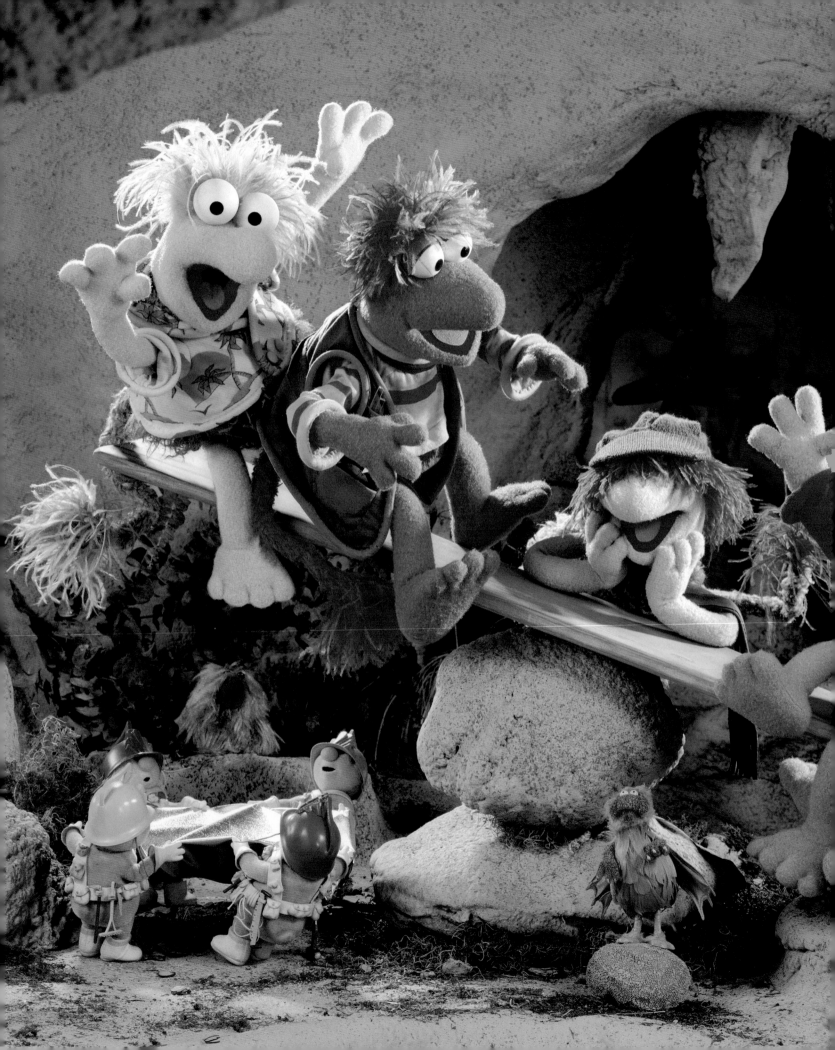

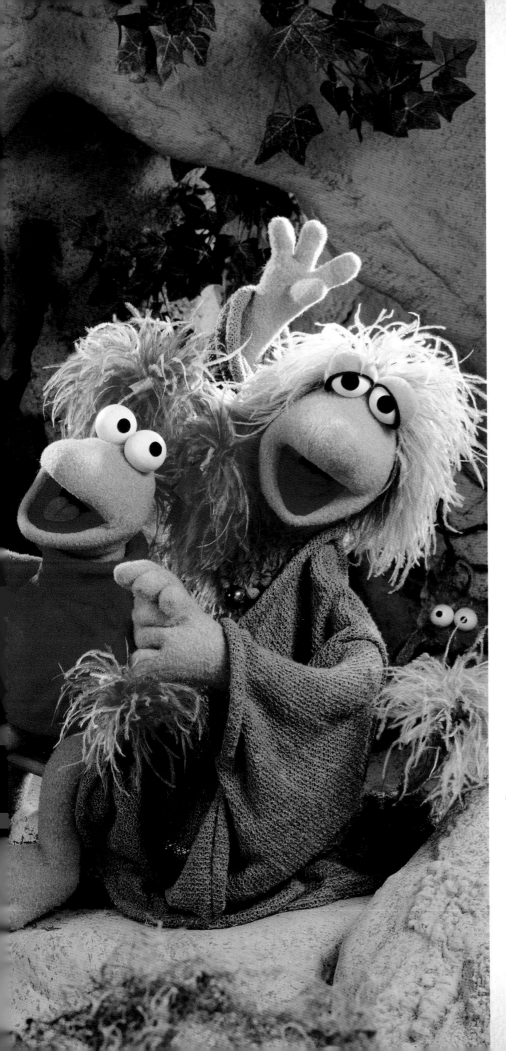

time. In this segment, you can really appreciate what is magical about puppets—specifically Henson puppets, and, even more specifically, the Fraggle characters. We know they are just felt and fur, but when Red asks Boober what he thinks it is like to die, you catch your breath. The perfect simplicity of his response, recalling a soap bubble that was "beautiful and shiny . . . and then it was gone," is as good as any philosopher's or poet's explanation. Whenever I watch it, I'm blown away by how believable these two dolls are. Their dialogue, their performance, and the tone of the show seem so real. And yet the world these characters inhabit is completely children's make-believe.

This sensibility is evident in all of Jim Henson's work, but *Fraggle Rock*, to me, represents a turning point. This was the mature artist at work in the most elegant expression of his vision to date. Elements of these sophisticated relationships and dynamics are traceable to *The Muppet Show* and *Sesame Street*, but *Fraggle Rock* brings them to the forefront. My only wish for the series is that it could have gone on longer—much longer. That's why I'm so excited for this book. I can't get enough of the Fraggles, and any chance to learn more about them or revisit even a part of their world is one I won't pass up. I'm fascinated by Jim Henson's creative process and legacy and am eager to unearth any nuance I can discover about him.

A few weeks after I had placed my fan letter in the mail slot of our local post office, I received a package from The Jim Henson Company. I don't think I was ever so excited to receive a package in my life. I opened the thick envelope immediately. Inside was a marvelous letter thanking me for my interest in *Fraggle Rock* and for my support of the show. The letter closed with a line or two encouraging me to pursue my dreams. Nothing could have been more inspiring. The rest of the contents of the envelope were beautiful glossy headshots of the characters in the show, some set renderings, and a *Fraggle Rock* sticker I promptly secured to the door of my room.

In retrospect, the act of writing that simple fan letter and getting in return a huge envelope of pictures is not unlike the experience of *Fraggle Rock* itself. One begins watching with the expectation of seeing some entertaining puppets, but leaves with the experience of having gained so much more.

OPPOSITE The Fraggle Five enjoy a seesaw ride while Doozers check construction plans. The small pink creature in front and green creature in back are known as "Extra Beings."

LEFT Early concept of the largest interconnected species by Michael K. Frith, drawn July 1981 at Hampstead.

PART ONE

A SHOW TO END WAR

THE IDEA FOR THE NEXT SHOW

IN THE WANING DAYS OF AUGUST 1980, as the final episodes of *The Muppet Show* were being taped, creator Jim Henson held a party in London, where the series had been filmed, to celebrate the show's highly successful run. After five seasons, 120 shows, four Emmys, and the fabrication of more than 450 puppets, Jim Henson had decided to end *The Muppet Show* in order to pursue new projects. Some of these endeavors were intended for the silver screen, including new Muppet movies and the original fantasy film *The Dark Crystal*. But for the smaller screen, there had been one idea percolating in Henson's head since his earliest days of puppeteering—a show that he imagined would do no less than end war and bring peace to the world. This show became *Fraggle Rock*.

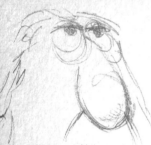

ABOVE Concept art of the largest species, drawn at the Hyde Park Hotel by Michael K. Frith, March 1981.

BOTTOM (Left to right) Sam, Jim Henson, Kermit, Yorick, and Jane Nebel pose for WRC-TV in the late 1950s.

INSET Journal entry from 1980 by Jim Henson noting the end of *The Muppet Show*. Henson kept a journal of his activities for the majority of his professional life.

OPPOSITE Jim Henson holds an engraved silver tray commemorating the end of *The Muppet Show* at the wrap party in August 1980.

Jim Henson had always been known for his desire to leave the world in a better place than he found it, and *Fraggle Rock* was the perfect vehicle to bring out his inner activism. The world of *Fraggle Rock* would be populated by three distinct species in three different sizes, all mutually dependent upon one another, albeit unknowingly. Over the course of the series the species would become aware of their interdependency, learn the importance of resolving the conflicts that arise between them, and recognize that their diversity is beneficial to all.

Born in 1936, Jim Henson spent his early years in Mississippi, a state blighted by racial conflict. "[There was] some pretty awful stuff going on," says his oldest son, Brian Henson, chairman of the board for The Jim Henson Company. Brian believes that this backdrop influenced his father's philosophy, which was "less about tribal loyalty and more about wanting to bring people together. I think a lot of that was probably from growing up in a very intolerant society."

Henson's family moved to the suburbs of Washington, DC, in the late 1940s, and it was there that he fell in love with the new technology of television. "I loved the idea that what you saw was taking place somewhere else at the same time," said Henson. "I absolutely *loved* television."[1] At the time, children's entertainment was entering its first golden age, with the puppet-based programs *Howdy Doody* and puppeteer Burr Tillstrom's *Kukla, Fran and Ollie*. Henson soaked up these rudimentary shows and, late in his high school days, began dabbling with puppetry, even making a few appearances on local television.

During his first year at the University of Maryland in 1954, Henson was seen regularly on the local Washington, DC, NBC affiliate, WRC-TV, after his performances caught the eye of James Kovach, an NBC program director. A few months later, Henson began a partnership with puppeteer Jane Nebel, whom he had met at school, and who would later become his wife.

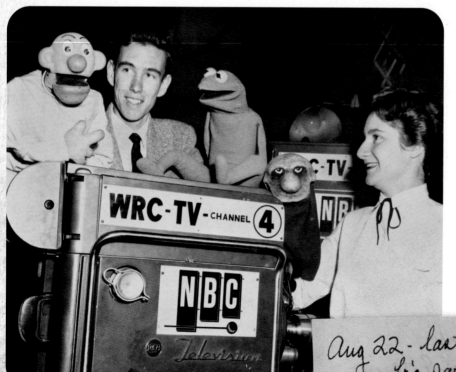

Aug 22 - last day taping MUPPET SHOW
big party - speeches by abe + Lew

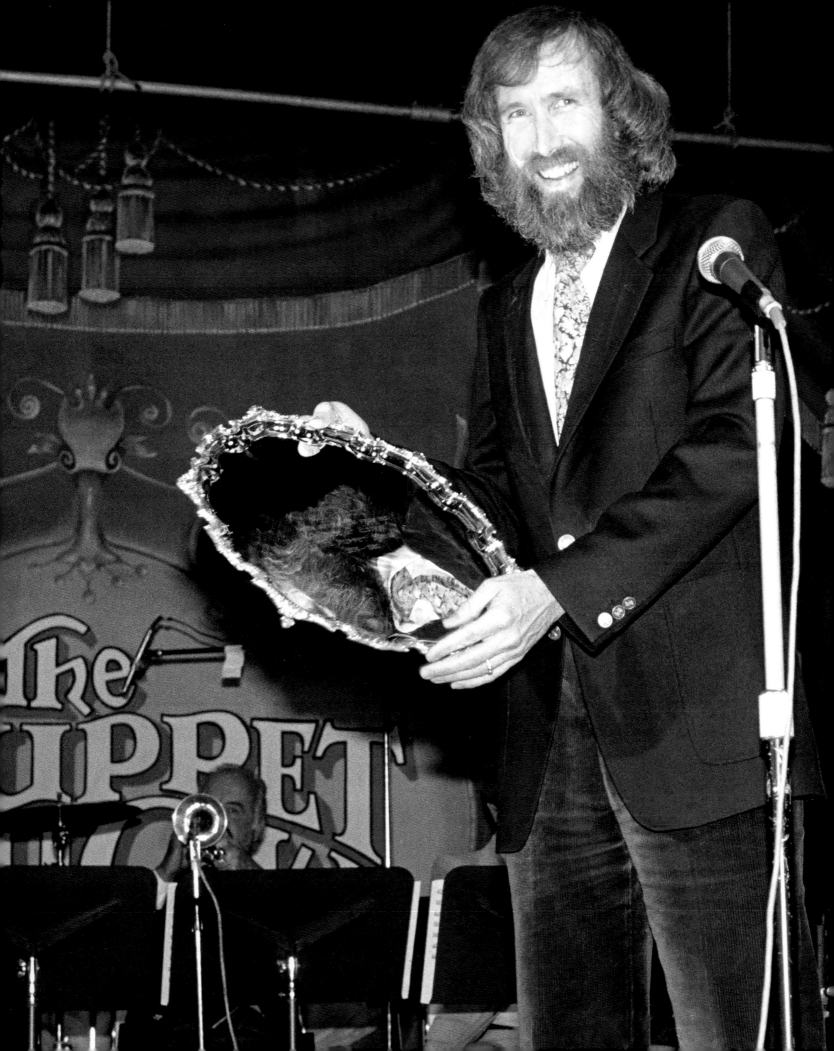

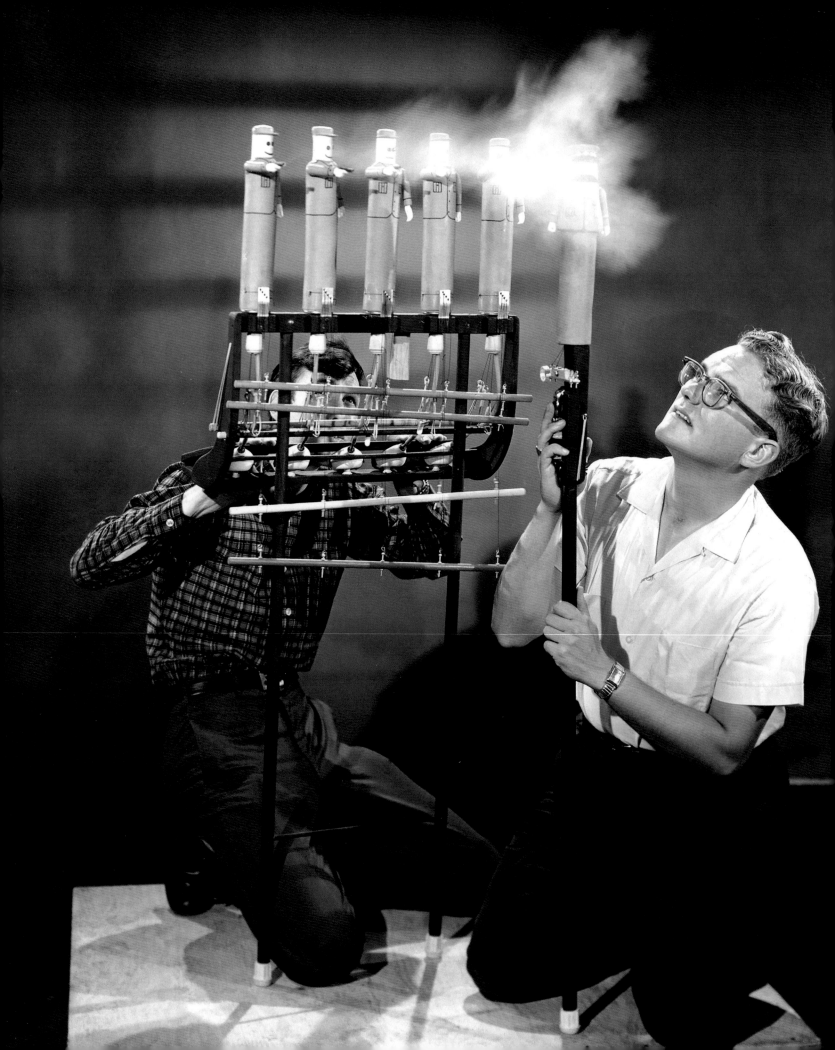

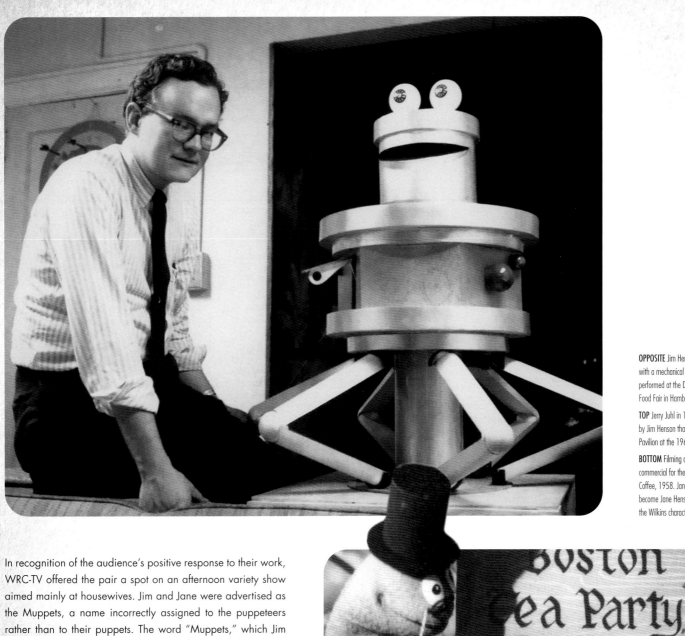

OPPOSITE Jim Henson and Jerry Juhl in 1961 with a mechanical drill team puppet they performed at the Department of Agriculture's US Food Fair in Hamburg, Germany.

TOP Jerry Juhl in 1964 with a robot created by Jim Henson that greeted visitors to the SKF Pavilion at the 1964 World's Fair.

BOTTOM Filming a Wilkins and Wontkins commercial for the tea products of Wilkins Coffee, 1958. Jane Nebel, who would become Jane Henson in 1959, performs the Wilkins character.

In recognition of the audience's positive response to their work, WRC-TV offered the pair a spot on an afternoon variety show aimed mainly at housewives. Jim and Jane were advertised as the Muppets, a name incorrectly assigned to the puppeteers rather than to their puppets. The word "Muppets," which Jim Henson had been using informally since 1954, was mistakenly thought to be a portmanteau of "marionettes" and "puppets." Henson later explained it was actually just a word they had made up.

The popularity of Jim Henson's work on WRC led to an offer to create a five-minute puppet-hosted show for the station. *Sam and Friends* established the more recognizable Muppet style: Sam was a bald, large-eared human; his friend Yorick was a prune-colored skull. Both were made of papier-mâché, but in order to bring more nuance to the additional cast members he needed to build, Henson turned to foam rubber and fabric. This led to the creation of a wool hand puppet made from a milky green coat that belonged to his mother. Henson named the little creature Kermit.

Jim and Jane were advertised as the Muppets, a name incorrectly assigned to the puppeteers rather than to their puppets.

Sam and Friends ran for nearly seven years, winning a regional Emmy Award in 1959. During its final year, Jane Nebel, now Jane Henson, stepped back from the show to raise their family, and so Jim Henson hired an assistant to help him finish out the last season. Following a recommendation from a young puppeteer, Frank Oznowicz, who would later take the stage name Frank Oz, Henson hired a West Coast puppeteer, Jerry Juhl, to take Jane's place. Like Henson, Juhl had worked on children's shows for local television stations while attending college.

After *Sam and Friends* ended, Henson and Juhl proposed a multiyear advertising campaign for the Celanese Chemical Company that would put the Muppets on television, as well as in newspapers, magazines, and retail venues. Henson suggested launching the advertising campaign with a short film that could be shown on television and viewed in stores. With Juhl, he submitted a two-page proposal that showed glimmers of the social awareness that would eventually surface in *Fraggle Rock*. "Although this film would first and foremost be an entertainment piece," read the proposal, "we hope to sneak in a couple of subtle moral themes. For instance, brotherhood would never be mentioned outright, but we would see that on

TOP RIGHT Character concept of what would become a Gorg, drawn by Michael K. Frith during the brainstorming sessions in Hampstead, July 1981.

BOTTOM The cast of *Sam and Friends* with Jim and Jane Henson.

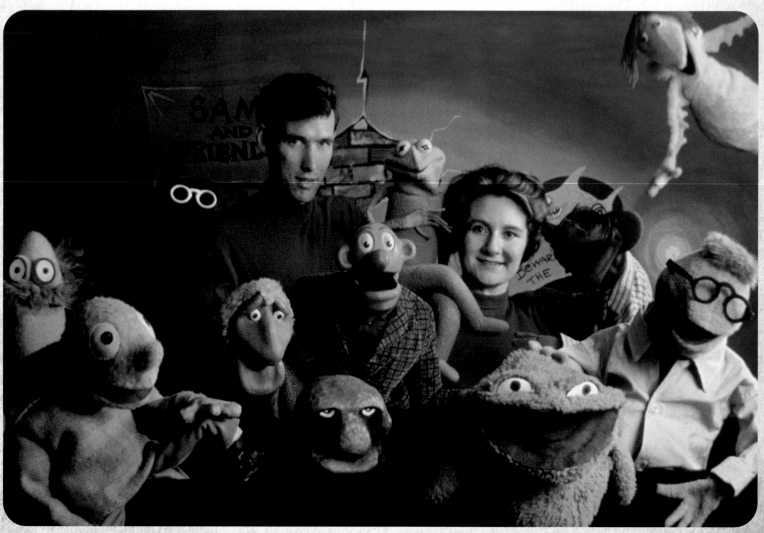

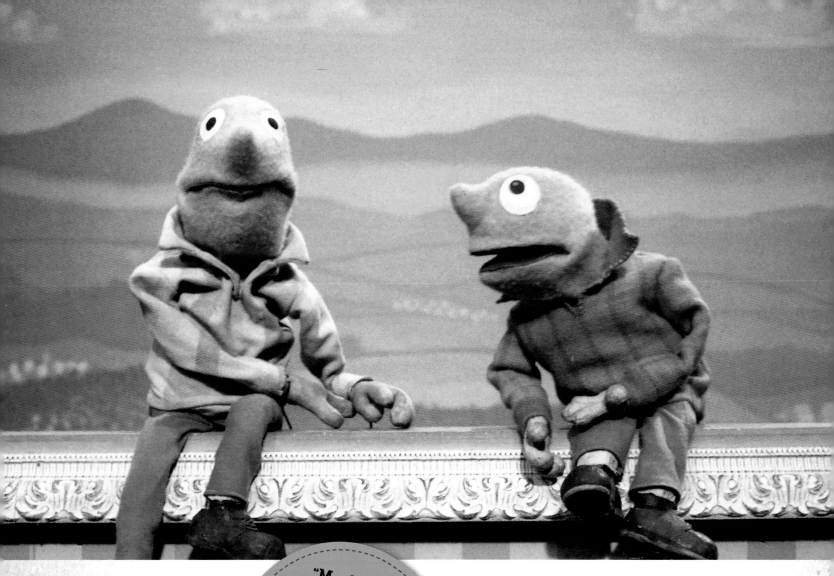

one planet, all colors of creatures live peacefully together." Unfortunately, the film was never made.

The Muppets continued to appear on television, gaining national exposure in advertisements and on high-profile programs including *The Ed Sullivan Show*. In 1969, the Muppets became key players for the innovative children's show *Sesame Street,* produced by the Children's Television Workshop (CTW). Through the years, Henson would film pilots and propose ideas for his own television series, through his company Henson Associates— often shortened to HA!—but it wasn't until 1975, after many popular Muppet television specials, that he was able to sell an idea he had developed for a weekly television series. This "variety show hosted by dogs, frogs, and monsters,"[2]—as *The Muppet Show* was described in Henson's pitch—was produced by Sir Lew Grade's ITC production company in the UK and presented in the US through the nascent primetime syndication format.

Because of Grade's international distribution network, *The Muppet Show* would go on to air in 108 countries, in

> "My father took it very seriously that children in great numbers would be watching his programs."
> BRIAN HENSON

multiple languages—a global reach that inspired Henson to consider the potential of communicating with a worldwide audience. He would later say, "The wonderful thing about creating television for children [is that] by making them aware, giving them a positive image of what the world can be, and showing them that they can make a difference, you can effect [a] kind of social change. And it's not just for today, it's for the future."

As the success of *Sesame Street* and *The Muppet Show* brought in increasingly widening audiences for his work, Henson felt that he had more opportunity than ever to incorporate important social ideas into his shows.

"My father took it very seriously that children in great numbers would be watching his programs," says Henson's oldest daughter, Lisa, CEO and president of The Jim Henson Company. "He had always been thinking about the building blocks of being socially conscious and caring for others, respecting people's differences, and having compassion for people who are other than yourself. *Fraggle Rock* was where it all bloomed and came to fruition."

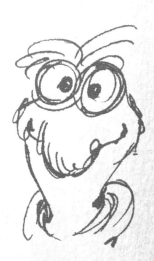

TOP Puppet characters Hank and Frank on the set of *Sam and Friends* at the WRC Studios in Washington, DC, 1959.

ABOVE Character concept for a Fraggle, drawn by Michael K. Frith during the brainstorming session in Hampstead, July 1981.

DRAFTING A TEAM

MANY OF THE KEY CREATIVE STAFF for *Fraggle Rock* would be drawn from *Sesame Street* and *The Muppet Show*, ensuring a direct connection between Henson's past hits and his new, more ambitious, socially conscious show. Several members of the team would also work on Henson's groundbreaking fantasy film *The Dark Crystal*, developing tricks and techniques they would go on to use on *Fraggle Rock*.

Fraggle Rock's first producer, Duncan Kenworthy, joined *Sesame Street* in its early days, working in the international production department, eventually becoming the supervising producer for the Arabic *Sesame Street*, titled *Iftah Ya Simsim*. But after years of flying back and forth between New York and Kuwait, Kenworthy wanted a new challenge.

On a trip to London in 1979, he was asked by Lutrelle "Lu" Horne, the head of his department, to help pitch a TV series to Jim Henson that CTW had developed. Kenworthy

didn't feel the proposal was good, "But you know, he was my boss, so I said 'Yeah, Lu, of course I will.'" Present at this meeting—which took place at Jim Henson's new house near Hampstead Heath, which overlooks the city of London—was an old friend of Kenworthy's from CTW, Jocelyn Stevenson. As the assistant editor of *Sesame Street Magazine*, Stevenson had worked out of CTW's New York offices before moving to the UK to write and edit for the children's book division of Henson's publishing department.

OPPOSITE Duncan Kenworthy, London, 1980
BOTTOM Writers Jerry Juhl, Jocelyn Stevenson, and Susan Juhl discuss a *Fraggle Rock* script.

TOP Jocelyn Stevenson and Duncan Kenworthy on the set of *Fraggle Rock*, 1982.

ABOVE Character concept for a Fraggle, drawn by Michael K. Frith during the brainstorming sessions in Hampstead, July 1981.

Just as Kenworthy predicted, Henson wasn't sold on CTW's pitch, but, at his hotel, after the meeting, he received a call from Stevenson. "She said the strangest thing. 'Jim was so impressed by you that he said, "I'd like that guy to make my next TV series."' And I said, 'Yeah, right. As if.'" Still in disbelief, Kenworthy called Henson's Elstree Studios offices and, to his surprise, a meeting was soon set. "I met him at his house, and we went for a walk on Hampstead Heath," says Kenworthy. "I made my pitch to work for him, and, as usual with Jim, he went for the person rather than the job. He said, 'Well, I think you'd fit in really well; I think it would be great to work with you. What could we come up with for you to do?'" Given his experience in the international market, Kenworthy began by joining Henson on promotional trips across Europe for the international release of 1979's *The Muppet Movie*, and was then asked to become associate producer on *The Dark Crystal*, which would be released in 1982.

As time passed and Kenworthy's professional relationship with Henson flourished, his thoughts turned to an idea he

"What if you were to create an international show that was designed from scratch to be dubbed and adapted into different languages?"

had mulled over while at his previous job, one he would share with an old associate. At CTW's international production department, Kenworthy had worked with Peter Orton, the head of international sales for the company. "Peter had been involved in setting up the business deal for the Arabic *Sesame Street*," Kenworthy explains. "The sales department and the production department obviously worked very, very closely together. No point in selling something if we couldn't make it. So, I had an awful lot to do on a daily basis with Peter." Orton was known as a "salesman's salesman." At the age of sixteen he had started his career peddling naval uniforms. By the age of twenty-four, he was selling international TV shows to the Middle East, Africa, and the Caribbean, before joining CTW as director of international programming.[3]

At some point after leaving CTW, Kenworthy caught up with his former colleague and discussed his ideas for a show featuring the Muppets that would be designed to work internationally. "I didn't have it fully formed; it wasn't *Fraggle Rock*," says Kenworthy. "It was just this idea of the way to

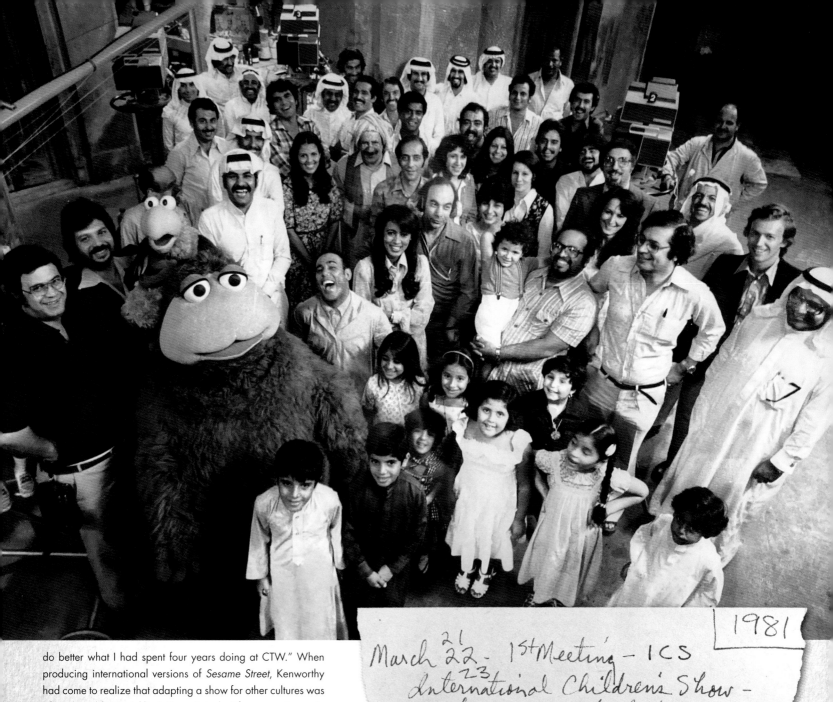

1981

March 21 22 23 — 1st Meeting — I C S
International Children's Show —
became Fraggle Rock

do better what I had spent four years doing at CTW." When producing international versions of *Sesame Street*, Kenworthy had come to realize that adapting a show for other cultures was rife with problems and limitations. But what if you were to create an international show that was designed from scratch to be dubbed and adapted into different languages? "*Sesame Street* had not been easy to do that with," he explains. "But I thought that if you just rejiggered it, you could make it very efficiently." Kenworthy thought that the new show should consist of puppet sequences created by Henson Associates and blended with segments starring human actors that would be filmed in each country so that each version could be localized. "That way, you could put together something that wouldn't be expensive for the foreign countries to adapt, and would benefit from [Henson's] investment in the puppet section." Orton instantly saw the potential behind Kenworthy's ideas and pledged to discuss them with Jim Henson.

In May 1980, Orton was invited to the christening of Jocelyn Stevenson's first son in Edinburgh, Scotland, where Stevenson—his sister-in-law—was now living. There was to be

a family dinner the night before, and Orton asked Stevenson to seat him next to Henson, who was also in attendance. "As much as I could overhear the conversation," recalls Stevenson, "between the appetizer and the main course, Peter pointed out to Jim that he had a once-in-a-lifetime opportunity. He said, 'You are the only producer in the world who is in a position to create a show that could be internationally coproduced.'"

Stevenson remembers Orton explaining that the puppet portion of the show could be dubbed into any language and that each territory could do its own live-action "wraparound" so it would feel local. "With *The Muppet Show*'s success, [Jim] could get the funding and put together something like this," she continues. "That's how Peter had been thinking. So Jim started to chew around this thing."

TOP Group photo taken in December 1978 of the cast and crew of the Arabic *Sesame Street*, *Iftah Ya Simsim*, which Duncan Kenworthy oversaw as supervising producer. The puppets are Melsoon the parrot and No'man the bear, equivalents to Oscar the Grouch and Big Bird. From the collection of Duncan Kenworthy.

ABOVE Journal entry from Jim Henson for the first International Children's Show meeting in March 1981.

THE INTERNATIONAL CHILDREN'S SHOW

IMMEDIATELY AFTER *THE MUPPET SHOW* WRAPPED IN AUGUST 1980, Jim Henson began filming *The Great Muppet Caper*—a follow-up to *The Muppet Movie*—while also working on *The Dark Crystal*. The international coproduction idea Peter Orton had discussed with him earlier that year seemed to be relegated to the back burner.

But early in October, the company that sold *Sesame Street* to broadcasters in Africa, Europe, and the Far East—Television International Enterprises (TIE)—contacted Duncan Kenworthy about the possibility of starting its own TV production company with him at the helm. Committed to Henson Associates and about to start work on *The Dark Crystal*, Kenworthy declined, "but we met and talked about what we might do." During the meeting, Kenworthy shared his idea for a new way to produce an international puppet show. After the meeting, Kenworthy felt obligated to tell Jim Henson what he had discussed with TIE. "And Jim, again, typical Jim, said, 'If you want to do that, why don't you just do that here, for us?'" says Kenworthy.

Henson recognized that an international coproduction would give him the opportunity to reach children all around the world: the perfect opportunity to create a show that would promote international peace.

"Like many of us at that time, Jim was socially conscious," says Stevenson. "But what I found so inspiring was that he truly regarded his work as a vehicle for his vision of a world where everyone understands that we are all connected. He dubbed the enterprise the International Children's Show (ICS) and saw it as a vehicle for presenting a theme of nonviolent conflict resolution that, if adopted on a large enough scale, might help stop war."

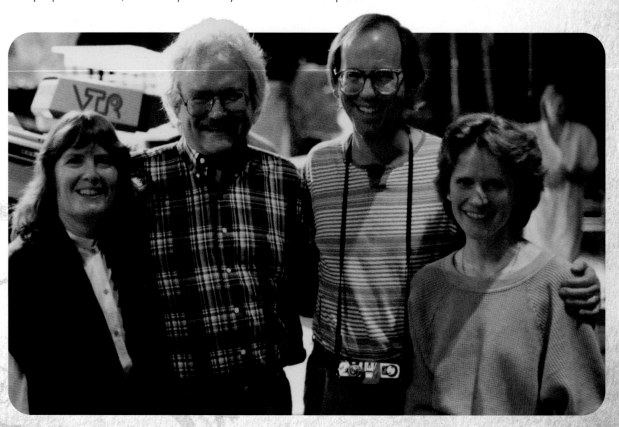

ABOVE Fraggle concept art by Michael K. Frith sketched at the 1981 Hyde Park Hotel ICS meetings.

BOTTOM Susan Juhl, Jerry Juhl, Lawrence Mirkin, and Jocelyn Stevenson on the set of *Fraggle Rock.*

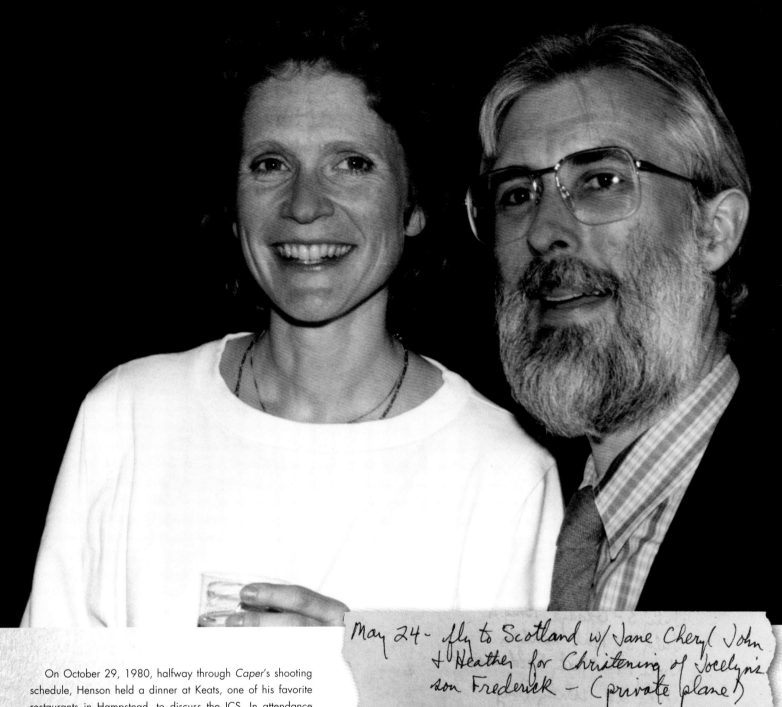

May 24 - fly to Scotland w/ Jane Cheryl (John + Heather) for Christening of Jocelyn's son Frederick - (private plane)

On October 29, 1980, halfway through *Caper*'s shooting schedule, Henson held a dinner at Keats, one of his favorite restaurants in Hampstead, to discuss the ICS. In attendance were Orton, Kenworthy, Stevenson, and David Lazer, *The Muppet Show*'s executive producer and second-in-command at Henson Associates. The idea for the ICS was very much in its infancy, and the thrust of the meeting would center on the business model that Orton and Kenworthy would develop.

During the gathering, and much to the surprise of his guests, Henson revealed that this would be the first of his company's television projects that he wouldn't be involved with on a day-to-day basis.

"I think he was trying to get the company to not just be everybody waiting for him to do something and they're going to help him," says his son Brian. "He wanted the company to start to become a *company*. He was now working in England and New York, and on longer projects. He wanted the New York group to stay in production, so he was trying to figure out

how to get the company to be more expansive than just relying a hundred percent on him."

Although this preliminary meeting focused on general business structure, ICS creative meetings would soon be scheduled. After filming wrapped on *The Great Muppet Caper* in February 1981, Jerry Juhl, one of the film's writers, was looking forward to heading back to the US to relax after several years of back-to-back Muppet projects. Recalled Juhl, "And then Jim said, 'No, before you go home, the day after the wrap party, I'm holding this big meeting at a hotel ballroom in London, so we can talk about the next show.' And we all went, 'The next show?!'"

TOP Jocelyn Stevenson and Michael K. Frith in the mid-eighties.

ABOVE Journal entry from Jim Henson for Jocelyn Stevenson's son's christening in Scotland, where the International Children's Show was proposed.

HYDE PARK HOTEL

THE FIRST ICS CREATIVE MEETINGS RAN from March 21 to 23, 1981, at London's Hyde Park Hotel. "These early ICS meetings were much broader than later ones," says Duncan Kenworthy. "They were with puppet builders and creative people. And that was the sort of person Jim was. Involve everybody. And everyone has good ideas. It was also a way, I suppose, of getting people on board."

The venerable venue, which has hosted royalty since it first opened as a hotel in 1902, now accommodated a gathering of almost thirty writers and creators chosen by Henson, including his wife, Jane; Jocelyn Stevenson; writer Jerry Juhl and his wife, Susan, also a writer; Muppet workshop supervisor Caroly Wilcox; and art director Michael K. Frith.

Frith came from the world of publishing, beginning his career as a children's book illustrator and editor at Random House. He was soon promoted to editor-in-chief of the Beginner Books series, a line of titles created by Theodor Geisel, aka Dr. Seuss, whom Frith had worked with closely for many years. In 1971, Random House began publishing *Sesame Street* books, and Frith was named editor and art director of the newly created imprint dedicated to the show, contributing his own illustrations for several of the titles. Noticing Frith's talent and creativity, Jim Henson asked him to join Henson Associates.

Sitting around a large table in the hotel ballroom, these highly skilled creative artists talked about the concept of international coproductions and doing a "big global idea." "We were circling around that without really having any idea of what that really meant," said Jerry Juhl. "But getting excited about it, despite the fact that [not long before] we'd all said 'No, let's just go home.'"

Michael K. Frith admits to thinking there were some very ill-formed ideas knocked around in the meetings. "At first, it felt to me like 'already been there and done that,' but you've got to start somewhere," he says. "I was drawing the whole time, and fortunately the Hyde Park Hotel had lovely big pads." As the conversations progressed, things began to come into focus for Frith, and the idea of doing a children's show on an international level, "using what we knew and, for me, what I knew, not simply as a designer, but somebody who came from that world of storytelling and creating worlds, became hugely exciting."

Susan Juhl remembers Henson telling them of his intention to bring peace to the world and end war with the ICS. "We were all bleary, but had notepads," she says. "We actually wrote that down."

OPPOSITE Hyde Park Hotel meeting sketch by Michael K. Frith showing early Fraggle-type creatures living behind the walls of a house.

BOTTOM Concept art by Michael K. Frith of an early Gorg in its environment, rendered at the Hyde Park Hotel.

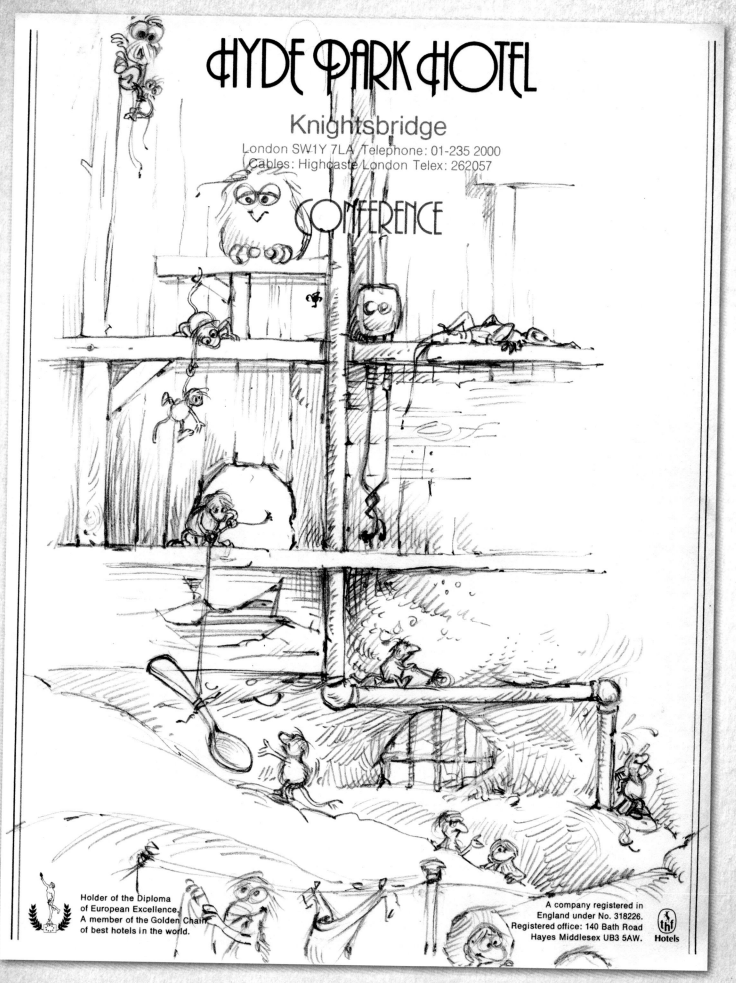

"[We thought], how do you do that?" says Duncan Kenworthy. "Well, you teach children the value of relative viewpoints. That people have different perspectives depending on circumstances, and one is often as valid as the other." To convey this idea, Jane Henson offered the concept of three different scales of creatures, with each being knee-high to the next. "So, I look down on him and he looks up at me, and I look up at him, and so on," says Kenworthy.

"And all three of these species are inter-dependent in various ways," said Jerry Juhl. "They really need each other and have no idea *why* they need each other."

It was also decided that the viewer would be the only one who could see all three species. "You could see each one, their point of view, and why they weren't understanding each other," says Jocelyn Stevenson. "We thought that would be

appropriate for the audience and quite an interesting way of getting conflict resolution."

During their three days at the Hyde Park Hotel, the creative team took inspiration from *The Borrowers*, a children's novel written by Mary Norton in 1952. The Borrowers are a family of tiny humans who live inside the walls of the home of a regular-size family and "borrow" items that they use to furnish their own dwelling, such as the matchboxes that they use for beds. "We knew that it had been done before," says Jocelyn Stevenson, "but we liked the idea that they lived behind the wall, and that you'd go through a hole in the skirting board to get into their world from ours. It was just a matter of figuring out what our world was."

Michael K. Frith sketched out the ideas on the Hyde Park Hotel stationery. "I started just to get my brain going, doing little people stealing spoons kind of things," he recalls. "I said, 'But living inside the walls? Come on. What's beyond the walls, where does that go, where's the world?'" Frith's drawings evolved into a location featuring crystalline caves with stalactites and stalagmites, with little creatures moving among them and shafts of light shining through from above. "And I thought, *I know this place*," he says. "*This is something that's part of my own DNA.*"

Frith had grown up on the island of Bermuda, a tourist hotspot in the Atlantic Ocean. Among Bermuda's most noted attractions is Crystal Cave, a destination Frith had explored throughout his childhood. Crystal Cave is a 1,600-foot long, 200-foot deep limestone system from the Ice Age—a seemingly endless underground world of fantastical rock formations and crystal-clear pools of water. The cave had remained unexplored for more than a million years, until its accidental discovery in 1905. Frith had always been fascinated by the story of how it was found. "Two twelve-year-old boys were playing cricket," he explains. "One boy whacked the ball and it disappeared down a hole. Having no ball meant no cricket, so they got a flashlight, got down on their bellies, and crawled through a dark, narrow crevice. Then, suddenly, their flashlight illuminated this magical cave that nobody had known was there."

Frith's fellow creators were unaware that the Fraggle caves he was drawing were from his own childhood. "To us, he was drawing the caves that lurked in our collective imagination, caves that could lead anywhere," says Stevenson.

The evocative nature of Frith's caves soon made them an important part of the world's geography. "One of the wonderful things about a cave is that you don't know where it's going to go," adds Frith. "It can either come to an end or bring you out to an even more amazing place than the place where you started. Right away it gave us a wonderful and never-ending possibility of exploration within this world.

"Then the drawings gradually evolved from the world of

BOTTOM Fraggle concepts by Michael K. Frith, drawn at the Hyde Park Hotel International Children's Show brainstorm.

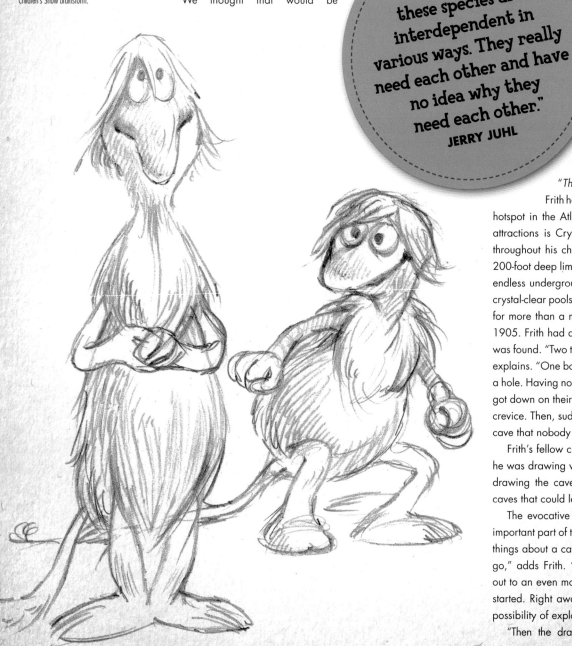

"All three of these species are interdependent in various ways. They really need each other and have no idea why they need each other."
JERRY JUHL

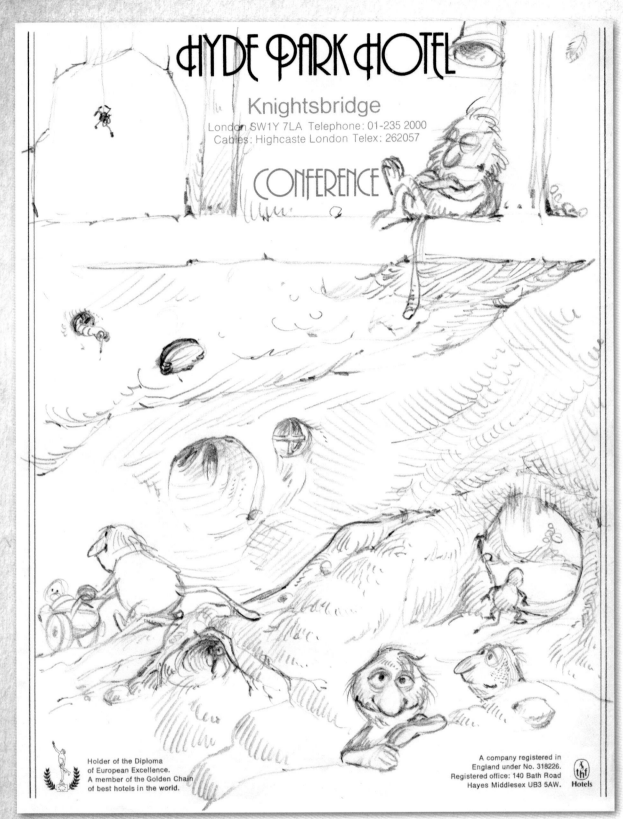

HYDE PARK HOTEL

Knightsbridge

London SW1Y 7LA Telephone: 01-235 2000
Cables: Highcaste London Telex: 262057

CONFERENCE

Holder of the Diploma
of European Excellence.
A member of the Golden Chain
of best hotels in the world.

A company registered in
England under No. 318226.
Registered office: 140 Bath Road
Hayes Middlesex UB3 5AW.

thf Hotels

the Borrowers," he continues, "to a world of strange little furry creatures who had their own lives, their own civilization, their own world down there in the earthy caves that we knew nothing about, and that, in turn, suggested that they knew nothing about us." Frith's Hyde Park Hotel concepts depict these diminutive creatures with disproportionately long bodies, long noses, and long hair.

After three days of feverish brainstorming, the Hyde Park Hotel meeting came to an end. A week later, Jim Henson flew back to New York on a Concorde supersonic passenger plane. During the flight, he took out a stenographer's notebook and wrote a treatment that synthesized all the ideas generated during the get-together. It was called *Woozle World*.

LEFT Michael K. Frith took great advantage of the Hyde Park Hotel stationery, drawing concepts for Fraggles and other beings in various poses in caves and tunnels.

RIGHT Gorg concept drawn by Michael K. Frith during the July 1981 brainstorming sessions.

WOOZLE WORLD

JIM HENSON'S WRITTEN NOTES ON *WOOZLE WORLD* describe a half-hour show featuring new, original Muppets in a unique environment. "Our first job," he writes, "is to make this world a fun place to visit," with "lots of music and rollicking nonsense." However, he continues, "what the show is really about is people getting along with other people, and understanding the delicate balances of the natural world."

The sole human in Henson's treatment is an inventor named the Codger, who has a dog, George. The dog is "bright, warm, and loveable. The old codger is warm and loveable, but you probably wouldn't call him bright."

The duo live in a tiny cluttered room known as "Home Base" that is filled with interesting junk and acts as a bridge between worlds. In the wall of this room is a hole that leads to the world of the Woozles. Woozles are about fourteen inches tall, live in family groups, and "are, by nature, goofy, enthusiastic, fun-loving, musical, not too bright, but quite loving to each other. They sing rousing, foot-stomping, hand-clapping-type songs that make you want to join right in."

What the Woozles don't know is that their "Woozle Hole" has an exit into a back garden that belongs to a second species, the Giant Wozles. There are three Wozles: a mommy, a daddy, and a "little boy Giant Wozle," who are "friendly and galumphy, and

really dumb." In order to show the differentiation in size with the Woozles, Henson proposed in the treatment that they could use actors in full-size costumes to play the large Wozle characters, with the Woozles portrayed using puppets.

Underneath the home of the Woozles live a third species, the tiny Wizzles. The Woozles despise the Wizzles, who, according to Henson's notes, live in a world just as elaborate and complete as the Woozles' in many ways, "but quite different. I won't bother to describe this at great length because we haven't thought about it yet."

The interactions between these interconnected species make the point that "everything affects everything else," Henson wrote, "and there is a beauty and harmony of life to be appreciated."

Two other specific characters are mentioned. One is a Trash Heap who lives in the back garden and acts as an oracle to the Woozles. This "keeper of wisdom and truth," was based on an idea suggested by Michael K. Frith at the Hyde Park Hotel meeting. The other character is a Woozle who ventures out of the Woozle Hole and into the Real World. This "wide-eyed Woozle wanderer," as he's described, presented another opportunity for international partners to include their own localized segments given that the character could visit any number of regions throughout the world.

Henson's notes were typed up and bound together into a booklet with a Michael K. Frith sketch on the cover before being distributed to the Hyde Park Hotel meeting attendees and other relevant members of Henson Associates. Almost immediately, concerns arose about the name "Woozles." Over the decades, there had been British kids' shows with characters named Worzel Gummidge, the Wombles, and the Woofits, which all seemed far too close to Henson's suggestion and had the potential to cause confusion. "We also knew we couldn't continue to call our central species Woozles," adds Jocelyn Stevenson, "because, though we loved the word, it had originally been invented by A. A. Milne for *Winnie-the-Pooh*."

Nonetheless, the ideas compiled in Henson's booklet formed a substantial jumping-off point for the ICS. "Everything we had gathered together so far was enough of a start to get some thinking going," says Michael K. Frith. "So, at that point, Jim said, okay, Jerry and Jocelyn and Michael—you three go make up a television series."

BOTTOM Inked concept art by Michael K. Frith of a Fraggle based on images from the Hyde Park Hotel meeting.

OPPOSITE First page of the stenographer's notebook Jim Henson used on the Concorde to draft his ideas for *Woozle World*.

INSERT A typed-up version of Jim Henson's *Woozle World* treatment.

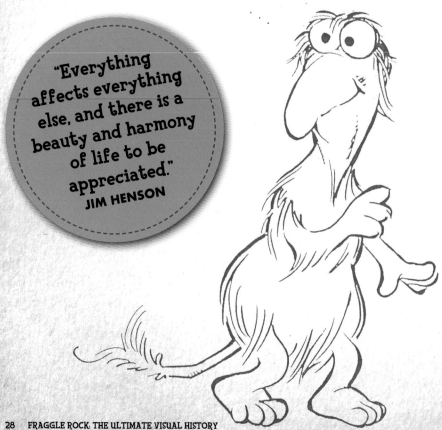

"Everything affects everything else, and there is a beauty and harmony of life to be appreciated."
JIM HENSON

APRIL 3, 1981

The Woozle Show
or
Woozle World
or
The World of the Woozles
~~Where the Woozles Were~~

~~Concept for children an international television~~ or

WOOZLE - WOOZLE!

— concept for an international children's television show.

———— INSERT B — goes here —

~~The following is an~~
~~outline for a half hour~~
~~weekly television program~~
~~aimed at children between the ages~~
~~of ten six to ten. It would be~~
~~produced by the Henson~~
~~Associates Ltd working~~
~~in conjunction~~

DISCOVERING SOMETHING THAT ALREADY EXISTED

IN JULY 1981, HENSON INVITED Jocelyn Stevenson, Jerry Juhl, Michael K. Frith, and Duncan Kenworthy to a ten-day brainstorm session at his Hampstead house with the goal of nailing down the characters and concepts for the International Children's Show. "We were kind of feeling around in the dark," said Jerry Juhl. "We wound up creating the show by making lists."

As they worked, the team wrote their ideas down on yellow pads and lined paper before typing them up and filing them in a three-ring binder with the overall working title "Things We Know About." Each individual list was also titled "Things We Know About," followed by a specific species or character name, such as "Things We Know About the Trash Heap."

Initial discussions explored the broader goals of the show, including how to tackle conflict resolution without ever using the phrase itself. "We wanted the world we created to embody basic principles," says Stevenson. "Appreciating differences, working together to find solutions, and caring for the environment—without overtly teaching them. But because Jerry Juhl, one of the world's great character comedy writers, was involved, there was no way we'd be starting with abstract ideas like conflict resolution or differing perspectives. We'd be starting with characters, preferably with characters who made us laugh."

With this in mind, the priority became crafting the main

BOTTOM Early concepts for Fraggles by Michael K. Frith, possibly Red (left), Mokey (center), and Boober (right), drawn during or immediately after the Hampstead brainstorm meetings.

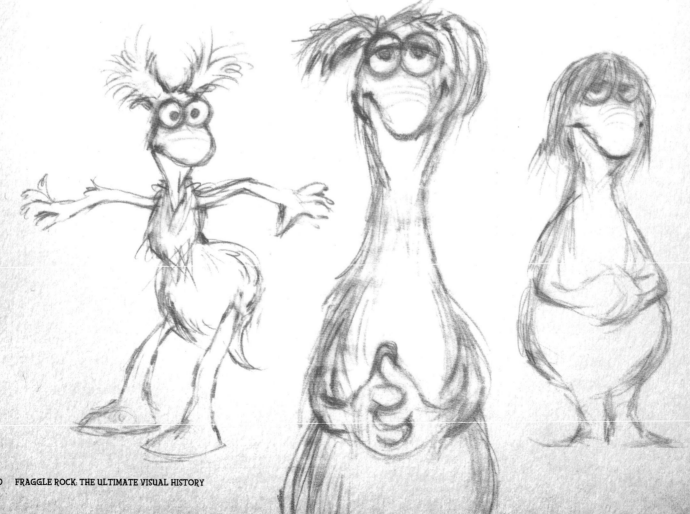

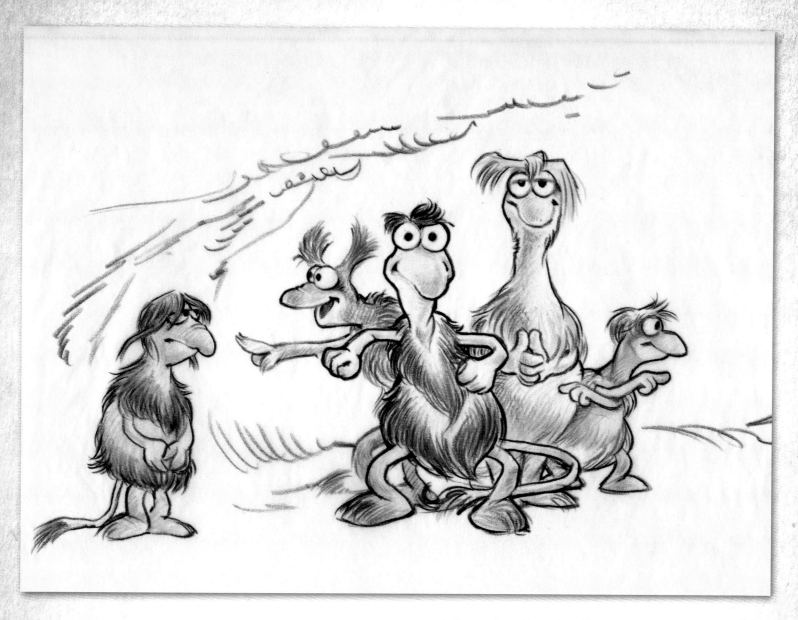

characters and developing relationships between the three species. "Jim and Jerry were huge fans of *Pogo*," says Frith, referring to the syndicated comic strip created in the late 1940s by cartoonist Walt Kelly. Pogo Possum lived in the southeastern United States' Okefenokee Swamp, surrounded by a gang of philosophical, witty, and trouble-prone animal pals. "There are several classic groups like that—*Winnie-the-Pooh*, *Peanuts*—and these groups of characters work because *collectively* they become the one character that defines their world," continues Frith. "What you do is you look at the whole group as a character and then you divide that character up into the different aspects of its personality."

Within this narrative dynamic, Frith adds, one character still emerges as the leader. "That's the one they all look up to, the one around which all the others revolve," he explains. "Though the central [character] is often the least interesting in many ways, because he's not the really quirky one." The leader for *Winnie-the-Pooh* is, obviously, Pooh; for *Peanuts*, it's Charlie Brown. For *The Muppet Show*, it is the seemingly unflappable

Kermit the Frog, surrounded by Miss Piggy, Fozzie Bear, Gonzo, et al. The leader of the group serves a most important role: He or she usually has the most defined perspective, is the character the audience can most easily relate to, and helps keep the story on track.

The creators' intuitive storytelling sensibilities came to the fore when distributing personality traits to the rest of the group. "We didn't sit down and think, 'Okay, what five archetypes are we representing here?'" says Jocelyn Stevenson. "We needed a good, solid group of characters who would give us the most potential for stories. And, for good stories, you need conflict. Out of the five characters, two had to be girls. It seemed obvious to me that one of them had to be a girl of action!" As conversations progressed, the basics of the main group of characters started to take shape: the artistic, slightly hippie-dippie girl; the enthusiastic innocent; the born leader; and a pessimist who would offset the other Fraggles' manically positive energy.

"But we never thought in terms of specific archetypes—just

TOP A "color experiment" for the Fraggle Five by Michael K. Frith illustrated sometime in the summer 1981 but deemed "a little too subtle" in handwritten notes. Frith played around with color to help the characters' personalities emerge.

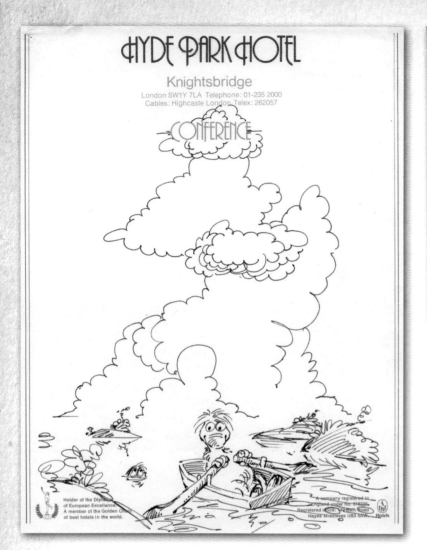

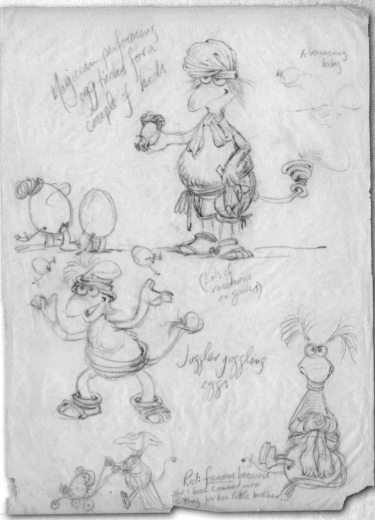

lovable characters with obsessions and vulnerabilities," says Stevenson.

Finally, "though each character may have some dominant trait, each also contains its opposite," Frith adds. The leader may have a bit more ego than is good for him, the indecisive character actually *can* see the other side to a question, the artsy girl may be trapped in her own unreality, the other girl's call to action can land her in deep trouble, and the pessimist may be the one who saves them all. "So, the end result is a collective character that would be woefully incomplete were any one of them to be lost," Frith explains. "And hopefully the viewer becomes invested in them collectively, identifying with each and all of those same traits that make that person who she/he is."

As ideas continued to fill the binder, the team came to realize that they had yet to address the most fundamental element of the show. "Every now and then, we'd stop our list making and face the fact that we needed to name these species and characters," says Jocelyn Stevenson. "Easier said than done!"

Searching for the perfect name for the main species—until then known as Woozles—Jerry Juhl suggested "Frackles," borrowed from a colorful group of monsters in the 1970 Muppet television special *The Great Santa Claus Switch*. "Then,

Jerry reconsidered and said, 'Well, I always loved the name Frackle, but those were bad guys, so we certainly don't want to call them Frackles,' " recalls Michael K. Frith. "We threw it around a bit. I don't remember who said what, but if you use the softer sound of *g* and you don't have that hard edge of the *ck*, suddenly it becomes a warm word instead of a hard word. We all went, *yeah*. So that's how they became Fraggles."

Once the name was chosen and that pressure was lifted, the lists the team created became more detailed, and connections between the species were explored. "Fraggles," they typed, "live by The Word. And The Word is 'WHOOPIE!'" Fraggles were described as being eighteen inches tall and furry. They love to sing and "explore ways to make merriment." It was decided that the Fraggles were also gatherers and took food from the nearby garden patch outside their home, not realizing these giant vegetables were farmed by the bigger species.

In the first compilation of the Things We Know About lists, the Fraggles' favorite food is a type of truffle dug up by the smallest species, who endlessly excavate beneath the Fraggle tunnels. To complete the circle, the team decided that the biggest species would not like Fraggles, but would tolerate their forays onto their property because the exuberant creatures

TOP LEFT A Michael K. Frith Hyde Park Hotel sketch depicting a rowing Fraggle.

TOP RIGHT Michael K. Frith sketches for various Fraggle characters, including a magician, a juggler, and Red.

INSERT A 1981 memo from Jocelyn Stevenson outlining the goals of the International Children's Show.

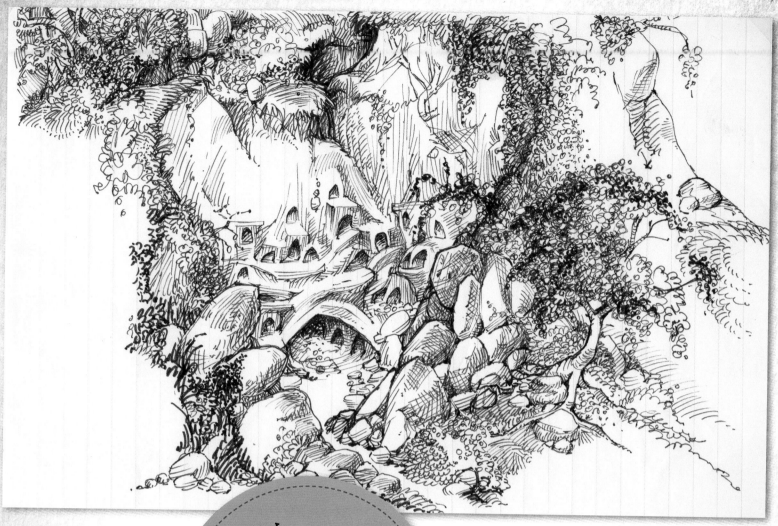

would collect garbage from the garden and sacrifice it to their sacred Trash Heap.

The Things We Know About notebook continued to grow, with the lists refining and fleshing out the cultures of the three species. A wide range of elements were covered, from how they spent their time to who was in charge of each community—which in the case of the Fraggles was the Omnipotent Venerable Council of Sages, composed of the first nine Fraggles to show up at City Hall each morning!

In addition to composing and singing songs, dancing, celebrating, playing games, and wearing silly hats, Fraggles were avid swimmers, and the swimming hole in the Great Hall of Fraggle Rock was the hub of most activity. Every Fraggle had a job, and was required to stick to it for at least thirty minutes a week. The Fraggles' favorite snack was changed from truffles to radishes, which they would now gather from the big creatures' garden. And the Solemn Fraggle Oath: "Weeba Weeba Waffa Waffa Garpox Gumbage Whoopee!" would be chanted while hopping in a circle.

> In addition to composing and singing songs, dancing, celebrating, playing games, and wearing silly hats, Fraggles were avid swimmers, and the swimming hole in the Great Hall of Fraggle Rock was the hub of most activity.

During this further development of the Fraggles' world, Michael K. Frith returned to his sketches from the Hyde Park Hotel meeting and drafted new character designs on the lined yellow pads. "With *Sesame Street* or *The Muppet Show*, characters can be instantly differentiated from each other," he says. "But here, for the first time, I was challenged to come up with a family of characters who were all from the same gene pool, so how could I make it really obvious which one was which? They would have to be much more subtle, but instantly recognizable individuals."

To solve the problem, Frith brought out his "big box of colored pencils" and began to play around, giving each character specific colors for their bodies and hair, plus hairstyles and clothes that would hint at what type of character they might be. All the Fraggles' legs became longer, and their bodies and noses were shortened. Their hair was shortened as well, and, for the most part, their colorful manes were styled in pigtails or would stick out from underneath a hat. As he worked, Frith made notes to himself. "Obvious things like color and texture

TOP Development concept by Michael K. Frith for an aboveground system of caves at Fraggle Rock.

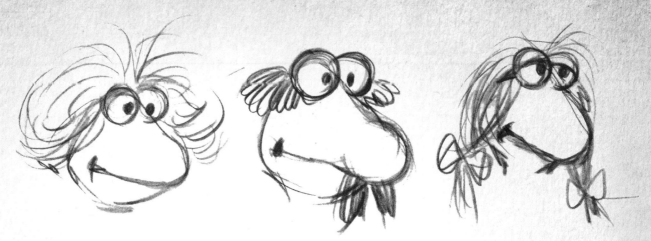

and what they wear," he says, "and things like which one has the spinny eyeballs and which one has the eyeballs that go up and down."

While Frith, Stevenson, and Juhl were compiling their ideas in the Things We Know About lists, Jim Henson and Duncan Kenworthy were finishing preproduction for *The Dark Crystal*. At the end of their workday, they would leave the world of Thra to review the Fraggle team's work. "Jim and Duncan would arrive with dust still on their shoes from a much darker place filled with malevolent creatures and impending doom," says Jocelyn Stevenson. "We'd be all goofy and say, 'Hey, Jim, we decided that the thing that the Fraggles want to do most is decide what to have for lunch.' He would collapse in laughter, just with such relief, with tears running out of his eyes, he was laughing so hard."

According to Frith, Henson was a master at coming up with character names, and many of the Fraggles were christened in the sessions he attended. Henson wanted to use "Boober," the name of a particularly angry cow one of his daughters had recently encountered in the county of Devon, southwest England.[4] Despite this association, Boober would be anything but aggressive. Boober Fraggle is described in his Things We Know About list as "hypochondriac, paranoid, superstitious, and near-sighted. He always seems sad and mournful, pessimistic and negative. To him, April showers bring nothing but colds and fever."

Boober's personality was rooted in conversations Jerry Juhl and Michael K. Frith had enjoyed with Dave Goelz, who would later become Boober's performer. Once, on a plane ride back to London to film a season of *The Muppet Show*, Juhl and Goelz began talking about the state of their lives. "I was riffing about being obsessed with death and laundry," Goelz recollects. "This is how I saw life at the time: constant laundry, and then you die. And Jerry just loved that." Back at *The Muppet Show* studio in London, Frith overheard Goelz speaking on the same subject. "I was walking by the greenroom and heard somebody ask Dave what he was doing. He answered, 'Oh, I'm doing my laundry list. Life, it's just death and laundry.' And I thought, *Thank you, Dave. That's going to be a character someday*." Not surprisingly, Boober was put in charge of the Fraggles' laundry—a task the gloomy Fraggle loved.

The origins of Mokey Fraggle's name are clouded in mystery, although it's possible it was drawn from a script treatment written by Henson and Juhl in the mid-1960s about a character who masqueraded as a famous model called Moki. Mokey was designated the artistic Fraggle. She "is the least Fragglish" of the group, now referred to informally in the notes as the Fraggle Five. "Mokey has amazing powers of observation," her Things We Know About entry states, "but if her friends are focused in one direction, she is almost always looking at something else—and that different way of thinking often finds the solution to a problem." Artistically talented in many disciplines, Mokey

TOP Michael K. Frith concepts for taking the already established Fraggle Five puppet heads and dyeing them different colors so they could be used as background Fraggles. *(Left to right)* Gobo, Wembley, and Boober.

BOTTOM A proportion chart showing the relative heights of the Fraggle Five.

OPPOSITE Fraggle Five art drawn by Michael K. Frith at the Sag Harbor American Hotel bar in August 1981. With this sketch, says Frith, "I now absolutely knew these characters—they were finally real and alive, no longer theoretical, and I could, from this moment, begin to flesh (fleece, fur, foam, feather) them out for the rest to see."

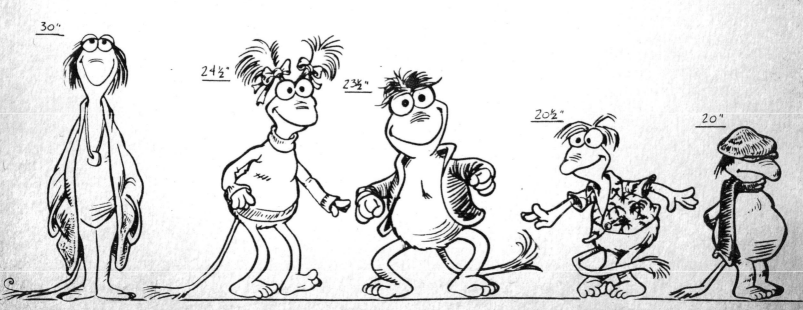

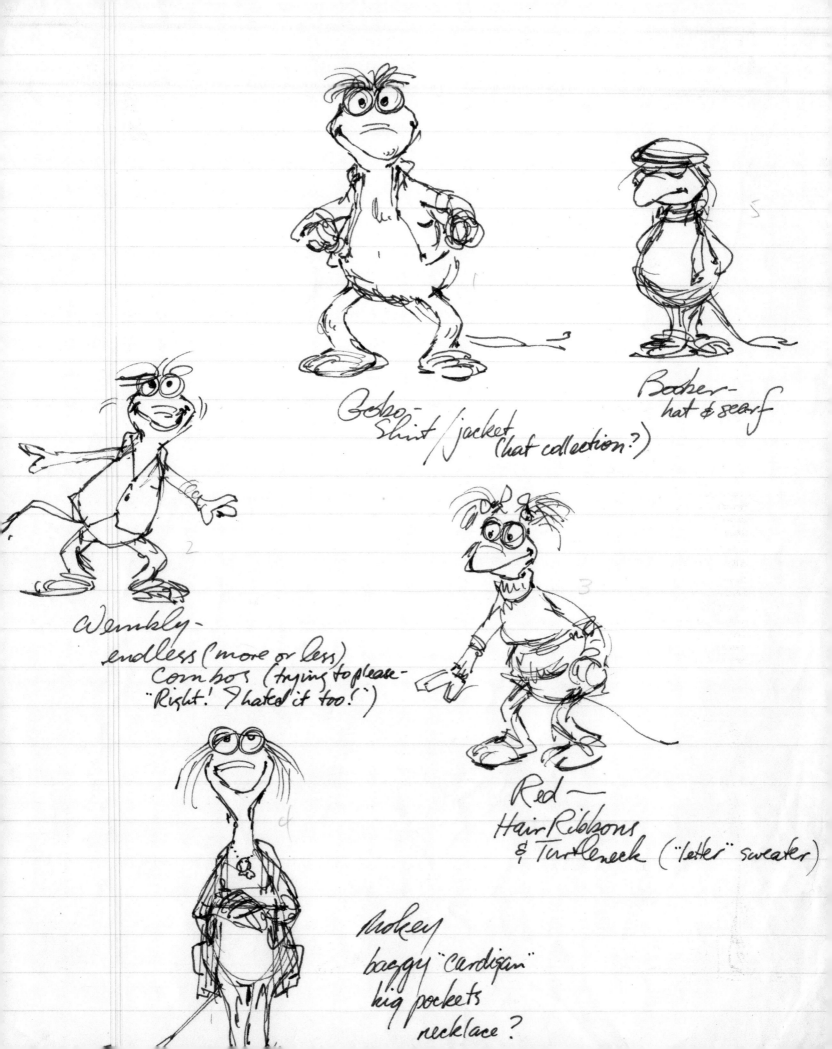

Gobo–
Shirt / jacket
(hat collection?)

Booher–
hat & scarf

Wembley–
endless (more or less)
combos (trying to please–
"Right! I hated it too!")

Red–
Hair Ribbons
& Turtleneck ("letter" sweater)

Mokey
baggy "cardigan"
big pockets
necklace?

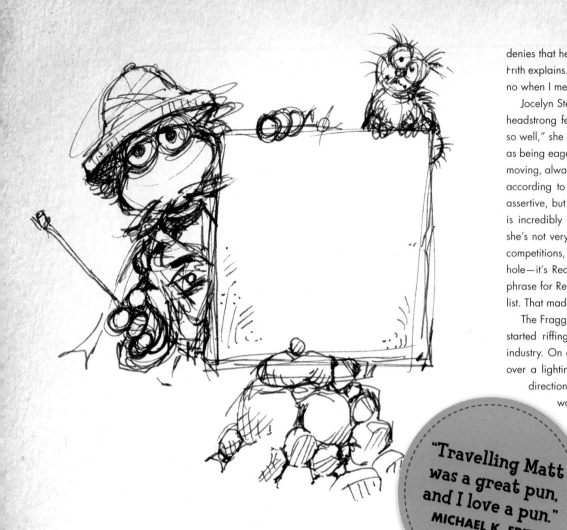

denies that he has. "But she tells him she just saw him with it," Frith explains. "And he replies, 'Yes, I meant yes. Why did I say no when I meant yes?' That became Wembley."

Jocelyn Stevenson suggested the name Red for the spirited, headstrong female Fraggle "because it fit her fiery character so well," she explains. Red, the "girl of action," was described as being eager, often to the point of impatience. "She's always moving, always poised, ready to jump (or fall) in any direction," according to Things We Know About Red. "She's loud and assertive, but only because she is terrifically enthusiastic." Red is incredibly energetic and loves sports of any kind, though she's not very graceful. She loves putting together events and competitions, and usually hosts them at the Fraggles' swimming hole—it's Red's job to keep the popular venue clean. "A key phrase for Red is 'action unencumbered by thought,'" says the list. That made her "particularly Fragglish."

The Fraggle group's leader would be named after the team started riffing on technical terms used in the entertainment industry. On a film set, a "gobo" is a screen or shield placed over a lighting source that masks or controls the shape and direction of the light. The team liked the name because it was also reminiscent of "Pogo," the character that influenced the Fraggles. They decided Gobo would be the leader of the group, writing in their Things We Know lists that he would be "the most stable and sensible of the five . . . at least by Fraggle standards." Gobo is a natural organizer and "the first one up in the morning." ("Go" is the first syllable of his name, after all.) It's Gobo's job to map the tunnels and caves of Fraggle Rock, a role he chose himself, inspired by his adventurer uncle.

> **"Travelling Matt was a great pun, and I love a pun."**
> MICHAEL K. FRITH

writes poetry, paints, and illustrates a diary of current events. She also has a passion for Fraggle history, and her desire to learn more about her species often leads to adventure. She's a dreamer and in a world of her own, so she depends less on the group for entertainment but often needs their help to get her out of a bind. Mokey always tries her best to be considerate of others' feelings, but she has a tendency to not think things through, and so, in trying to save the world, she often wrecks it first.

Jerry Juhl suggested the name "Wembley" for the most hesitant character in the group. "Jerry saw a reference to Wembley Stadium in the newspaper," says Jocelyn Stevenson. "We all loved the name because it also gave us the verb 'to wemble,' meaning 'to dither,' which is what Wembley did." "But Wembley has a strong moral sense," reads his description. "He'll wemble to a point and then, watch out! His sense of right takes over and he digs in his little green heels."

Wembley's indecisive nature evolved from an exchange of dialogue in The Great Muppet Caper that had made an impression on Michael K. Frith. In the film, Kermit, Gonzo, and Fozzie Bear travel to England to find the thief of the priceless Baseball Diamond necklace owned by Lady Holiday (played by Diana Rigg), a rich, acerbic fashion designer. When she discovers the necklace is missing, Lady Holiday asks her brother, Nicky (Charles Grodin), if he has seen it, and he

That traveling uncle character, who would leave the hole and go out into the "Real World," was taken straight from Henson's *Woozle World* treatment. "Once we got Gobo [from tech jargon]," says Kenworthy, "we all came up with the name Travelling Matt." A travelling matte is a visual effects technique commonly used with blue screen, which combines the silhouette of a moving character or object with a background film plate. "Travelling Matt was a great pun, and I love a pun," says Frith.

Frith based his sketches for Uncle Travelling Matt on his own uncle Will, who was not a bumbling adventurer, but a general and World War II hero. Frith did not know him well because Will lived in the US and visited his nephew in Bermuda only three times. "He was this distant romantic figure," Frith remembers. "Uncle Will was that person who was the messenger from beyond, for me, beyond the sea, out there in the other world, that mysterious place." Travelling Matt is the only known Fraggle who has walked through the Fraggle Hole and outside into "Outer Space." Matt mails postcards of his adventures to his nephew Gobo, which relate his experiences among the "Silly Creatures," his name for anything (man, woman, dog, or fire hydrant) he might come across in his explorations.

TOP Character design for the unflappable, safari-hatted Uncle Travelling Matt Fraggle by Michael K. Frith.

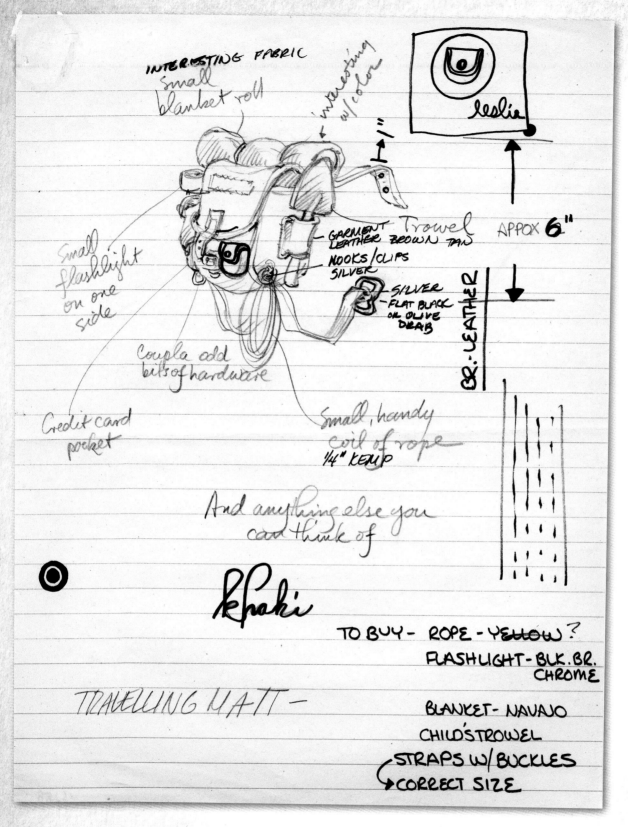

INTERESTING FABRIC
small blanket roll

interesting w/color

leslie

APPOX 6"

Small flashlight on one side

GARMENT LEATHER BROWN TAN Trowel

NOOKS/CLIPS SILVER

SILVER
FLAT BLACK
OR OLIVE DRAB

BR. LEATHER

Coupla odd bits of hardware

Credit card pocket

Small, handy coil of rope
1/4" KEMP

And anything else you can think of

Khaki

TO BUY - ROPE - YELLOW?
FLASHLIGHT - BLK. BR.
CHROME

TRAVELLING MATT -

BLANKET - NAVAJO
CHILD'S TROWEL
STRAPS W/ BUCKLES
CORRECT SIZE

As they worked on names and personalities for the Fraggle characters, Kenworthy, Frith, Juhl, and Stevenson concentrated on fleshing them out with hopes, fears, and idiosyncrasies. Central to this was creating the relationships among the Fraggle Five themselves.

"Each of those characters has its own personality," says Michael K. Frith, "and within that, what you do is create duos, because it's always the duos that create the energy." Gobo and Wembley were paired off often, as were Mokey and Red. "Boober was like the odd man out, but he interacted with all of them," Frith continues, "so he could have a relationship with each of them on its own terms, whereas the other two pairs had very particular relationships. They all related to each other all around, but when they were together you had the pairs doing material, if you will, that just grew naturally out of their relationships."

TOP A sketch by Michael K. Frith for Travelling Matt's trusty backpack.

INSERT A 1982 draft of the *Things We Know About Fraggles* document.

THE BIG, THE SMALL, AND THE LEAFY

TO FIND NAMES FOR OTHER CHARACTERS, the team would try out different sounds and nonsense words "until an appropriate one that we all liked came out," says Jocelyn Stevenson. This process led to the name "Gorgs," chosen for the show's biggest species, previously known as Giant Wozles. "Ninety-nine percent of names are just noises that sound as if they should be that thing," says Michael K. Frith. "'Gorg' sounds big and round, and *Gorg*. It just has that kind of feeling about it."

According to Things We Know About Gorgs, the species once "ruled the universe. Now all that remains of the Gorg Royal Family is Ma, Pa, and Junior Gorg. How the Gorgs fell from power is unknown, but it probably had something to do with stupidity." The Gorgs live in a crumbling castle, and, with no subjects to rule, have become farmers in order to eke out a living. Junior, the heir to the throne, does most of the work, while Ma and Pa spend most of their time bemoaning their lost status.

The name of the smallest species, originally Wizzles, tripped up the team for a while. "We just couldn't name those

little guys," says Stevenson. "We knew they were going to be working. We knew a lot about what they were doing, we just didn't know what to call them."

After an intense morning brainstorming session attended by Henson and Kenworthy, Henson suggested that he, Stevenson, and Juhl take a walk to clear their heads.

The trio headed to one of Henson's favorite spots: "Don's bench" atop the highest hill on Hampstead Heath. Henson had this particular bench inscribed in tribute to the memory of his close collaborator Don Sahlin, who had died three years earlier.

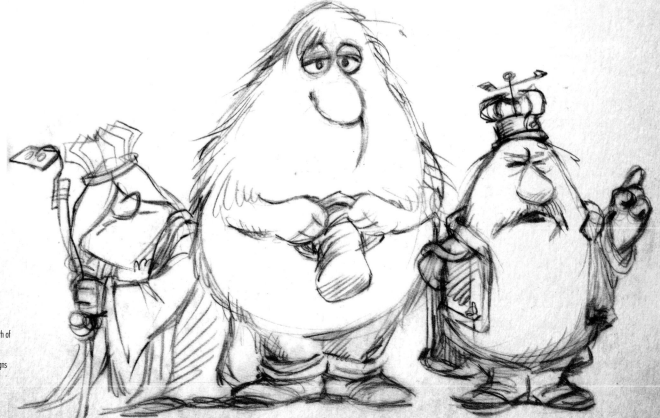

BOTTOM Concept sketch by Michael K. Frith of Ma Gorg, Junior Gorg, and Pa Gorg.

OPPOSITE TOP Early Michael K. Frith designs for the Gorgs.

OPPOSITE BOTTOM A range of very early Doozer sketches by Michael K. Frith.

Sahlin was hired in the early 1960s to design and build Muppets for Henson's earlier company Muppets Inc.—the first being Rowlf the Dog—and his aesthetic ended up having a huge impact on the look of Henson's TV shows and films for years to come.

"As we were walking, we talked about how much he would have loved those little creatures," says Stevenson, "Jim and I sat down on Don's bench at the same time, and we simultaneously said *Doozers*. And then, immediately, we went, 'Thanks, Don.' That was a magical moment."

During the development process, the Doozers became compulsive builders rather than excavators like the Wizzles. "They build because they always have built and they always will build," reads Things We Know About Doozers. Unlike Fraggles, Doozers never stop working. But they don't work because they have to; they work because they love to. The towers and bridges they build are considered delicious by Fraggles. Michael K. Frith originally imagined the Doozers' building materials being derived from sugar cubes or sugar sticks, until the team made radishes the Fraggles' food of choice. From this grew the idea that Fraggles would constantly snack on the Doozers' constructions, inadvertently creating more work for the industrious little creatures. "Radishes are funny," Frith says. "It's a funny vegetable. It doesn't taste great, and that's part of what's funny about it. But both Fraggles and Doozers think they're just wonderful and can't get enough of them."

"They don't mind when the Fraggles eat their constructions," adds Jocelyn Stevenson, "because it just gives them the chance to build more. As [Doozers] say, 'Architecture is meant to be enjoyed.'"

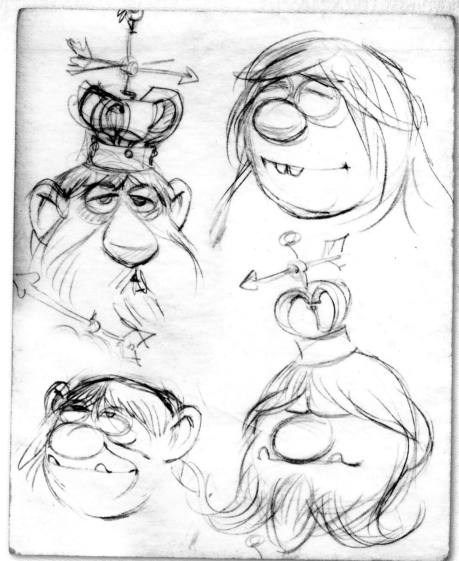

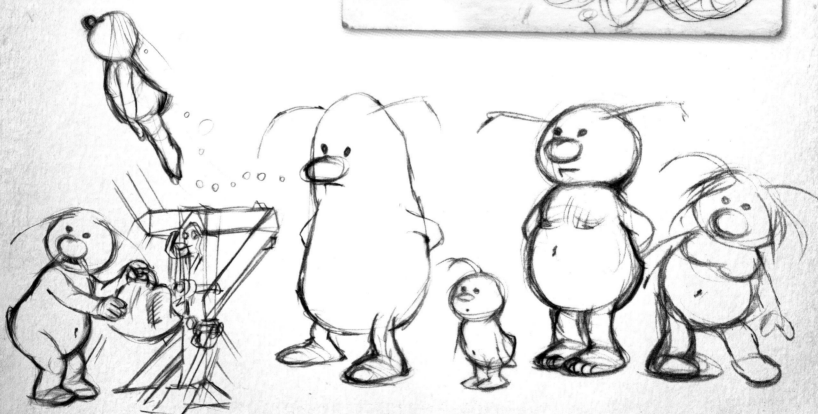

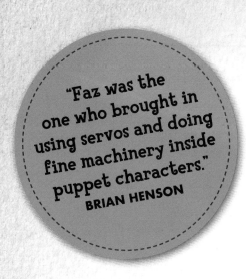

"Faz was the one who brought in using servos and doing fine machinery inside puppet characters."
BRIAN HENSON

During the brainstorming sessions, the human inventor character known in the *Woozle World* outline as the Codger was renamed Faz. This was Jerry Juhl's tribute to the head of the Muppet Workshop's electromechanical department, Franz "Faz" Fazakas. Fazakas started as a puppeteer with the Bil and Cora Baird marionette troupe in the 1950s and in 1970 joined Henson Associates, where he built puppets for the fairy tale–themed *Tales from Muppetland* specials. Once his talent for technology was recognized, he was switched to the Muppet Workshop full time, where he was responsible for many technical breakthroughs for the company. "He came from a family of working builders and super-high-level craftspeople," says Brian Henson. "Faz was the one who brought in using servos and doing fine machinery inside puppet characters. When Faz came in, that's when we started building with machined aluminum parts and motors—that was Faz."

There was one more central character who needed to be named—a species unto herself who was an important part of the Fraggles' world. The all-knowing trash heap character had first been suggested by Michael K. Frith at the Hyde Park Hotel meetings, and then later worked into the *Woozle World* treatment by Henson. "When archaeologists look into an ancient civilization, they don't go to the castle, they go to the dump," Frith explains. "It's where you really find out how people lived. So, I've always loved the idea of a dump as being a great repository of knowledge, and a living dump could then impart that knowledge to you."

Frith had originally suggested the trash heap idea several years earlier, when *Sesame Street* was looking to revitalize its cast for the show's tenth anniversary in the late 1970s. Never realized, the idea had sat in Frith's drawer for years until he finally had the opportunity to bring the character to leafy life as Marjory the Trash Heap, mystic oracle of the Fraggles, who resides in the Gorgs' garden. One of Marjory's main functions in the show would be to provide a voice of reason among the clashing perspectives of the three species. "My aunt Marjory always claimed that it was named after her, but I can't swear to it," says Duncan Kenworthy. "I have no recollection who threw

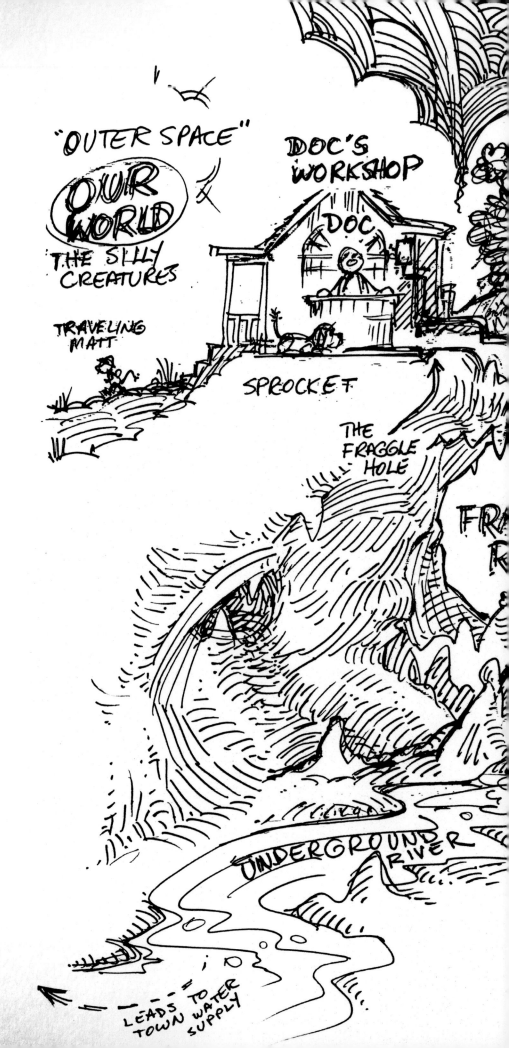

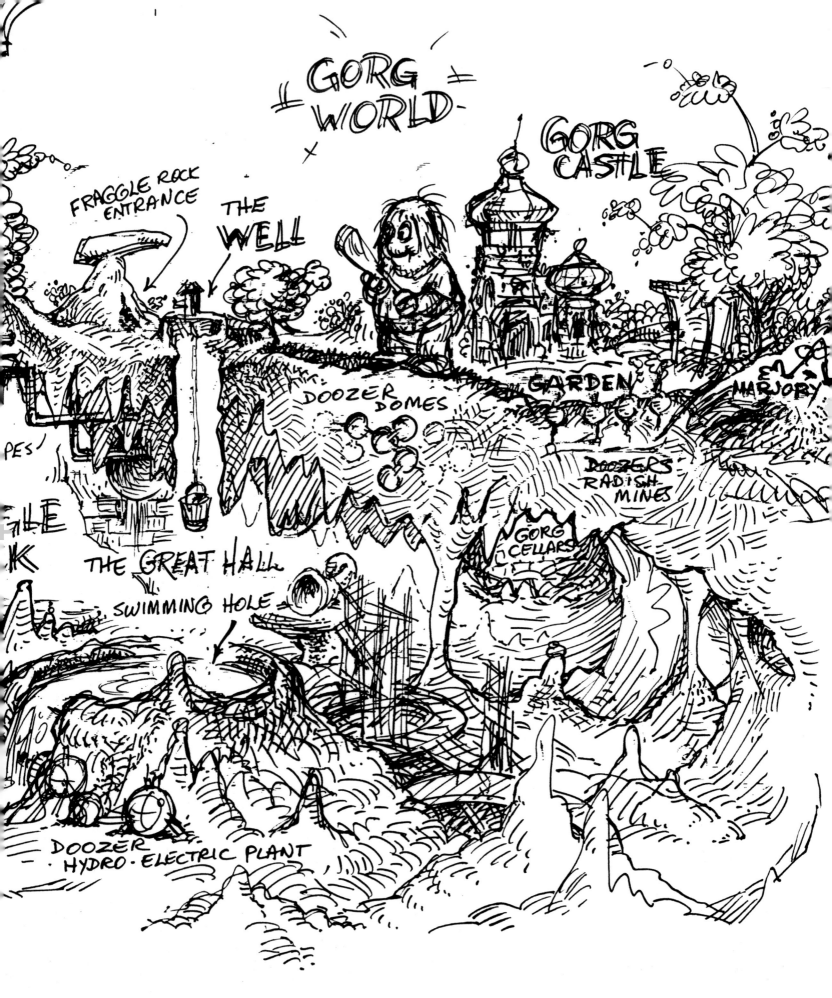

GORG WORLD

GORG CASTLE

FRAGGLE ROCK ENTRANCE

THE WELL

DOOZER DOMES

GARDEN

MARJORY

DOOZERS RADISH MINES

GORG CELLARS

THE GREAT HALL

SWIMMING HOLE

DOOZER HYDRO-ELECTRIC PLANT

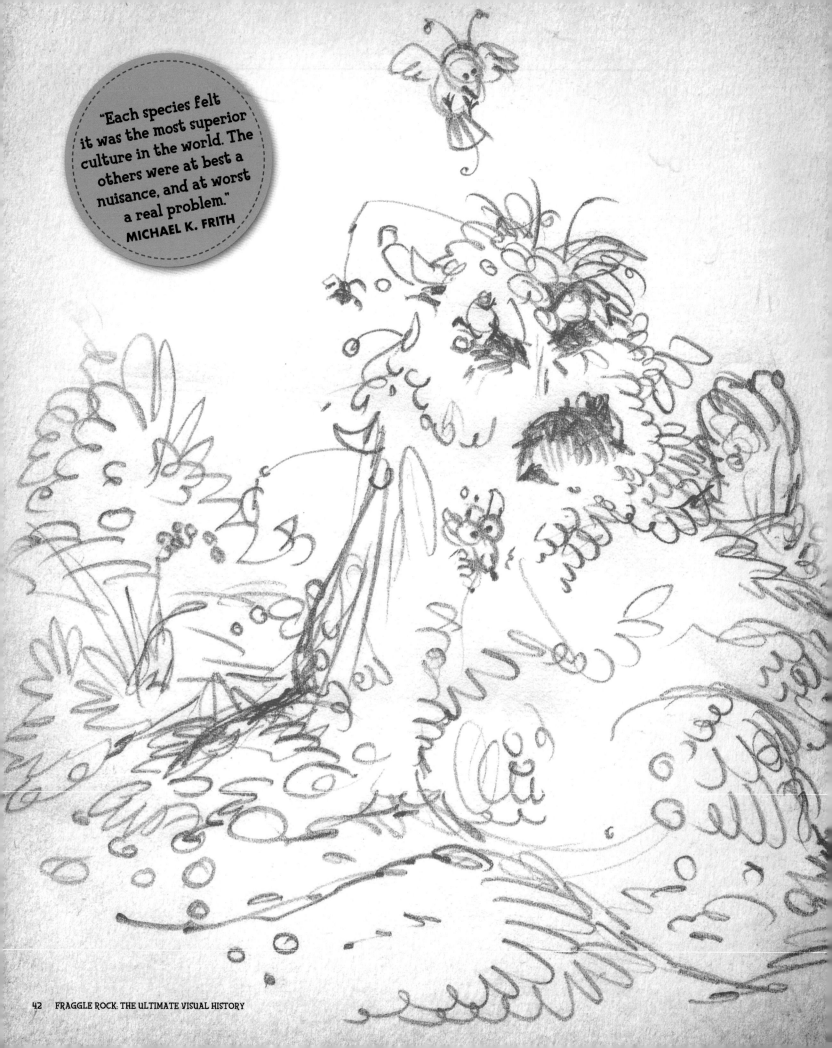

"Each species felt it was the most superior culture in the world. The others were at best a nuisance, and at worst a real problem."
MICHAEL K. FRITH

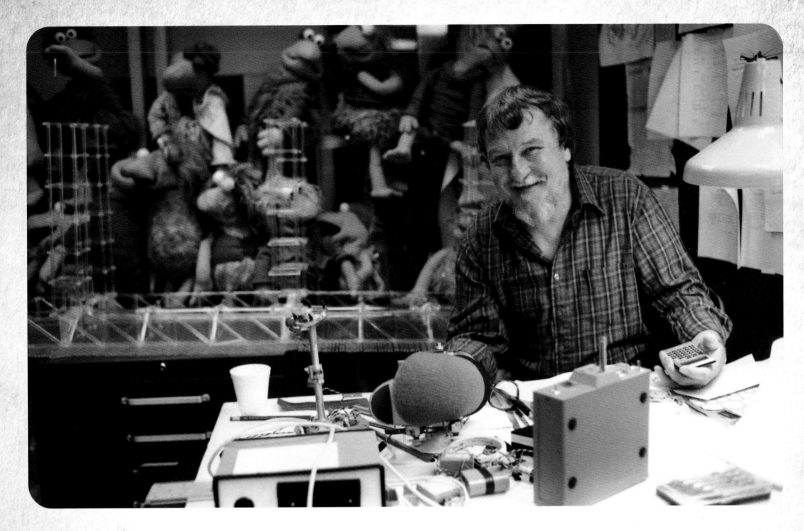

it in. My aunt was a fount of all wisdom, though, and wonderful." Marjory the Trash Heap knows all and sees all—she *is* all. "I'm orange peels," says her description in the Things We Know About binder. "I'm coffee grounds, I'm wisdom!"

For the creators, the sheer size difference between the beings was fertile ground for misunderstanding. "Everyone accepts that a Fraggle might be frightened of a gigantic Gorg and may think that the smaller Doozers are beneath notice," says Stevenson. "Similarly, Gorgs think of Fraggles as pests, and are so much bigger than the Doozers that they don't know they exist."

As a consequence of their physical differences and perspectives, "each species felt it was the most superior culture in the world," adds Frith. "The others were at best a nuisance, and at worst a real problem. And as cultures do, they misunderstood each other completely, particularly failing to understand how each one of them was absolutely dependent upon the others for its existence. And that, of course, was the crux of the whole thing."

To accentuate the dependency among the species, the creators wanted to find a tangible incentive that would define their bond. "Since all these species lived in the same world, they were naturally connected," says Jocelyn Stevenson. "But how? The first connection was water. As everyone on Earth is connected by the need for water, it was particularly exciting to find out how it worked in [this world]."

PAGES 40–41 Map of Fraggle Rock by Michael K. Frith showing the flow of water from human character Doc's pipes and the Gorgs' garden well to the Fraggles' swimming hole, descending to a hydroelectric plant run by the Doozers.

OPPOSITE A preliminary study of a humanoid Trash Heap by Michael K. Frith, drawn at the Hyde Park Hotel meeting in 1981.

TOP Franz "Faz" Fazakas in his workshop.

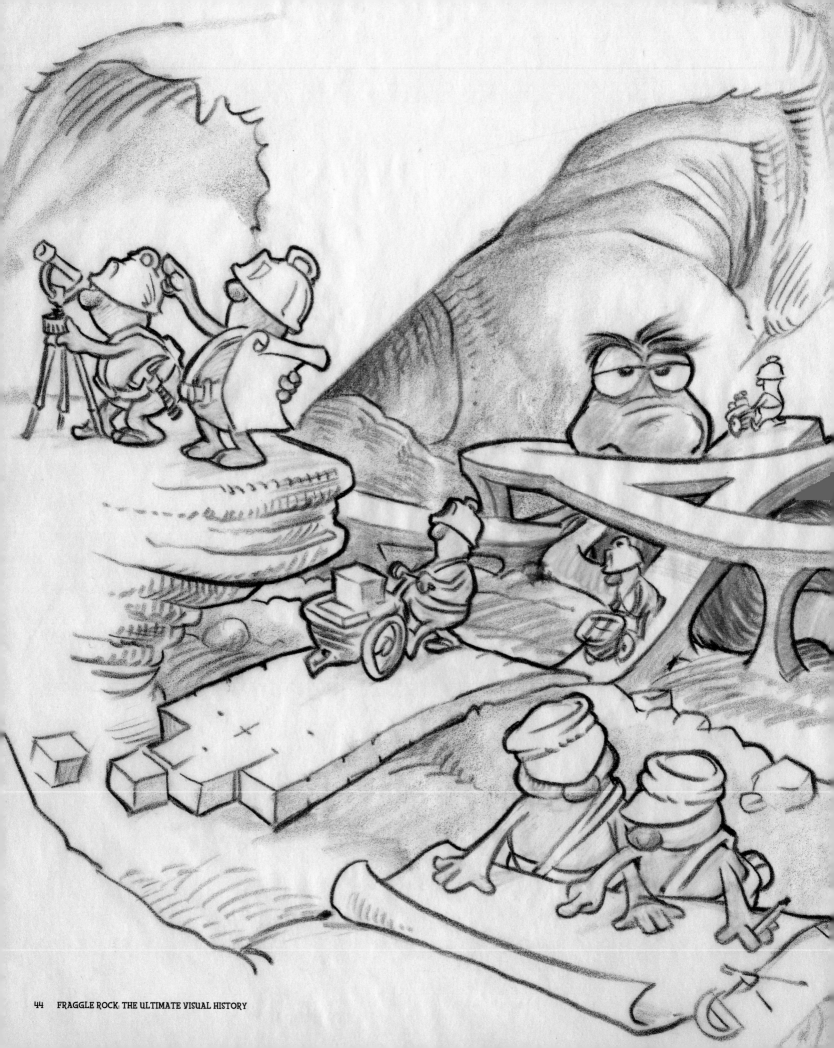

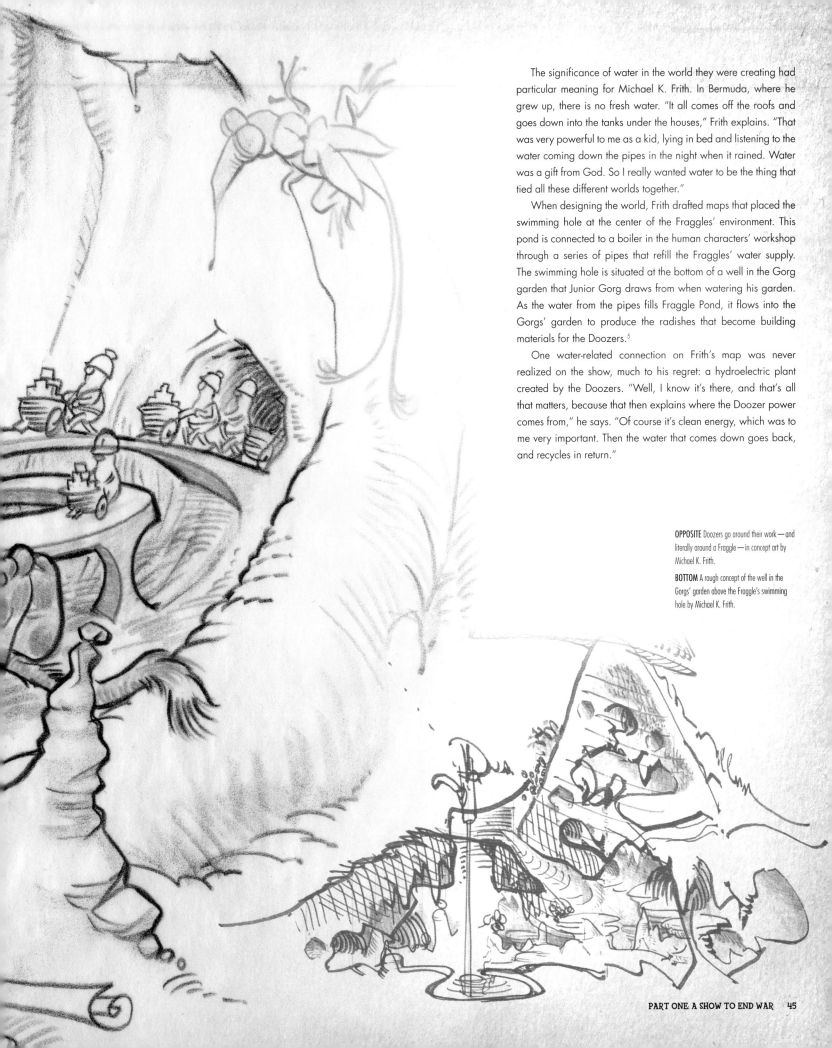

The significance of water in the world they were creating had particular meaning for Michael K. Frith. In Bermuda, where he grew up, there is no fresh water. "It all comes off the roofs and goes down into the tanks under the houses," Frith explains. "That was very powerful to me as a kid, lying in bed and listening to the water coming down the pipes in the night when it rained. Water was a gift from God. So I really wanted water to be the thing that tied all these different worlds together."

When designing the world, Frith drafted maps that placed the swimming hole at the center of the Fraggles' environment. This pond is connected to a boiler in the human characters' workshop through a series of pipes that refill the Fraggles' water supply. The swimming hole is situated at the bottom of a well in the Gorg garden that Junior Gorg draws from when watering his garden. As the water from the pipes fills Fraggle Pond, it flows into the Gorgs' garden to produce the radishes that become building materials for the Doozers.[5]

One water-related connection on Frith's map was never realized on the show, much to his regret: a hydroelectric plant created by the Doozers. "Well, I know it's there, and that's all that matters, because that then explains where the Doozer power comes from," he says. "Of course it's clean energy, which was to me very important. Then the water that comes down goes back, and recycles in return."

OPPOSITE Doozers go around their work — and literally around a Fraggle — in concept art by Michael K. Frith.

BOTTOM A rough concept of the well in the Gorgs' garden above the Fraggle's swimming hole by Michael K. Frith.

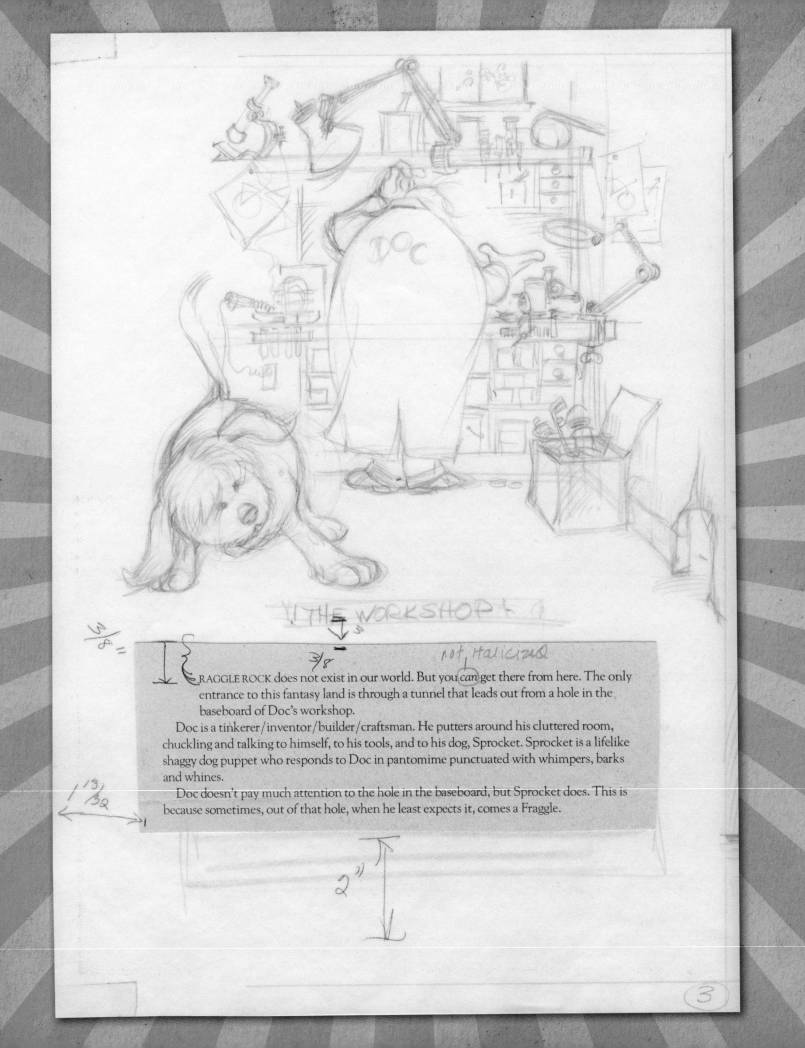

THE WORKSHOP

FRAGGLE ROCK does not exist in our world. But you *can* get there from here. The only entrance to this fantasy land is through a tunnel that leads out from a hole in the baseboard of Doc's workshop.

Doc is a tinkerer/inventor/builder/craftsman. He putters around his cluttered room, chuckling and talking to himself, to his tools, and to his dog, Sprocket. Sprocket is a lifelike shaggy dog puppet who responds to Doc in pantomime punctuated with whimpers, barks and whines.

Doc doesn't pay much attention to the hole in the baseboard, but Sprocket does. This is because sometimes, out of that hole, when he least expects it, comes a Fraggle.

3/8"

3/8

not italicize

1 13/32

2"

ON THE SAME PAGE

THE TEN-DAY BRAINSTORM SESSION PROVED TO be a watershed moment in the creation of the International Children's Show. Although they had faced the daunting task of building an ambitious television series from scratch, Jerry Juhl, Michael K. Frith, and Jocelyn Stevenson all felt as if they weren't creating anything at all. "It was always as if this world of the Fraggles already existed in some great encyclopedia and we were turning the pages and making these discoveries," says Frith. "And because our discoveries emerged one by one, as discoveries do, we kept track of them. It was great fun. As each 'Thing' revealed itself to us, we whooped and hollered and threw stuff around." So raucous were the meetings that after the gathering in the Hampstead Heath house came to an end, the property's gardener approached Lisa Henson to ask if she was okay. For two weeks, he had heard screaming and yelling coming for the house and had grown worried when it suddenly became quiet!

Frith, Stevenson, and Juhl scattered to their respective homes in New York, Scotland, and Northern California to work on other projects, but kept up the brainstorming process over the following weeks. Through phone calls and memos, more ideas were added to the Things We Know About notebook until it was decided that Jerry Juhl, as the professional writer, should use what they had compiled to start basic plots for the show. In mid-August 1981, Juhl sent his co-creators a script featuring a half-dozen sample scenes, apologizing in a cover memo that there was no attempt at continuity in the story fragments. For the purposes of this early draft, he was "not paying attention to our noble and worthwhile goals" of "cooperation, social interaction, and all those other -tion words." These matters would be addressed in the next draft.

In the script, Juhl swapped one letter in the human character's name, turning "Faz" into "Foz." Juhl had Foz breaking the fourth wall and directly addressing the camera when explaining his latest invention, but this approach was soon abandoned. Juhl's scenes included a sequence in which the Gorgs are revealed to be commoners pretending to be royalty; in this version the "prince" of the family is named Jerome. Another scene had the Fraggles assembling in a town square where they burst into a "rousing, foot-stomping, hand-clapping, tail-wagging song called 'Fraggles Forever.'" Notably, as he describes this scene, Juhl inserts the question "Do Fraggles have tails?"

Juhl's accompanying memo ended with a plea to Michael K. Frith: "There are a lot of holes here where I need all the visual help you can give me. What does the world of the Fraggles look like?" These holes were all part of Frith's process: He often opted to avoid finalizing concept art until the very end of the brainstorming period. "I always drive people crazy when I work on a project because I seldom sit down to do final drawings or

designs on anything until I really know everything about it," he says. "I need to really know it and internalize it and understand it before I do a lot of miscellaneous scribbling."

Pressure to get the show up and running was beginning to build. Filming for *The Dark Crystal* would be finished by the end of summer 1981, so Jim Henson was ready to finalize the Fraggle concepts and get the ICS into production. A follow-up meeting attended by Frith, Stevenson, and Juhl took place at

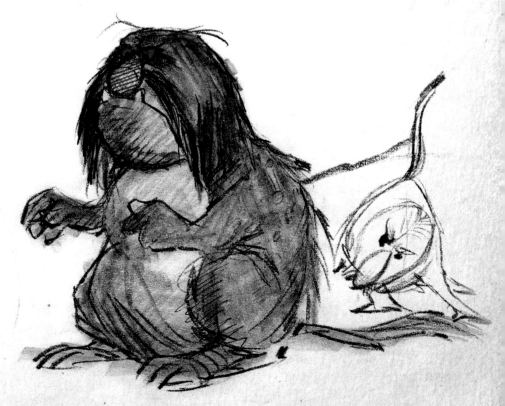

OPPOSITE Preliminary page layout for a descriptive concept book used to pitch potential broadcasters, producers, crew, backers, and licensees on the show. The design combines concept art of Doc's Workshop by Michael K. Frith and text about the characters and location. Per Frith, this is "*the* introduction to the worlds of Fraggle Rock, key to the whole thing."

BOTTOM A background creature known as Aretha illustrated by Michael K. Frith.

the end of August, in Sag Harbor, New York, where Jocelyn Stevenson had rented a house for a family vacation. Michael K. Frith and the Juhls stayed at the nearby American Hotel.

"In Sag Harbor, we looked at the big book of Things We Know About and went, 'Oh, yeah,'" says Michael K. Frith. "That was to say, we've been away from this for a while, we've come back to it, this is working." It was during this reconvening of the creative team that everything began to coalesce, according to Frith. "I had done some scribbles beginning with the very first meeting, but this is when I felt I could begin being really specific about the exact look for each of these characters," he says. "My focus shifted from creating the world and the characters in theory to creating them in fact. I started to do more specific and finished drawings for the shop and the builders, communities that I loved working with."

Much had been accomplished in Hampstead, but there were still some details to work out and final decisions to make during the Sag Harbor gathering. Juhl's earlier question about Fraggles having tails was answered with a resounding "Yes!" It was also agreed upon that all Doozer names should come out of a hardware catalog, leading to designations such as Drillbit, Wrench, and Wingnut. The name of the inventor was changed again, from Foz to Doc, and his dog's name, which had remained George since the *Woozle World* treatment, was changed to Sprocket. "I think it was because how really nice 'Doc and Sprocket' sounds as a combo," says Michael K. Frith, "and my own penchant for names that played on production tech terms." (In film, a sprocket is a wheel with teeth that engages with the perforations in a film strip to move it through a camera or projector.)

After Doc and Sprocket received their final names, the co-creators nailed down the details of the duo's special relationship. According to their combined Things We Know About entry: "Sprocket is the perfect companion—intelligent, responsive, and he knows where all his tools are. As far as Sprocket is concerned, Doc is the best thing since sliced steak, only crazier." Doc talks endlessly to Sprocket, who communicates back through whimpers, barks, yelps, and physical pantomime. Sprocket can see the Fraggles when they enter Doc's workshop, and tries to alert him, but the human doesn't believe they exist; he can't see them and dismisses any sounds that come from behind the Fraggle Hole as plumbing noises.

Doc's neighbor is Ned Shimmelfinney, who alternates between being a friend and a competitor, depending on the circumstance. Ned is never seen or heard, but Doc talks to him on the phone or through the door. However, Ned's cat, Fluffinella, who loves to antagonize Sprocket, occasionally leaps through the workshop doorway to cause trouble.

The team also tried to add a fourth species to the mix. In the original *Woozle World* treatment, Henson had jotted a note about strange, tiny insects called Squeezles. They could be seen by the Woozles, but they were so small that humans were able to see them only through a microscope. Their relationship to the other species was not defined; Henson gave the impression that they were just another layer to the hierarchy. But the latest Things We Know About lists now included an entry about the smallest species of all, called Ditzies, "possibly the most intelligent creatures in the galaxy," resembling dots of light or pieces of colored dust. The list of what the creators knew about the Ditzies was, not surprisingly, the shortest in the notebook, concluding with the admission that very little is known about them. "Certainly not enough to write them into a show," they wrote cheekily. The Ditzies would ultimately be put on the back burner and revisited at a later stage.

The Sag Harbor meeting led to one more important breakthrough: the name of the place where the Fraggles, Gorgs, and Doozers lived was finally established. Michael K. Frith suggested "Fraggle Hill." "And Jocelyn said, that's so damn wimpy!" Frith recalls. It also sounded too British to them. Stevenson then said, "How about Fraggle Rock?"

"Oh, yeah," Frith replied. "Perfect."

As if it was always there, and they just had to discover it.

The three co-creators were now ready to begin realizing the show in physical form. Michael K. Frith remembers sitting at the bar of the hotel on the last night of the Sag Harbor trip. "I sat there and drew those first 'final' sketches of the characters. I finally knew for sure exactly who they were," he says. The American Hotel was known for its fine wines, "some of which I availed myself of the night we declared ourselves done," he jokes. "That might also help account for the slightly scribbly nature of the drawings."

On September 1, 1981, after the Sag Harbor meeting, Jerry Juhl sent a memo to Jim Henson, Michael K. Frith, Jocelyn Stevenson, Duncan Kenworthy, and puppet builder Bonnie Erickson, opening with the words "You know, this thing just might work." The memo confirmed that they were moving ahead with two stories proposed at Sag Harbor, one to be written by Juhl, the other to be written by Stevenson. The stories selected were not meant to be opening episodes necessarily, but, rather, an opportunity to explore ideas that had arisen while compiling the Things We Know binder. "I was a rookie scriptwriter, so it was really scary!" recalls Stevenson. "But we knew we had to start writing to see what we could discover."

Juhl also suggested that a formal "writer's stylebook" be put together, describing the show and characters in detail. This would be sent not only to prospective scriptwriters, but also to everyone who would be working on the show. His hope was that the reference document would be open-ended and develop into an "encyclopedia of Fraggle Lore."

"Sprocket is the perfect companion—intelligent, responsive, and he knows where all [Doc's] tools are."

OPPOSITE Preliminary draft page for the descriptive concept book handed out to potential partners. Concept art by Michael K. Frith depicts Sprocket watching the unreachable Fraggles in endless frustration.

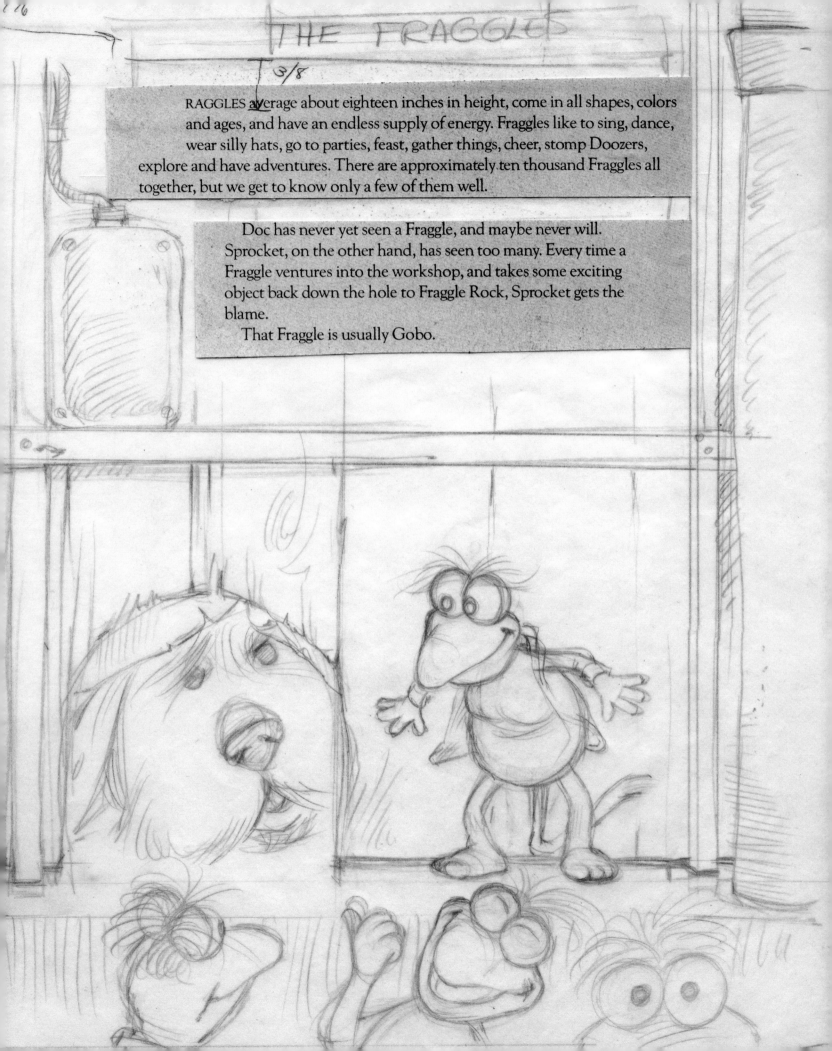

3/8

RAGGLES average about eighteen inches in height, come in all shapes, colors and ages, and have an endless supply of energy. Fraggles like to sing, dance, wear silly hats, go to parties, feast, gather things, cheer, stomp Doozers, explore and have adventures. There are approximately ten thousand Fraggles all together, but we get to know only a few of them well.

Doc has never yet seen a Fraggle, and maybe never will. Sprocket, on the other hand, has seen too many. Every time a Fraggle ventures into the workshop, and takes some exciting object back down the hole to Fraggle Rock, Sprocket gets the blame.

That Fraggle is usually Gobo.

THE PARTNERS

AS THE FIRST SCRIPTS WERE BEING DRAFTED, a concept booklet was put together both for internal reference and to showcase the coproduction concept of *Fraggle Rock* for prospective international partners. Utilizing the plentiful material from the Things We Know About pages, the booklet contained preliminary descriptions of the characters and locations, with illustrations by Michael K. Frith. In order to find the large budget necessary to realize the show, Henson Associates looked to broadcast networks and the rapidly growing pay-cable field, rather than following the model for *Sesame Street* and working with a public television partner.

Duncan Kenworthy and Peter Orton first approached the Canadian Broadcasting Corporation (CBC), based in Toronto, as a potential partner on the production costs. Henson himself had a long history of working in Canada, dating back to his days making commercials in the early 1960s; and several Henson Associates television specials—including *Hey Cinderella!*, *The Cube*, *The Great Santa Claus Switch*, and *The Frog Prince*—were shot in Toronto.

As anticipated, the meeting with the CBC went well. "We were in a boardroom with about fifteen people, all of them head honchos because Jim was such a big deal, talking about CBC getting in on the ground floor of a new Jim Henson puppet series," says Kenworthy. "You could see little smiles creeping from the corners of the mouths of the executives. And by the end of it we got the sale."

The Canadian Broadcasting Corporation would typically

BOTTOM Jocelyn Stevenson writes a *Fraggle Rock* script, taking advantage of early 1980s computer technology.

INSERT The concept book created to explain *Fraggle Rock* to broadcasters, financial backers, creative partners, and the Henson team.

have financed a kids' show through its children's department. Instead, it chose to finance the project through its variety department, headed by Stan Colberg. The CBC made more money available for variety show budgets, and they wanted to allocate as much funding as possible to the first new TV project from Jim Henson after *The Muppet Show*.

To find their second partner, the company that would pay talent costs, Henson went to the subscription television network HBO. At the time, HBO was the top pay-television service with the largest viewing audience, but the race for viewers was increasing in intensity after its subscription channel competitors, The Movie Channel and Showtime, had begun screening movies and sports programming twenty-four hours a day. When Henson Associates approached HBO, it had been airing feature films and live sports events for only nine hours a day, but, to take on the competition, was about to become a round-the-clock service starting in January 1982. As a result, HBO executives were in search of additional content that would help fill their expanded schedule and, as luck would have

> *"You could see little smiles creeping from the corners of the mouths of the executives. And by the end of it we got the sale."*
> **DUNCAN KENWORTHY**

it, they were looking for quality children's programming. Duncan Kenworthy was asked to run the pitch, but did not feel well on the day of the meeting. "Maybe it was a bit of nerves, I don't know," Kenworthy says. So, Jim Henson stepped in. "Of course, whatever he said, that was it," adds Kenworthy. "That was the magic." HBO went for it, commissioning its first original scripted series.

Children's programming had moved almost exclusively to Saturday mornings by the early 1980s, and HBO had their own kids' block scheduled in the early morning hours between 6 and 9 a.m. But the network had the shrewd idea of airing *Fraggle Rock* in its designated "family viewing" time slot, between 5 and 7:30 p.m.[6] This would encourage viewers of all ages to tune in, whether with children or not.

"You've got to give [the people] something they can't get anywhere else, and do it better than anyone else can," said Michael Fuchs, HBO's senior vice president of programming when the deal was announced. "I can't imagine anything that would do that better for us right now than something from Henson."[7]

BOTTOM A Doozer machine concept by Michael K. Frith.

A PLACE TO CALL HOME

NOW THAT THE FINANCING WAS IN PLACE, the team turned their focus toward hiring production staff and choosing the studio where the show would be filmed. Co-creator Michael K. Frith was named conceptual designer; Jerry Juhl was made head writer and creative producer. Susan Juhl became an editorial assistant and script editor; and Faz Fazakas, the model for Doc, was tapped to head the show's special effects department, which was responsible for creating the electromechanical elements for the puppets.

The first season of the series would consist of twenty-four episodes. Duncan Kenworthy would produce, with Martin G. Baker as associate producer. Baker had been floor manager for *The Muppet Show* and produced a documentary on the series during its fifth season. "Duncan and I had a long history with Jim both before and after *Fraggle*," says Baker, "and that was the power of working with Jim Henson—he sort of dragged you into his world and you didn't want to leave it. It was very special, and certainly a very important part of my life!"

Diana Birkenfield was named executive producer. "Jim had worked with Diana some years earlier," says Baker, "and had asked Diana to come back and join the company when we

started to set up *Fraggle Rock*." Birkenfield's involvement with Henson Associates went all the way back to the late 1960s/early 1970s, when she acted as associate producer for the early TV specials *The Frog Prince* and *The Muppet Musicians of Bremen*.

Because *Fraggle Rock* would be filming in Canada, the production was required by law to hire a certain amount of Canadian talent. Fortunately, there was no shortage of candidates, many of whom Henson had worked with previously. "Everyone wanted to do the show," says Martin Baker. "We were coming off the success of *The Muppet Show*, and it was big news. *Fraggle Rock* became the show that everybody wanted to work on."

During Kenworthy and Baker's search for production

BOTTOM Constructing the pit at Eastern Sound.

no need to run across town to record music, edit videotape, and add visual effects. And with everyone on the show working in the same building, it would take personnel mere minutes to move between the postproduction facilities and the sets. As Jocelyn Stevenson observed, "The corridors, hallways, and stairs that linked the different parts of our home-away-from-home for five years made the whole thing feel like an actual physical extension of Fraggle Rock."

There were a few downsides to Eastern Sound. The building wasn't as big as the producers had hoped for, and right outside the sound department was an active fire station. When Jim Henson reviewed the blueprints, he was particularly concerned that the main studio's ceiling would be too low for filming the multiple levels of the Fraggles' world. Upon his first visit to the facility with Kenworthy and Baker, Henson came up with a possible solution to the problem. "Jim started tapping his foot on the floor, asking, 'What's underneath here?'" recalls Baker. "He said, 'What if we made a little pit down there, if we went down about four feet?' The next thing I know, we're drawing up plans to dig a pit in the concrete floor."

The construction crew hired to dig the pit arrived in the middle of the night. They chose what they thought was the best possible place to dig and started breaking up the concrete with a jackhammer. "And as soon as they did, the electricity of the entire city block went out," says Kenworthy. "It was a disaster."

Despite the occasional setback, by January 1982, everything was falling into place and production of Fraggle Rock was cranking into full gear. HBO had requested that the first episodes be ready to broadcast in early spring 1983, so the next step was to put sewing needles to fabric, hammers to nails, and fingers to keyboards: The show that could end war was on its way.

personnel, Jim Henson suggested hiring Stephen Finnie. Baker asked, "Who's Stephen Finnie?" "A great set decorator," said Henson. To which Baker replied, "Jim, we don't even have a studio!"

Baker and Kenworthy discovered that Finnie was still at the CBC, having worked with Henson previously on *Tales from Muppetland*'s *The Muppet Musicians of Bremen* as well as *Emmet Otter's Jug-Band Christmas*. "And, God, was he right," Baker says. "Stephen, like so many key people that we managed to put together, would go to the ends of the earth for Jim and the Muppets and to work with *Fraggle*."

There were two more key people Henson was eager to work with on the show: William "Bill" Beeton, also an alumnus of many Muppet specials, was brought on as set designer, and George Clark, who had started with Henson Associates on *Emmet Otter's Jug-Band Christmas*, was hired as special effects supervisor.

Kenworthy and Baker eventually found a home for the *Fraggle Rock* production in a large, Victorian-style building in Toronto that housed the studios of two entities: VTR Productions and Eastern Sound. The location, collectively known as Eastern Sound, was ideal, and even came equipped with a puppet workshop, created for the earlier Henson productions that had been shot there. Eastern Sound also had a video department in the front section of the building—including a control room, two studios, and other rooms for editing, audio recording, and postproduction—and sound studios in the back. With each episode of *Fraggle Rock* scheduled to be rehearsed and filmed in the space of a week, the on-site facilities created an incredible advantage: There would be

TOP LEFT The front of Eastern Sound, home of the *Fraggle Rock* studios.

BOTTOM Early Fraggle development art by Michael K. Frith created in New York as part of the concept book development but ultimately not used for it.

PART TWO

A SHOW
OF HANDS

FUR, FOAM, FEATHERS, AND FLEECE

TOWARD THE END OF FALL 1981, members of Jim Henson's puppet workshop in New York were called to a meeting in the conference room of one of Henson's offices, on East 69th Street. Since 1963, Henson had kept a workshop location in the city that specialized in building and costuming puppets for his television and film work, and in 1973 he added another location, on 67th Street, to keep the business offices separate from the workshop. In 1977, with the success of *The Muppet Show*, Henson was able to expand the operation to a grand double townhouse on 69th, which became the company's primary headquarters. The extra space helped accommodate the increasing innovations in technology, such as the animatronic and radio-controlled systems being devised by Faz Fazakas.

At the meeting, Bonnie Erickson, who ran the New York workshop, and the *Fraggle* creative team described the show's characters to the puppet builders and showed them Michael K. Frith's concept art. Among the attendees was Tim Miller, a Muppet designer and builder since *The Muppet Show*, who would become supervisor of the puppet workshop in Toronto during the production of *Fraggle*

Rock. Also attending was Connie Peterson, who, having joined only a year earlier to work on characters for the *Sesame Street Live!* arena shows, was excited to be involved in creating a new world from the ground up. "We were told that we were going to be doing a new show and the purpose was to encourage world peace," says Peterson. "Fine with me!"

ABOVE Concept for background Fraggle by Michael K. Frith.

BOTTOM Puppet builder Rollie Krewson works on various iterations of Uncle Travelling Matt in the Muppet Workshop.

OPPOSITE In the Toronto workshop, the large versions of Mokey, Red, and Wembley sit among the smaller radio-controlled versions of the entire Fraggle Five.

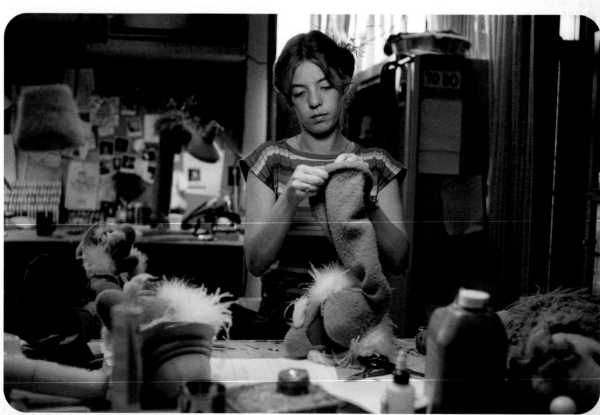

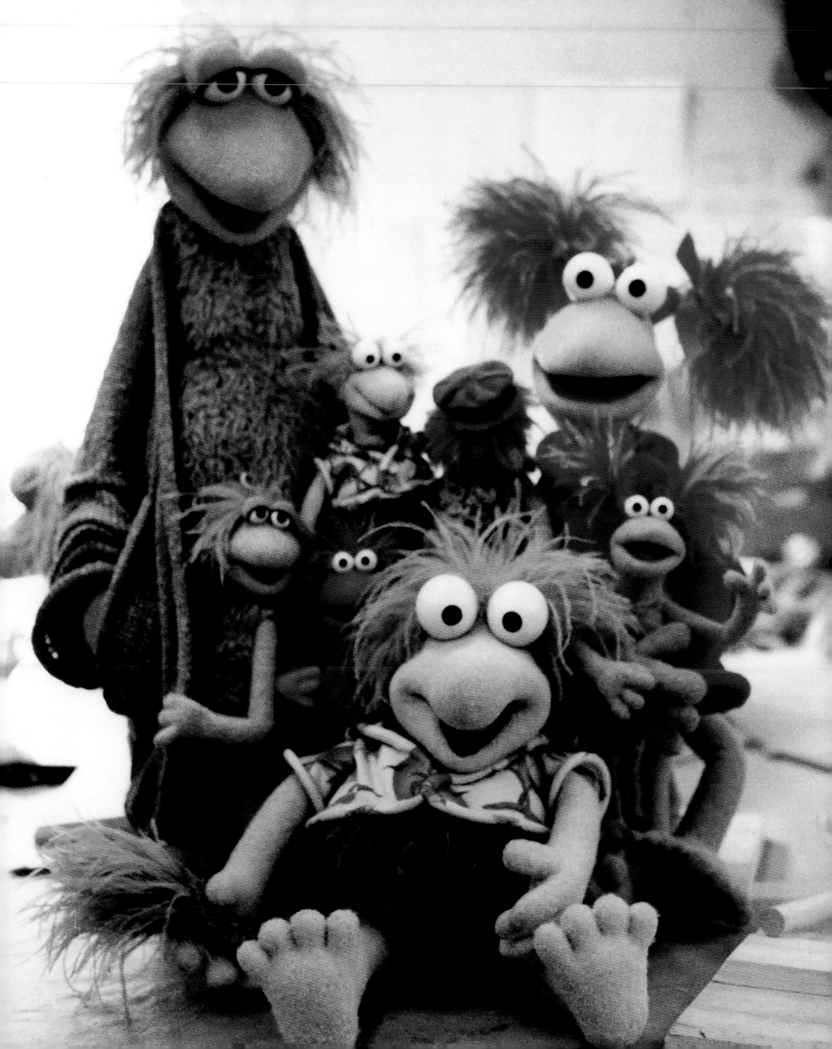

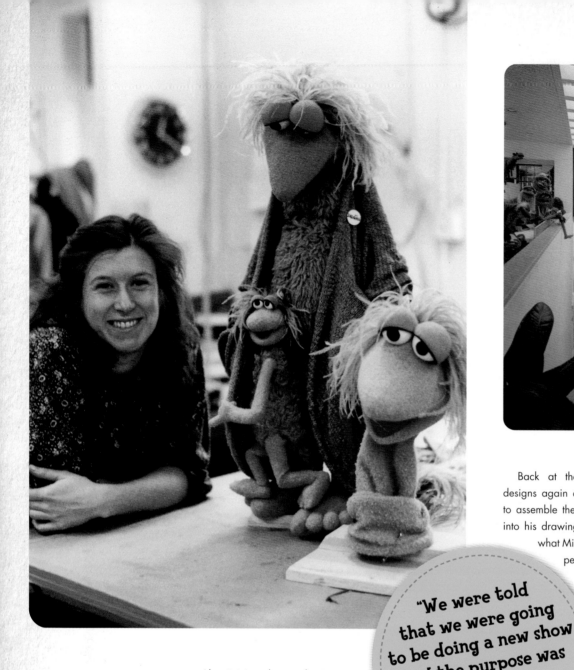

TOP LEFT Puppet builder Jan Rosenthal poses in the Muppet Workshop with various versions of Mokey.

TOP RIGHT The steps leading to the Muppet Workshop at the Upper East Side townhouse that housed Henson Associates in Manhattan. Photographed in 1980 by Jaime Ardiles-Arce for an *Interior Design* magazine feature on the building.

OPPOSITE TOP Jan Rosenthal works on a puppet build in front of ongoing builds of Red, Wembley, Gobo, Boober, and Mokey at the Muppet Workshop.

OPPOSITE BOTTOM Two unfinished puppet builds of Uncle Travelling Matt at the Muppet Workshop. In the background, a Matt design sketch by Michael K. Frith can be seen.

Also joining the production was Rollie Krewson, who began as an intern at Henson Associates in 1973 and had since contributed to almost every Henson production as a designer and builder and, occasionally, as a performer. Krewson was happy to hear that, in contrast to earlier projects, the puppet builders would have input on which characters they would be assigned. "This time, we were asked, 'Who are you interested in building?'" says Krewson. "We got to choose." Krewson chose to build two Fraggles: Red and Wembley. "Every once in a while, you get a character that you know you were supposed to build," she says. "Wembley was the first one I really felt that with. He's a happy character, but anyone could sway him, and that was how I felt about myself at that point, so I was the perfect person to be making him. I went for Red, because I really always wanted to be more like Red," she says with a laugh. "Wembley was who I really am."

Back at the workshop, the builders reviewed Frith's designs again and discussed the techniques they would use to assemble the Fraggles. "Michael puts a lot of personality into his drawings," says Connie Peterson. "So we try to do what Michael drew, and then make things absolutely as performable as possible, because the performers add so much."

Though they are all the same species, the Fraggle Five are visually distinct individuals. There are subtle differences in the features of their faces, and not so subtle differences in their proportions. The Red and Gobo puppets are the same height. Mokey is the tallest, and Boober and Wembley are the shortest. Wembley is also a bit wider than the others.

Mokey was built by Jan Rosenthal, who had previously worked on *Sesame Street* and *The Muppet Show*. The Mokey puppet was unique within the Fraggle Five because she was built to be operated with "live hands." A "live-hands" puppet is performed by one puppeteer who manipulates the character's mouth with their right hand and uses their left hand to operate the puppet's left hand. A second puppeteer, positioned close to the first, operates the right hand, which is literally called "right-handing." Jim Henson and Frank Oz used this technique frequently throughout the years, notably for *The Muppet Show* character Rowlf the Dog and *Sesame Street*'s Cookie Monster, both of whom were required to make complex moves with one or both of their hands. Given that Mokey often painted and wrote in a journal, it was vital that the puppet have "live hands."

> "We were told that we were going to be doing a new show and the purpose was to encourage world peace."
> CONNIE PETERSON

Puppet builder Caroly Wilcox chose to build the group's de facto leader, Gobo. Wilcox was an experienced designer and puppet builder for the company who had trained many of the Muppet builders. She was also the workshop supervisor for *Sesame Street* and had been instrumental in designing lovable Muppet megastar Elmo, who made his debut in 1980. The intrepid Gobo—always out exploring, often while carrying a variety of objects—posed his own challenges. When he had to hold a relatively light item, the object was stuck onto his hand with double-sided tape. Heavier items needed to be sewed or glued on, his arm sometimes safety-pinned in place to prevent it from detaching under the weight of the object.

When working on the Gobo puppet, Wilcox drew a diagram for the puppeteers' edification—and amusement—entitled "Typical Muppet Muppeteering." It illustrated the position of the puppeteers' monitors that would, in real time, allow them to watch their puppet performance from the perspective of the camera; how the cameras would frame the Fraggles as the puppeteers performed them over their own heads; and suggestions for placement of the performers' mics and cables.

TOP Puppet builder Caroly Wilcox works on the Gobo puppet.

BOTTOM Boober puppet build in progress in the Muppet Workshop.

Typical Muppeteer Muppeteering

mouth line
average 1½"
6' Playboard Ground Row Height – Bottom Cut off (usual)
6'

Arm wire or rod

Beard (much preferred)

Head – often in the way. Watch out for furry animals 1" up above camera cutoff.

Headset – with mike positioned in front of mouth

Head set cable.

FLOOR

↑ Helps to have people to dress the mike cables as needed if performers are moving around

Small Monitor

sandbags or braced

Monitors need repositioning in each new scene location.

All puppeteers should have vision of a monitor.

"Ideal Muppeteer (we don't quite have them yet)

– C.W.

With a wry sense of humor, she also added a note stating that beards were preferred for Muppeteers: Henson, Jerry Nelson, and Goelz all had them. She also added another illustration that depicted the "Ideal Muppeteer," a malformed being with three arms and a head placed below their waistline—heads often accidentally drifted into frame during performances, and watching monitors was always a neck-cricking nightmare, so a puppeteer with a head near their knees would be perfect![8]

Boober was taken on by Leslee Asch, who began building puppets for Henson Associates in the late 1970s. While Asch was constructing Boober, she took pieces of him home one night and stuck them together using Barge glue, a cement-type adhesive. The next morning, she brought Boober back to the workshop via train and stuffed the bag holding him under her seat, next to a heater. "Barge glue comes apart when heated," says Rollie Krewson, "so when Leslee got to work, she unpacked the same number of pieces of Boober as she had left with the night before. It's funny now, but looking back, this is so apropos of Boober's attitude, turning Murphy's Law into Boober's Law: If it can go wrong, it will."

Each Fraggle's body and tail was made of a furry synthetic blend, and their heads, arms, and legs were made of fleece. Two versions of the bodies were created: One was a "half-body," without legs and with an elongated torso. Half-bodies are performed from the puppet's waist up, so the torso is lengthened to cover the puppeteer's arm. Half-body versions have snap attachments for securing legs to the puppet if they need to be seen on camera. Other times, the puppeteers used a "full-body" puppet with a shorter torso and sewn-on legs. Half-body versions were used more frequently, so two or three copies of each were made to account for wear and tear during shooting.

Both half- and full-body versions were designed with snap-on arms. Caution had to be taken to prevent the arms from accidentally being torn off during filming, but, every once in a while, if a puppeteer made a really strong gesture, an arm might be seen flying across the set! With few exceptions, the Fraggles' hands and arms were controlled by rods. Each foam puppet hand had a tiny slit at the wrist that housed the arm control wire. The puppeteer would operate the arm wire using his or her left hand while their right hand performed the character's mouth.

TOP Caroly Wilcox's Muppeteering memo, which not only illustrates how a puppeteer should work with a monitor, but also what a physically ideal Muppeteer should look like.

TOP Some of the crew at the Fraggle workshop in Toronto, Ontario. Top row (left to right): Rollie Krewson, Sherry Arnott, Sherry McMorran, Amy Van Gilder's husband, Amy Van Gilder. Bottom row (left to right): Jan Rosenthal and Karen Prell. The radish T-shirts were made by Workshop workers. From the personal collection of Rollie Krewson.

Fraggle tails had a long piece of wire inserted in them, which was looped on the end. "The puppeteer would slip their hand through that loop," Rollie Krewson explains. "At the base of the loop was a counterweight that would cause the tail to swing back and forth." According to Krewson, the idea was to make the movement of the tails natural, and not something the puppeteers would have to think about. The wire loop, braced against the wrist, would keep the tail up, and then as the performer's hand moved, the tail would bounce and sway. Like the arms, the tails were snapped onto the bodies. Surgical tubing was fitted into the tails to give them a springy movement.

With one exception, each puppet's foam head had a mouth created in two pieces, with the bottom jaw hinged at the back using gaffer's tape, and the felt pulled and tucked to create what Krewson calls the signature Muppet "smile curve," where the cheeks meet the mouth. The exception was Wembley, whose mouth was created in one piece, with a piece of pliable gasket rubber in the interior. This would allow the mouth to be puppeteered in any and all directions—up, down, and sideways—creating myriad expressions including whooping, hollering, and wembling.

The Wembley puppet also had a uniquely long nose that ended in a bulbous tip—underneath the fleece was a Ping-Pong-type ball that helped the tip keep its shape. A hole in the back of the ball enabled the puppeteer to insert his finger and move it in different directions to create a variety of bewildered looks.

After the puppet bodies were constructed, the last stage was to add feathers for the hair as well as a tuft of fluff at the end of each tail. "Jim liked feathers; they always gave great movement," says Krewson. With Michael K. Frith's overall color palette in mind, the puppet builders dyed a variety of boas made from ostrich and marabou feathers. Each Fraggle's hairstyle required a combination of colors, so feathers were plucked individually from the boas, then twisted together and made into a "plug"—a group of feathers glued together at one end, which was then affixed to netting cut to fit the puppet's head. Next, the netting was applied to the head—if the hair needed to be fixed or replaced, this piece could be removed entirely.

Red's pigtails were made by attaching a group of plugs to form large puffs of hair. "She did have those wacko pom-poms up there," says Krewson. "And they got bigger and bigger

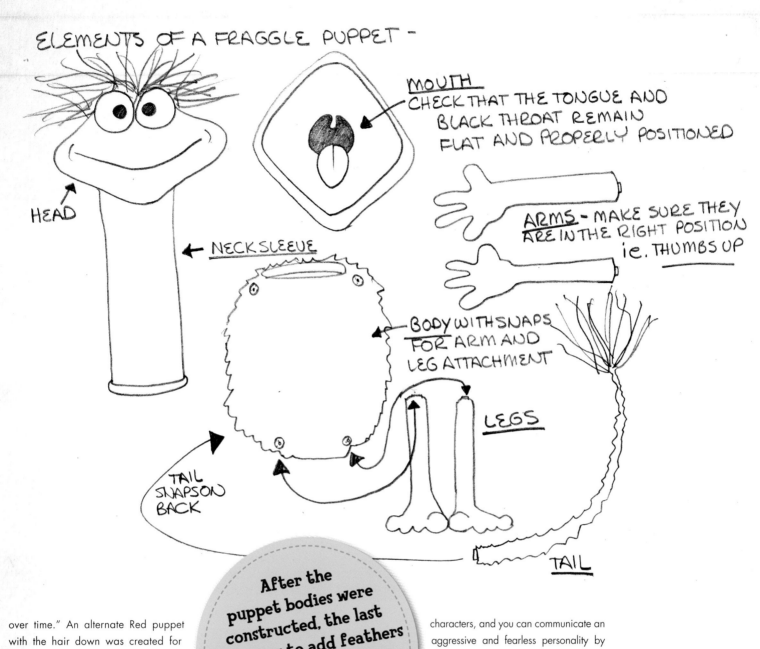

ELEMENTS OF A FRAGGLE PUPPET -

HEAD

MOUTH
CHECK THAT THE TONGUE AND BLACK THROAT REMAIN FLAT AND PROPERLY POSITIONED

ARMS - MAKE SURE THEY ARE IN THE RIGHT POSITION ie. THUMBS UP

NECK SLEEVE

BODY WITH SNAPS FOR ARM AND LEG ATTACHMENT

LEGS

TAIL SNAPS ON BACK

TAIL

After the puppet bodies were constructed, the last stage was to add feathers for the hair as well as a tuft of fluff at the end of each tail.

over time." An alternate Red puppet with the hair down was created for sleeping scenes.

The final step in the puppet build was to add the eyes. In his early years working with Jim Henson, puppet builder Don Sahlin developed the "Magic Triangle." This was a method of positioning a puppet's eyes in relation to the nose and mouth to create the illusion that the character is looking directly at the viewer. One way Sahlin achieved this was by aiming the pupils slightly toward each other instead of placing them in the center of the eyeballs. "If you think about it too hard," says Michael K. Frith, "if you look at the character in the abstract, very often you'll think he or she is cross-eyed and it feels wrong, but when you step back—and particularly when you see it on camera—the puppeteer uses [this arrangement] to get the eyeline right and make a greater connection with the audience."

Eyes are indeed the window into the soul of a Fraggle. "The eyes can accomplish a lot in terms of the personality of the character," said Tim Miller. "Wembley and Red are more energetic

characters, and you can communicate an aggressive and fearless personality by leaving off eyelids. That might make them looked wired, but that was, in a way, a part of their personalities." The eyes on the Mokey puppet have a deep, half-closed eyelid, as if she's in dreamy thought, while Gobo's eyes are wide open, taking in everything he possibly can all at once. Boober's eyes are not visible at all, an important visual clue to the character's personality. "Boober is so withdrawn, and the fact that he doesn't have eyes is what helps evoke that sense of him," said Miller. "For a doomed look, forget the eyes altogether."

When the puppets were complete, each was reviewed by Jim Henson and Michael K. Frith. When evaluating Wembley, they suggested it would be funny if the puppet's eyes could spin around or move in different directions to indicate that the character struggles to make up his mind. For this to happen, a mechanical device would need to be installed. Adding mechanics to a puppet's head after it's been built can cause complications, especially when it reduces the amount of space

TOP Illustration from the Workshop handbook created by designer Amy Van Gilder that contains information regarding best practices for puppet wrangling.

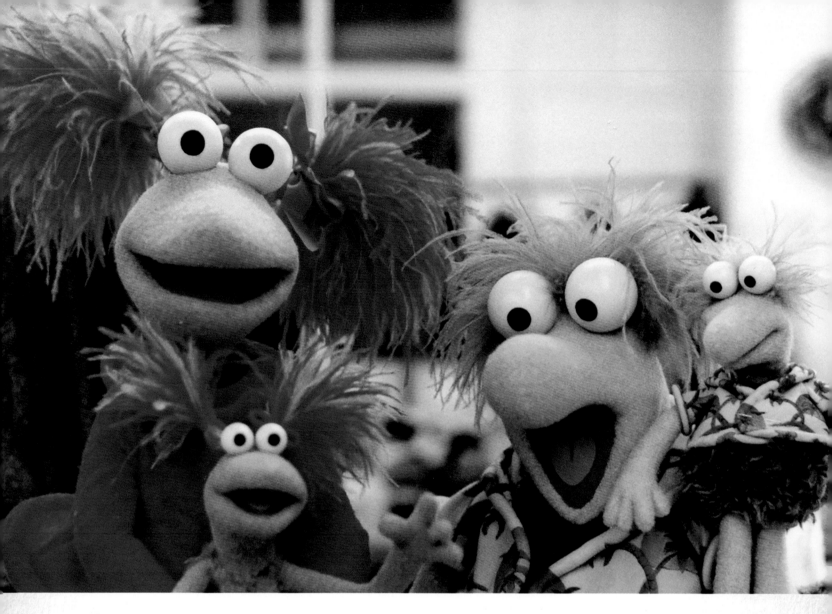

ABOVE Pa Gorg development art by
Michael K. Frith.

TOP The Red and Wembley puppets with their
smaller, radio-controlled versions.

available for the puppeteer's hand. Although Krewson managed to reshape the Wembley head to fit the new eye mechanisms in a way that didn't impede the puppeteer's performance, it was no small feat. "You tend to go backward before going forward," she says. The original nonmechanical version of Wembley's head was used for scenes in which his eyes didn't need to move.

In his *Woozle World* treatment, Jim Henson had proposed showcasing the different heights of the various species by creating multiple puppets of each character in proportional sizes. For interaction between Woozles (now called Fraggles) and Wizzles (Doozers) he had conceived that puppeteers in human-size Woozle costumes would perform on a suitably proportioned set alongside handheld Wizzle puppets. Budget and timing quashed this idea from the start, and so there were never any human-size Fraggles.

From the start, Henson envisioned the Wozle characters, now called Gorgs, being played by performers in full-size costumes. For scenes in which Fraggles would need to be seen in correct

proportion to the Gorgs, the regular three-foot-tall Fraggle puppets could not be used, and so the production turned to Faz Fazakas and the mechanical engineering department.

Fazakas and his team developed versions of the Fraggles that were 47 percent smaller than the hand puppets, putting them in perfect proportion to the towering Gorgs. "This was something I had originally insisted upon," says Michael K. Frith, "because I wanted to establish that scale with the Gorgs."

The plan was to use these smaller, less articulated Fraggle models during dramatic scenes featuring the Gorgs: for instance, when a Fraggle was captured in a Gorg's giant hand, or when the little creatures were fleeing. But these mini-Fraggles would end up appearing far less often than originally intended; for many Gorg-Fraggle scenes, normal-size Fraggles were filmed in front of blue screens and later composited with Gorg footage in a way that captured the correct scale of the two species.

According to Frith, "The rod puppets, while they were charming and delightful, were never quite as believable as the hand puppets."

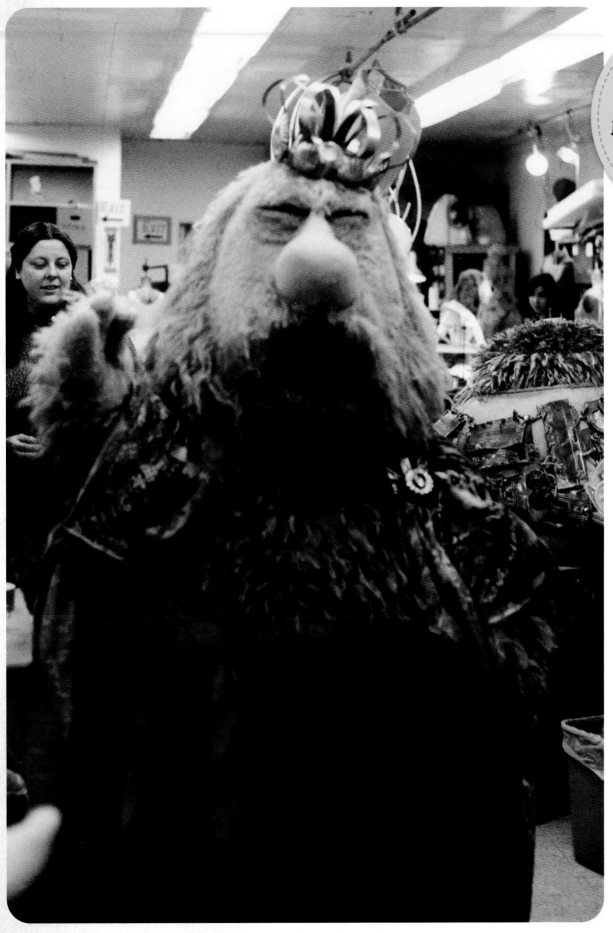

"The eyes can accomplish a lot in terms of the personality of the character."
TIM MILLER

LEFT Connie Peterson and Pa Gorg in the Muppet Workshop in New York. From the personal collection of Rollie Krewson.

FRAGGLE ROCK FASHION

THE *FRAGGLE* ROCK WARDROBE WAS CREATED by Polly Smith, who had designed and fabricated costumes for *Sesame Street*, *The Muppet Show*, and *The Dark Crystal*. Smith's initial impression after reviewing Michael K. Frith's sketches was that Fraggle clothing needed to have a sense of movement. "I looked at the drawings and thought, *How am I going to do that?*" she remembers. "Piping of any kind would just fold in on itself. Wire would bend. This had to be flexible." In order to get the swing and bounce she was looking for, Smith came up with the idea of sewing latex surgical tubing into the hems of all the garments, the same material used in Fraggle tails. "We needed something that was springy, could hold its shape, and not be heavy," she notes. "If you bend surgical tubing, it pops right back into its shape, and comes in all different sizes, so we could use it on [any size puppet]."

Michael K. Frith's concept art for the Fraggles had a well-defined color scheme, which made it easy for Smith to find corresponding materials. "The palette was very important, because he was designing the whole world," she explains. "Then the whole group had to look good in the world they were in. It was very thought out." Smith used store-bought fabrics for the Fraggles' costumes: "And once we had settled on something, we bought a ton of it."

Along with helping to define a character, costuming plays an important part in maintaining the illusion that puppet characters are living beings. Most notably, items of clothing are often used to cover up the visually jarring division between a puppet's head and neck. To hide the Fraggles' gaps, Smith outfitted Red in a turtleneck sweater, put Gobo in a high-necked sweater covered by a cardigan, and draped a scarf around Boober's

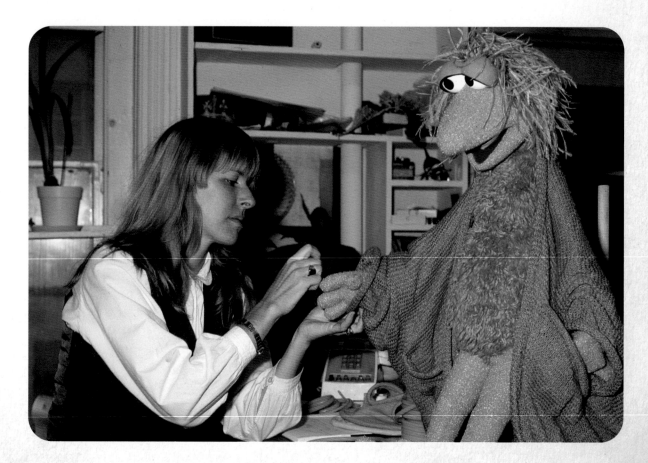

BOTTOM Costumer Polly Smith works on the Mokey puppet.

OPPOSITE Costume ideas for background Fraggles by Polly Smith.

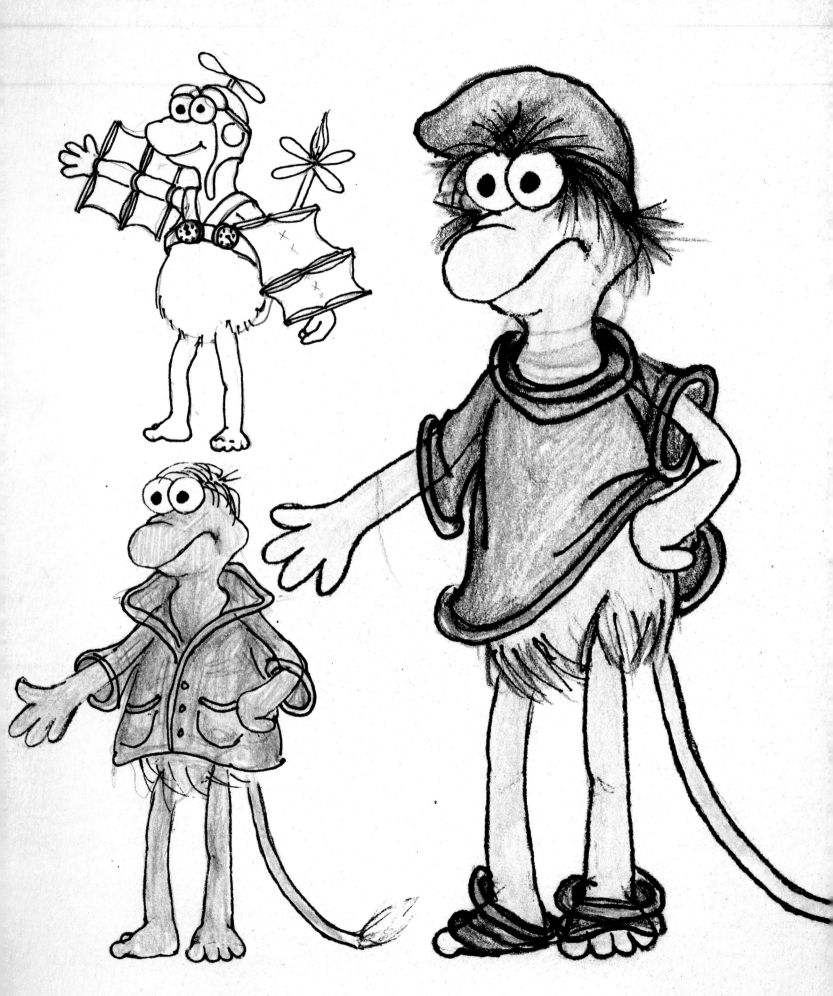

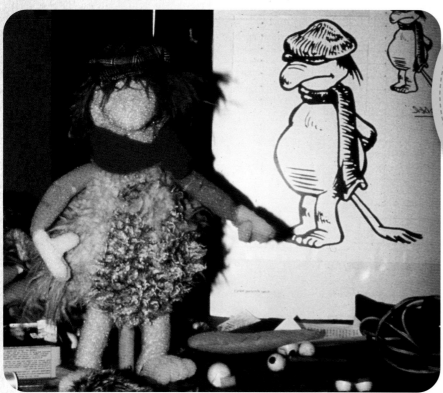

"They're built like footballs or basketballs or something, and then you're trying to make them wear clothes that are recognizable as clothes."
POLLY SMITH

throat. Meanwhile, Mokey was given a robe-like sweater and Wembley was fitted with an open-necked shirt featuring a collar that covered about three-quarters of his neck, enough to hide the divide. "In many cases, if you just distract from the divide, it's not obvious," Smith says.

The banana tree pattern on Wembley's Hawaiian shirt, first seen in Frith's sketches, was painstakingly applied to the material by Smith using a fabric spray over homemade stencils. "Silk screen would've been the obvious way to do it," she says. "I don't know if I was just doing what I was comfortable doing, or there just wasn't time." Smith cut out three stencils for the shirt's images: a sun, a palm tree, and an island, which she would need to duplicate throughout the life of the production. "I know I guarded those stencils for dear life! I didn't ever want to cut them again," Smith says with a laugh.

Michael K. Frith designed Uncle Travelling Matt's outfit, drawing inspiration from his school days. "I grew up in a British school system, and one of the things I loved was that there were guys who were the heroes of my childhood who are the great villains of today," he explains. "People like Cecil Rhodes and Robert Clive of India and other real colonials, who would go to another country with basically just a flag and a pistol and they'd go, 'All right, this now belongs to the queen, anybody got a problem with that?'" Frith's concept art had dressed Matt in the consummate explorer's gear: a pith helmet and scarf, jacket with many pockets, rucksack, hiking boots and thick socks, and khaki shorts called "empire builders." The pith helmet and the majority of other Fraggle hats, including Gobo's, were created by Joanne Green, a puppet designer who worked alongside Polly Smith.

Although many of the basic ideas for the clothes began with Michael K. Frith's drawings, Smith says she was encouraged to add little details to make them feel more like real items from a Fraggle's wardrobe. "Working with puppets is a lot different than working with humans," she admits. "I mean, their body shapes are just so bizarre. They mostly don't have any shoulders. They're built like footballs or basketballs or something, and then you're trying to make them wear clothes that are recognizable as clothes. You just have to finagle it until you get it." But just like Frith, Smith says she had a larger vision in mind: "I was trying to create a world."

GILLIS FRAGGLE

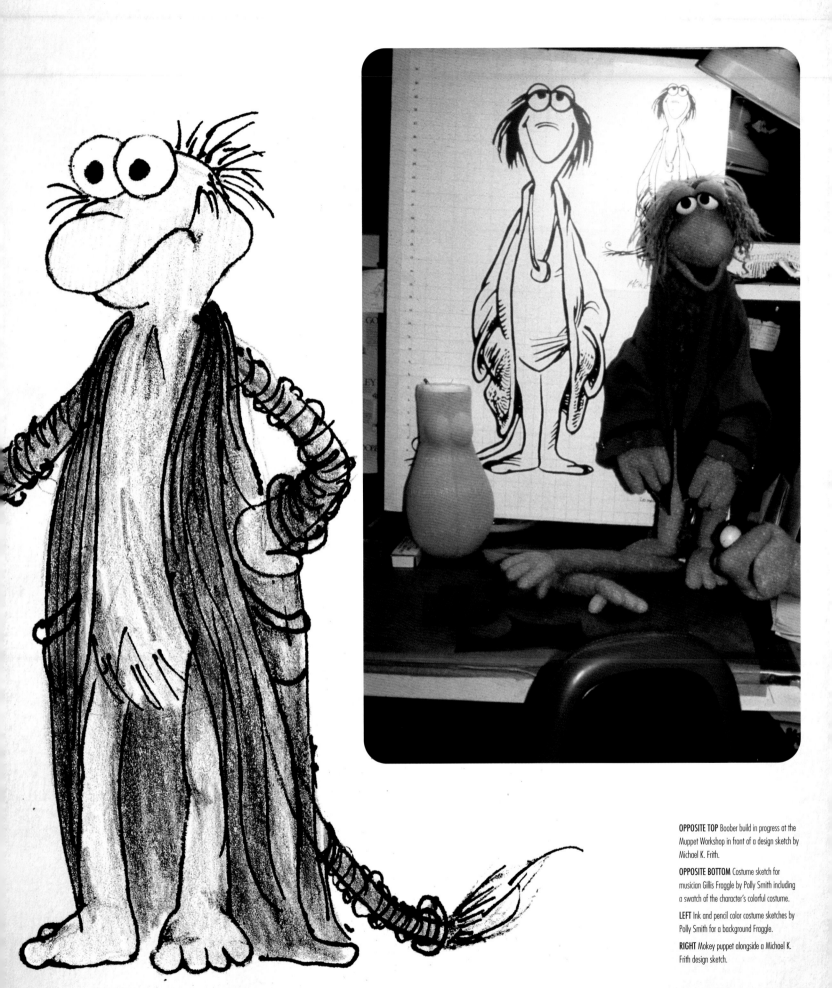

OPPOSITE TOP Boober build in progress at the Muppet Workshop in front of a design sketch by Michael K. Frith.

OPPOSITE BOTTOM Costume sketch for musician Gillis Fraggle by Polly Smith including a swatch of the character's colorful costume.

LEFT Ink and pencil color costume sketches by Polly Smith for a background Fraggle.

RIGHT Mokey puppet alongside a Michael K. Frith design sketch.

GORGS INSIDE AND OUT

MICHAEL K. FRITH'S INITIAL DESIGNS FOR THE Gorgs were influenced by traditional ideas of fairy-tale giants and trolls. "How boring!" he quips. "Fortunately, they evolved." Though the size, shape, and fuzziness of the species changed little from his Hyde Park drawings, Frith was able to develop their personalities through his sketches, bringing in some of their traits from classic clown archetypes. "[Pa Gorg] was like 'The Auguste,'" he explains. "The one who thinks he's in charge, and the fool." Ma Gorg draws on the "Whiteface" clown: the one who's really in charge and the top of the pecking order. "And, of course, the giant baby has been a staple of comedy forever. That's our Junior!"

The Gorg characters would be portrayed by performers in "full-costume" puppets. Henson Associates had built similar puppets before—*Sesame Street*'s Big Bird, for example—but those had been self-operated: The puppeteer inside was responsible for all aspects of the performance and also voiced the character, through a microphone in the costume. The *Fraggle Rock* team wanted to reinvent that paradigm. There would still be a performer inside the full-costume puppet delivering a physical performance while navigating the set using monitors housed in the suit. However, the character's facial movements would be performed by a second puppeteer using radio-control mechanics developed by Faz Fazakas.

This second puppeteer would also perform the character's voice.

When designing the Gorgs, Frith had Fazakas's radio technology in mind. "You can't *not* have the idea of the mechanics in the back of your head," he says. "You know what the tools are that are at your disposal, but I was thrilled because I knew that those tools were being developed exponentially even as I was working on this. I knew I'd be able to create puppets on scales that had never been done before." Many of Frith's concepts for the Gorgs included suggestions for how the performer could be housed in the full-costume puppet and areas where the monitors could be installed.

RIGHT Tim Miller and Alan Eggleston attend to Pa Gorg.

OPPOSITE Various puppet builders with Pa Gorg in the Muppet Workshop.

Standing, left to right: Unknown crew member, Holly Cole, Polly Smith, Alan Eggleston, Connie Peterson, Mary Strieff, Rollie Krewson, unknown crew member.

Seated, left to right: Janet Knechtel, Barbara Briggs, Jan Rosenthal.

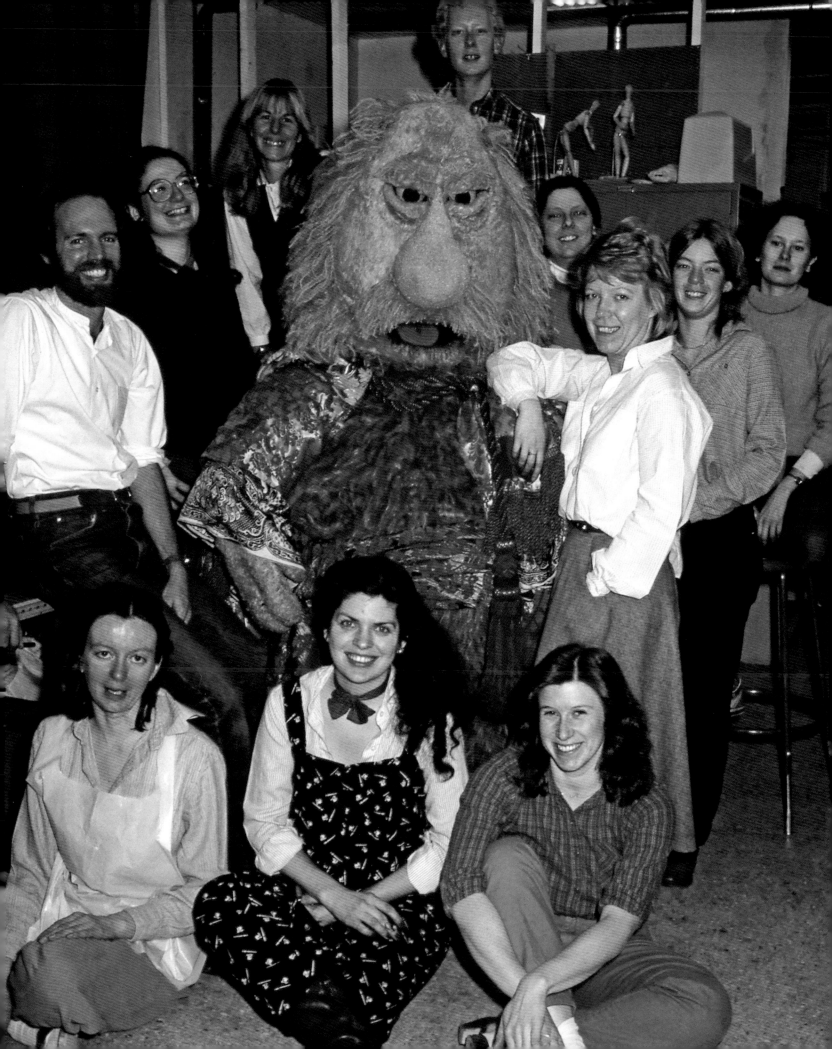

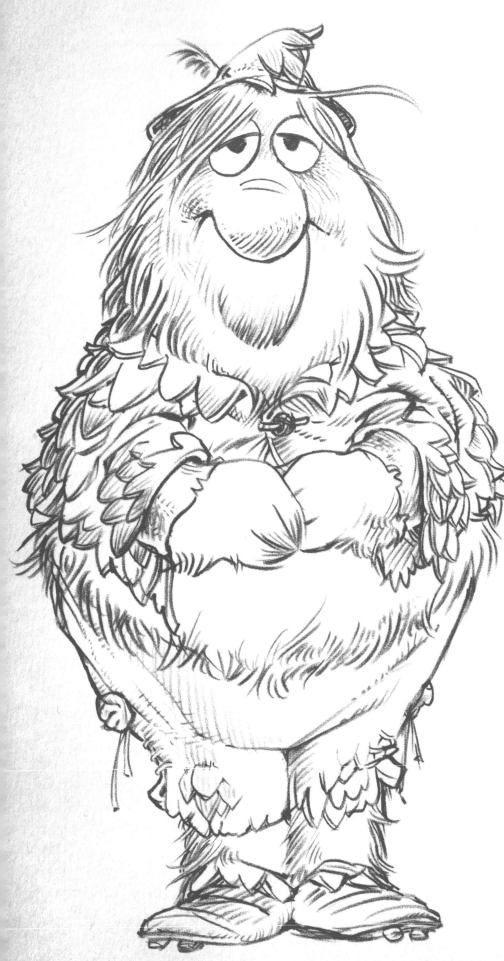

The bodies for the gigantic Gorgs were built by Connie Peterson, who was known for her expertise in working with large characters; Tim Miller was responsible for building the heads.

Because of the size of the Gorgs and the mechanics they contained, it was essential that the puppets be relatively lightweight so the puppeteers could perform within them without experiencing too much fatigue. Peterson also needed to keep in mind the physical movements the puppeteers were required to perform on set—every Gorg would dance and skip, and Junior spent a good amount of time running after Fraggles and doing pratfalls. "That got me thinking how Junior could fall and not have the puppeteer hurt himself," says Peterson. The costume needed to be soft inside to protect the performer, but at the same time it required mass and density—without this bulk, the Gorgs' physical movements wouldn't ring true.

Once the underlying support structure for the Gorgs was complete, the puppet was covered with a furry skin.

With all this in mind, Peterson began building the Gorgs by developing a complex underlay that incorporated two parts: a top and a bottom, joined by a zipper around the waist. In order to guarantee that everything stayed rounded at the Gorgs' portly midsections, she began by placing a circle of a rigid nylon material around the outer circumference of the bottom half of the underlay in a process called "boning."

When performing a Gorg, the puppeteer would wear a pair of cotton net briefs that would connect to a circular "plate" of stiff fabric attached to the costume's waistline, distributing pressure equally around the body. Below the circular plate, and sewn onto the cotton briefs, was layer upon layer of ruffles, made from the same type of netting used for a ballerina's tutu, but arranged in a unique configuration that would achieve the greater density needed to create the Gorgs' shape (and also to maintain it, during the many times that the creatures plopped down on their rear ends). Below what Peterson calls "all this tutu hoorah," the Gorgs' legs were each boned using one continuous piece of thick, flexible nylon that formed a spiral from thigh to ankle.

The boning, along with the density of the ruffles between the performer and the costume, ensured that there was no wasted movement on the part of the puppeteer. "So if you're dancing away in there, what you're doing is transferring that movement

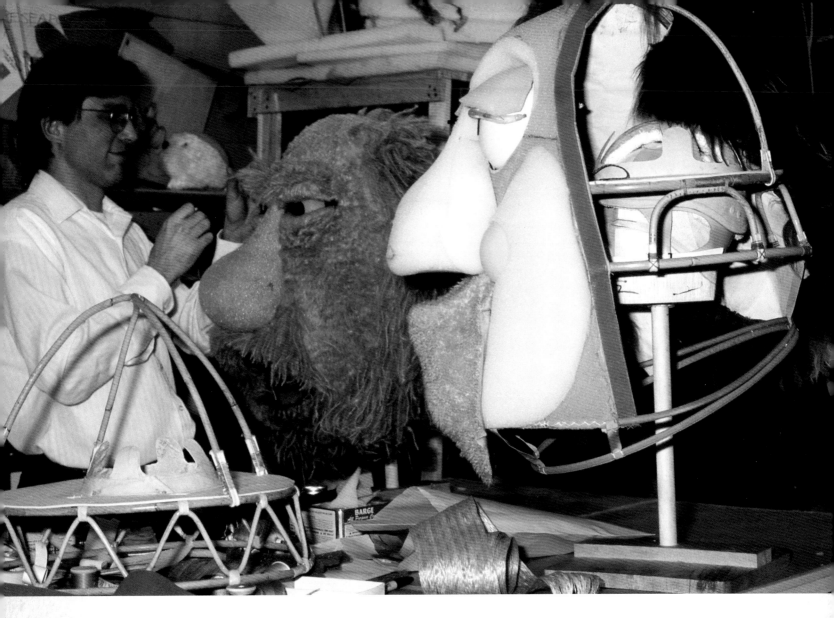

to the outside of the costume," Peterson explains. "Otherwise, the puppeteer could be doing all sorts of stuff inside, but on the outside, it would look as if the character was just standing still."

For the top part of the costume, the performer wore a snug cotton yoke piece around the neck and shoulders. This held its own spiral boning that rounded out the chest and arms of the puppet. Peterson also fashioned several unattached arms for each Gorg that were not used in conjunction with the puppet. "They're called 'wild arms,'" she says, "and were used for filming close-ups of the [Gorgs' hands when they are] holding objects."

Once the underlying support structure for the Gorgs was complete, the puppet was covered with a furry skin, created by hand-latching a range of yarns of various sizes and textures onto a woven polyester net. "A really time-consuming thing, but it looks great," says Peterson.

While Connie Peterson was constructing the Gorgs' bodies, Tim Miller was building their heads. The Gorgs' faces were made from a sheet of celastic, a treated canvas that could be molded into a lightweight hard shell. Miller would build up the face by attaching pieces of foam for cheek shapes and noses, then

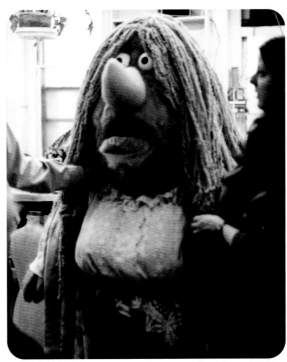

OPPOSITE Costume concept art of Junior Gorg by Michael K. Frith.

TOP Tim Miller works on the heads for Pa and Junior Gorg.

BOTTOM Connie Peterson and the early Ma Gorg in the Muppet Workshop at 201 East 67th Street in New York. From the personal collection of Rollie Krewson.

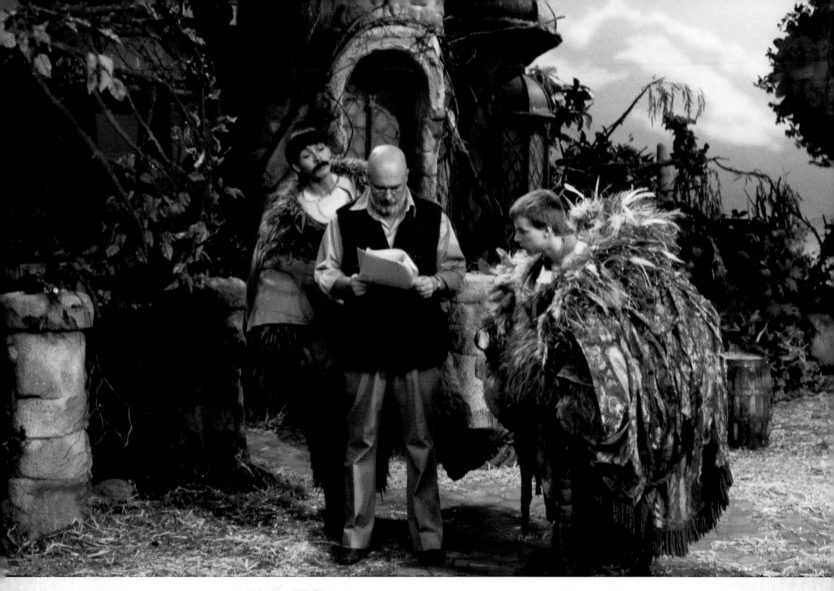

cover the whole thing in a material referred to as "bunny fur," though it was not from a real rabbit. "I never knew why it was called that," says Peterson, "but that's what it was called in our stock. It was soft like a bunny and took dye really well."

The structure of the head was constructed from a basketlike framework made of cane and rattan. The radio-controlled mechanics that would operate the Gorgs' mouths and eyes were fitted into the heads as early in the process as possible to ensure that they were positioned correctly, thereby avoiding any unnecessary later adjustments.

The Gorgs' heads were removable and would be placed directly onto the performer when they were in the full-body puppet. The head was fitted with straps that buckled onto the cotton yoke worn by the performer. Because the heads were especially heavy in the front due to the mechanics of the radio-controlled system, weights were added to the back of the fabricated Gorg skulls.

Two heads were created for each Gorg. One iteration contained facial articulation mechanics that would be radio-controlled by voice actors Jerry Nelson (Pa Gorg), Richard Hunt (Junior Gorg), and Myra Fried (Ma Gorg). The interior of these heads contained a monitor so the puppeteers could see outside

TOP Rob Mills (Junior Gorg), director George Bloomfield, and Gord Robertson (Pa Gorg) in front of the Gorg Castle set.

BOTTOM Concept sketch of Ma Gorg in her nightwear by Michael K. Frith.

the costume, although not directly through the character's eyes, at least not in the early episodes. (This process would be improved in later seasons.) The second head was fashioned without monitors so it could be used for stunt work.

Initially, the plan was that puppeteers using the stunt heads without monitors would be able to navigate by looking out through the characters' mouths, but that proved problematic. "The Gorgs' mouths were not always open all the time," says Connie Peterson, "so a way needed to be figured out for the people in the costumes to see." To fix the issue, the "stunt" heads were constructed with a screen-type area on their chins that would provide the performer with some visibility. The chin piece was made of horsehair or buckram embroidered onto netting in a squiggly vermicelli stitch to help it blend into the character's face.

When Michael K. Frith and Jim Henson reviewed the Gorg puppets, Frith asked if Pa Gorg could be given a squint. "What I wanted with Pa Gorg was his ability to go, basically, from stupid to really stupid," says Frith. "It's as if he's always trying to figure things out, but, of course, can't admit it. And when he's really baffled, his squint gets squintier. You can feel his pain!" Fazakas's team successfully incorporated the expression into Pa's radio-controlled movements.

In his initial drawings of Ma Gorg, Frith had put a great deal of emphasis on her hair. "The original notion was that most of the time Ma's eyes would be obscured by her long, lank locks," says Frith. The hair would be radio-controlled so that when she was surprised by something (which happened often) it would part like a curtain to reveal her reaction.

Once the Gorg puppet heads and bodies were constructed, Polly Smith began fabricating their costumes, which needed to be unrestrictive and lightweight for the sake of the performers. "They had to have an incredible physicality, so you don't want to add more weight than you need to," says Smith.

Pa Gorg was dressed in a gilded robe of state, with a large collar of orange and gold ostrich feathers, and a golden sash over his purple fur. If the occasion warranted it, he might wear a hat other than his crown, and perhaps a fancy suit. Ma Gorg wore a crown atop her straight orange hair, and a pink-and-white kimono-sleeved robe over a lace-fronted dress. The fifteen yards of material used for her outfit, which encircled her ninety-two-inch waistline, showed very little of her rhubarb-colored fur. "It was sort of a shame to cover her all up," Smith explains. "[Being able to see as much of the character's body as you can] helps indicate what the character is."

Junior was clothed solely in a stained and patched-up shirt made from a cotton jersey knit. Since Junior was a hard-working farmer, albeit intermittently, Polly Smith wanted to give his costume a distressed appearance. "Polly is fantastic at aging things, truly brilliant," says Connie Peterson. Smith acquired the nickname "Our Lady of the Cheese Grater," because, among her many techniques for wearing down fabric, she was particularly fond of using said utensil. "It works like a charm," says Smith, who discovered the technique while creating costumes for *The Dark Crystal*. "You need to put a

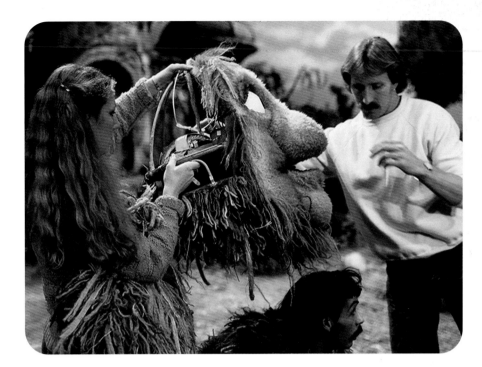

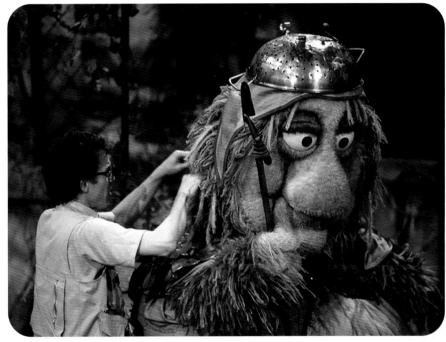

piece of leather on your hand to keep from grating yourself," she explains. "But Junior's shirt was easy to distress because the knit jersey material doesn't unravel on you."

Smith also used kitchen utensils as part of the Gorgs' costumes, imagining that they would repurpose found objects from the Trash Heap to craft whatever they needed. Pa's crown was made from a pie tin and bent spoons. Junior required Gorg armor, including a colander-style helmet, for scenes in which his father encouraged him to practice military maneuvers. Polly Smith created the headpiece by taking a regular colander and drilling additional holes into it. "I donated all my mother's colanders to one show or another," says Smith with a laugh. "They're all gone, and I really regret it!"

TOP Joanne Green and Zeke Livingston work on Junior Gorg's animatronic head while Rob Mills, in Junior's suit, crouches below them.

ABOVE Junior Gorg is tended to on set by puppeteer Bob Payne while shooting the season 1 episode "The Thirty-Minute Work Week."

DESIGNING DOOZERS

THE INDUSTRIOUS DOOZERS ARE FURRY, GREEN, and knee-high to a Fraggle, with big round noses and antennas hidden beneath their helmets. "They're funny and so goddamn cute," says Michael K. Frith. "I love the idea that they've all got their helmets down to their noses and you can't tell one from the other. . . . And while on the job, they act as one, with a collective consciousness like a beehive. When the helmets come off, unique personalities come out.

"One of the things that was always interesting about the characters was to figure out who they were in their own world," he continues. "Doozers were always part of an ensemble but they were also individuals, so you wanted to make sure that they felt like, looked like, and behaved like individuals."

Frith's initial concept drawings gave the Doozers little, round, human-like backsides. "Like a baby's bottom," he says. When Jane Henson saw the artwork, she told Frith that he should go back to one of his earlier concepts, which envisioned the Doozers as ants or termites. "She seemed to take exception

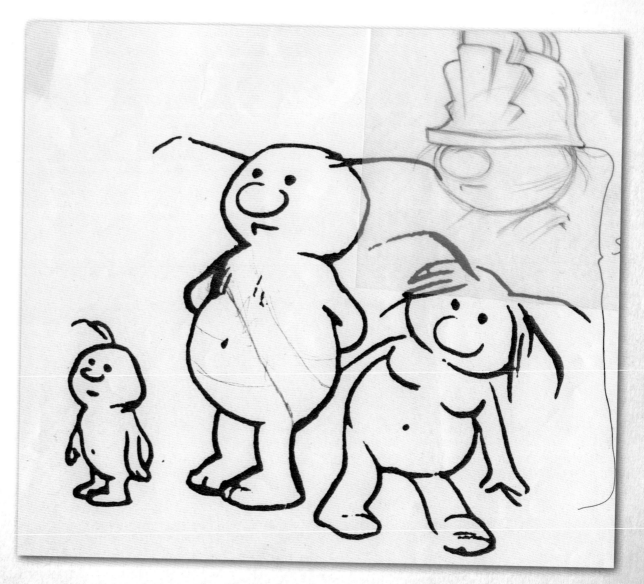

RIGHT Early Doozer designs by Michael K. Frith.

OPPOSITE Muppet special effects director Leigh Donaldson works on a Doozer puppet build.

to the way I'd drawn them, and suggested giving them little termite tails. And she was right," he says. "The baby bottoms were nixed, and I turned them into pointy tails. I thought her suggestion really quite powerful and revolutionary."

Another of Frith's early ideas stipulated that Doozers who supervised crews and projects would be called Bull Doozers and would wear yellow helmets, while the helmets of the Doozers under their direction would be orange or red, indicating a hierarchy within their world. During production, the rules broke down, and the crew in the props department ended up using a variety of bright colors for the helmets—

although the Bull Doozers' headgear bore a medallion that identified their rank.

In addition to helmets, work gloves, and boots, each Doozer wears a well-equipped tool belt. While he was developing the characters, Frith exhaustively listed every tool that could possibly be in the Doozers' belts and gave a copy to Jerry Juhl. "He looked at it and said, 'You were really drunk when you did this, weren't you?'" Frith says with a laugh. "Actually, somebody had given me a book called *Everything Sold in Hardware Stores*, which I found very handy, especially when I was coming up with names for new Doozers."

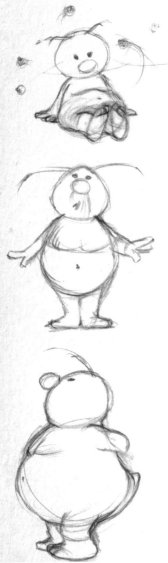

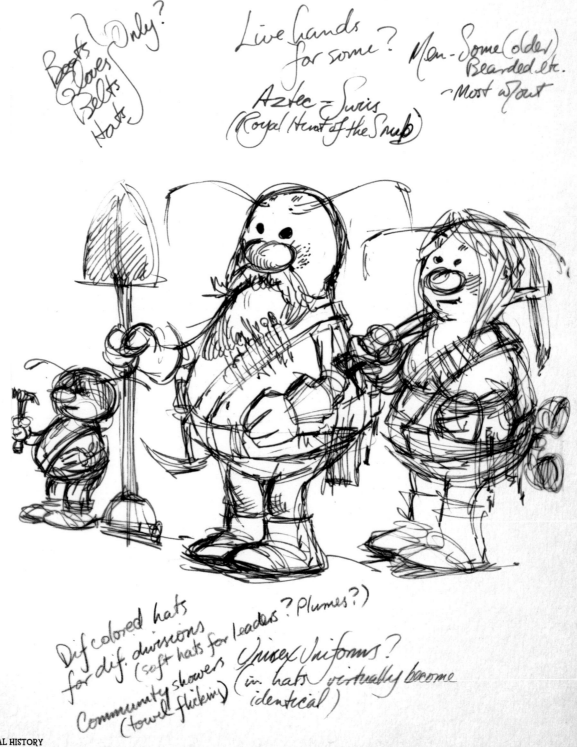

LEFT Various studies by Michael K. Frith exploring Doozer proportions.

RIGHT As seen in this early sketch, Frith put a great deal of time into determining the tools and other equipment that Doozers would carry.

OPPOSITE TOP Mimi Kingsley (left) and others work on Doozer builds. A design sketch by Michael K. Frith can be seen in the background.

OPPOSITE BOTTOM Frith considered giving the Doozers baby bottoms until Jane Henson suggested he revert to his termite tail design.

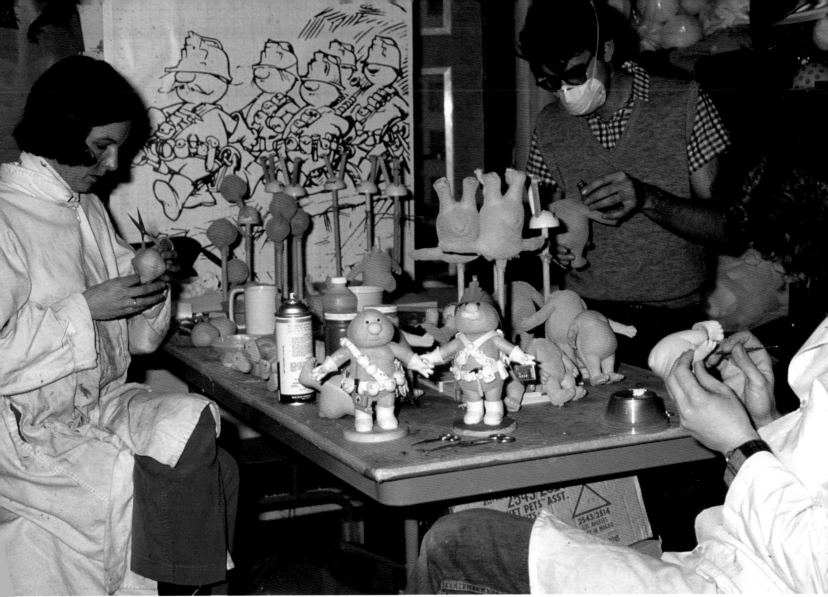

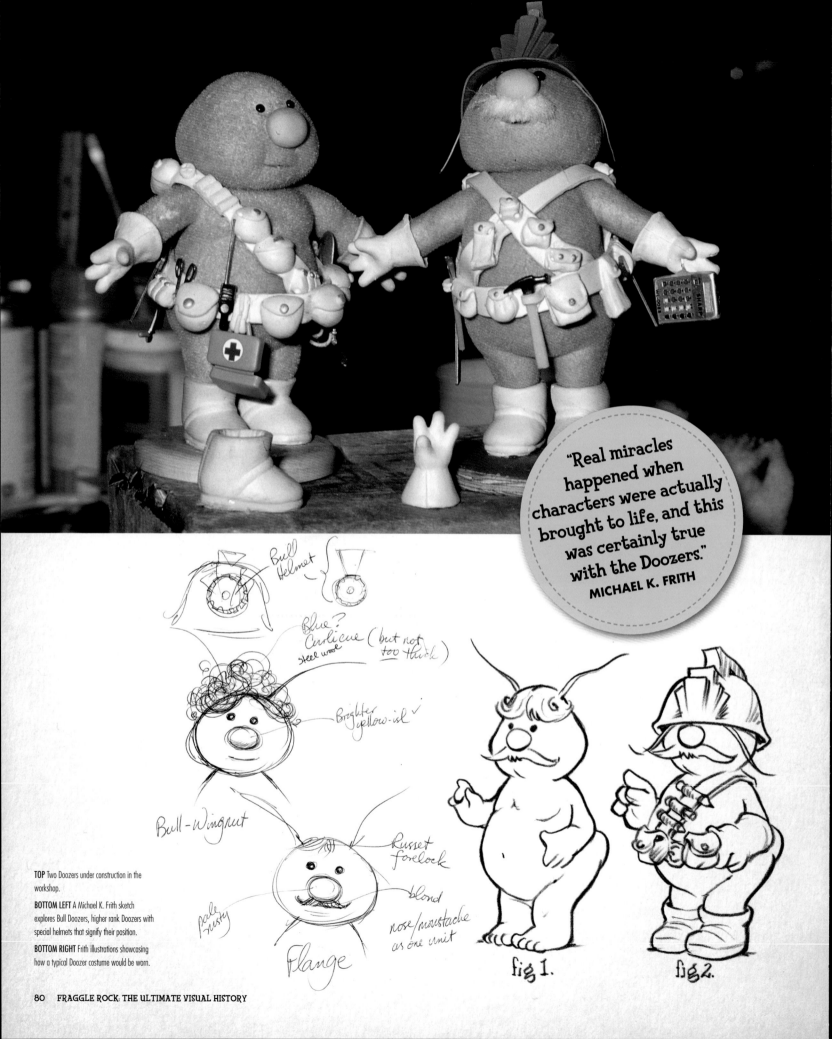

"Real miracles happened when characters were actually brought to life, and this was certainly true with the Doozers."
MICHAEL K. FRITH

Bull Helmet

Blue? Curlicue (but not too thick)
steel wool

Brighter yellow-ish

Bull-Wingnut

Russet forelock

pale rusty

blond

nose/moustache as one unit

Flange

fig 1.

fig 2.

TOP Two Doozers under construction in the workshop.

BOTTOM LEFT A Michael K. Frith sketch explores Bull Doozers, higher rank Doozers with special helmets that signify their position.

BOTTOM RIGHT Frith illustrations showcasing how a typical Doozer costume would be worn.

DOOZERS

SYSTEMS ON TOP OF SYSTEMS AND ROUNDABOUT
METHODOLOGY, WORKING INTO AN AMBIGUOUS
MORFIC MASS. A MAZE OF STRUCTURE THAT,
LIKE A GEODE, SEEMS TO SUPPORT FRAGGLE ROCK

FRAGGLE ROCK — A DRIPPY PLACE WHERE
SEDIMENTS CLING INTO TOWERS AND PEDISTALS
OUT OF WHICH GROW DOOZER CONSTRUCTIONS.
DOOZERS DON'T HAVE TO LAY FOUNDATIONS
FOR THEIR CONSTRUCTIONS BECAUSE FRAGGLES
EAT THEM. THEY JUST KEEP BUILDING THEM UP
THE WAY THAT THEIR ANSESTORS DID. TECHNOLOGY
HAS BEEN IMPROVED ON BUT IT HASNT BEEN A
BOOM AS IT HAS BEEN FOR US. THE STUFF THEY
USE IS PRETTY OLD AND THEY ONLY REPLACE
THINGS AS THEY WEAR OUT. THEIR POPULATION
IS BEGINING TO INCREASE DUE TO A RECENT
BABY BOOM BUT FOR THE MOST PART THEIR
NUMBERS ARE QUITE CONSTANT THANKS TO
LONG HOURS AND RELITIVELY DARK DWELLINGS,
DOOZERS DO HAVE "LIGHT" AT THEYR DISPOSAL
BUT THE ARE ONLY VERY SOCIAL ON CERTAIN
OCCASIONS BECAUSE THEY SEE EACH OTHER ALOT
AT WORK. THE DOOZERS ARE NOT A POSSESIVE
RACE. THEY DO NOT, LIKE FRAGGLES, HORD OR
COLLECT THINGS. THEIR DWELLINGS ARE SIMPLE
RECESSES THAT ARE SPARLLY BUT COMFORTABLY
FURNISHED AND ARE SECURELY SUPPORTED WITH STICKS
TO PREVENT COLLAPSE. THEY ARE NOT PROTECTIVE
OF THE BUILDINGS THEY BUILD IN THE LARGER
HALLS BECAUSE THEY HAVE NO SPECIFIC PURPOSE FOR
THEM EXCEPT AS ACCESS TO FURTHER CONSTRUCTION
THE GREATER FOUNDATION OF WHAT THEY ARE DOING

IS LOCKED IN THEIR CONSCIENCE, AND WHEN THEY ADRESS THIS, IT IS PATRIOTIC IN NATURE. THEIR SOCIAL GATHERINGS IN THEIR COMMON LODGE INVOLVES A MIXTURE OF THIS SENTIMENT, SHOP TALK, BACHI BALL AND DANCING. THE DOOZERS ARE VERY PERCUSSIVE AND THE LET THEIR TECHNOLOGY ENTER INTO THEIR MUSIC. THEY ILLUMINATE BY PHOSPHERECENT MATERIAL THAT THEY MINE FROM UNDER THE TRASH HEAP AND MIX WITH THEIR STICKS. THE EXCAVATIONS UNDER THE HEAP INVOLVES MANY OTHER THINGS THAT THEY USE IN MAKING THEIR TOOLS. DOOZER DISPLAY GREAT REVERENCE TO THAT AREA OF THE CAVES AND GENERALLY BELIEVE THAT THE GROUND THERE TO ABOUND WITH GREAT WISDOM AS WELL AS GENEROUS GIFTS. THE OTHER MATERIAL THAT DOOZERS PULL FROM THE EARTH IS THE MAIN INGREDIENT FOR THE DOOZER STICKS. THIS IS TAKEN FROM ONE SECTION OF CAVES WHERE IT IS PLENTIFUL AND REQUIRES VERY LITTLE REFINING. THE DOOZERS ARE CONSERVATIVE WITH THIS PURE MATERIAL AND OFTEN MIX IT WITH CHOPPED UP RECYCLED MATERIAL THAT THEY CONTINUOSLY COLLECT AS FRAGGLES TAKE BITES OUT OF TOWERS. THEY MINE THIS IN A REVERSE DRILLING FASHION THROUGH THE ROOF OF THE CAVE. WHEN THEY HIT A "VEIN", THROUGH TRIAL & ERROR, IT POURS DOWN LIKE A GUSHER UNTIL IT IS CONTAINED BY A SORT OF VALVE. DIRECTLY ABOVE THIS IS DOC'S STORAGE ROOM AND THE MATERIAL IS, OF COURSE, SUGAR FROM NUMEROUS BIG BAGS THAT HAVE BEEN SITTING THERE FOR A LONG TIME. TAD KRAZNOWSKI IS RESPONSIBLE FOR THIS WONDERFUL IDEA. DOOZERS BASIC WORKING OPPERATIONS ARE

AS FOLLOWS:

I. IN THE FIELD:

A. CONSTRUCTION. OF TOWERS AND BRIDGES
 1. SURVEYING FUTURE SITES
 2. REPAIR OF EXISTANT ROADWAYS
 3. FABRICATION OF SCAFOLDS & STRUCTURES
 4. PREPARING EXISTANT FOUNDATIONS
 5. ERECTION OF STRUCTURES

B. DEMOLITION AND COLLECTION OF BROKEN STRUCTURES
 1. "PRUNING" OF BROKEN STRUCTURES
 2. HAULING DOWN OF WEAKENED TOWERS
 3. TRANSPORTING OF RECYCABLE MATERIAL

C. MINING AND EXTRACTION OF MATERIALS
 1. SUGAR MINING & COLLECTION
 2. EXCAVATION BELOW THE TRASH HEAP

II IN SHOP

A. BREAK DOWN AND RECYCLING OF RUBBER
 1. COLLECTION OF OLD STICKS
 2. CHOPPING AND REFINING
 3 SEPERATION

B. MAKING DOOZER STICKS
 1. MIXING OF MATERIALS
 2. DOOZER STICK MACHINES
 3. TRANSPORTING STICKS TO SITE

C. TOOL SHOP OPERATIONS
 1. MAKING OF HAND TOOLS
 2. REPAIR AND CONSTRUCTION OF MOBILES ETC.
 3. MAKING (ILLUMINOUS) MATERIAL
 4. POWER PLANT - WATER WORKS
 1. HARNESSING WATER TO MAKE (AMBIGUOUS)
 PORTABLE POWER SOURCE FOR VEHICALS
 2. DIRECT LINKAGE TO LARGER MACHINES
 IN SHOP

III IN HOME
 1. SUPPORTING CAVE DWELLINGS
 2. DOMESTIC ACTIVITIES.
 3. FOOD PREPERATION? (ROCKS & MOSS)

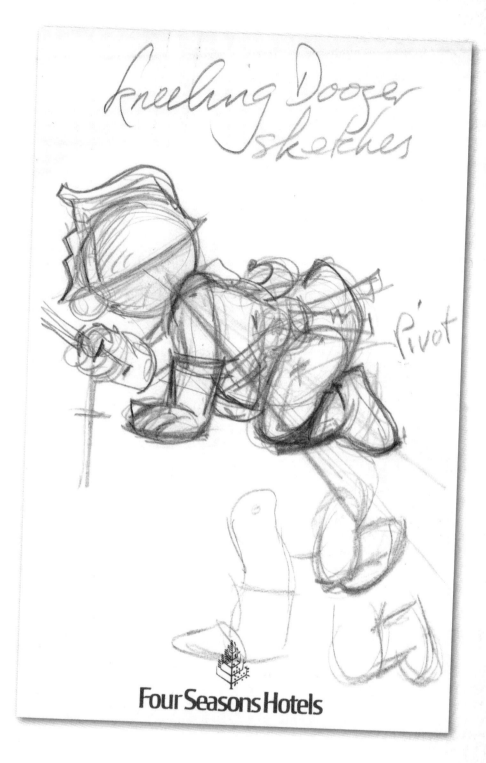

kneeling Doozer sketches

Pivot

Four Seasons Hotels

Nomi Frederick and Norman Tempia used Frith's designs to sculpt the first Doozer puppets at the New York workshop. Their bodies were made from foam latex and were flocked to give them a subtly fuzzy appearance. Frederick and Tempia sculpted the outside *and* the inside of the Doozers. "Their core has a special shape that allows the mouth to open and close in a very organic and charming way, with the simplest of controls," says Tom Newby, Faz Fazakas's technical assistant.

The first attempt at Doozer articulation involved the little puppets being fitted with manual hand controls that were attached to a thick rod extending down from their bodies. Various mechanisms on the rod allowed the puppeteers to swivel a Doozer's body, make the head turn, the body bend, or the arms move. The rod also had a trigger that would open and close the Doozer's mouth. Unfortunately, the puppeteers found the movement offered by the rod-based mechanism to be very limited, so, before filming began, Faz Fazakas decided to remove this device and redesign the Doozers.

Fazakas inserted two radio-controlled metal tabs inside the revised Doozer mouth that allowed the puppeteer to execute a wide range of expressions, including amazement, pouting, and joy. "By closing the tabs, the lips would purse," Newby explains. "Opening the tabs would give quite a bit of expression." The Doozer bodies would be manipulated by a second puppeteer using rods attached to the puppet's arms and legs that could be used to make the little creatures gesture or walk.

Using two puppeteers to animate the Doozers—one on the rods, one on the radio—was more logistically complicated. But according to Michael K. Frith, the extra trouble was worth it, because the characters looked so much more alive than they had when operated by rods alone. The intricate, miniaturized controls also allowed the designers to maintain a sense of scale between the adorably tiny, ever-disciplined Doozers and the bigger, floppier Fraggles.

"Real miracles happened when characters were actually brought to life, and this was certainly true with the Doozers," says Frith. "One of the great challenges was the miniaturization of everything needed for their movement. This is where the geniuses of both the puppet builders and the mechanics met the expectation and surpassed it. It never occurred to anybody that they couldn't do it."

TOP LEFT Michael K. Frith designs for Doozer machines.

TOP RIGHT A Frith sketch showing possible mechanics for a kneeling Doozer puppet.

INSERT A series of notes on the Doozers created by Tom Newby.

THE TRASH HEAP HAS SPOKEN

MICHAEL K. FRITH HAD TAKEN HIS FIRST pass at sketching Marjory the Trash Heap during the early meetings at the Hyde Park Hotel. In later drawings, Frith explored the question of how the puppet could be built and performed. His notes included thoughts on the puppet's body shape, which he thought could be maintained using spiral boning. With the boning and a big interior rod—with triggers embedded in the rod to move the eyes and mouth—Marjory could rise up out of an indistinct pile of refuse and mulch to engage with the Fraggles, and then could collapse back down just as suddenly and lie flat. Frith also gave her a lorgnette—a pair of spectacles with a handle—as an affectation.

BOTTOM Development sketch by Michael K. Frith showing how Marjory's body shape could be maintained with circular boning that could collapse upon itself when the puppeteer lowered her back into the ground.

OPPOSITE Richard Hunt performs Gunge, one of Marjory's shills.

Frith imagined that Marjory would be surrounded by a group of little creatures who would act like carnival barkers, extolling her words of wisdom. This phalanx of "shills," as the puppeteers referred to them, were narrowed down to just two characters during the scriptwriting process, Philo and Gunge.

Jerry Nelson described Philo and Gunge as essential to defining Marjory's personality: "They were always fighting and she was always threatening to send them back where they came from. It was a wonderful character. Very rich and warm, and she had a sense of humor about Philo and Gunge and also about the Fraggles. She sort of saw and understood what they were going through even though they didn't."

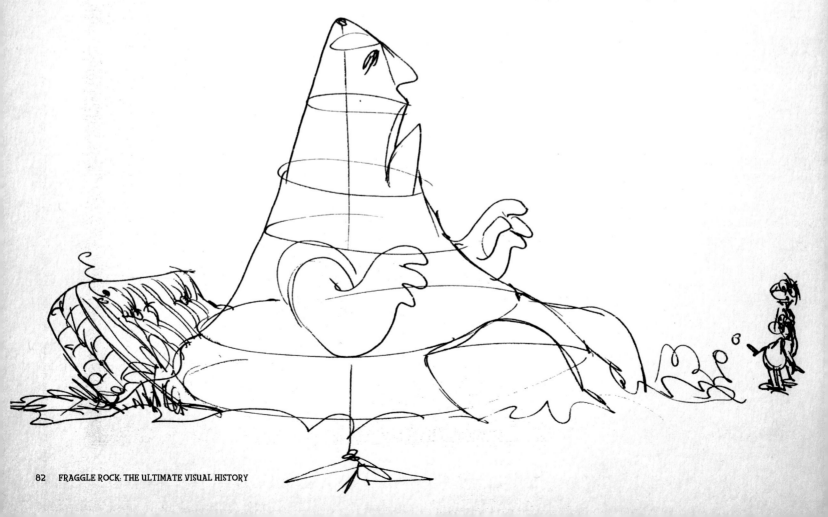

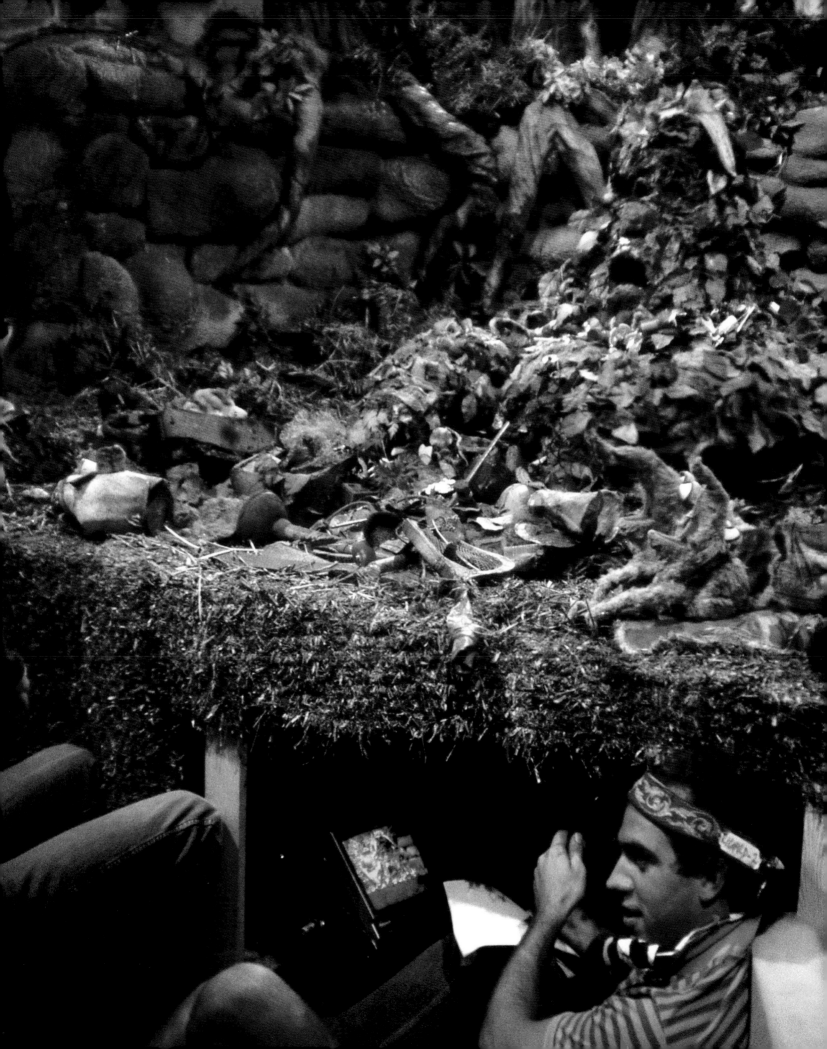

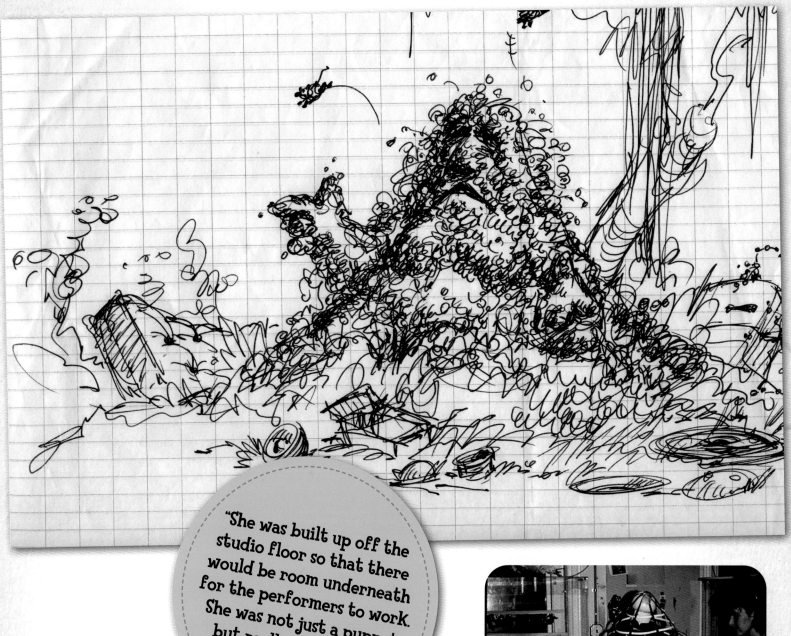

"She was built up off the studio floor so that there would be room underneath for the performers to work. She was not just a puppet but really a whole set."
MICHAEL K. FRITH

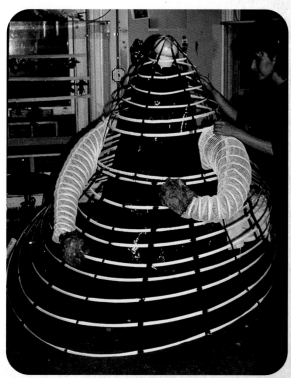

The "Heap" was made from a heavy, dense foam rubber, and dressed with fabric made to look like several kinds of moss and lichen. She was also decorated with more than a dozen types of silk leaves, rocks, fake orange peels, coffee grounds, and a scrunched-up fiber referred to as a "cow patty." It took three puppeteers in all to work Marjory, according to Jerry Nelson: one to lift the rod and work its triggers, and one each for the two hands.

"She was built up off the studio floor so that there would be room underneath for the performers to work," says Michael K. Frith. "She was not just a puppet but really a whole set."

TOP A close-up of the Trash Heap from Michael K. Frith's map of Fraggle Rock and its environs.

BOTTOM Unidentified puppet builder works on the frame for Marjory the Trash Heap.

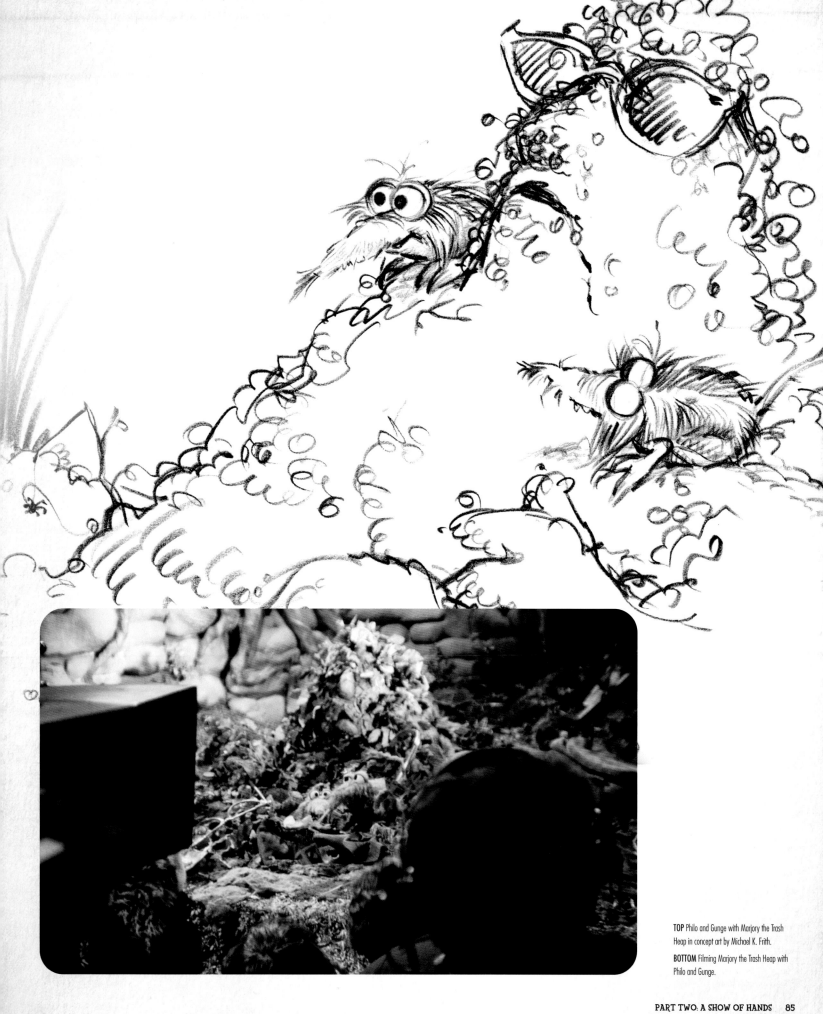

TOP Philo and Gunge with Marjory the Trash Heap in concept art by Michael K. Frith.

BOTTOM Filming Marjory the Trash Heap with Philo and Gunge.

A SILLY CREATURE'S BEST FRIEND

SPROCKET THE DOG PLAYS AN ESSENTIAL role in *Fraggle Rock*—he's the only being in Outer Space who is aware of the Fraggles, and is constantly trying to convince Doc that these magical creatures exist.

Michael K. Frith feels that his sketch for Sprocket was less final than the other designs he provided the puppet builders. "In my initial drawings I'd done a kind of pro forma, medium-sized, floppy-eared, friendly looking, vaguely border collie-ish, shaggy dog. Period," he explains. "Not much in the way of character, but that was all that was needed at the time." Frith credits puppet builder Tim Miller with breathing life and personality into Sprocket. "Tim just got it and ran with it," he says. "He created the unforgettable character that was the bridge between our world and the one behind the baseboard. A dog more human than his human companion, a wonderful, magical, believable bearded collie you just had to love."

While developing Frith's design into a final puppet, Miller found himself looking at a lot of dogs as he traveled between his home and the workshop at Eastern Sound. "[I was absorbed with] the construction of their bodies, their faces, and

expressions," he said. "Sprocket had this wonderful woeful quality that Michael drew in the original drawing. Really sad eyes." Upon reading the scripts, Miller also became aware of a key element of the character that would be reflected in his final hangdog design: Sprocket was always put-upon: "He was this long-suffering companion, which was a really sweet relationship."

Sprocket's fur was a combination of materials stockpiled at the workshop, along with traditional Muppet fur. "We would always send out people to find stock," said Miller, "but usually, it ended up that we had something hidden in our stores that was better. Fortunately, Jim had a habit of stocking up on the really good stuff."

Sprocket's snout was fashioned from the same type of ostrich feathers used on the Fraggles, with some added yak hair. "Yak hair is used a lot for wigs, because it's coarse," Miller

BOTTOM LEFT The first concept for Sprocket drawn by Michael K. Frith.

BOTTOM RIGHT A reference Polaroid captures the structure of Sprocket's eyebrows.

OPPOSITE TOP Steve Whitmire and Karen Prell perform Sprocket in Doc's Workshop for the season 1 episode "The Terrible Tunnel."

OPPOSITE BOTTOM Promotional photo of Sprocket.

HAYWIRE UNDER BROWS
DONE FOR HIT #2,3

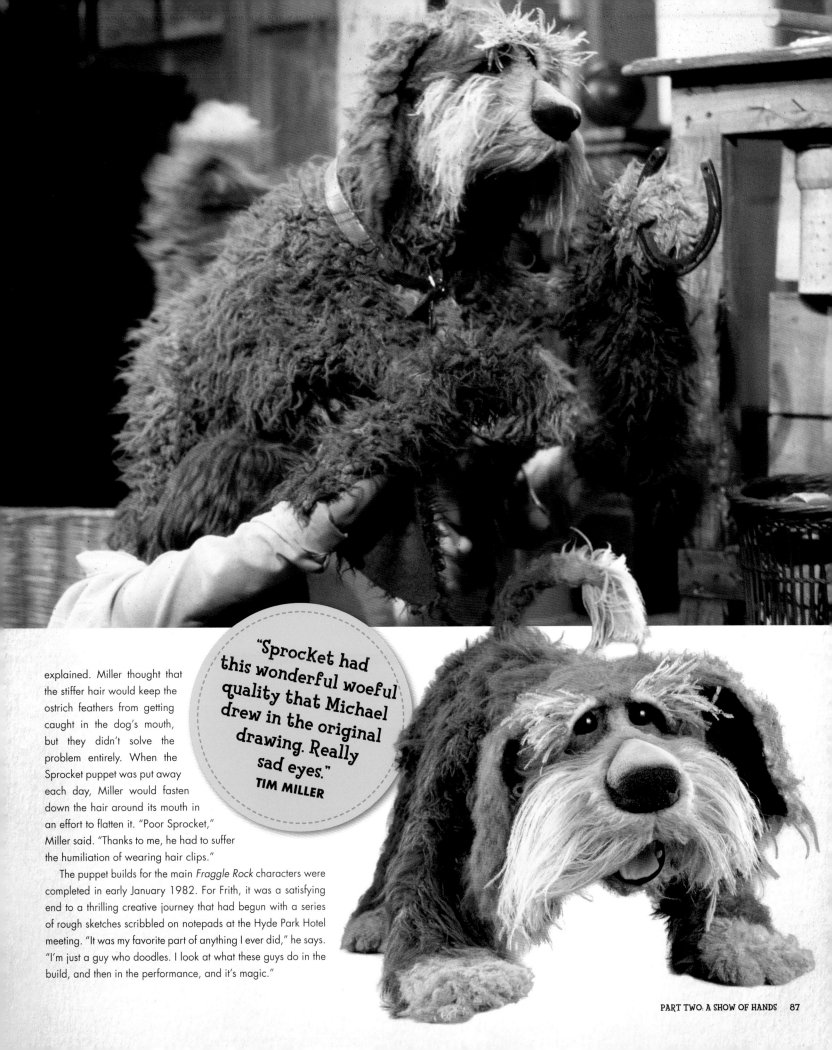

"Sprocket had this wonderful woeful quality that Michael drew in the original drawing. Really sad eyes."
TIM MILLER

explained. Miller thought that the stiffer hair would keep the ostrich feathers from getting caught in the dog's mouth, but they didn't solve the problem entirely. When the Sprocket puppet was put away each day, Miller would fasten down the hair around its mouth in an effort to flatten it. "Poor Sprocket," Miller said. "Thanks to me, he had to suffer the humiliation of wearing hair clips."

The puppet builds for the main *Fraggle Rock* characters were completed in early January 1982. For Frith, it was a satisfying end to a thrilling creative journey that had begun with a series of rough sketches scribbled on notepads at the Hyde Park Hotel meeting. "It was my favorite part of anything I ever did," he says. "I'm just a guy who doodles. I look at what these guys do in the build, and then in the performance, and it's magic."

CASTING ABOUT

IN LATE 1981, WHILE THE Fraggle puppets were being finished, the creative team began the process of gathering together a top-notch group of puppeteers to play the new characters. Over the years, Jim Henson had established a group of core players that he would tap from production to production. "And Jim wanted the A-team for this," says Jocelyn Stevenson, "especially as he didn't want to have to be there every day."

That A-team started with veteran puppeteer Jerry Nelson, who had just come off *The Muppet Show* and *The Great Muppet Caper.* Nelson had previously performed myriad characters including Count von Count and Mr. Snuffleupagus on *Sesame Street*, and Lew Zealand, Camilla the Chicken, and Dr. Teeth and the Electric Mayhem's bassist, Floyd Pepper, on *The Muppet Show*. Nelson had also performed Kermit's nephew Robin, with a sensitivity and sweetness that suggested the puppeteer had a lot more to give. Way back during the Hyde Park Hotel meeting, Frith had suggested that Nelson perform the new project's lead character. "I really thought it was time," says Frith, "that we built a show around Jerry, who had always been kind of a third banana."

Toward the end of November 1981, Nelson and five other puppeteers were invited to Henson's New York offices on 69th Street to discuss the project. "I was one of the main guys, and so I was involved in all the major projects," says Dave Goelz. "So it was a given that 'we' were going to do this—'we' meaning the core performers. All of them except for Frank [Oz] and Jim, who were busy with other things." Joining Nelson and Goelz were Steve Whitmire, Karen Prell, Kathryn Mullen, and Richard Hunt. Before the meeting, they each received a copy of the conceptual booklet so that they could familiarize themselves with the Fraggle characters.

During the session, the five performers began workshopping the puppets, improvising with each of the characters. Goelz felt

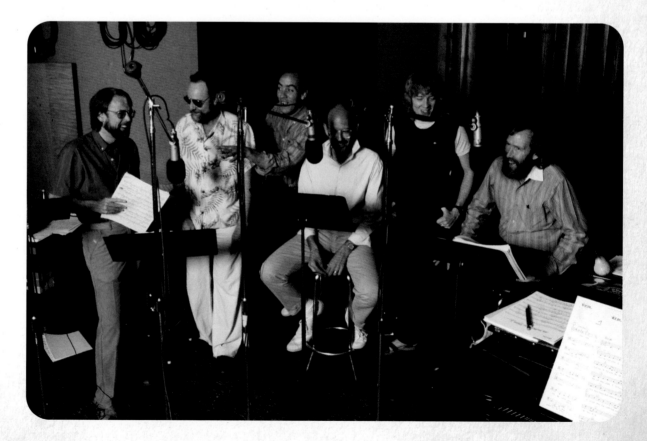

BOTTOM Several of the puppeteers from *The Muppet Show* would go on to work on *Fraggle Rock.* In this 1984 photo (left to right) Dave Goelz, Jerry Nelson, Richard Hunt, Frank Oz, Steve Whitmire, and Jim Henson record together for a subsequent project.

OPPOSITE Karen Prell (left) performing Red and Kathryn Mullen (right) performing Mokey in preproduction rehearsals, 1982.

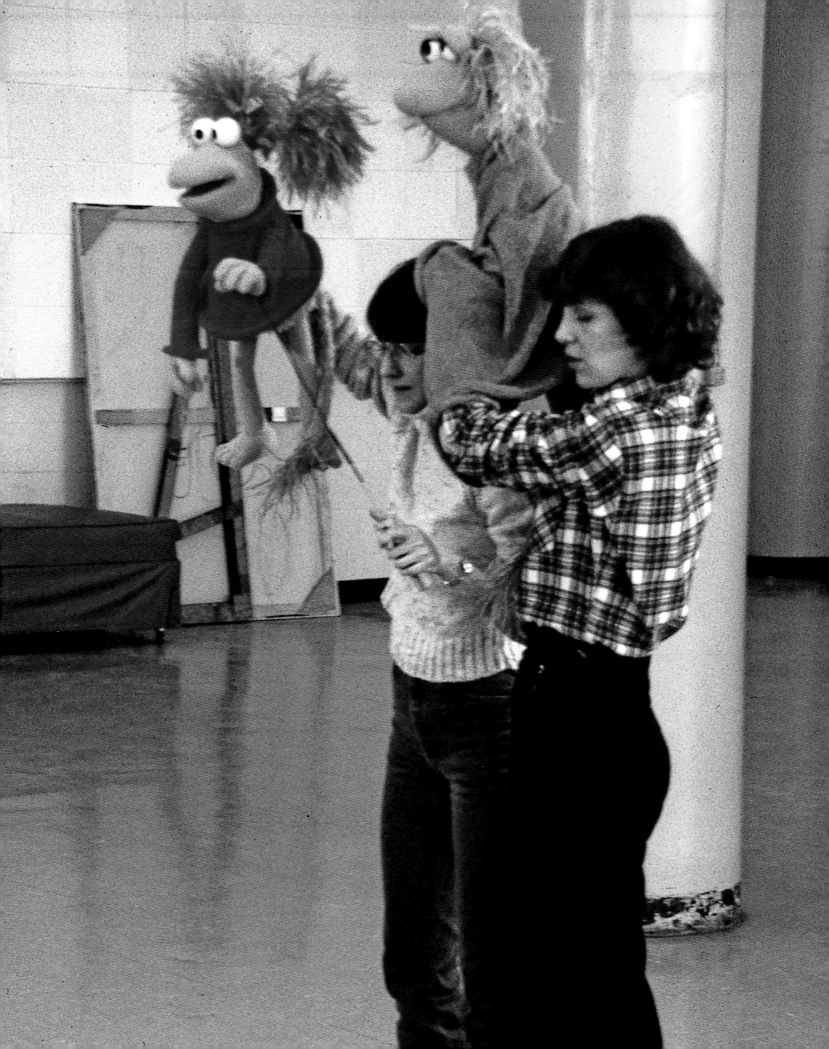

the whole day was a bit farcical, "because I was pretty sure they had created the characters for us." At the end of the meeting, Goelz asked Juhl if that was the case. "And Jerry said, 'No, no, I didn't,' with that innocent smile of his. For years he denied that he had written each character for a performer. Eventually, he finally copped to it." Of course, it was as certain as death and laundry that Goelz would perform Boober Fraggle, "who was sort of grumpy and inflexible, just like I could be a lot of the time."

Goelz started out as an industrial designer, but had an interest in puppetry from an early age. After meeting Frank Oz at a puppetry festival in 1972, he got the chance to show Jim Henson his portfolio of original puppet designs, and was soon hired to be a puppet builder in the New York workshop. "But I told

Jim that I was really interested in performing," says Goelz. "He said, 'We don't need any at the moment, but if you came and worked in the shop, we could find ways to try you out as a performer.' And true to his word, that's what Jim did." In this early role, Goelz constructed three members of Dr. Teeth and the Electric Mayhem's band for *The Muppet Show*: drummer Animal (performed by Frank Oz), Floyd Pepper (Nelson), and saxophone player Zoot, the first major character Goelz performed. He subsequently became a full-time performer, best known for playing beloved Muppets Gonzo and Dr. Bunsen Honeydew.

When Goelz took his first look at the Boober puppet, he remembers thinking, "Here we go again!" Boober would be the third character he performed who had no eyes, after Zoot (hat and sunglasses) and Dr.

"I've gone through several jobs that offered security and dental insurance, but none gave me the opportunity to become hairy monsters or singing animals."
KAREN PRELL

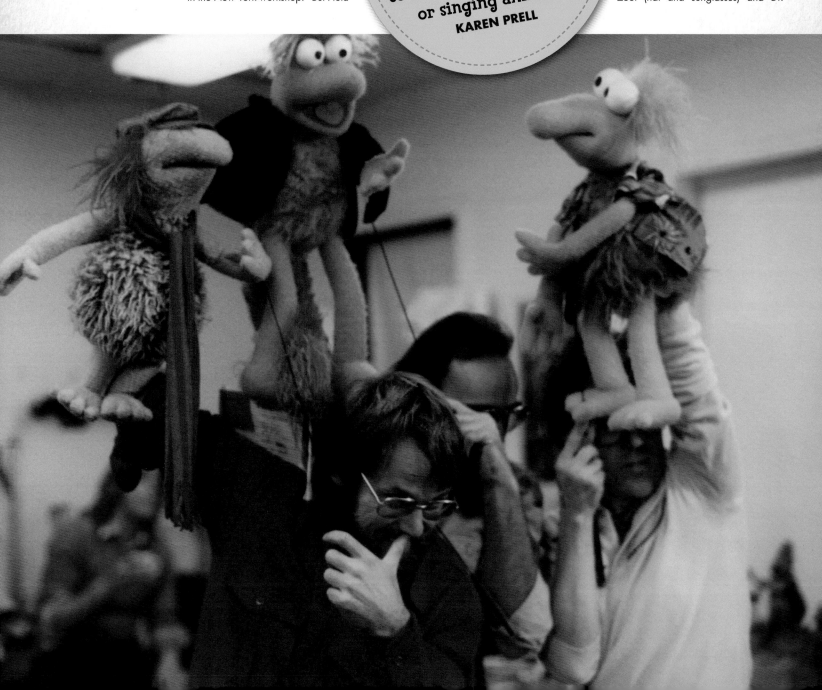

Bunsen Honeydew (glasses, but no eyeballs behind them). "It's a little bit harder to perform a character like that, because you can't connect with the audience, you can't look into the camera, you can't look at things as clearly as you can with eyes," he explains. "Wembley has huge eyeballs, so there's a very, very intense contact we make with him, because we can see those eyes. Working without eyes is a little harder. Boober had his cap pulled down; there aren't even any eyes under there. But I understood the reason for that, because Boober was afraid of everything."

Although Frith wanted Jerry Nelson to play Gobo, the puppeteer was initially set on playing Boober. "Boober was kind of silly and fun, and I remember telling Jim that I'd like to do that part," recalled Nelson. "He said, 'I had Gobo in mind for you. He's like the cement that holds it all together.'" But Nelson didn't think of the character as a front-and-center role: "Gobo was the coherent one that kept things a little focused, because Wembley wembled, Boober was fixated on things going bad, Mokey

was very airy. The real competition was Red, who was very competitive with Gobo and tried to be sort of a scout leader."

Steve Whitmire was immediately drawn to Wembley Fraggle. "I just felt really comfortable with the character," says Whitmire. "I really pushed to do [Wembley], but we did ad-lib improvisations where I would play Gobo, and Boober, and all the different ones, but I knew which one I wanted to do."[9][10]

Whitmire received his first big break when, as an aspiring eighteen-year-old puppeteer, he met Big Bird performer Caroll Spinney. Spinney encouraged him to contact Jim Henson. Impressed by his talent, Henson hired Whitmire and eventually sent him to England to hone his craft on *The Muppet Show*, where he performed many background characters. His scene-stealing character Rizzo the Rat marked him as a major talent, but Wembley would be Whitmire's first lead role.

Whitmire felt a natural kinship with the little Fraggle. "I wore bright Hawaiian shirts when I was little and wimpy like Wembley," says Whitmire.[11] Whitmire was so taken with Wembley's dress sense that he even asked costumer Polly Smith if she could make him a human version of the banana tree shirt. "Sadly, I never got around to it," admits Smith.

At the meeting, Karen Prell also assumed that her character had been pre-chosen by Juhl and Henson. "Mokey sounded just like me," she says of the sweet, lavender-haired Fraggle. As a young puppeteer and puppet maker, Karen Prell had written to Jim Henson in 1979, asking to work with the "Muppet people" in New York. "I've gone through several jobs that offered security and dental insurance," she wrote, "but none gave me the opportunity to become hairy monsters or singing animals."[12] Prell was asked to send in a tape and was soon hired to perform background puppets on *Sesame Street* and *The Muppet Show*.

At the meeting, Prell and fellow puppeteer Kathryn Mullen

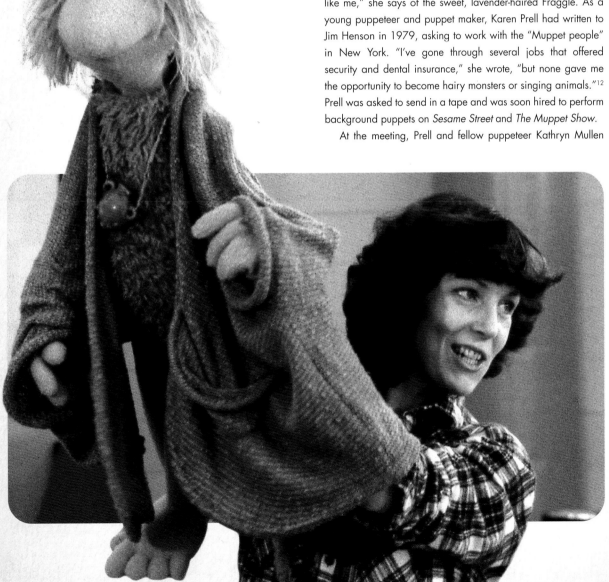

OPPOSITE Dave Goelz performing Boober, Jerry Nelson performing Gobo, and Bob Payne performing Wembley at the Fraggle puppet workshop tests in Toronto, December 1981. Payne had previously puppeteered Pod People on *The Dark Crystal*.

BOTTOM Kathryn Mullen performing Mokey in preproduction rehearsals, 1982.

TOP Kathryn Mullen and Karen Prell use a
mirror when practicing with Red and Mokey in
preproduction rehearsals, 1982.

improvised different scenarios with the Mokey and Red puppets, taking turns playing the two characters. "We knew that there was a feisty one and a dreamy one," says Mullen, "and I always thought that I should be the feisty one."

Mullen had fallen into puppeteering accidentally, having started out as an actress. Her first work with Henson Associates was as an assistant puppeteer on Camilla the Chicken (Gonzo's great love) after joining *The Muppet Show* in its third season. Just before being cast in *Fraggle Rock*, she played the central character Kira in *The Dark Crystal*. She also assisted Franz Oz with his performance as Yoda in *Star Wars: Episode V—The Empire Strikes Back*.

A few days after the auditions, Prell got a call from Jim Henson. "He said he wanted me to play the part of Red Fraggle," she remembers. "I was, of course, excited that I got a part on this show. I hung up and called my parents. 'They want me to be Red Fraggle.' And then I said, 'I don't want to be Red Fraggle! I wanted to be Mokey!'"

But once Red clicked for Prell, she couldn't imagine being another character. "And Rollie Krewson built Red like a Stradivarius," she says. "It was just so wonderful having an expressive puppet that was as beautiful on the inside as it was on the outside as far as being able to communicate everything with just the most subtle movements of the hand."

Mullen was perfectly happy to play Mokey although the character presented a number of challenges. The Mokey puppet was taller than the other Fraggles, which meant Mullen's hands often had to be up higher than those of her colleagues. Mullen found it physically challenging to keep her head ducked low enough while her hands were way up in the air. "It was a perfect storm of possible head-in-the-shot disasters," she says.

Despite the technical difficulties Mullen faced, she soon proved to be the perfect choice for Mokey. "We always thought of Mokey as the sort of mother of the group—not quite as crazy and frenetic as the others," says writer Jocelyn Stevenson. "There was a danger that she could have been too earnest or serious. But Kathy found a level of committed goofiness in Mokey that made her the most wonderful character to write."

The other member of the A-team present at the meeting, *Muppet Show* alumnus Richard Hunt, didn't end up being cast as one of the Fraggle Five, but still became a key player on the show, performing the voice and face mechanics of Junior Gorg. Hunt began with Henson Associates in 1970, performing background characters before finding his rightful place among the performers on *The Muppet Show*, playing Scooter, Beaker, Sweetums, Statler (of Statler and Waldorf), and guitarist Janice from Dr. Teeth and the Electric Mayhem.

"Richard would start a production by learning everyone's

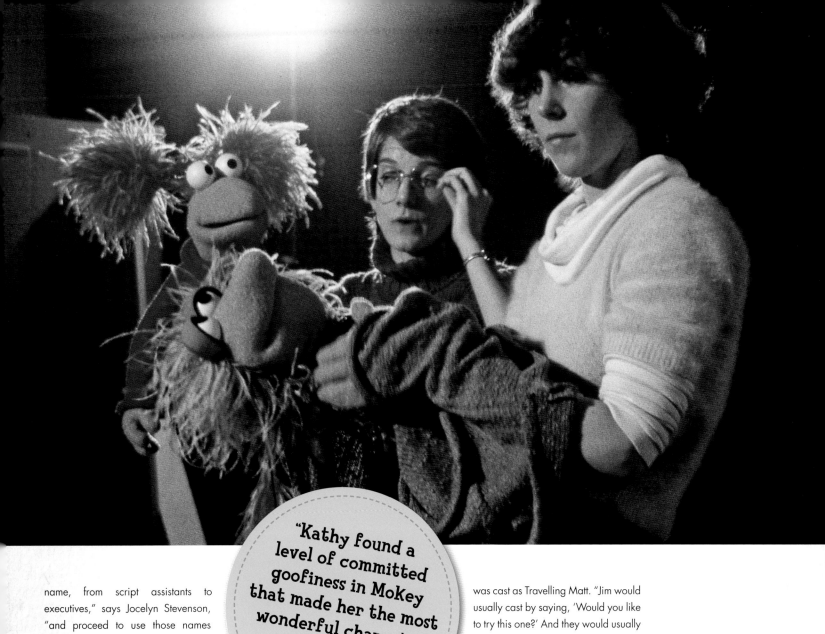

"Kathy found a level of committed goofiness in Mokey that made her the most wonderful character to write."
JOCELYN STEVENSON

name, from script assistants to executives," says Jocelyn Stevenson, "and proceed to use those names regularly and loudly. He was gregarious and hilarious and everyone loved him." Hunt often acted as a mentor to young puppeteers at the company, and on *Fraggle Rock* would frequently supervise the auditions for new Canadian performers.

Jerry Nelson admitted to being in awe of Hunt. "Richard was an integral part of the show," Nelson said. "He was at the same time going down [to New York] and working on *Sesame Street*. He would travel back and forth. But he brought immense energy and depth to so many roles. Richard had this amazing ability to not show up until just before he's needed. He'd magically appear. The other thing he would do is read a script and know it. He could sit and do a crossword puzzle and then they'd say, 'Richard, you're on,' and he would look like he'd never looked at a script and yet he'd do it and boom, it was done."

In addition to playing their principal characters, the core group of puppeteers would also perform other members of the *Fraggle Rock* population. "There were only five of us, so we always had more than one character," says Dave Goelz, who

was cast as Travelling Matt. "Jim would usually cast by saying, 'Would you like to try this one?' And they would usually end up doing it, because Jim was good at casting and knew what everybody could do."

Jerry Nelson was asked to voice and perform Marjory the Trash Heap, but her shills were up for grabs. "When it came time to read the Trash Heap scripts, Dave and Richard simultaneously headed for the puppets and started doing them at the same time," recalls Karen Prell.

Richard Hunt picked up the gray puppet, Gunge, first and voiced the character with his native New Jersey accent, ending every last line of dialogue with a drawn-out "naaaah." "Richard immediately had a character for him that seemed so good to me that I just copied him," says Goelz, who would play Philo to Hunt's Gunge. "Richard was a very natural performer, and spontaneous. He didn't over-polish. He just delivered, and it was brilliant."

A few weeks later, the production team set out to find the full-costume performers who would inhabit the Gorg puppets. Frith remembers that when he was designing the Gorgs, he worried that casting suitably sized puppeteers would be a challenge.

TOP Preproduction rehearsals with Karen Prell performing Red and Kathryn Mullen performing Mokey, 1982.

"One's got to be very tall; one's got to be middle-sized, and one's got to be short," he says. "This is never going to happen." He was also concerned about the chances of finding three puppeteers of the right size who were athletic and could work together cohesively.

Frith's fears abated after an audition by the Toronto-based act the Mime Associates, comprising five-foot-five Gord Robertson, five-foot-six Trish Leeper, and six-foot-three Rob Mills. The trio had formed the mime company about six months earlier, and, along with their mime skills, had experience in commedia dell'arte, clowning, juggling, dance, acrobatics, and mask work. When they heard that Jim Henson was coming to Toronto to shoot a new show with the CBC, they jumped at the opportunity.

The somewhat chaotic Gorg auditions were run by the irrepressible Hunt. Potential Gorg performers were lined up in a hallway, waiting to be called into an audition studio one at a time. When it was Mills's turn, "Richard stuck his head out the door and yelled at me: 'You! Get in here!'" Mills remembers. When the mime artist entered the room, carrying a battered suitcase filled with masks and props, Hunt told him to stand against the wall and "try to look intelligent," recalls Mills. "*Flash*—he takes a Polaroid, writes my name on it, clips it to my résumé, and tosses that onto a pile of others." Hunt had him run through a short series of exercises, making moves that Mills was required to mimic. "Then he says, 'Okay. Get out. Who's next?' I ran out to Trish, handed her the suitcase, and told her to do what I just did." Leeper came back into the hallway as quickly as Mills had, and handed over the suitcase. "Then it was Gord's turn . . ."

"I got maybe four steps into the room," says Robertson, "and Richard Hunt yells at me, 'Are you with them?' Yup. He says, 'Get outta here.' So, I went, 'Okay, thanks a lot,' and turned to walk out, which was the absolutely perfect thing to do for Richard. He said, 'No, no, come back in.'"

Hunt brought all three in for a group audition in front of Jim Henson and Duncan Kenworthy, who watched them perform a piece incorporating mask work. Afterward, the three were asked the same question: Had they ever worked in big bodysuits or with big puppets? Mills and Leeper had, but not Robertson. "I'm seriously freaking out," Robertson recalls. "I was afraid they'd think I wasn't strong enough to do it. So, when they asked me if I had any experience, I said, 'Well, no, but I worked in a lumber mill once.' Everyone cracked up, and somehow that was good enough."

THESE PAGES In 1982 preproduction rehearsals, Trish Leeper (Ma Gorg), Gord Robertson (Pa Gorg), and Rob Mills (Junior Gorg) get to grips with performing their characters.

CASTING IN OUTER SPACE

THE ONLY HUMAN CHARACTER SEEN IN *Fraggle Rock* is Doc—a passionate, though rather inept, tinkerer who develops many of his inventions to benefit his loyal, furry companion, Sprocket the Dog. Doc has an infectious enthusiasm for "bettering" things, and glorious aspirations, but his most outstanding attribute is his heartfelt friendship with Sprocket.

Among the actors testing for the part was Gerard "Gerry" Parkes, an Irish-born actor who began his career on the stage before moving to film and television. Parkes had performed in many CBC productions by the time he was asked to audition for *Fraggle Rock*. Thinking it was a music show, Parkes replied that he didn't sing or play guitar. After being assured that his role didn't require a shred of musical talent, Parkes met with the producers. "I was sitting and talking to Jim Henson when a dog came up and started breathing in my ear," he said. Parkes didn't realize it was the Sprocket puppet rather than an actual canine: "I said something like, 'Get outta here,' and several weeks later, I got the part."

Never having owned a dog, Parkes wasn't sure how his character and Sprocket would get along, particularly as his furry companion was a puppet. "But I got to believe in Sprocket," he said. "When he had these quizzical looks, it got to me. I really liked him."

Steve Whitmire was asked to play Sprocket, performing his head and left paw, and vocalizing his barks, whines, snuffles, and growls. When Sprocket couldn't get his point across with sounds, the puppeteer would use pantomime to communicate the dog's thoughts. "[Steve] did all this with a sort of sign language," said Tim Miller. "It was very silly but the most

BOTTOM In Doc's Workshop, Karen Prell (left) and Steve Whitmire (hidden at right) rehearse their performance as Sprocket.

incredible bit of puppeteering. It was such a joy to watch these guys work, and we certainly appreciated the joy they brought to the characters."

Karen Prell performed the right paw and the tail, which was not attached to the body. "The tail was as long as a flyswatter, if you can imagine holding up a flyswatter and wagging it," she says. "There's a lot of technical work involved with making the illusion and the life all come together. The tail might be four feet away from the camera, but on camera, you have to make it work for two dimensions."

Prell also worked Sprocket's ears, which were operated using a bar attached to cables that was housed in the puppet's body. "Steve had his right hand in Sprocket's head, where he had a mechanism to manually move Sprocket's eyebrows up and down," she explains. "His left hand was in Sprocket's left hand. I

had my right hand in Sprocket's right hand, so when we needed a strong ear reaction for something, I would pull down on the bar to raise up Sprocket's ears." Prell had to pull very carefully on the bar so that she didn't yank Whitmire's right hand. "Sometimes, I was switching between doing his ears, bringing up his tail, back and forth, while keeping my right hand in Sprocket's paw," she adds. "It was a fun little dance, juggling all those parts of the Sprocket instrument."

With the main *Fraggle Rock* cast set, head writer Jerry Juhl sent Hunt, Nelson, Goelz, Whitmire, Mullen, and Prell two prototype scripts and the most recent version of the Things We Know About lists. "Now that the parts have been handed round and we all know the players," wrote Juhl in a memo sent the first week of December 1981, "it is time to get down to business and really create these characters!"

TOP Jim Henson confers with Gerry Parkes (Doc) on the set of Doc's Workshop.

PUTTING PEN TO PAPER

IN THE FIRST SEASON OF *FRAGGLE ROCK*, the personalities and relationships of the main characters needed to be established and then explored through obstacles overcome and lessons learned. "For the first season, we asked, 'What is this and where are we going?'" says Jocelyn Stevenson. The lists of Things We Know About provided factual information about the characters and their environment, but had not placed them in situations that would reveal their strengths and weaknesses, their integrity and temperament.

BOTTOM Writer Jocelyn Stevenson and Red in an impromptu script conference.

OPPOSITE TOP Jocelyn Stevenson and Red during the filming of season 1's "New Trash Heap in Town," 1983.

OPPOSITE BOTTOM Promotional shot of Jocelyn Stevenson and Jerry Juhl in 1984 on the set of *Fraggle Rock*, surrounded by a cast of characters.

Additionally, "Until the performers are brought in, it's hard to find a real chemistry with the characters," said Jerry Juhl. "They find the sparks that make the characters seem real. That gives the writers something to draw on and enables them to develop richer material to give back to the performer."[13]

The sample scripts sent to the puppeteers had given them enough insight to begin exploring their characters, but now twenty-four half-hour shows needed to be scripted. It was decided the show would start filming in March 1982, so every aspect of the production ramped up to meet that date.

Jerry Juhl set out to gather together a team of storytellers who could explore the central theme of conflict resolution throughout the twenty-four-episode arc, but present it in a fun, humorous way. His desire was to find "real interesting people," as he described it, to tell the tales of *Fraggle Rock*. "Jerry categorically did not want to bring any professional children's television writers on board," says Jocelyn Stevenson. "He was much more interested in bringing in poets and playwrights—people with wild imaginations who would help us create a series that wasn't just another kids' TV show."

Meetings were arranged with potential writers in which the world of *Fraggle Rock* and ideas for stories would be discussed. Juhl brought in novelists, screenwriters, and playwrights to write an episode or two to "test" them out. There was Laura Phillips, a young television script editor, and B. P. Nichol, a well-known poet (who styled his pen name as bpNichol). Sugith Varughese had written a number of screenplays for Canadian television. During his first meeting with Juhl, Varughese was taken into a little room where the Fraggles were kept on pegs when they weren't being used. "It was like the Sistine Chapel of puppetry," says Varughese. "Jerry took one of the puppets off its peg, put his hand in it, and said, 'You know, without us these are just socks.' That's when I knew that I could work on this show, because he cared about the writing, above all else."

Stevenson acknowledges that Juhl did "most of the heavy lifting choosing the writers. I was busy trying to figure out how to be a writer myself." After the development meetings in Hampstead and Sag Harbor ended, Jocelyn Stevenson felt that her co-creators already had a role in the show—Jerry Juhl as head writer, Michael K. Frith as designer, and Duncan Kenworthy as producer—but was unclear about what she would be doing once production began. "I could have worked on the books and magazines that would come out of the series once it was up and running, yet I really wanted to be on the writing team for the show," she explains. Stevenson had edited children's books based on the Henson properties, but at this point had written only one sample *Fraggle* script.

Stevenson asked Juhl if he would be okay with training her: "He said to me: 'Understanding the characters and their relationships,

> "[The performers] find the sparks that make the characters seem real."
> **JERRY JUHL**

that takes talent, and you've got that. The rest is just skill.'" She then went to Jim Henson to let him know she wanted to write for *Fraggle Rock*. "He said, 'That's great, and if it doesn't work out, then you can always go back to publishing the books.' How's that for plan B?"

Now confirmed as a key member of the writing team, Stevenson dived right in. "[For the first season,] we decided what general stories we needed to tell to get across the idea of what *Fraggle Rock* was," says Stevenson, "and figure out what we wanted to say. We wanted to tell stories that helped us discover more about the world, and to learn as much as we could about our characters. We wanted to show connections in the Rock—to radishes, for example, but also water."

Writer Laura Phillips describes *Fraggle Rock* as "a work of art at the development stage. And because it was, it made it possible for us to be able to write in our own voices while still being true to the voice of the series, which was universal, nonjudgmental, heartfelt, and utterly, joyously silly."

BUILDING A WORLD

AS THE *FRAGGLE ROCK* PRODUCTION TEAM was working on writing episodes for the first season, set designer Bill Beeton took a trip from Toronto to New York City for a meeting with Jim Henson. "Jim and I sat down together and looked at the bible that Michael K. Frith had prepared," said Beeton. "We discussed what the show was supposed to be about, how Jim wanted it to work." Two of Beeton's most important takeaways were the idea that the Rock itself could be a major character, "just without any lines," he said, "and that the environment supported the action and the story."

Upon Beeton's return to Toronto, he began sketching possible looks and configurations for the caves, which he would send to Frith for review. "The caves for me were the number one environment, and I had two approaches," he said. His first potential concept was to make the caves a crystalline, diamond-like, hard-edged, sparkling environment. The second idea, the one ultimately chosen by the creative team, was what Beeton termed "Dr. Seuss as interpreted by Henry Moore"—a mixture of Theodor Geisel's artistic blend of surrealism and nonsense and the revered sculptor's abstract, biomorphic style. Beeton eloquently described this interpretation of the Fraggle caves as "a soft, curved, rounded-shaped environment that looked somewhat like a cross between melting ice cream and the bone structure of some huge prehistoric monster the size of a football field, whose bits of joints and rib cage were still floating around."

Bill Beeton's concept complemented Michael K. Frith's notion that the Fraggles' cave system is analogous to the human imagination. "Underneath the floorboards, it's a new world," says Frith, "and from that world, there are an infinite number of tunnels that lead off, and every tunnel is a different adventure. That's like the way your mind works. And each of these places presents its own world, its own possibilities, its own story."

While Beeton's caves would offer endless possibilities, his budget was far from limitless. To deliver the myriad locations within Fraggle Rock in a cost-effective manner, he designed a modular system with intersecting reusable cave and tunnel sections that could be rearranged easily and quickly. Whatever configuration was needed for a scene, the pieces could be shuffled, repositioned, and even placed upside down for variety, like a jigsaw puzzle with no straight sides.

Beeton refined this cave design in the early months of 1982 and then handed it to Tim McElcheran to lead the cave build. McElcheran worked primarily in the special effects department, but he also had a strong background in sculpture and model-making. This interdepartmental cross-pollination was common on *Fraggle Rock*. "If something needed to be constructed, carved, sculpted, or fabricated involving machine tools, then it was me and George [Clark]," explains McElcheran. "But if something needed to be done outside your specific department, and if you had that skill set, [your help] was welcomed."

McElcheran built the largest rock pieces using plywood covered with chicken wire to create a basic shape. The chicken wire was then overlaid with muslin fabric, glue, and a thin coat of insulation foam. Once this hardened, the faux rock could be painted.

Although the modular cave system worked perfectly, the background often needed to be augmented with boulders to fill it out and prevent it from looking too stark. Beeton came up with several tricks for creating these quickly. One of his favorite methods was to semi-inflate a large garbage bag, tie it off, and spray it with an industrial insulating foam that, when painted, would look like rock surface. "He would pick it up by a corner and throw it up in the air," says McElcheran, "The foam would heat the air inside it and make it swell out, not quite enough to show its bag shape, but to give you a free-form boulder-type shape." These "instant" boulders would be sent to the

BOTTOM An unidentified set decorator provides atmosphere inside the caves for the episode "The Terrible Tunnel."

OPPOSITE In an early concept, Michael K. Frith experiments with the way light falls within the caves of Fraggle Rock.

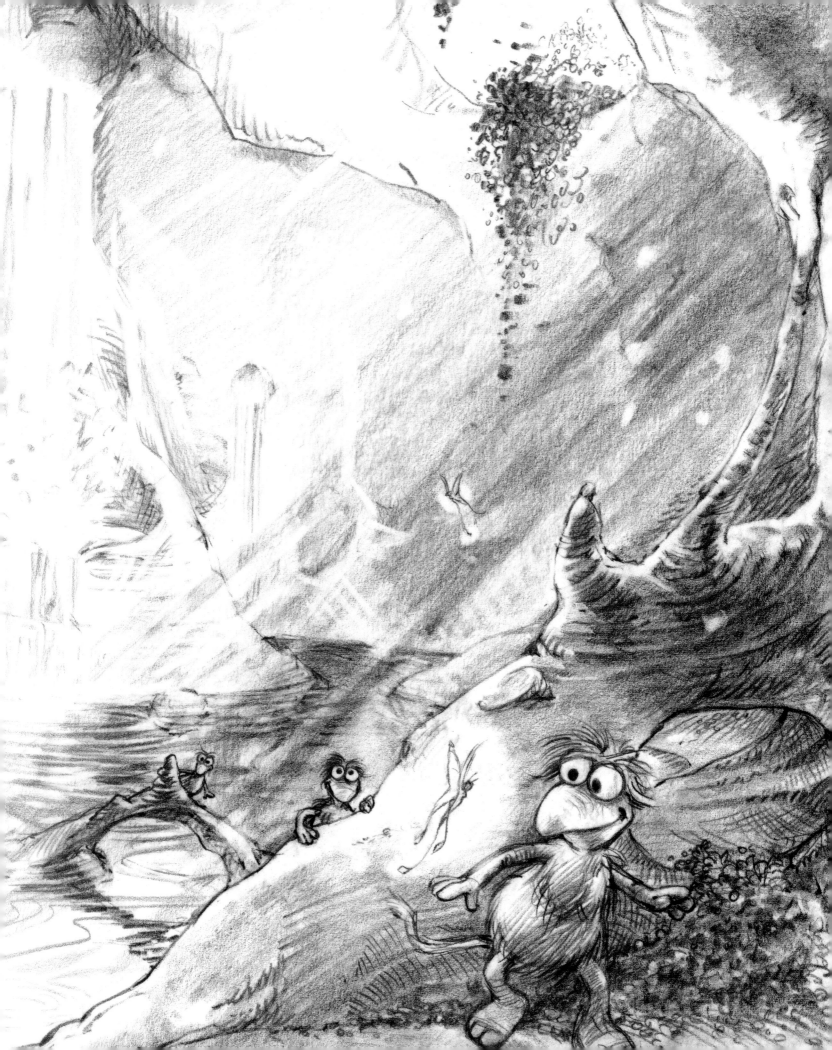

set decoration department, headed by Stephen Finnie, to be painted with neutral tones to give them a uniform look.

The set decoration department was responsible for rearranging the modular parts and boulders to create the specific caves required by each episode's script. Lighting designer Gordon Luker would use different light intensities and colors to relight the rocks in creative ways that would give each rejiggered cave its own unique look. An assistant set designer would usually be assigned to apply moss to the rocks to give them an additional layer of reality. "It was quite comical to see the assistant decorator, maybe Eric Gilks or Dana Spot, with a pincushion full of T-pins around his or her neck and a bucketful of florist's sheet moss," McElcheran says. Applying the moss gave the rocks not only a distinctive look, but also a distinctive smell. "It was a nice, organic smell," he recalls. "The smell of damp sheet moss will always be the smell of *Fraggle Rock*."

In addition to the many tunnels within Fraggle Rock and the Great Hall where the Fraggles gathered for meetings and celebrations, the cavernous locale also included living quarters for the Fraggles. In the first season, Boober, Mokey, and Red would have individual rooms. Meanwhile, Gobo and Wembley would share a room, which was designed in a way that would conceal the puppeteers. Their beds were set at different levels, and built into the cave's walls and floors in such a way that the puppeteers could stand or crouch well apart from one another, hidden either behind or below the part of the set that was visible to the camera. "My main job was to design the invisible," Frith says. "To create spaces where you could not see what was going on. To me that's one of the greatest joys in designing anything that has to do with puppetry."

Outside Fraggle Rock sat the Gorgs' castle and gardens. Michael K. Frith's sketches for the Gorgs' home were loosely

based on the Flemish Renaissance–style offices of the famed satire collective behind the *Harvard Lampoon* in Cambridge, Massachusetts. "The actual design was Bill Beeton's," says Frith, "taking off from the concept sketches I'd done for general tone, mood, and decrepitude." Although the plan was to show only the back of the castle on the show, as seen from the Gorgs' garden, Frith always hoped that viewers might someday be able to see a more expansive view of the building, describing it as "a lofty aerie perched on a cliff looking out on that entire universe over which the Gorgs, after their fashion, hold sway." Unfortunately, this unseen side of the castle would not make it into the show.

Using Frith's concepts as reference, Beeton constructed an exterior that he felt was "every mixture of castle architecture I could think of." The Gorgs had been conceived as a royal family reduced to the station of farmers, and so the castle was created to feel like a barn. The castle's interior was a mash-up of farm and fiefdom. Most activity took place in a large kitchen area with a stone hearth where Ma did her cooking. There were whitewashed plaster walls and built-in cabinets set below an arched ceiling. Decorations included maces, swords, and an ancestral Gorg portrait, trappings of lost sovereignty. Beeton juxtaposed these with unrefined tables and chairs and scattered straw, "so that there was a rough quality to their lifestyle," he said.

The outdoor set, featuring the castle exterior, proved to be a little more problematic for Beeton, though. The background of the set was decorated with two-dimensional trees that were clearly painted cutouts, so camera angles had to be carefully planned to avoid revealing the façade. Real greenery was placed in front of the fake trees to make the background more natural looking. "Anything to try and sell the idea that this was an outdoor environment," he explained.

BOTTOM Concept design of the Fraggle tunnel interiors by Bill Beeton, 1982.

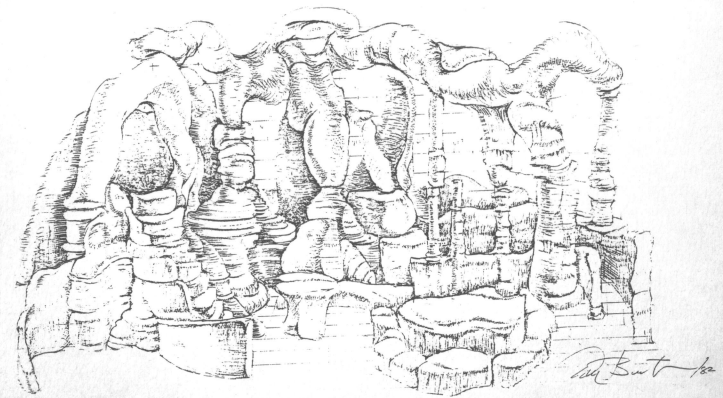

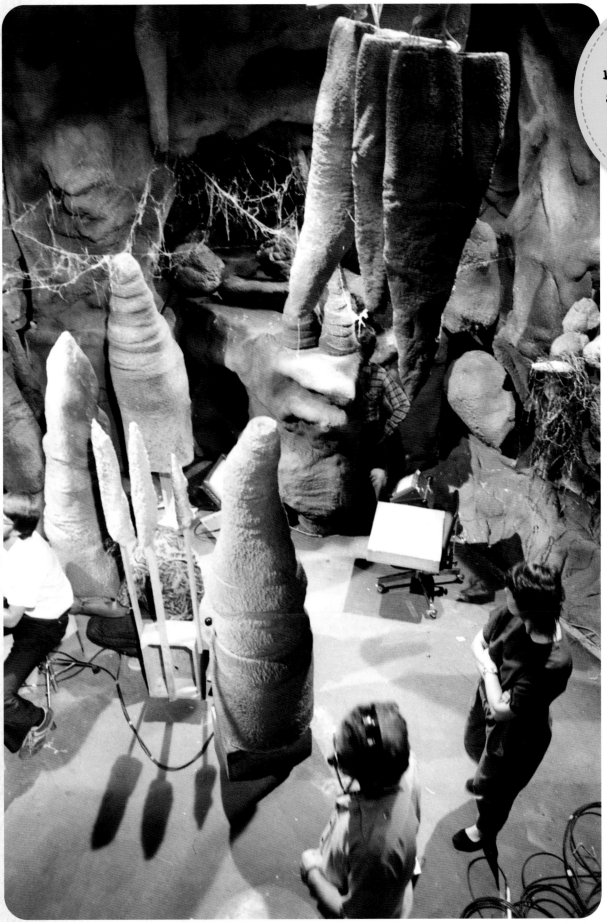

"The smell of damp sheet moss will always be the smell of *Fraggle Rock.*"
TIM MCELCHERAN

LEFT Filming "The Terrible Tunnel." Bill Beeton's modular concept for the sets provided endless possibilities for new tunnels and caves throughout the seasons.

INSIDE OUTER SPACE

ABOVE THE TUNNELS OF *FRAGGLE ROCK* is Outer Space, where the Silly Creatures live. It's a terrifying place to the Fraggles, but in order to pick up the postcards sent by his Uncle Travelling Matt, Gobo must face his fears and venture through a hole in the tunnels. This hole opens into the workshop of Doc, who tinkers on his inventions there, accompanied by his "scary monster," Sprocket. Doc's workshop is filled with overflowing toolboxes, a battered workbench, and a temperamental boiler. It's also where Sprocket's wicker basket bed and dog food supplies are kept.

Michael K. Frith drew his concept designs for Doc's workshop from the point of view of the Fraggles, capturing their perspective when peeking through the hole into the workshop. "It was just a place full of all kinds of strange stuff," says Frith. "There was a telescope, binoculars, beakers, a bellows, and trunks full of odd objects."

Bill Beeton combined Frith's fanciful designs with ideas inspired by memories of his own father's workshop. "[My father] liked to fix radios in the early days of radio," said Beeton, "so there were vacuum tubes, condensers and resistors, oscilloscopes, and weird bits of wire. Little drawers with different screwdrivers

and tack hammers. It sticks very much in my memory of that time in my life, so I put all that to life for Doc's workshop."

Beeton also designed the first few feet just inside the hole in the workshop wall that leads to Fraggle Rock. "You plug a lamp in your wall socket, but do you ever think of what's on the other side of the wall?" Beeton said. "It's very mysterious—strange pipes, dials, knobs, and meters. There are things that don't seem to do anything that are just there and just look interesting. Sometimes they drip water, usually they give off steam. One never asks what they are for, that's just the way things are."

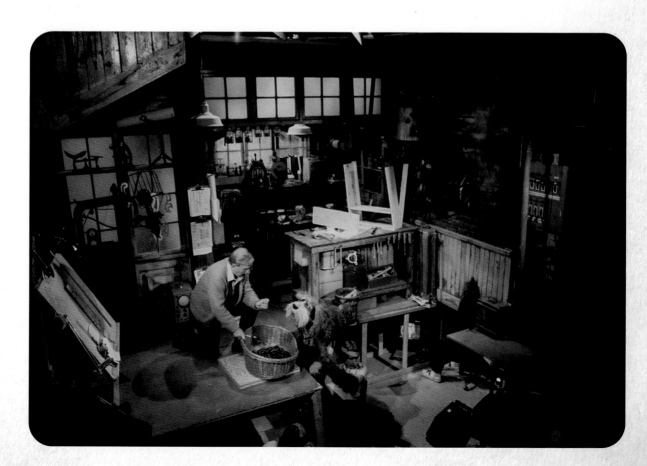

BOTTOM A bird's-eye view of Doc's Workshop with Gerry Parkes (Doc) and Steve Whitmire (Sprocket).

OPPOSITE Michael K. Frith peers through the Fraggle Hole from Doc's Workshop.

INSERT Production art for Doc's workshop by Bill Beeton.

ARCHITECTURAL TASTE

DOC ISN'T THE ONLY BUILDER ON the show, of course—the Doozers endlessly create architectural wonders that are then eaten by the Fraggles, making room for the tiny species to build yet more. As Jocelyn Stevenson, Jerry Juhl, and Michael K. Frith wrote in Things We Know About Doozers, "What they build is a rather beautiful and surely endless collection of structures that look a little like freeway interchanges decorated with high-tech minarets. These wonderful buildings have no purpose or function at all, except perhaps to form the foundations for the next set of Doozer buildings."

Although the Doozer's constructions were sometimes simply background dressing for a scene, their structures were given the same attention as the Gorg castle and the Fraggles' caves. Frith initially conceived and sketched the little buildings so that they resembled toy blocks; but then, shortly after he sent in the artwork, he had a change of heart after passing through Chicago's O'Hare Airport. "I was struck by the geometry of its architecture, all those triangles joining together to create this soaring, airy structure," he recalls. "So, those brick-like lumps became gleaming futuristic shards." The look of the airport also reminded him of Tinkertoys, a model construction system for kids that had been around since the 1910s. He saw an immediate connection between the complexity of a major

architectural project and "something really basic that kids could quite literally grasp."

Designer Bill Beeton also had input on the Doozer architecture. He wanted a unique, sparkly appearance for the Doozer buildings and so gave them the crystalline look he had originally considered for the Fraggle caves.

The concepts were all sent to Faz Fazakas and his special effects division—which included his technical assistant Tom Newby, plus Larry Jameson and Fred Buchholz, among several others—before any builds began. The effects team was then encouraged by the writers to find an underlying logic to how the Doozers' towers fit into the overall picture of the integration among *Fraggle Rock*'s species. Newby discussed this with his

BOTTOM Jim Henson takes in the complex design of a Doozer-constructed road.

OPPOSITE TOP Leigh Donaldson works on a Doozer construction in the electromechanical workshop.

OPPOSITE BOTTOM Unidentified builder with Doozer constructions.

coworkers. "[The logic should be] something that's nonverbal," he says, echoing Frith's sense that children should understand the meaning and purpose of the Doozer constructions just by looking at them. "You don't have to explain it," Newby says. "It just gives you a sense that there's order to everything."

The buildings appeared as if they were either being built up or broken down. "The structures are always seen in different states of decay," says Newby, "as Fraggles take pleasure in destroying them and eating the pieces."

Early artwork that Michael K. Frith had provided the department showed the Doozers creating a road out of what looked like sugar cubes. Muppet special effects designer Tad Krzanowski sketched his own idea for where the sugar came from. "Tad thought it would be interesting if they had drilled up into Doc's workshop, where there was a big bag of sugar in the back," says Newby. Krzanowski drew a picture of an upside-down oil field, with oil derricks hanging down from the wooden floorboards of Doc's workshop, spewing sugar. "And the Doozers react like they'd found a gusher!" Newby sent the picture to the production office, which sent back a memo explaining that though the idea was good, the actual substance could not be sugar. "The Doozer material was always to have been a radish derivative," says Michael K. Frith.

Fazakas's team first experimented with making the Doozer towers out of breakaway glass—the harmless and, ironically, sugar-based material used for fight scenes in movie productions—but it was too fragile. Eventually, it was discovered that acrylic, a glasslike thermoplastic material, had the right durability. Acrylic rods were fabricated and used to build the square Doozer towers that featured ladderlike rungs. Half-inch equilateral triangles that looked like prisms were also created and could be combined with the rods to create a wide variety of structures.

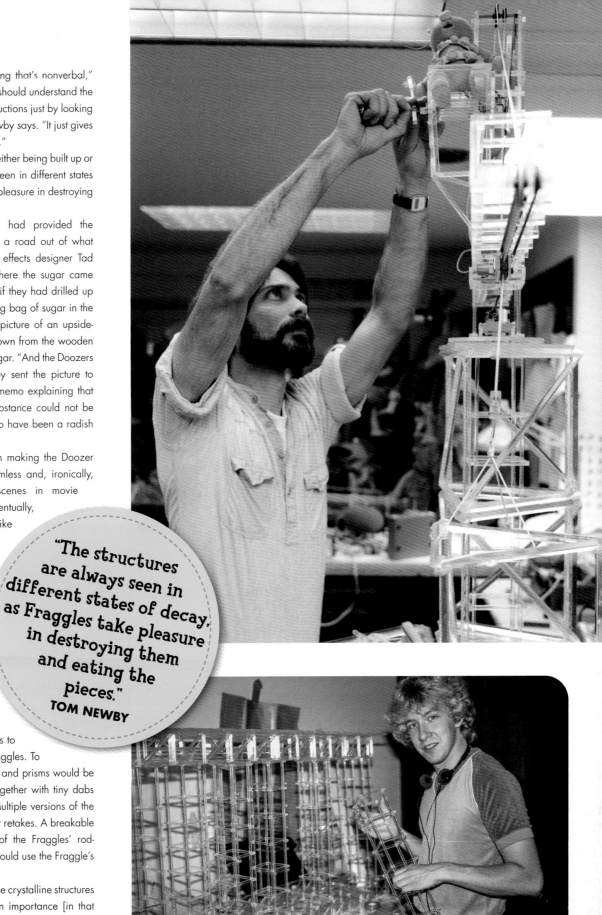

> "The structures are always seen in different states of decay, as Fraggles take pleasure in destroying them and eating the pieces."
> **TOM NEWBY**

The acrylic ladder and prism-style constructions proved to be tough enough to survive multiple takes during shooting. But the main reason for their existence was to be grabbed, broken, and eaten by the Fraggles. To facilitate this wanton destruction, the sticks and prisms would be sawed into pieces and then stuck back together with tiny dabs of hot glue, making them easy to snap. Multiple versions of the breakable constructions would be made for retakes. A breakable construction would be attached to one of the Fraggles' rod-controlled hands and then the puppeteer would use the Fraggle's mouth to pull it to bits.

"Fraggle Rock was really built around the crystalline structures the Doozers built, so the Doozers had an importance [in that they created] the foundation of the world," says Tom Newby. "Now, this just may be us trying to increase the importance of our contribution, of course, but that's how we thought about it," he adds with a laugh.

LET ME BE YOUR SONG

THE FIRST THINGS WE KNOW ABOUT FRAGGLES list noted that singing is something that Fraggles must do "at regular intervals." Music and song have been an important part of Jim Henson's productions since his earliest works, and became a vital part of Fraggle nature. Fraggles use song to express emotion and friendship, celebrate discoveries and festivals, find a connection with old friends and new, and even solve problems. Fraggles play an assortment of musical instruments, and can even perform using their tails, stretching them upright and plucking them like a bass fiddle.

The creators planned that each thirty-minute episode would include at least two songs, possibly three. The songs were not intended to be add-ons; they would not stop the action, but move it forward. "There was one rule the scriptwriters were asked to follow related to the *Fraggle Rock* music," says Jocelyn Stevenson. "A song must always advance the story. We were not allowed to write, 'And they sing a song' in our scripts. We had to describe how the song fit in and its purpose in the story. They were integral parts of the storytelling."

In December 1981, a call went out to find musicians and lyricists who could help tell the story of *Fraggle Rock* through song. After the announcement, it seemed that every musician who had ever worked in children's media sent in a demo tape. "I listened to hundreds of songs," said Jerry Juhl, who was tasked with reviewing the songwriters' work. He soon found that the demos invariably contained cheerful, up-tempo children's songs that were disappointingly generic. "Nothing seemed to quite play, no matter how talented these songwriters were," he said. "We were looking for *Fraggle* songs."

All this changed when Stan Colberg, head of the CBC's variety department, handed Juhl a tape of songs by lyricist Dennis Lee and musician Philip Balsam. "For the first time, there was Fraggle music," Juhl said. "It was different, and the reason it was different was that it did not have the sensibility that this is for children. It had a sensibility of innocence, and a kind of perceived wisdom."

Dennis Lee had been an English teacher, the founder and editorial director of a literary press, and a writer-in-residence for several Canadian universities before he landed at *Fraggle Rock*. Lee initially wrote poetry for adults, but then turned to penning verse in a contemporary style that would appeal to Canadian children. He felt that Mother Goose–type poems were less relatable to kids of the '80s, and so wrote about hockey games, skyscrapers, and visits to the laundromat in award-winning collections including *Alligator Pie* and *Garbage Delight*.

Composer Phil Balsam's father was an important cantor in Russia, where Balsam was born. They later moved to Canada. "My father had a full range of all kinds of songs from different parts of the world," says Balsam, "and I grew up with that. I heard soul music, rock and roll, blues, and Latin American music, which had just come to North America."

In the late '70s, Lee and Balsam were both active in the social world of Canadian musicians and artists, and met through a mutual acquaintance. Lee played the melodica and joined Balsam's living room band, the Balsamettes, which played funky folk-rock blues. Balsam felt that the lyricism of Lee's children's poems lent itself to melody, so he experimented with setting his verse to music. These compositions were well received by Lee, and they decided to write original songs together for fun. At first they wrote in the same room, but realized that this setup didn't suit either's creative style. To solve the problem, they worked out a system called the "two solitudes." Balsam would write music for a song and record it three or four times on tape, singing the melody line without lyrics. The tape would then go to Lee, who would pen the lyrics. Balsam would often wake in the morning to find a lyric sheet dropped through the mail slot on his door, "like a pizza delivery."

Jerry Juhl played the tape he had received of Balsam and Lee's music to Duncan Kenworthy and Jim Henson, who immediately saw the duo's potential. "They were miles above everybody else,"

BOTTOM On set with (left to right) Jerry Nelson, director George Bloomfield, Steve Whitmire with Wembley, Dave Goelz with Boober, songwriter Phil Balsam, unidentified crew member.

OPPOSITE Songwriters Dennis Lee (left) and Phil Balsam (right) with Travelling Matt.

said Jim Henson. "Their music sounded like it came right out of the Fraggles' mouths."[14] Lee was brought in for an interview. "The entire thrust of the conversation from Dennis's point of view was why we shouldn't use him on the show," said Juhl. "He was a poet; he was working on editing projects. Phil was doing this basically as a hobby. It would be a complete mistake. I'm happy to say we didn't listen to him and hired them anyway."

The pair were under the impression that other musicians and lyricists would be composing for the show, but soon discovered they were the sole musical artists on the project. "We wrote the first show, then the second, then the third," Balsam recalls. Dennis Lee jokes that they were hired simply because they kept showing up and writing songs.

The duo continued to write separately while working on *Fraggle Rock*. After a couple of days of going back and forth on a song, the two would meet in Balsam's living room, where he would play guitar and sing Lee's lyrics for the first time. "Then we'd make little changes," says Balsam. They made a conscious effort not to reference the Fraggles and their world in the lyrics, hoping to create songs that could stand alone, outside the world of the show. "Sometimes it was inescapable," says Balsam. "But otherwise, it was agreed upon between us that the lyric should be general, so that it could refer to life anywhere, rather than just the small world of the Fraggles."

While Lee was writing the lyrics, Balsam would record the instrumental tracks by himself in his home studio. Balsam played guitar, drums, and piano, but would also use odd instruments and even household objects to create the sounds he was imagining. "I would arrange and mic cardboard boxes in a certain way to get a marching beat," he explains. "Or I'd use kids' toys, like a little plastic trombone."

Balsam used a two-track recording process, but this proved laborious, and produced music that sounded a little muddy. "When proposing my song ideas for each *Fraggle Rock* episode to Jim, I liked to present a recorded version which contained the full intended musical arrangements, rather than a version containing just a simple voice and melody," he explains. "Jim seemed to also prefer this approach because it simplified the learning of the songs by the [performers] who would be singing them, and expedited the production of the final version by the musical director and the studio band. I would record a track of, say, voice, guitar, and percussion and bounce that recording to the second track, then record a track of additional instruments and/or voices and bounce that track, and so on until I had recorded the complete musical version of the song. [But] each time I needed to combine the recorded tracks, the intrinsic tape noise would also be combined, increasing the noise level of the tape closer to the level of the music.

"Then, at one point, there was a knock on my door," Balsam recalls, "and I found, to my surprise, that Jim [Henson] had sent a state-of-the-art eight-track tape deck for me. Jim understood the technology and my method of working very well. His gift also helped facilitate the speed at which the songs would be written, rehearsed, and produced, which was of tremendous value given a very tight schedule." According to Balsam, Henson just seemed to grasp how music worked. "Jim was fantastic to work with, and he had an astonishing sense of musical phrasing," he says.

Once the instrumental elements of a song were completed, Balsam would record the finished lyrics, singing the feature character's vocals, plus all harmonies. The fully produced version would be presented to the producer and writers at Eastern Sound. Both Balsam and Lee would be there—during the meetings,

BOTTOM Songwriter Phil Balsam with the folk singer Phil Fraggle puppet, who appeared in the season 1 episode "New Trash Heap in Town."

OPPOSITE LEFT Michael K. Frith's sketches and notes on various Fraggle musicians and instruments.

OPPOSITE RIGHT Concept art for Fraggle musical instruments created from natural objects—such as shells and gourds.

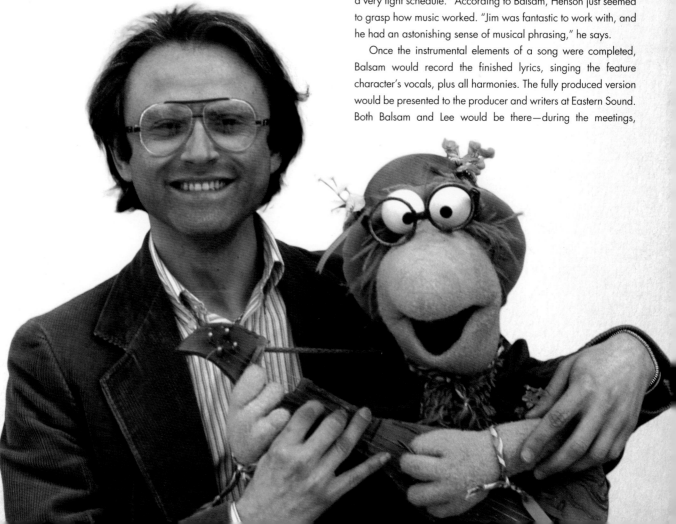

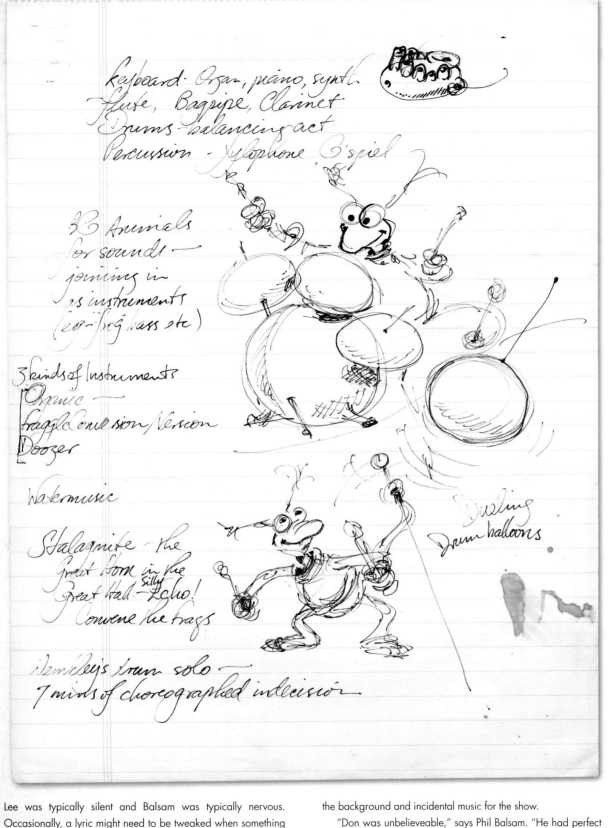

Keyboard - Organ, piano, synth.
Flute, Bagpipe, Clarinet
Drums - balancing act
Percussion - Xylophone, G'spiel

X Animals
for sounds -
joining in
as instruments
(eg - frog bass etc.)

3 kinds of Instruments
Organic -
Fraggle Convession/Version
Doozer

Watermusic

Stalagmite - the
Great Horn in the
Great Hall - silly Echo!
Convene the frags

Wembley's drum solo -
7 minds of choreographed indecision

Dusting
Drum balloons

Lee was typically silent and Balsam was typically nervous. Occasionally, a lyric might need to be tweaked when something in the script had changed, or the song might need to be dropped from an episode because of runtime issues, but no song was ever rejected.

Balsam's recorded tracks would then be passed over to music director Don Gillis, who had been working at the CBC for several years. Gillis would arrange the songs, rehearse the musicians, lead the orchestra, teach the puppeteers the songs, and compose the background and incidental music for the show.

"Don was unbelievable," says Phil Balsam. "He had perfect pitch. He also had a perfect whistle. He would compose by whistling! He could write the entire score that way."[15]

"Gillis was very different from Phil and Dennis," says Duncan Kenworthy, "though I'm sure he actually wasn't. He seemed to me to be very serious and adult, but underneath all that he was the biggest fan. He managed to take what Dennis and Phil had come up with every week and turn it into serious music."

FINISHING TOUCHES

THROUGH THE WINTER OF 1981 AND INTO EARLY 1982, the puppeteers worked at refining their characters while scripts were written, songs composed, and sets constructed. As spring began, the production embarked on several weeks of rehearsals using the first batch of scripts. Meanwhile, the special effects department worked out any last mechanical kinks.

The rehearsals identified a major issue with the mechanical Gorg heads. The headpieces were fitted with a monitor system that gave performers a Gorg's-eye view of the action. Each monitor was made from a proctoscope, a thin, flexible tube usually used by doctors to examine a patient's intestines. Faz Fazakas and his team filled the proctoscopes with bundles of fiber-optic strands, then mounted them individually onto something resembling a riding helmet, which the puppeteers would wear. One end of the scope was fitted with a lens that was similar to an apartment door peephole, which was placed behind the Gorg puppets' eyes. The other end of the scope was

attached to a leather patch that the puppeteer would wear over one eye to see what their Gorg would be seeing.

While this system seemed well conceived, it proved problematic for the performers. "Because the helmets were not bolted to our skulls," says Rob Mills, "they would shift around on our heads no matter how tightly we were strapped in. Or the forward weight of the servos would drag the helmet down, moving the patch from our eyeline."

"What we saw from inside was honeycombed," adds Gord Robertson, "a little bit fish-eye, and everything looked about six feet farther away."

BOTTOM First season Gorg rehearsals performed by Trish Leeper (Ma Gorg), Gord Robertson (Pa Gorg), and Rob Mills (Junior Gorg). Junior sports the helmet Polly Smith created using one of her mother's colanders.

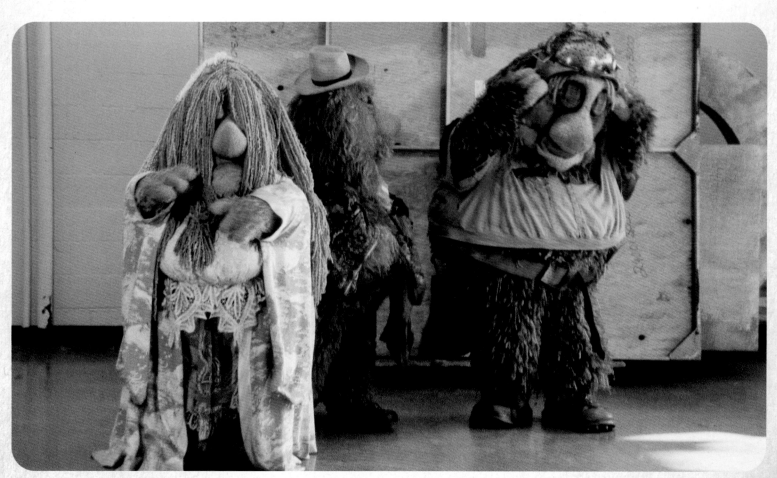

Unfortunately, it was too late to completely revise the monitor system, and so the three Gorg performers were required to make the best of it. "There was a big learning curve," says Robertson. "Every time you see a Gorg step over something [in Season 1], that's a leap of faith." Because of these spatial difficulties, the Gorg puppets had to be led to the set by production personnel. "But you always felt like royalty walking from the dressing room with your entourage of dressers and handlers," says Trish Leeper.

Given the challenges the Gorg performers were facing, each pair of voice and face puppeteers—Jerry Nelson and Gord Robertson as Pa Gorg, Rob Mills and Richard Hunt as Junior Gorg, and Trish Leeper and Myra Fried as Ma—needed to be particularly well synced.

Mills and Hunt found a common ground in Junior Gorg right away through their shared love of classic physical comedy. "Both Richard and I stole liberally from the likes of Charlie Chaplin, Buster Keaton, Groucho Marx, and other greats," Mills explains. "Just as we were about to start a scene, Richard would say, 'Remember that *Honeymooners* episode where Jackie Gleason did this thing when he's at the table . . .'" and Mills would know just what he was referencing. "And if it worked, we used it." Mills describes Hunt as "wonderful and annoying—all at the same time."

> "Every time you see a Gorg step over something [in Season 1], that's a leap of faith."
> **GORD ROBERTSON**

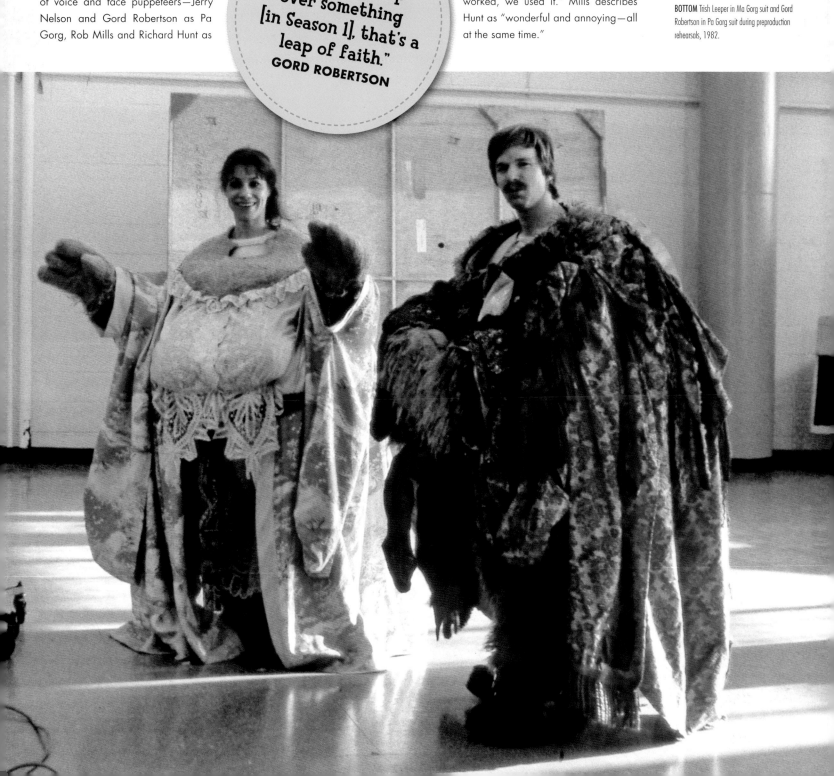

BOTTOM Trish Leeper in Ma Gorg suit and Gord Robertson in Pa Gorg suit during preproduction rehearsals, 1982.

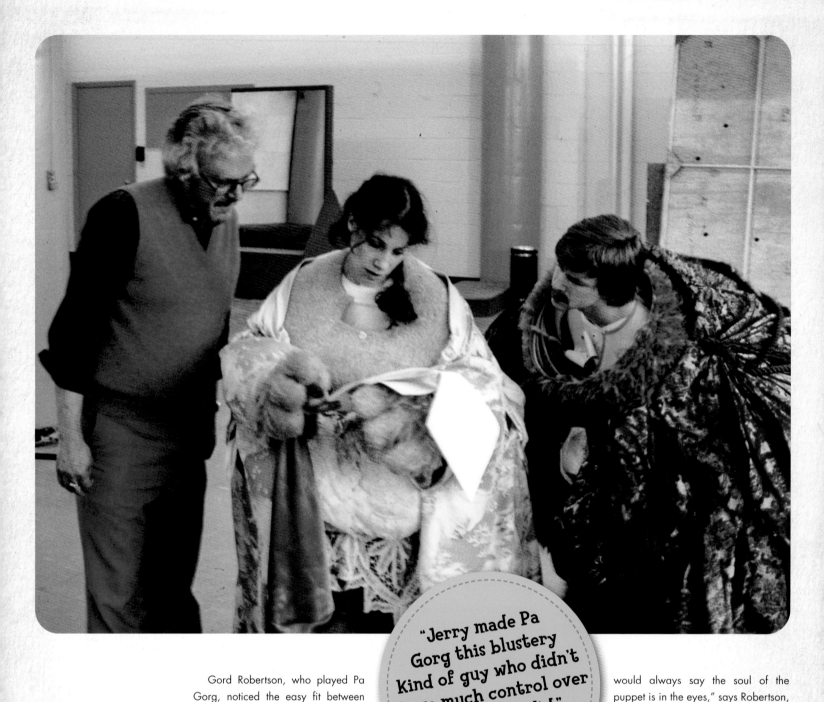

TOP Writer Jerry Juhl with Trish Leeper in the Ma Gorg suit and Gord Robertson in the Pa Gorg suit during preproduction rehearsals, 1982.

Gord Robertson, who played Pa Gorg, noticed the easy fit between Mills and Hunt. "They had a great relationship right from the beginning, just automatically quick," he says. "Jerry [Nelson] and I were solid, but a little bit slower. I think Jerry was patient with me because it took me a while to figure out what exactly I could do in the costume, with the head, for example." Robertson initially thought that because Pa was the self-proclaimed "King of the Universe," he should play the character as overly regal, positioning the head in such a way that it would appear the character was "looking down" on others. But when he watched video playback of his performance, Robertson realized that Pa's eyes were not connecting with the characters he was supposed to be looking at, leading to an effect that was rather off-putting. "Jim Henson

> "Jerry made Pa Gorg this blustery kind of guy who didn't have much control over anything he did."
> GORD ROBERTSON

would always say the soul of the puppet is in the eyes," says Robertson, "so you want to believe that the puppet sees, because if you believe it *sees*, well, then, you believe it *thinks*. That was a learning curve for me, realizing that I couldn't play him that way."

To get his performance back on track, Robertson reworked Pa's physicality to match Nelson's vocal interpretation. "Jerry made Pa Gorg this blustery kind of guy who didn't have much control over anything he did," he continues. Because Pa was essentially a henpecked husband, Robertson made Pa's gait less regal and more downtrodden. "Once I changed that, Pa Gorg's characterization was much better."

"Pa was big, rotund, and, yeah, he's dumb," said Jerry Nelson. "And Pa thought his son was totally useless, but of

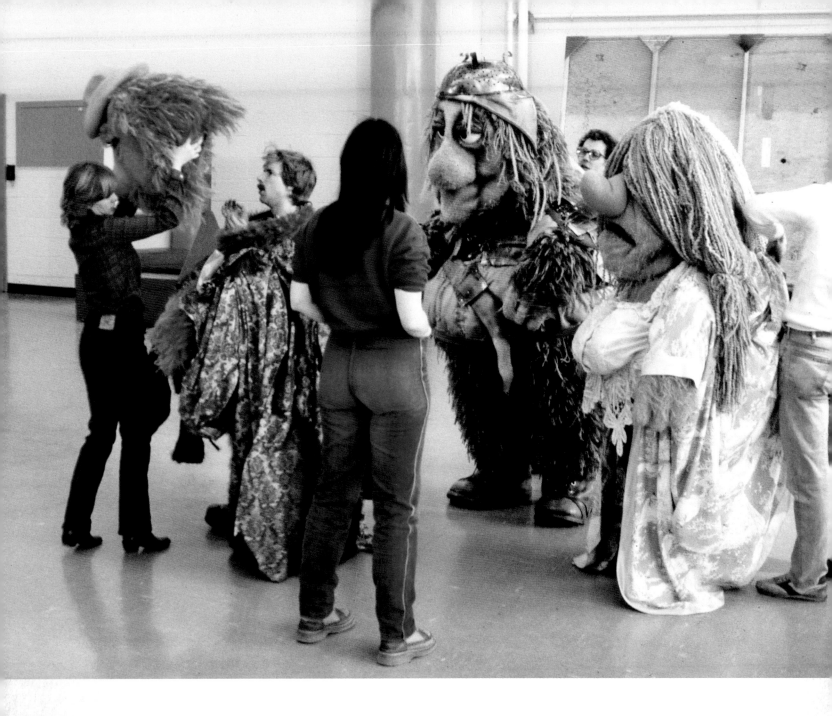

course, Pa was more useless than anybody. It [echoes] the fallibility of many people in the world who know they're right and everybody else is wrong, and that's the way Pa Gorg thought."

Once Nelson and Robertson got in sync, they realized that neither liked to rehearse a lot. "Let's do it once and get the blocking. Then let's just play it, let's just *go*," says Robertson, explaining their approach. "That was wonderful. I just had to key off Jerry's voice, and it was all there."

As rehearsals continued and the Gorgs' performances began to jell, puppeteer Steve Whitmire was still struggling to master Sprocket the Dog. Whitmire had his own unique style that involved ad-libbing character dialogue rather than sticking to the lines in a script. But because Sprocket didn't speak, Whitmire was at a loss. "Suddenly, [I] had to read the script, particularly stage directions," he says, "because Sprocket was

mostly about stage directions in terms of what he had to do."

Just before the first episode was shot, Whitmire spent several days rehearsing with Doc actor Gerry Parkes. "We were trying to get the hang of this character who didn't talk, who made dog noises," says Whitmire. "I thought, *We have to shoot this thing tomorrow and I don't have a clue how to get any point across with this puppet!*"

Fortunately, there was a lot of support on hand for Whitmire. "Gerry Parkes was terrific that day, and Jerry Juhl helped set me at ease," he remembers. Jim Henson was also present to give Whitmire some gentle feedback, ultimately calming his nerves and helping him nail the Sprocket performance.

With as many production issues addressed as possible, the team was finally ready to embark on filming Season 1 of *Fraggle Rock*.

It was time at last to let the Fraggles play.

TOP Preproduction rehearsals, 1982. (Left to right) Rollie Krewson, Gord Robertson in Pa Gorg suit, Myra Fried, Junior Gorg (Rob Mills), unknown, Ma Gorg (Trish Leeper), unknown.

BEGINNINGS AND ENDINGS

SEASON 1: IT IS A ROCK AND FRAGGLES LIVE THERE

FILMING FOR THE FIRST SEASON OF *Fraggle Rock* began March 8, 1982, with the episode "The Thirty-Minute Work Week." Written by Jerry Juhl, the story centered on Wembley's indecision over choosing a job—given that every Fraggle must work at least thirty minutes a week. After much introspection, and a visit to Marjory the Trash Heap, Wembley joins the Fraggle Rock Volunteer Fire Department, where qualifications include *not* knowing how to start a fire.

After "The Thirty-Minute Work Week" was finished, the show went on break for a month. "That was planned," explains Michael K. Frith. "We wanted to have the opportunity to shoot an episode and live with it, study it, and improve upon it in the way a pilot provides before lunging into full production. It was essential, and everyone learned an enormous amount." The episode was also shown to the brass at HBO, but Frith does not remember receiving any comments from them: "In fact, I never heard that HBO had anything to say—ever!"

While "The Thirty-Minute Work Week" was the first episode

filmed, it was not intended to be the first episode shown when the series premiered. "You usually don't write first episodes until you've written a bunch of other episodes to find out as much as you can," explains Jocelyn Stevenson. "Then you go back and write the first episode."

"You're still figuring out the characters and the concept," adds Karen Prell. "Then, once you're warmed up, you shoot the first show of the series, because then everybody is clicking and in the groove."

During the break from shooting, the special effects

BOTTOM Filming the "Workin'" musical number for the season 1 episode "The Thirty-Minute Work Week."

"Once you're warmed up, you shoot the first show of the series, because then everybody is clicking and in the groove."
KAREN PRELL

department continued to refine the mechanics in the Doozers and Gorgs, and the workshop made some minor design tweaks to two of the puppets. More leaves and detritus were added to the top of Marjory the Trash Heap's head, and her mouth was changed from being triangular to a crescent shape. Sprocket the Dog's eyebrows and the mustache-like whiskers were thickened with more feathers and yak hair, and the whiskers were combed to lie straight back over his cheeks to keep them from getting in his mouth. A more noticeable adjustment was made to Sprocket's eyes: Originally positioned with an acute downward slant, they were readjusted to be rounder and less angled.

Production resumed the second week of April 1982, and

continued for five weeks, capturing the first six episodes of the show. The stories covered a wide range of subjects, including the first of many episodes where Boober loses a lucky charm ("I Don't Care"); Mokey's concerns that eating the Doozers' structures hurt the little creatures' feelings ("The Preachification of Convincing John"); and what would happen should Gobo ever be trapped in Doc's workshop ("Don't Cry Over Spilt Milk").

"We didn't actually have a pile of scripts before we started shooting, in case of some discovery we'd make in shooting one of the others," Stevenson explains. "We needed to remain as flexible as possible while meeting a production schedule!"

"[But one] idea would give us an idea for another story," she

TOP Jerry Nelson (center) puppeteering the ladder brigade of the Fraggle firemen, with Jim Henson (right) for "The Thirty-Minute Work Week."

continues, "and ideas were coming in from everyone: potential writers, performers, people in the workshop. We developed the ones that seemed right, and navigated our way through the first season."

After another break from the middle of May to the end of June—a period in which some of the *Fraggle Rock* crew moonlighted on other Henson Associates projects—production resumed from June 28 to August 6. Six more episodes were shot during this period, including the series' opener. "Beginnings," by Jerry Juhl, aptly begins with Doc and Sprocket moving into the workshop and Doc removing a box that reveals the hole in the wall that leads to Fraggle Rock. Simultaneously, Gobo's uncle Matt, who is mapping the last known uncharted area of Fraggle Rock, witnesses the sudden unblocking of the tunnel.

He realizes it leads into the legendary "strange and mysterious Outer Space," which Matt believes he is destined to investigate. When he leaves the Rock, Matt makes Gobo promise to retrieve postcards from his adventures that he intends to send to Doc's workshop. Gobo balks at the task—he's already seen a "great furry thing" (Sprocket) confront Uncle Travelling Matt in the workshop—but nevertheless agrees.

After a visit to the Trash Heap, who tells him that "friends will help," Gobo tells the others of his worries and asks their advice. Boober suggests he hide and whimper, Red is skeptical that there really is an Outer Space, and Wembley agrees with everything. Mokey, though, is enthusiastic about the adventure, and says that not only should Gobo go into the workshop, but that his friends should all accompany him.

TOP Behind the scenes in the Gorgs' garden. (Left to right) Gord Robertson in the Pa Gorg puppet, director Norman Campbell, Trish Leeper in the Ma Gorg puppet, Richard Hunt (in red shirt at right), others unidentified.

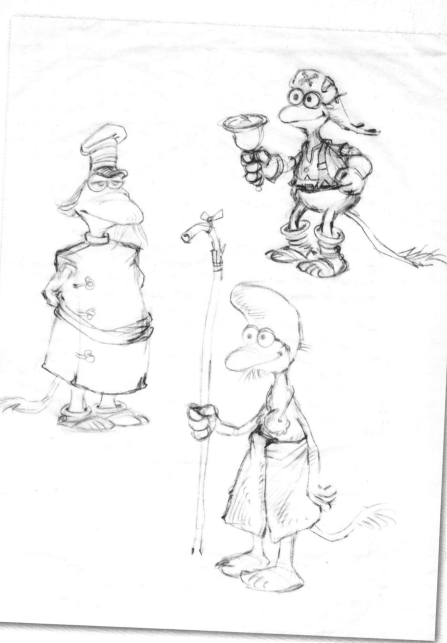

With their encouragement and support, Gobo faces his fear and gets the postcard.

As Juhl and Stevenson worked on the earliest *Fraggle Rock* stories, they endeavored to find a balance between the need to introduce the individual characters and the need to layer in the overarching theme of differing perspectives. Central to the wider themes of the show were two basic necessities, first established in the Things We Know About lists, that could create potential conflicts among the Fraggles, Doozers, and Gorgs: food and water. In "Beginnings," the Fraggles' consumption of radishes, which are grown by the Gorgs and used to create Doozer constructions, was established. The third episode, "Let the Water Run," by Jocelyn Stevenson, showed how the species of *Fraggle Rock* are connected by water. When Junior pumps water for the radishes in his garden, the Rock's swimming hole empties out. After this happens, the Pipe Bangers, a group of Fraggles who wear pickle-shaped hats (their leader, the Archbanger, has a faucet embedded in his), are summoned, and arrive carrying sticks with which to bang the pipes.

"By their own Fraggle logic, they believe that by going through the ritual of the pipe banging, they get the great water god to refill their pond," explains Michael K. Frith. "As the Pipe Bangers bang on the pipes, Doc is up in his workshop, swearing at the radiator, trying to figure out how to get it to stop banging." Frith continues. "He fiddles with all the knobs until he flushes the radiator, which fills Fraggle Pond." Tim McElcheran, who worked on the water special effects, jokes, "Doc must have had one heck of a water bill."

TOP Michael K. Frith concept art for several Fraggles, including the Pipe Bangers (bottom right).

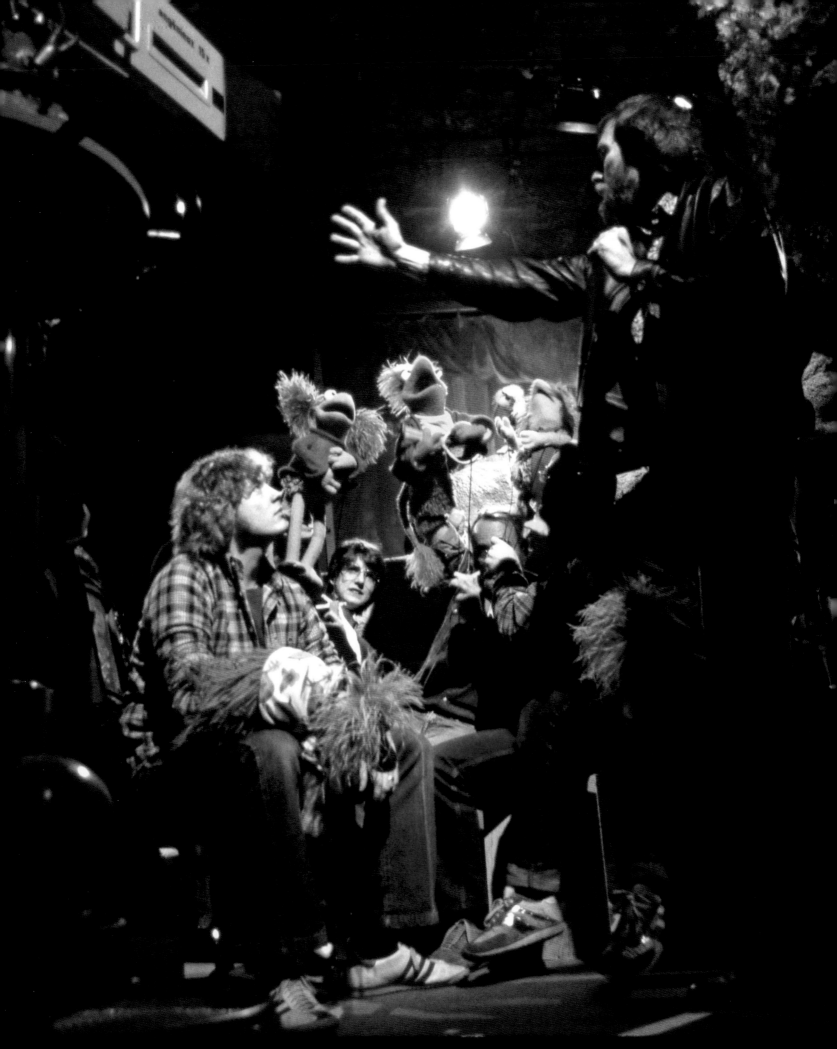

GIVING DIRECTION

THOUGH JIM HENSON HAD DECIDED TO LIMIT his involvement with *Fraggle Rock*, working mainly as the executive producer, he directed half a dozen of the first season's episodes. For Michael K. Frith, Henson's first episode—the fourth one produced, "The Preachification of Convincing John"—was the "turning point" for *Fraggle Rock*, showing future directors how to make the show come alive: "Jim—who knows puppets and was a good director and had a kind of innate understanding of what I've always called 'the dance' between the camera and the characters—came in and just, doing what he always did, moved the characters around and moved the camera with him in a way that said to me and I think to everybody else looking at it, 'Oh! Okay. That's what we intended. This thing breathes. This thing has a life.' And after that I think it just went from strength to strength."

Beyond his deeply developed sense of how to film puppets dynamically, Henson had a kind of relaxed perfectionism that inspired his cast and his writers to do their best work. Trish Leeper recalls asking him once for notes on one of her scenes as Ma Gorg, and he just smiled and shrugged and said, "Make it better."

The other directors on the series were new to puppetry shows, with the exception of Stephen Katz, who had directed episodes of *The Muppet Show* and the satirical show *Spitting Image*. Canadian director George Bloomfield helmed Canadian TV movies and television series for more than twenty years before joining *Fraggle Rock*. These included *SCTV* and

OPPOSITE Director Jim Henson with puppeteers (left to right) Steve Whitmire with Wembley, Karen Prell with Red, Jerry Nelson hidden behind Gobo, and Dave Goelz with Boober.

BOTTOM The crew watches playback on a monitor. (Left to right) director George Bloomfield, Jerry Nelson, Steve Whitmire with Wembley, Dave Goelz with Boober, and unknown crew members.

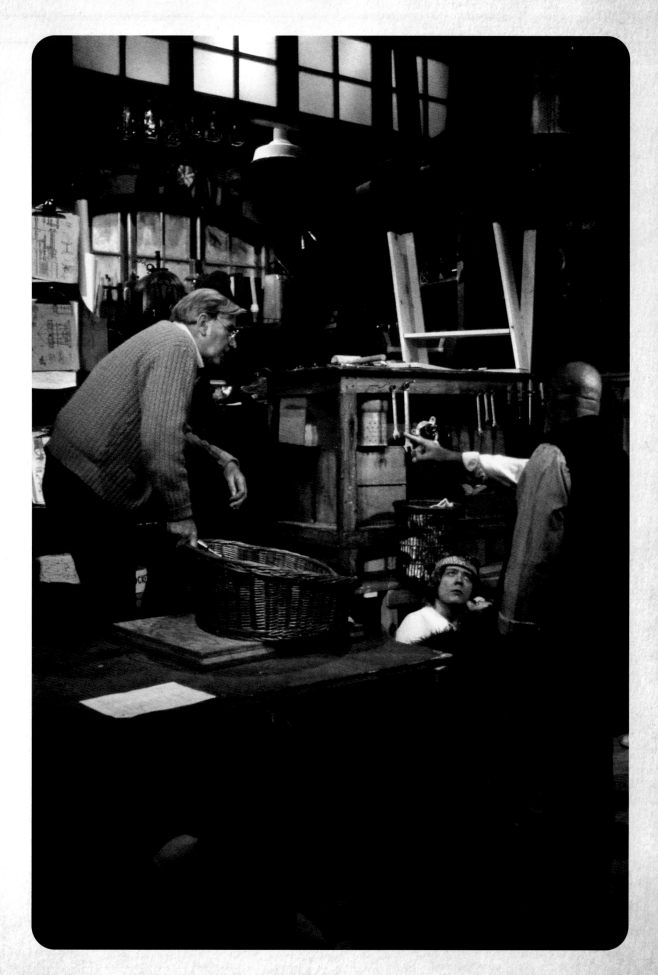

RIGHT Gerry Parkes (Doc) and Steve Whitmire (Sprocket) with director George Bloomfield.

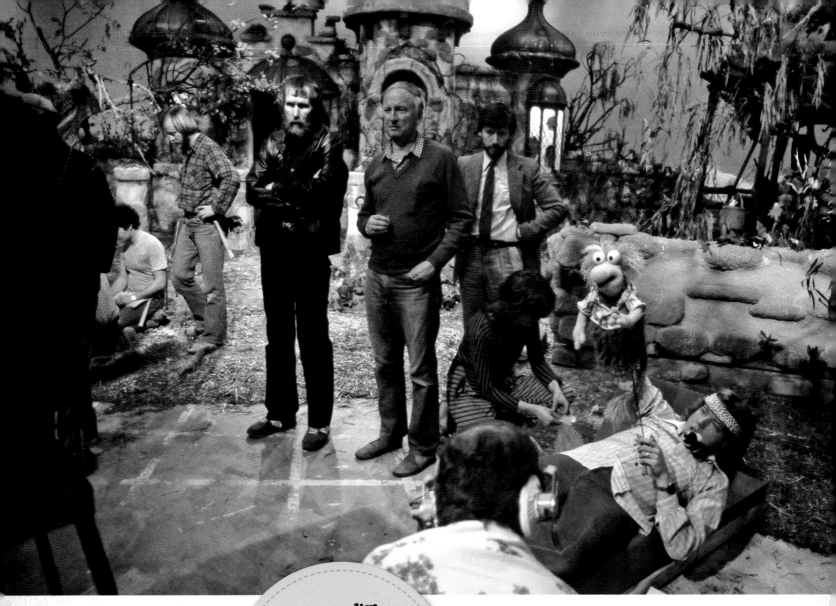

"I knew Jim Henson, and that meant [Fraggle Rock] was going to be a quality production."
GEORGE BLOOMFIELD

Festival, an entertainment anthology show featuring classic plays and music that numbered a young Gerald Parkes among its performers. "I knew Jim Henson, and that meant [*Fraggle Rock*] was going to be a quality production," said Bloomfield. "I remember wanting, really wanting, to be in it!"

Bloomfield observed Henson directing a few early episodes before he directed his first, "The Terrible Tunnel." "Henson's manner was so gentle and he was open to hearing from anybody," said Bloomfield. "It was, like, best idea wins. There was always the feeling that he was going to determine what the best idea was, but he was very sharing in the whole creative process."

The majority of directors chosen for *Fraggle Rock* did have rich experience on children's or variety shows, but working with puppets often required a new skill set. During one of Bloomfield's first stints on the show, he was reviewing a scene on the playback monitor and noted that one puppet's line of sight was off. When he went on set to rectify the problem,

"Suddenly," said Bloomfield, "I hear a voice from down under the floor that says to me, 'I don't have an eyeline, those are Ping-Pong balls.' That was what made me adjust to a different way of working than before."

Shooting *Fraggle Rock* presented unique challenges for the directors. The show was filmed before the days of wireless microphones, so each puppeteer's headset was fitted with a cabled mic for recording dialogue. Coordinating the movement of all those performers was almost impossible to do without getting all their wires tangled up by the end of a shot. And while the sets were constructed to allow for long, uninterrupted takes featuring the characters, the directors still had to factor in multiple cameras and other pieces of equipment when trying to block a scene.

"There is more room below [the set] than above, because people are bigger than puppets," says Dave Goelz. "But everything has to be choreographed, and it still gets crowded down below. Personal hygiene is very important," he laughs.

TOP Between scenes in front of the Gorg castle set. (Left to right) two unidentified crewmembers, Jim Henson, director Norman Campbell, producer Duncan Kenworthy, Amy Van Gilder (Muppet Workshop), Steve Whitmire with Wembley, unidentified crewmember in foreground.

IN CHARACTER

AS THE WRITERS CRAFTED STORYLINES THAT would define the characters and themes of *Fraggle Rock*, and the directors figured out how to work with characters made of fur and foam, the puppeteers also found themselves on a learning curve.

Karen Prell acknowledges that it took several episodes for her to really come to grips with Red. Paradoxically, it was the episode "I Want to Be You," by Jocelyn Stevenson, in which Red imitates Mokey, where things finally clicked for Prell. "Red puts on a Mokey robe and lets her hair down," says Prell, "She's going to be an artist and do Mokey stuff. She's doing the worst Mokey possible, and thinking that was a good thing. Exploring how much Red is *not* Mokey helped me discover who Red really is, and from that point, the most fun thing was discovering all the different levels in Red.

"Red served a great purpose in the show—she was the 'cut to the chase' character," says Prell. "The Fraggles had this

innocent wisdom where they would think things through and figure things out. Gobo was so good at being the voice of reason, and Mokey would try to analyze things, but after a certain point, you just want to grab the ball and run, so that's when they would bring in Red. Time for Red to say, 'Let's get going, what are we standing around talking for?' She was definitely this weapon they would employ when it was time to move things along in the script."

Kathryn Mullen also found it took some time for her to get a handle on Mokey. "There was nothing obvious to attach to Mokey," says Mullen, "though I think we all had the idea that this particular character should be the mother of the group, in

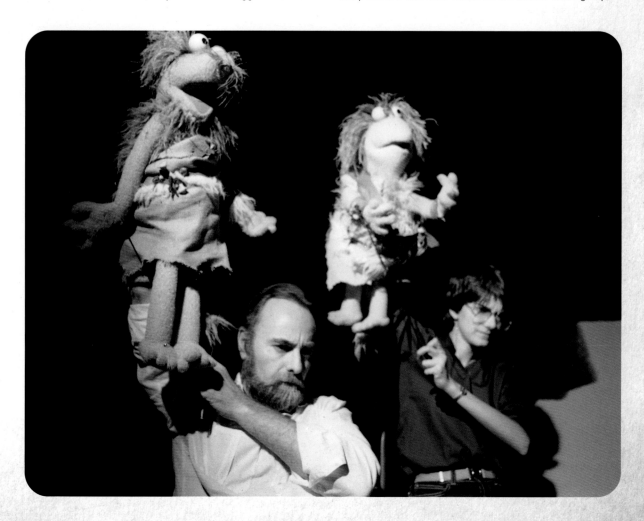

BOTTOM Jerry Nelson and Karen Prell perform background Fraggle characters.

OPPOSITE Karen Prell with the Red puppet.

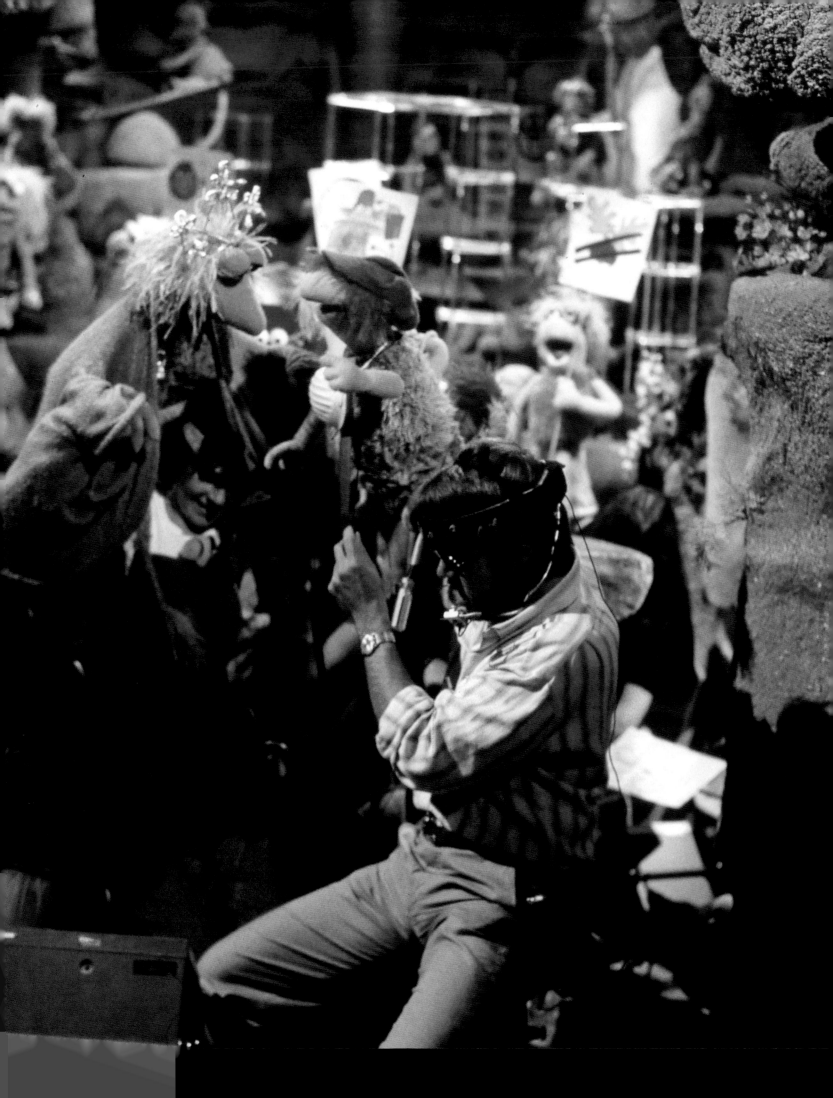

a way. She should feel somewhat older; she wasn't going to be racing around like the rest of them . . . There needed to be at least one in the group of five that represented the thoughtful part, the empathic part. That's where I started." In fact, Michael K. Frith had his sister Wendy in mind when the Mokey character was being developed—Frith describes Wendy as "a hippie then and a hippie today." Mullen, who is married to Frith, also knew Wendy well and found her personality and artistic talents a great source of inspiration for Mokey.

The look of the Mokey puppet also aided Mullen when trying to find her character. "[That] informs the acting a lot," she explains. "If you try to develop the character without knowing the actual, physical puppet, it's going to change a lot when you put that puppet on. They're designed to look like something, and if Michael is designing, they always have a strong feeling of that character."

As Mokey developed over the early episodes, it became clear that whatever course of action she took, it always worked out in the end for the laid-back Fraggle. "She would go blithely into an area known for Poison Cacklers or some other

danger and walk right past or through or over the danger without ever even knowing," says Mullen. "We saw her as being sort of Mr. Magoo-ish in that way. She might go off into the worst part of the Rock knowing that it was full of scary creatures, but she would just be like, 'It'll be fine!' Meanwhile, anyone fool enough to follow her would get trashed."

Steve Whitmire took to Wembley easily, but "I still worked at stretching Wembley as a character," he says. "To be as silly as I could and do all the goofy things I wanted to do, and just go crazy with him." One particular idiosyncrasy Whitmire brought to Wembley was his habit of punctuating his own and other Fraggles' conversations with squeaks, boinks, and other unique sounds. This affectation started with a head cold Whitmire caught as the first season began shooting. Before each take, the congested puppeteer would clear his throat. This segued into Wembley clearing *his* throat, and soon enough "it went from being throat clearing into a percussion instrument," explains Whitmire, "and then it became Wembley. He did it every time he walked into a room." Dave Goelz swears that Whitmire would make the sounds when he was off duty as well.

> One particular idiosyncrasy Whitmire brought to Wembley was his habit of punctuating his own and other Fraggles' conversations with squeaks, boinks, and other unique sounds.

OPPOSITE Filming the episode "Finger of Light," with Dave Goelz (at center) puppeteering Boober and Karen Prell (hidden) performing Mokey.

BOTTOM Puppeteer Steve Whitmire and the Wembley puppet inside the Fraggle caves.

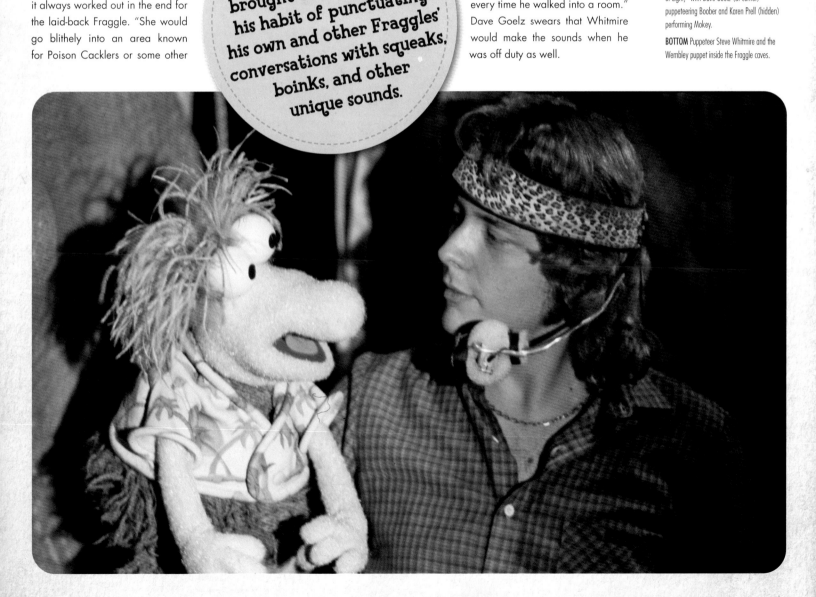

TRAVAILS WITH TRAVELLING MATT

DURING BREAKS IN THE FIRST SEASON, Dave Goelz and a film crew would shoot the Uncle Travelling Matt sequences at various outdoor locations around Toronto. But once he was "out in the field," and not interacting with other Fraggle characters, Goelz ran into difficulty. "When I got out there, I found it was hard to create a character who was so alone," he explains. "Humans couldn't see Matt, and there were no other Fraggles around. He would see a little red thing in a parking meter and think it was a tongue, so, he'd figure that these were little creatures that just stood in one place. It was very hard for me to work with that. It was an intellectual flaw that required no physical or personal reaction."

Unable to bounce verbal gags off other characters, Goelz decided that Matt's shtick, initially based solely around his misinterpretation of real-world elements, should be augmented with physical comedy. "I thought, [wouldn't it be] kind of funny for a grandiose character, the 'great explorer,' to stumble over things," says Goelz. "So at least I could make it funny by bumping into things, stumbling, creating little disasters."

Goelz then added one more thought, which solidified the character. "What if Matt couldn't acknowledge his failures? We see him make a mess of things, but in the postcards, he claims something completely different. When Gobo reads the postcard, he's visualizing something different from what actually happened, while the viewer at home sees how it really was." This gave Matt a third flaw—an emotional one.

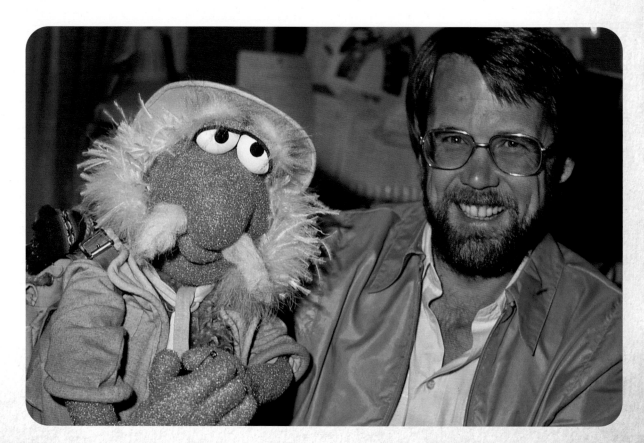

BOTTOM Performer Dave Goelz with the Uncle Travelling Matt puppet.

OPPOSITE On location in Toronto, Karen Prell and Dave Goelz perform Travelling Matt for the season 1 episode "Mokey's Funeral."

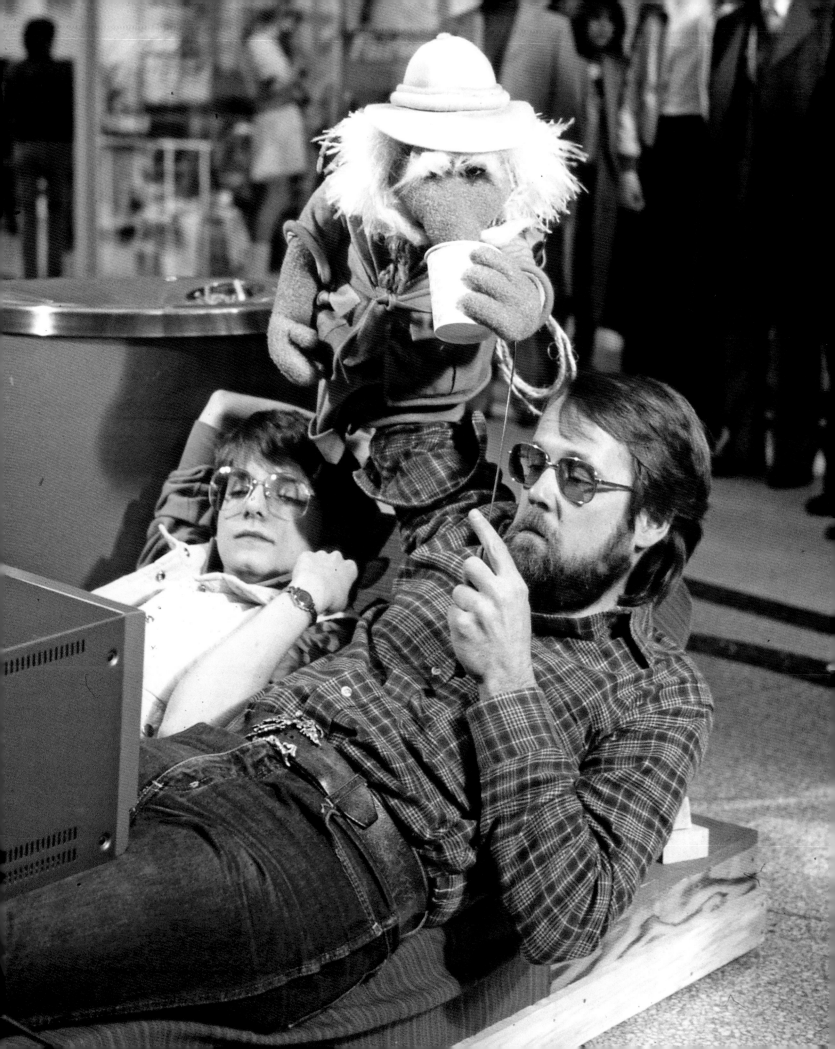

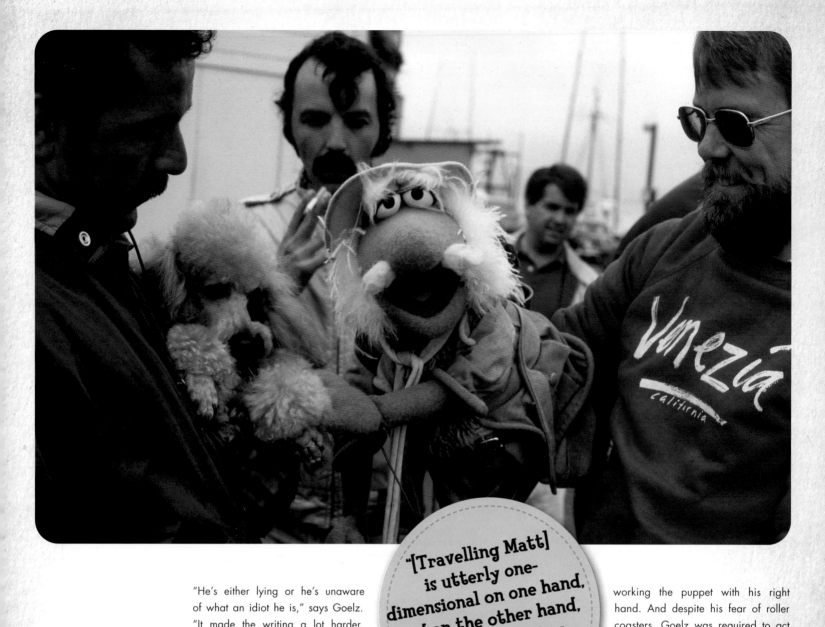

TOP On location in San Francisco, California, with Dave Goelz performing Travelling Matt, for the first season episode "The Terrible Tunnel."

"He's either lying or he's unaware of what an idiot he is," says Goelz. "It made the writing a lot harder, because the postcard's words would say, 'So, I decided to leave,' but the stage directions would say, 'The store manager picks up Matt and throws him out of the store. He lands in a trash can.'"

"Travelling Matt became one of my very, very favorite characters," says Michael K. Frith, "because he is utterly one-dimensional on one hand, and on the other hand, there's a lot going on there. He goes out in the world, but believes that everybody would rather be a Fraggle, as he is coming from the most important place in the world."

In one of the first Uncle Travelling Matt sequences filmed, the intrepid explorer tries out what he believes to be a "rapid transit" system, but which turns out to be the wooden roller coaster at Canada's Wonderland amusement park. "Jerry Juhl knew I didn't like roller coasters," explains Goelz. "So he wrote a scene with Travelling Matt on a roller coaster."[16] In order to operate Matt, Goelz had to appear on camera as a roller-coaster patron sitting beside the character, while

"[Travelling Matt] is utterly one-dimensional on one hand, and on the other hand, there's a lot going on there."
MICHAEL K. FRITH

working the puppet with his right hand. And despite his fear of roller coasters, Goelz was required to act as if he were enjoying the ride while performing a terrified Matt. "I had to just smile as the puppet went crazy."[17] The scene took thirteen rides on the roller coaster to complete. "I learned to love roller coasters, given there was no other alternative!" says Goelz.

Travelling Matt turned out to be a popular element of the show, but fitting a Matt segment into each episode was a challenge for the writers. "Every episode had to have a Matt postcard, and there had to be transition into and out of that postcard," said Juhl. "There would be some shows where it was really difficult to find that moment and a reason for the postcard." Whenever possible, the writers could use what Matt wrote on the card to present an insight or a solution to a problem the Fraggles were trying to solve. "Other times, this postcard came out of the blue," said Juhl, "and we had to coax it into the script and make it look natural. It was a challenge from the writers' point of view as well as the performers'."

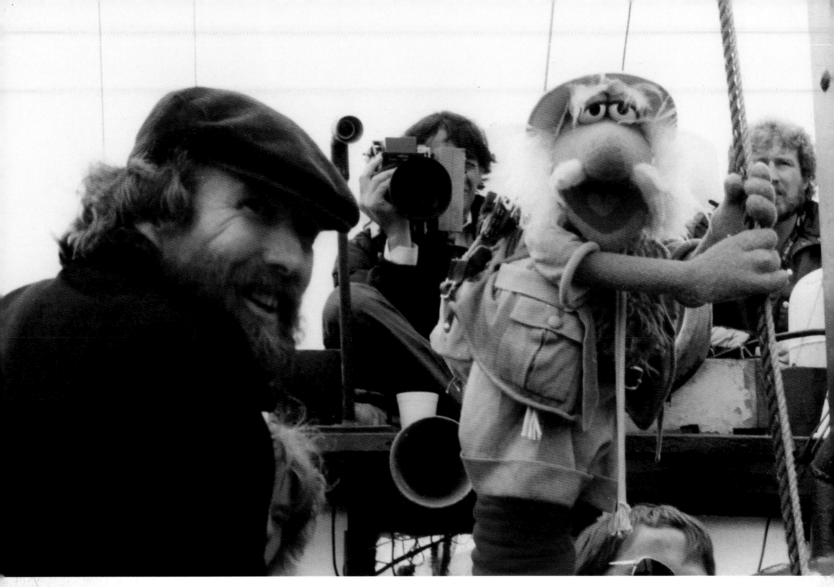

TOP Jim Henson accompanies Dave Goelz and Rollie Krewson (hidden behind Henson) as they perform Travelling Matt for the episode "The Terrible Tunnel" in San Francisco.

BOTTOM On location in Toronto, Dave Goelz performs Travelling Matt for the episode "Beginnings."

DANCE YOUR CARES AWAY

ABOUT FIVE OR SIX SHOWS INTO the shooting of the first season, Jerry Juhl and Duncan Kenworthy approached Phil Balsam and Dennis Lee about writing a theme song for the show. "We were having so much fun, we forgot that shows actually have themes," says Balsam. But penning the opening ditty turned out to be the biggest challenge the duo would face on *Fraggle Rock*.

The theme song would need to portray the complex, multilayered world of the show using catchy, memorable music and lyrics that, in sixty seconds, spoke to the ethos of the Fraggle universe. Up until this point, Balsam and Lee had composed the songs based on a subject or viewpoint that would move the plot of each episode along, but there was no script for the theme song. "So where would we start?" says Balsam. "We knocked one out, I went home, tried something else. Gave it to Dennis, boom, we had another version. Okay, that's not working, I went home, a couple of hours later, there was another one." Balsam remembers that by the beginning of spring 1982, "we had several versions of themes with all kinds of lyrics and melodies floating around. Hey, you want a theme? We've got lots of them."

Because the composers needed a story to follow, Jim Henson decided to help them out by filming an idea he had for the opening sequence that started deep inside the caves of Fraggle Rock and showcased the relationships of the various species. Henson had the footage overlaid with one of Balsam's potential themes and played the clip in a meeting with Balsam, Lee, Duncan Kenworthy, and Jerry Juhl. "What emerged was [Henson's] idea of starting from the outside and going through the window of Doc and Sprocket's [workshop]," says Balsam. "The camera would go in a serpentine fashion through the hole in the workshop, into the tunnels, and into the Great Hall." After staying in the Great Hall for a moment, the action would zoom through the tunnel into the Gorg kingdom, then back to the Fraggle pool. "Once we had that meeting, I knew what we were going to do," says Balsam.

The short length of the intro presented a challenge for Balsam, however: With a running time of just one minute, there was no time to feature a conventional "verse-chorus" song structure. "We had the chorus, 'Dance your cares away,' and all that," says Balsam. "We had the rhythmic hand-clapping for a musical punctuation. This had appeared in two or three versions of the

"Dance your cares away, worries for another day, let the music play, down at Fraggle Rock."

theme, and everybody liked that part of it. It was the verse that just didn't quite jell." So Balsam threw out the traditional structure. "We found that there was no point in having the verse," he explains. "The chorus was the strong point, and the camera and the visuals would describe everything. There would be a musical signature, and then chorus, chorus, chorus, and out."

Recording a temp track version of the theme in his home studio, Balsam started with thumping bass line and a hi-hat drum, "just punching it along, through Doc's workshop. Then I played an electric guitar chord backward, so it goes *yyyyooooowww*, and into the hole, past all its pipes, and into the cave." Unfortunately, Don Gillis informed Balsam that for the final version of the theme they wouldn't be able to re-create the same lo-fi backward guitar sound with their higher-tech gear. "I was able to do it at home with my analog equipment, but their studio setup just wasn't able to do that type of thing," says Balsam. "So they did it digitally, with a synth. They got a pretty good simulation, but mine was a little better," he says with a laugh. "I'm not bragging, it just was!"

With the theme song coming together, one of the last aspects that needed to be figured out was which character would provide the vocals: Would it be one Fraggle, all Fraggles, or a combination of the three species? The lyrics of the song clearly dictated that Fraggles and Doozers would sing. The Gorgs wouldn't sing, but would appear during the mid-song instrumental break. "When we first hear the chorus of the theme, the entire Fraggle world is singing," says Balsam. "'Dance your cares away, worries for another day, let the music play down, at Fraggle Rock.'" Then the scene changes to the industrious Doozers, and the words of the first line of the chorus are flipped for a contrary viewpoint as they sing: "Work your cares away, dancing's for another day." "After that, it goes back to the Fraggles and 'Dance your cares away,' which repeats in various forms about three times," Balsam says.

"When Jim told us he wanted to introduce Gobo, Mokey, Wembley, Boober, and Red [individually] in the song, both Dennis and I dropped our jaws," he continues. "We didn't think it would be possible—all five characters sing out their names in the space of one bar—that's very quick." Balsam admits it was so fast that he couldn't sing it by himself. "Jim could do it, of course. And I thought, *There's a man who really understands timing!*"[18]

The end of the opening sequence was to feature one of the Fraggles delivering the final phrase of the song, "down at Fraggle Rock," an idea Balsam believes came from Jim Henson. Each of the Fraggle Five was filmed singing the final line, and the thought was to evenly distribute these throughout the seasons, but it was Boober's version that was most frequently used.

The show's official opening sequence (not Henson's demo version), featuring the Fraggles clapping along with the theme music, wasn't filmed until January 1983. At the time, the weather in Toronto was freezing, and many of the crew had caught colds or the flu. Karen Prell was one of them. "It was a big day," she remembers. "Jim was there, and all the Fraggles and puppeteers, and I was so sick my skin hurt!" The Fraggle puppets were fitted with devices that would make their hands clap together to the tune, but during the shoot the mechanism on the Red puppet broke. "Rather than stop and get it fixed, because I wanted to just lie down, I ducked her down and hid her behind a rock," Prell continues, "where you can't see her hands, because her hands won't clap." Prell hung in long enough to get the opening filmed: "I'm *barely* hanging in there, but we got through it, and that's what's in the credits you see."

OPPOSITE Development art for Red's "flower drums" by Michael K. Frith.

TOP Scenes from the opening credits of *Fraggle Rock*.

THE DAY-TO-DAY

FRAGGLE ROCK WAS PRODUCED AT A fast pace, with three production phases in process on any given day: production on the current week's show, postproduction on the show shot the previous week, and preproduction for the show that would be shot the following week.

Typically, Mondays started with a script reading of the current week's show involving all key personnel: the performers, Duncan Kenworthy, Jerry Juhl, Jocelyn Stevenson, and that episode's writer—if it wasn't Juhl or Stevenson—along with the show's director and the key tech people: Bill Beeton, Faz Fazakas, Tom Newby, George Clark, Tim McElcheran, and Tim Miller. One puppet builder from the New York workshop was usually in attendance as well. After the read, the performers would be dismissed and discussions concerning technical, schedule, or budget issues would begin.

> "Studio musicians . . . were handpicked by Don–the best studio musicians in Toronto."
> **PHIL BALSAM**

On Monday afternoon, Kenworthy, Juhl, Stevenson, and musical director Don Gillis would listen to demo versions of the songs Balsam and Lee had written for the following week's episode. Once the approval meeting was finished, Balsam and Gillis would meet to go over the songs for the current week's episode. "Don transcribed the song into its final musical chart form," says Balsam. "My orchestral arrangement would always be kept, but Don did a great job of refining it for our studio musicians, who were handpicked by Don—the best studio musicians in Toronto. Don would then have a session with the puppeteers, who

OPPOSITE TOP A script read-through meeting. Jocelyn Stevenson can be seen center, front, with Susan and Jerry Juhl on the opposite side of the table. From the personal collection of Jocelyn Stevenson.

OPPOSITE BOTTOM Jim Henson in preproduction, 1982.

BOTTOM A workshop production meeting, 1982. (Left to right) Amy Van Gilder, Faz Fazakas, Jocelyn Stevenson, producer Duncan Kenworthy, director Norman Campbell, Jim Henson.

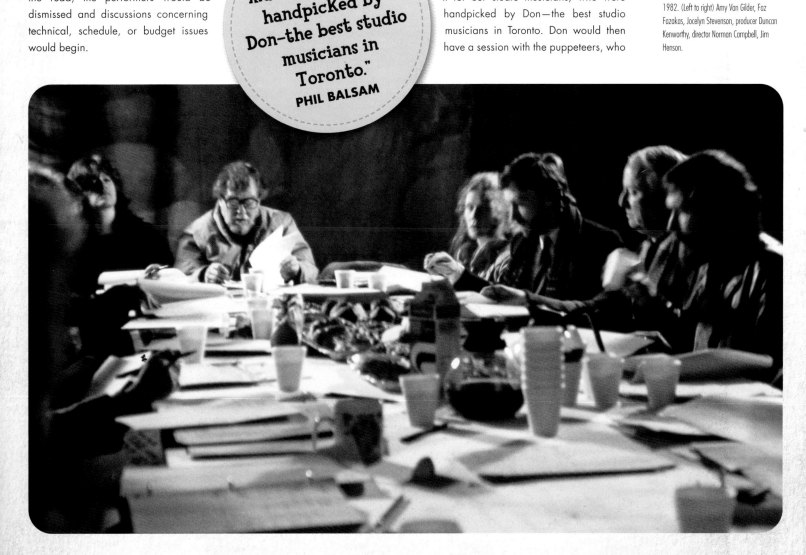

by this time were familiar with the songs." During this gathering, Gillis would be at the piano, with the cast surrounding him, rehearsing their individual parts and vocal harmonies. Cassette copies of the rehearsal would be distributed to the performers, who would use the tapes to further familiarize themselves with their parts before the recording session the next day. "This entire process occurred every week," says Balsam, "and as soon as filming of one show was completed, I'd get a new script in my hands for the next week."

"It was really a mad thing that we set out to do, in retrospect," says Duncan Kenworthy. "The idea of having two or three brilliant original songs every show. I don't know how we had the nerve to do it. Without Dennis and Phil, it wouldn't have worked. And I don't think there's a dud in there."

Additional Monday meetings were scheduled for any other needs related to scripts or production. The day ended with Kenworthy in the editing room, making final tweaks to the previous week's show, which would have been edited by the director and video editor on Sunday. The episode would next be sent to the postproduction sound facility on the other side of the building for sound editing.

On Tuesday mornings, the music for the current week's show would be recorded, minus vocals, in a studio at Eastern Sound, with Don Gillis conducting. "Tuesday was our 'at home' time to learn the songs and the harmonies," Kathryn Mullen explains, "practicing with our tape recordings." In the afternoon, the puppeteers would come into the recording

studio. "Their mics would be placed in a row," explains Balsam, who attended the sessions, "and they would set down the vocals over the musical tracks that had already been completed by the band. You didn't have enough time for too many takes, so they got a chance to be spontaneous, in a sense. The first take was sometimes the best take, and we'd go on." The finished songs would be used on set as a backing track when the puppeteers performed on camera later in the week.

The show was shot from Wednesday to Friday, with the first two days' filming ending at 7 p.m. sharp. Filming on Fridays took as long as was required to complete the episode. "When we started, we had absolutely no idea how long it would take to shoot anything," says Jocelyn Stevenson. "We didn't realize how complicated it would be to set scenes in the Gorgs' garden, how difficult it would be to visit the Trash Heap, how, or if, the Doozers would work, etc. Never mind all the unanswered questions about the relationships between the characters." Stevenson feels producer Duncan Kenworthy's guidance got them through the early shows. "We learned a *lot* from those first episodes," she says.

"The idea of having two or three brilliant original songs every show. I don't know how we had the nerve to do it."
DUNCAN KENWORTHY

TOP LEFT A musical rehearsal during preproduction for the show, 1982. (Left to right) Dave Goelz, musical director/composer Don Gillis (at piano), Karen Prell, and Kathryn Mullen.

TOP Richard Hunt (center, in white shirt) leads a group of puppeteers in a preproduction rehearsal, 1982.

BOTTOM Puppeteering practice in front of a mirror during preproduction rehearsals, 1982.

GOOFS AND GAGGLES

WITH SUCH A TIGHT SHOOTING SCHEDULE, there was no room for errors. Not that mistakes didn't happen—most noticeably in the episode "You Can't Do That Without a Hat." "The whole point of the show was that Boober feels that wearing his hat gives him magical powers," says Karen Prell, "and then he loses it and it's a total disaster." When the hat reappears, there's a huge final musical number in the Great Hall. "The scene was full of dozens and dozens of Fraggles," Prell continues. "We sang about how your hat's been found, and at the end of the song, Gobo gives Boober the hat to put back on, all triumphant." But later, while reviewing the footage, the team realized that through the majority of the song, Boober was wearing the hat. "We had shot for hours and hours late at night to do the song, but the bit where he gets his hat back from Gobo was filmed at another time," she explains. "Everyone was just used to Boober having his hat on. And we were performing it with such conviction, as if Boober *didn't* have his hat on. We believed it, so the audience believed it—there was no hat for that song."

These kinds of big musical numbers often required a large number of background Fraggles. To cut down on how many puppeteers were needed for crowd scenes and to make shooting more efficient, the puppet builders constructed what they called "Gaggles," gangs of radio-controlled Fraggles designed to move in sync with one another during group songs.

Six groups of four Gaggles were made initially, each operated by a single controller. To fill out the scenes further, twenty-four individual hand puppet Gaggles were fabricated, each fitted with snap-on legs.

Rollie Krewson and Jan Rosenthal built most of the Gaggles, using the patterns for the Fraggle Five. "The head shape of the

BOTTOM Sherry McMorran (left) and Jan Rosenthal (right) repair Sir Blunderbrain during filming for "The Terrible Tunnel."

OPPOSITE TOP On set filming Fraggles, firemen Fraggles, and Doozers for a scene in "The Thirty-Minute Work Week." (Left to right) Jerry Nelson, Steve Whitmire, Richard Hunt, unidentified crew member, unknown, Faz Fazakas.

OPPOSITE BOTTOM Color character design for an unidentified creature by Michael K. Frith.

INSERT A sketch of a simple mechanical "Extra Being" by Caroly Wilcox.

G. WIND UP BIRD WITH CAMSHAFT
WING MOTION

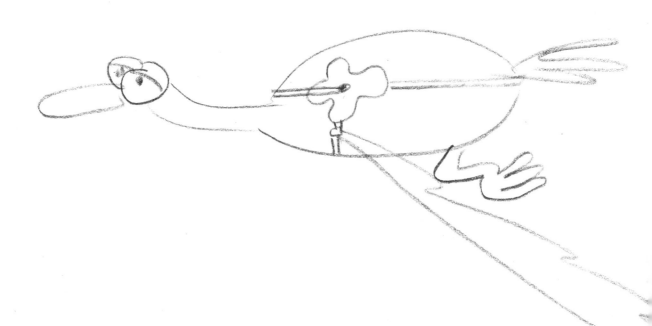

RUNS ON STRING
AS RUBBER BAND IS WOUND.
CAM SHAFT TURNS - BUMPS
ON SHAFT IN TURN CAUSE
WINGS TO GO UP AND DOWN

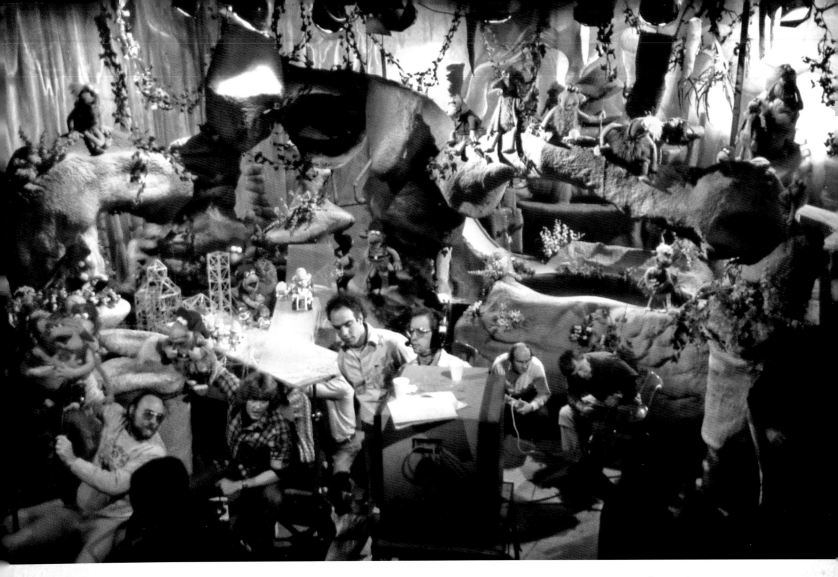

main Fraggles could be remade in different colors," Michael K. Frith explains. "For example, Gobo's orange head could be made in magenta and turned into a female with pale yellow hair. Wembley could be blue with pale cerise hair, and Boober could become an orange female with lavender hair."

While Gaggles were a clever solution to the problem of populating the Rock, their mechanics were often compromised by the shortwave radio used in the fire station next door. "When there was a call into the firehouse on an emergency, it would come in on their shortwave," says Michael K. Frith, "and the shortwave would activate all the Gaggles. They'd all be there on the set, singing 'doody-doody-doo,' and then they'd all suddenly start going *gahgwrghhhaa*."

The Gaggles were not the only background element needed to fill out the *Fraggle Rock* sets: The caves and tunnels also needed to be chock-full of unique flora and fauna, props, and creatures fabricated in the Toronto workshop. There were blooming flowers and bizarre killer plants, along with little critters and bugs that were seen crawling down the rock walls or flying above the characters. Known as "Extra Beings" by the puppet builders, these creatures were further broken down into categories such as "Extraordinary Flyers," "Fuzzy Runners," and "Creepy Sillies."

A lot of the techniques that went into making the *Fraggle*

Rock set seem more three-dimensional and fully populated— including the remote-controlled puppets—originated with *The Dark Crystal*. Frith jokes, "I've always thought of *The Dark Crystal* as like a $25 million research and development program for *Fraggle Rock*."

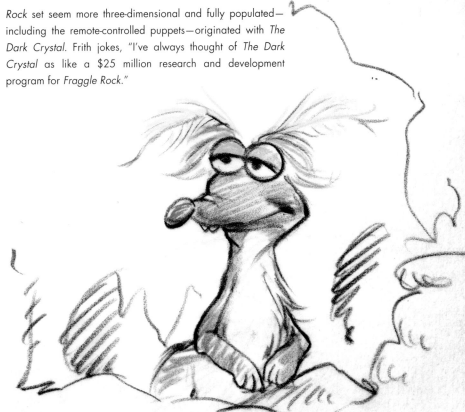

CHANGING PLACES / CHANGING FACES

THE FIRST TWELVE EPISODES OF *FRAGGLE ROCK* had been shot by August 6, 1982, and filming went on hiatus for the remainder of the year as the puppeteers and associate producer Martin G. Baker filmed the ABC special *The Fantastic Miss Piggy Show* at Eastern Sound. The company was also gearing up for the premiere of *The Dark Crystal*, which would take place in New York City on December 13.

But before the show went back into production in February 1983, the production was required to find a new producer to replace Duncan Kenworthy. Kenworthy had committed to setting up the show and producing the first twelve episodes, but had always planned to become the international producer of the show. Now that *Fraggle Rock* was up and running, it was time for him to switch to overseeing the foreign territory partners that would be producing their own wraparound segments. "It was sad, because it had been such enormous fun," says Kenworthy, who returned to London for his new role.

Nevertheless, Kenworthy was looking forward to his new responsibilities, which included producing new international Travelling Matt sequences that would take the explorer much farther afield than Canada. As Kenworthy prepared to depart, the company searched for a Toronto-based producer who not only could oversee the show but also would be able to work closely with the writers. They soon found Lawrence S. Mirkin, who'd been working as a writer and producer in the CBC's TV drama department since 1976.

Meeting with Mirkin in New York, Henson was immediately taken with the producer's approach. "I'm a best-idea-wins kind of guy, and I'm very collaborative," says Mirkin, "but still the buck will still stop with me." Henson offered him the job on the spot.

"Everyone talks about what a great puppeteer [Henson] was," Mirkin continues, "which he was—puppet maker, director, visionary—but he was a wonderful producer, because he could find the right people and put them together. Everyone who worked for him has a story like this. What he knew about me, which I didn't know yet, was I had the personality and the way of working together that this group needed."

Mirkin was then flown out to California to meet Jerry Juhl, "because if we didn't get on, it was going to be a problem!" says Mirkin. The prospective producer had already formulated some ideas for improving *Fraggle Rock* and wasted no time sharing his opinions with Juhl. "[I told him] every show takes a lot of time to find itself," Mirkin says. "But a lot of the earlier scripts were trying to do too many ideas at the same time. They were trying to do big ideas, attempting to give the five Fraggle characters equal weight in the story while they were still trying to figure out who the characters were. And Jerry looked me right in the eye and smiled and said, 'You're absolutely right.'"

With Juhl's blessing, Mirkin returned to Toronto and shared his thoughts with the writing team. Following his feedback, it was decided one character would take center stage in each episode, overcoming an obstacle with the support of the other characters. "In consideration of [balancing out the character-focused episodes], if someone came in with a great story, we would ask, 'Can you make this about Wembley instead of Gobo?'" adds Mirkin. "We also kept the development of the Doozer and Gorg characters in the mix. You just can't do justice to everything, but over the course of a series you can."

During the late-1982 hiatus, the New York workshop continued producing Gaggles along with a number of new characters for the next batch of episodes. They also set about reevaluating and redesigning their lead Fraggle.

BOTTOM On the set, Jocelyn Stevenson, Larry Mirkin, and Jerry Juhl offer their versions of "See No, Hear No, Speak No." From the personal collection of Jocelyn Stevenson.

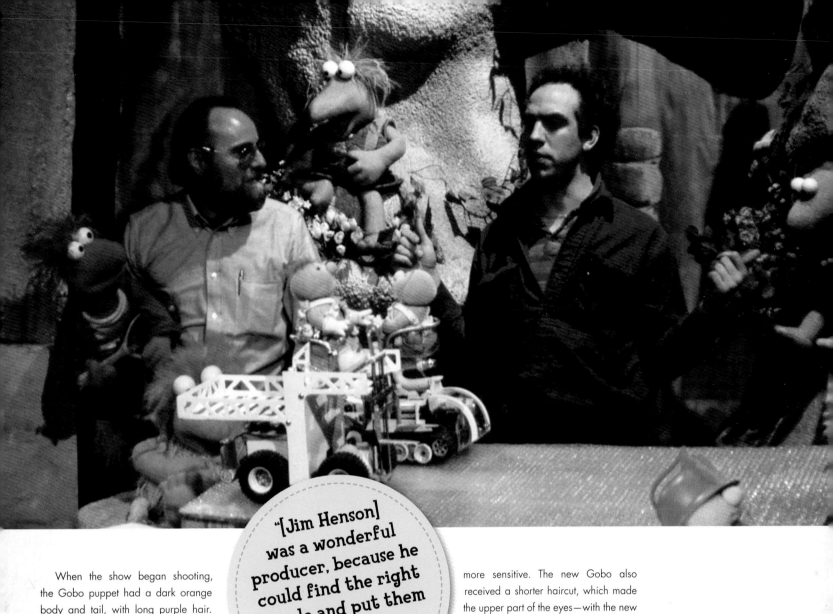

"[Jim Henson] was a wonderful producer, because he could find the right people and put them together."
LAWRENCE S. MIRKIN

When the show began shooting, the Gobo puppet had a dark orange body and tail, with long purple hair. He also wore a yellow shirt underneath a magenta cardigan sweater. But puppeteer Jerry Nelson wasn't satisfied with Gobo's overall look, so during the six-month break after the first twelve episodes were completed, the Fraggle leader underwent some cosmetic changes.

Nelson described Gobo's original face shape as "Skeksis-ish," referring to the villainous birdlike creatures from *The Dark Crystal.* Nelson asked for a warmer look, so with Jim Henson's input, Michael K. Frith sketched a new approach to Gobo's expression.

Describing how that collaboration went, Tim Miller said: "It was wonderful, just to see Jim Henson and Michael K. Frith work together. Jim would talk and Michael would draw, and suddenly there was the Gobo as we know him now from all the rest of the shows, boom, there on the paper. Hey, I had the easy job! I just had to go down in the shop and make him, put him together."

Working from Frith's ideas, Miller took on the rebuild of Gobo, adjusting the puppet's mouth to make it rounder and slightly smaller, which eliminated the beakish look. Miller also gave Gobo eyelids, which he felt would allow the character to express a richer palette of emotions, and thus make him appear more sensitive. The new Gobo also received a shorter haircut, which made the upper part of the eyes—with the new lids—easier to see.

Frith was pleased with the design. "It's important to note that there was always considerable autonomy among the puppets builders," he says. "When a [puppet builder created] their puppet, it was theirs and theirs alone, and that would have been true for all the builders. Everyone shared ideas and materials—and gossip—all bent on the contribution to the greater cause."

Jerry Nelson was also pleased with the result. "It's funny with puppets—certain angles can drastically change the look," he said. "They gave a little more definition to his face, changing his snout and fixing the eyes so he didn't look so goofy. It didn't affect the character at all, it just had a better look."

Nelson had one more request—that Gobo be dressed to better reflect his role as an explorer, his official job at Fraggle Rock. Gobo's cardigan was subsequently ditched in favor of a brown vest with lots of pockets, each filled with the postcards sent by Uncle Travelling Matt. And his yellow shirt was given red stripes, to add a little more visual excitement. "The stripes were painted on, because it would have been hard to find a striped fabric in two sizes," says costumer Polly Smith.

TOP Jerry Nelson with Gobo and Richard Hunt, with Doozers and assorted background Fraggles in the Fraggle caves set.

THE SECOND TWELVE

WHEN THE SHOW RESUMED PRODUCTION IN the second week of February 1983, Jerry Juhl, Jocelyn Stevenson, and Larry Mirkin took what they had learned from the first twelve episodes and tried to push the show further. "For the second twelve, we would ask: What two unlikely characters can we throw together?" says Jocelyn Stevenson. "That's how an episode like 'Marooned,' would occur. What happens if we put Boober and Red together? So, we tossed that idea to David Young to write, and he did a great job."

In "Marooned," Red must keep Boober occupied while preparations are made for his surprise birthday party. She takes him to the Spiral Caverns, where a rockslide traps them in a cave. "Boober and Red wouldn't have much to do with each other at all if they could help it, and then they get trapped together," says Karen Prell. "Red's usual way of coping is screaming or overreacting or running, and suddenly she's in a situation where none of that will work. This is a new experience for her."

Boober does his best to comfort Red as they contemplate their possible deaths. "Boober is an expert on fear and operating under fearful conditions, and rises to the challenge," continues Dave Goelz. "What I found interesting about the show was this type of writing [for a TV series] lets you go forward and enlarge the characters. Red was something more than she had been before that episode, and so was Boober. You can still revert to

the original character stance, but you now have this richness and this place you can go in the future."

When he was hired, 'Marooned' writer David Young was always upfront about wanting to tackle dark subjects such as mortality and fear. "Fortunately, Jerry Juhl was always willing to let you go there," says Young. "And then he would show you how to re-illuminate it from within, so you could be full of despair, but you could also flip it over to something that was very funny and light." According to Young, Juhl was like a big, happy kid whenever he got excited about a strange or silly idea; and the writers all tried to please the kid inside him.

Lawrence Mirkin puts it a different way: "Jerry was really the literary voice of the Muppets, and he created what I always called 'lunatic humanism,' which was sort of the spirit to me of the Muppets. That certainly was true in *Fraggle Rock*."

Every story idea submitted by the writers was filtered through Juhl, Stevenson, and Mirkin, who would discuss them before meeting with the writer. "Jerry always made the process of showing him your work as painless as possible," says Stevenson. "He always started a script meeting by saying something positive, even if it was to compliment you on your choice of typeface. He respected everyone's process—appreciated that we were all different—and was committed to advising, not prescribing." Additionally, every word change and scene revision was made solely by the writer, a rarity in television, where scripts are often taken out of the hands of the original author to be rewritten.

Juhl wanted to involve the writer all the way through the process—never, as he said, "letting them off the hook." Since Juhl's writers were scattered in many different locations, the staff relied on an early form of email, transmitting scripts and notes between computers via phone lines. Jocelyn Stevenson recalls sitting in her house in rural Wales, slowly sending pages across the Atlantic via a modem, and realizing that the Henson team had come up with an advanced way of doing business internationally. She says with a laugh, "I offered to write British Telecom a pamphlet telling people how to do it, but [the company] scoffed. They thought I was a lone lunatic."

The writers were on set throughout the shooting of their

BOTTOM Performers puppeteering the Fraggle Five. (Left to right) Jerry Nelson with Gobo, Karen Prell with Red, Dave Goelz with Boober, Kathryn Mullen with Mokey, Steve Whitmire with Wembley.

specific episodes, another very rare practice in television production. Having the writer available at all times allowed the production team to make necessary changes to episodes quickly while keeping the story intact—a puppeteer might need an extra line to move the character from one place to the next, or lines might need to be deleted for pacing reasons.

When the first episode that Jocelyn Stevenson wrote ("You Can't Do That Without a Hat") was being filmed under director Perry Rosemond, Henson was on set and quickly identified that the camera blocking in one scene was problematic. "He leaned over to me and whispered, 'This isn't working,'" Stevenson recalls. Henson told her she needed to rewrite the scene, and she made a note of that in her script. Then she realized that he expected her to do the rewrite immediately. "They couldn't shoot the scene until I did!" Stevenson learned not only how to write well, but how to write fast.

Having the writers in the studio also allowed them to observe between-scene improvisations by the puppeteers, who frequently stayed in character when the lights or set were being adjusted. "The puppeteers kept doing things," says Mirkin, "and so lots of ideas would come out of just watching them goof around."

In another unique shift from the norms of TV production— and for the first time in the company's history—puppeteers were welcomed into the writers' room. "Jerry was very adamant about having a lot of involvement, a lot of collaboration," says Susan Juhl. "It wasn't only that we had the writers on the floor so that if something went wrong, they could oversee it. He felt the same way about the performers, so he would invite them up to the writers' studio. He'd say, 'This is a show about Boober, what is your input, what do you think, is this something that Boober would do?' That was invaluable."

Visits to the writers' room were not required, but were definitely encouraged, especially if a performer's character was featured in the episode being discussed. "[The attitude was] 'If you want to contribute to this, jump in,'" says Dave Goelz. "So I did. I always did that, though they were usually on track and I didn't have a lot to add."

"Most times, it would just be a little bit of a tweak," says Karen Prell. "But there was one proposal for a show that didn't even get as far as a script." The doomed story idea saw Red and Mokey fighting over a boyfriend. "And we were like, whoa, time out!" says Prell. She argued that Red and Mokey were strong characters in their own right: "We don't need to do the girlie-boyfriend stuff on this show."

"Dave always came. Jerry Nelson came occasionally, when he had a question," remembers Larry Mirkin. "Steve [Whitmire] was always, 'Oh, that'll be fine.' Very Wembley-like. Karen Prell was always funny, and always had things to say. When Kathy Mullen came in, she would say, 'Oh, I just love this. I just

"Jerry was really the literary voice of the Muppets, and he created what I always called 'lunatic humanism.'"
LAWRENCE S. MIRKIN

have one or two little word things.' And then three hours later, you'd have worked through every single line."

Whitmire believes that Jim Henson used *Fraggle Rock* as a training ground for his performers. "It was a place for us all to grow," he explains. "Whether he consciously planned it like that I don't know, but it certainly turned into that. He wasn't overseeing things in the way that he had in the past. He left it up to us, and we had to rise to the challenge."

"Everyone who was accustomed to going to Jim for an opinion had to make the decisions themselves," adds Dave Goelz. "It was a great vote of trust. We had a chance to take on major characters that we hadn't been able to do before. With *Fraggle*, we were invited into the process. For the performers, suddenly the fleece ceiling that was provided by Jim and Frank [Oz] was gone. It was an exciting time for everybody."

TOP Performers on set (left to right) Jerry Nelson with Gobo, Steve Whitmire with Wembley, Dave Goelz (not visible) with Boober.

MUSIC MAKES US REAL

ALTHOUGH JIM HENSON NEARLY ALWAYS HAD multiple projects in the works, he would visit the set of *Fraggle Rock* when time permitted. While there, he'd perform new characters, including two Fraggles that made their debut in Season 1. One was a mesmerizing master of persuasion named Convincing John—as first seen in "The Preachification of Convincing John." The other was Cantus the Minstrel, a guru-type singer and magic-pipe player who encouraged the Fraggles to look deep inside themselves for answers to their problems.

"Convincing John was the guy whose charisma (and great backup singers) could convince the Fraggles to do anything," says Michael K. Frith, "no matter how dumb or destructive." It's discovered in a later episode, "The Secret of Convincing John," that he's actually as indecisive as Wembley, and that's why he can convince everyone, for he can see all the angles and possibilities of any situation. "[Convincing John] had a lot of my dad in him, because he could never have been as successful as he was if he wasn't a salesman, if he wasn't somebody who liked convincing people to do things," says Henson's daughter Cheryl, president of the Jim Henson Foundation and member of the board of directors of The Jim Henson Company.

Cantus the Minstrel leads a band of traveling musicians that includes Murray (Steve Whitmire) and Brool (Tim Gosley) who play stringed instruments, cymbalist Brio (Terry Angus), and the familiarly named Balsam (alternately Jerry Nelson and Karen

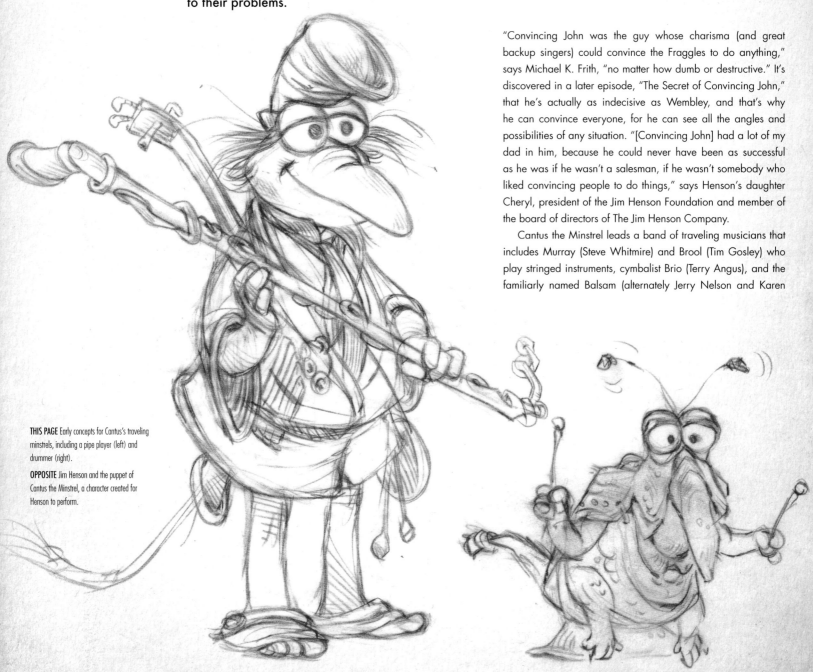

THIS PAGE Early concepts for Cantus's traveling minstrels, including a pipe player (left) and drummer (right).

OPPOSITE Jim Henson and the puppet of Cantus the Minstrel, a character created for Henson to perform.

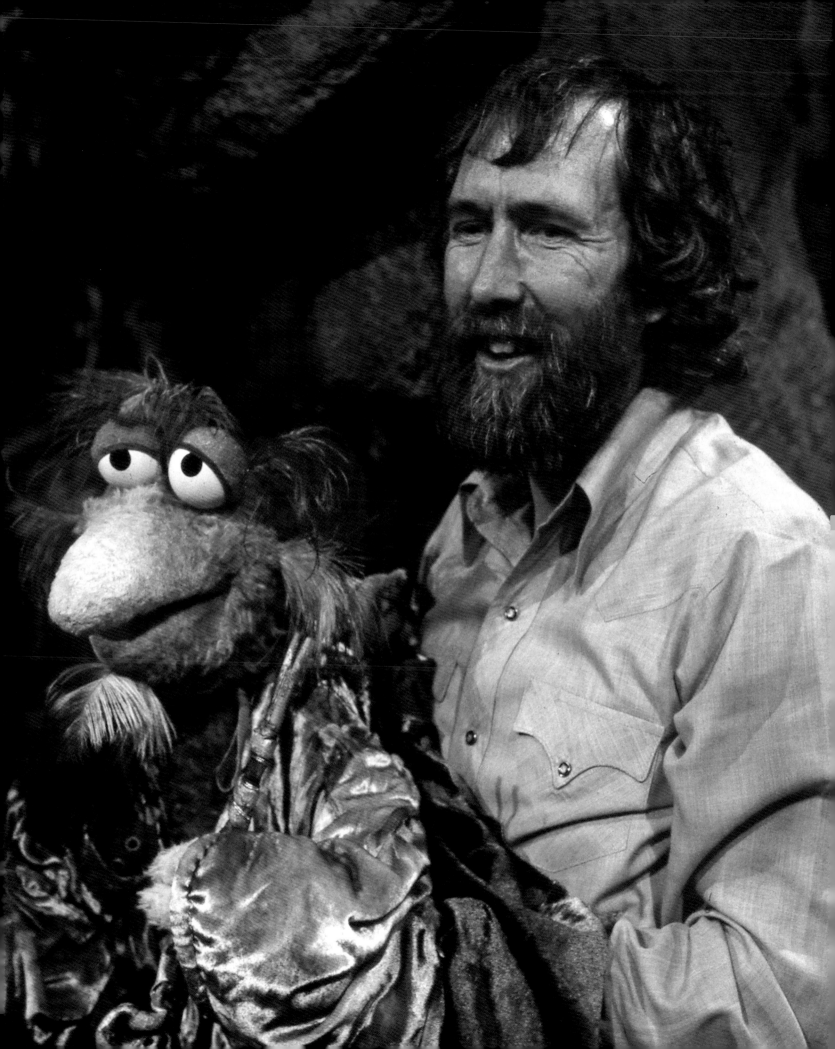

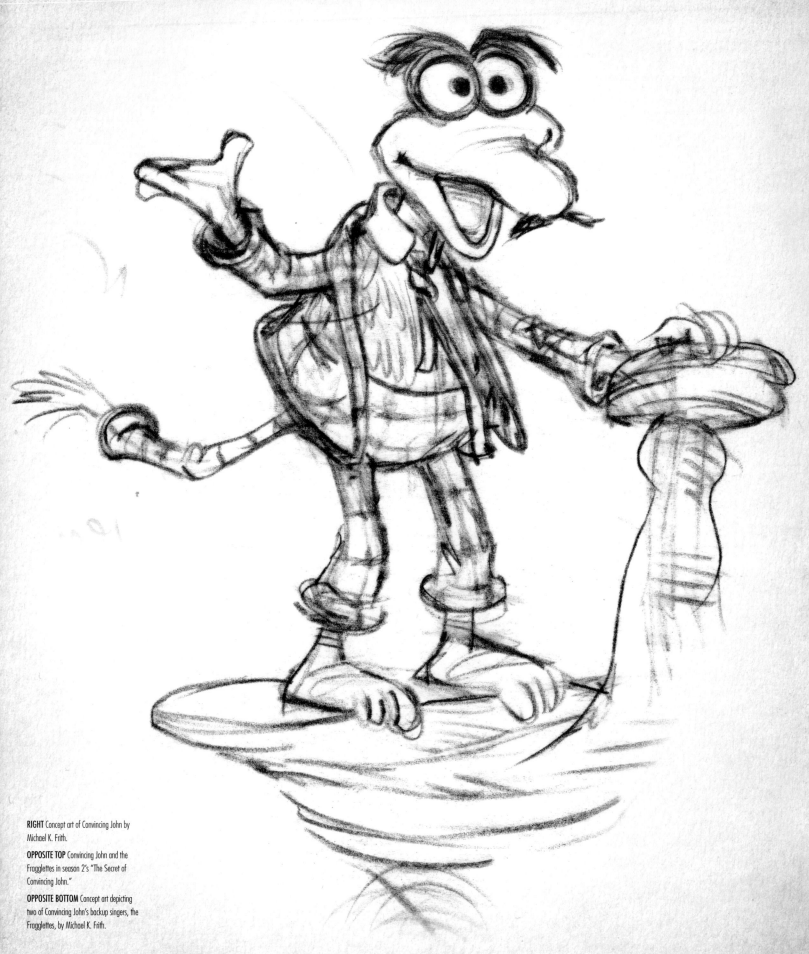

RIGHT Concept art of Convincing John by Michael K. Frith.

OPPOSITE TOP Convincing John and the Fragglettes in season 2's "The Secret of Convincing John."

OPPOSITE BOTTOM Concept art depicting two of Convincing John's backup singers, the Fragglettes, by Michael K. Frith.

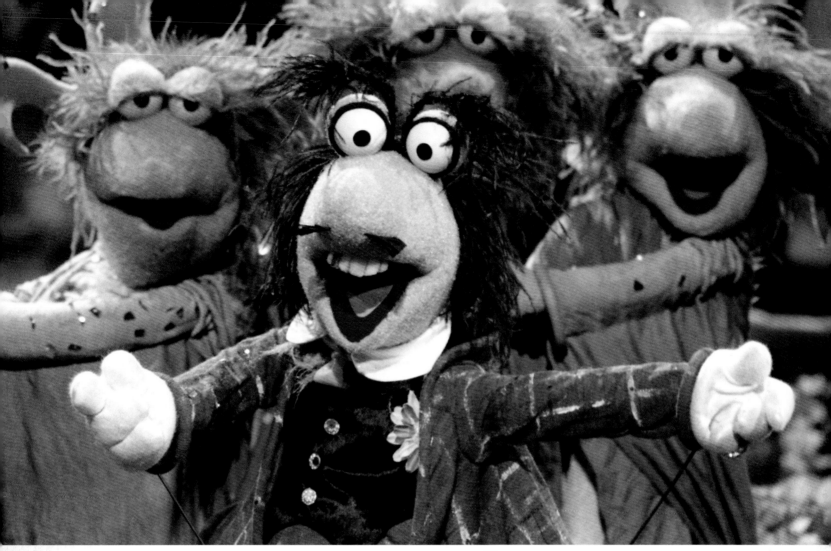

Prell) on bongo drums. "Cantus would always arrive at a point where there was some wisdom to impart to someone who was in big trouble," said Jerry Juhl. "It would come out of his mouth in an amazing riddle that nobody really understood and that nobody but Jocelyn could write."

In order to justify the occasional appearances of Convincing John and Cantus, Frith and Stevenson presupposed that there were other Fraggles who lived in unseen locations in the Rock. "Cantus and his Musicians have been far and wide—like priests who go to places before these places are officially discovered," she wrote in a December 1982 memo. "And wherever they go, they bring music. In this way, the musicians can be in some shows and not in others without causing too much philosophical angst."

"What an absolute honor to create a character for Jim," says Stevenson, "and he loved Cantus, which means 'song.' And I loved writing Cantus." Stevenson swears that, although she created Cantus, she had no idea that the character reflected Jim Henson's personality so closely until Jerry Juhl pointed it out to her. "[Jim] was zen and he was Fraggle. He was wise and he was goofy at the same time, and that was Cantus," says Stevenson.

"He loved going back and performing," says Cheryl Henson. "It was really, really fun for him to go in and be those characters, who are, delightfully, my father."

A TRULY INTERNATIONAL CHILDREN'S SHOW

IN EARLY FALL 1982, DUNCAN KENWORTHY had joined Peter Orton, head of the new Henson International Television company, at Henson's London offices. Working together, they set out to get the international versions of the show off the ground. Three major territories had boarded the project—the United Kingdom, France, and Germany—and so Kenworthy began assembling European crews that could produce the localized Doc and Sprocket wraparound segments. He also began searching for actors who could dub the Fraggle portion of the show into French and German.

"Germany was the home of *Sesamstrasse*, the first *Sesame* coproduction, so there was a comfort zone there," explains Henson archivist Karen Falk. "It made sense to do a French version because so many television markets in the world had French-speaking audiences, especially in North and West Africa. And with England being home to *The Muppet Show*, it was an obvious third location for a partner."

In Germany, the segments for *Die Fraggles*, which was broadcast on the public service channel ZDF, were shot in Munich. The German version was similar to the original—its Doc, played by Hans-Helmut Dickow, was also an inventor. He worked in a shed at the bottom of his garden along with his dog, Sprockie. The original Doc and Sprocket scripts were translated almost word for word to be used in the German wraparound segments, and, for the first season of the show, Sprocket puppeteer Steve Whitmire traveled to Germany to play Sprockie.

"And I didn't speak any German at all," says Whitmire. At the first shoot, Whitmire placed two scripts below him for reference: the original in English and the German version. But when Dickow said his first line, Whitmire quickly realized he was out of his depth. "And I'm scanning the scripts to figure out what he just said," he says. "I look at the monitor, and Sprocket is just staring at him. Which is basically what I was doing inside, like, *What did you say?*" Whitmire called Kenworthy over and whispered, "Duncan, we are in big trouble."

Whitmire was also thrown by the acting style of Dickow: "He was very stern, not like Gerry Parkes, and I thought, *He's not enjoying this at all*. But it was just the difference in cultures, which was what the show was to begin with. The purpose of doing this was to bring cultures together, and we certainly did that."

The wraparound segments for France's *Fraggle Rock*, shown on the free-to-air channel FR3, went in a different direction: In this version, Doc, played by Michel Robin, was a chef who owned a dog named Croquette. The French Doc had inherited a bakery from his Uncle Georges, an inventor. This conceit provided the justification for Doc to interact with mechanical devices in the bakery, echoing story points in the Fraggle footage, and ensuring that the bookend material synced up with the puppet scenes.

The United Kingdom's Doc, played by Scottish actor Fulton Mackay, was known as the Captain: a retired sailor who was now a lighthouse keeper. (When Mackay's health failed, just before his death in 1987, he was replaced by John Gordon Sinclair for Season 3 and then Simon O'Brien for Season 4. Both played relatives of the Captain.) The lighthouse was located somewhere off the rocky southwestern coast of England—Kenworthy liked the idea because he felt it gave more validity to the *rock* aspect of the name *Fraggle Rock*. UK segment producer

BOTTOM Fulton MacKay as the Captain, a lighthouse keeper, in the UK edition of *Fraggle Rock*. Like Doc in the US version of the show, he was paired with Sprocket.

OPPOSITE Uncle Travelling Matt observes a Scottish bagpiper for the United Kingdom version of the episode "The Minstrels." In the storyline, Matt believes that bagpipes are creatures being tortured, hence the screeching noise they make.

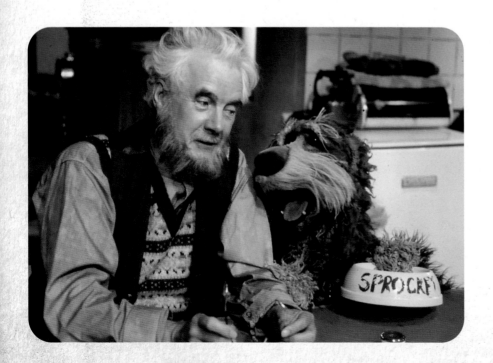

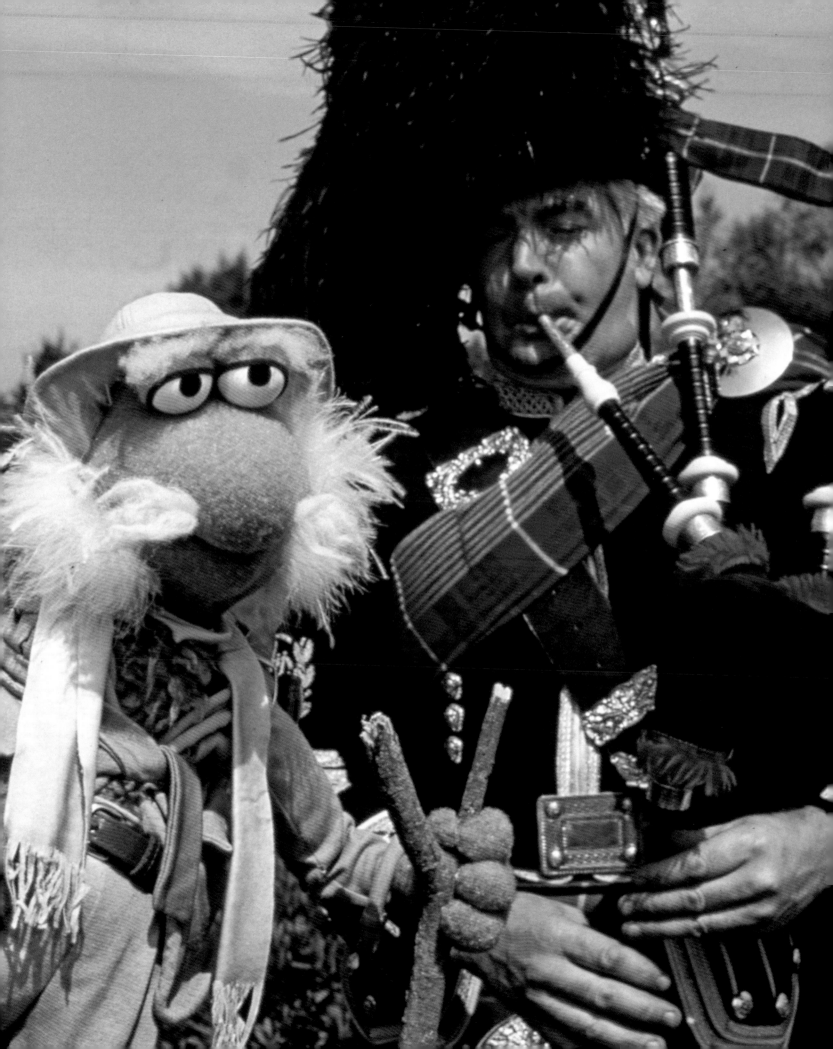

Victor Pemberton rewrote the Doc and Sprocket scripts for the British version, which was shown on the free-to-air network ITV.

Both France and Germany began airing their episodes of *Fraggle Rock* in November 1983, with the UK following in January 1984.

To Duncan Kenworthy's chagrin, not every country would opt to localize *Fraggle Rock* by adding their own Silly Creatures. Each territory approached by Orton and Kenworthy had the option of dubbing or subtitling the Canadian-produced wraparound sequences featuring Doc and Sprocket, rather than creating their own. Many TV networks took the dubbing/subtitling route because it was the simplest and cheapest way to add *Fraggle Rock* to their lineups, a disappointment for Kenworthy, who had looked forward

to seeing multiple variations on the framing device.

Nevertheless, *Fraggle* business was booming. To sell the show, Kenworthy and Orton leaned on connections they'd made years earlier when exporting *Sesame Street* to the world. By October 1982, *Fraggle Rock* had been sold to seventy-five countries and would eventually be broadcast in ninety-five territories and in thirteen languages.

When adapting *Fraggle Rock* for foreign markets, one of the biggest challenges that overseas production companies faced was how to handle the songs. "Often, if a broadcaster is taking a program in another language that has one song, they'll leave the song in the original language and not bother to dub it," Kenworthy explains. "But because [the songs were] so integral to

BOTTOM LEFT Uncle Travelling Matt meets a member of the Queen's Guard in London in the season 3 episode "Believe It or Not." Matt decides the reason the guards don't speak is to avoid waking the animals sleeping on their heads.

BOTTOM RIGHT Sprocket's whiskers wave in the wind outside the Captain's lighthouse in the UK *Fraggle Rock*.

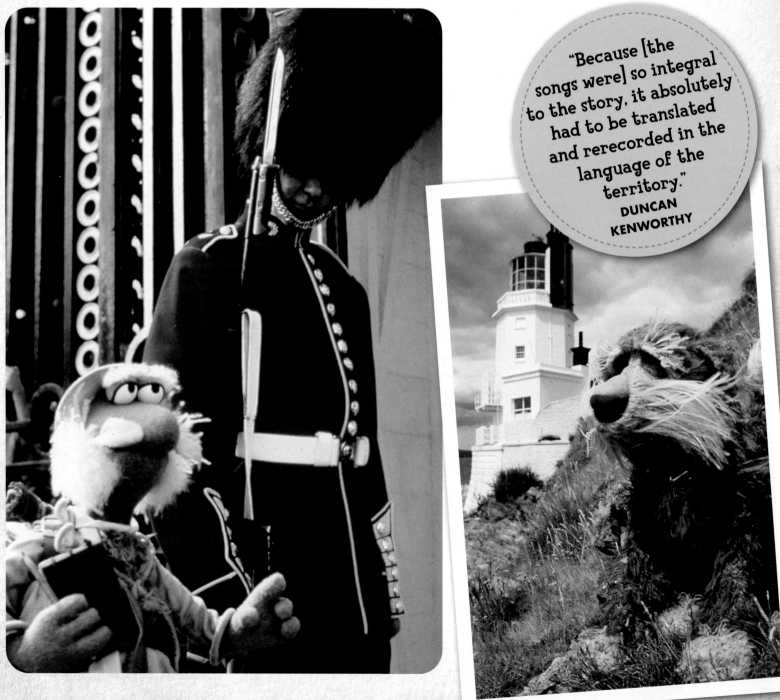

"Because [the songs were] so integral to the story, it absolutely had to be translated and rerecorded in the language of the territory."
DUNCAN KENWORTHY

the story, it absolutely had to be translated and rerecorded in the language of the territory."

To ensure that the songs were reproduced to the expected standard, Kenworthy auditioned international voiceover actors, looking for performers who could sing like the *Fraggle Rock* characters. He also oversaw the dubbing sessions. "All of this was complex, as you can imagine," he continues. "I remember going to dubbing theaters all around the world, not just in the places where we did the coproductions, like France and Germany, but in Sweden, Finland, Norway, and Holland."

In November 1982, Duncan Kenworthy flew back to the States and joined Dave Goelz on a trip to Australia and New Zealand, where they would film twenty Travelling Matt segments. Five of these would be inserted in *Fraggle* episodes throughout the first season, interspersed with the continuing Toronto shoots. A production company was hired in Melbourne to assist.

Over the course of three weeks, they filmed segments featuring Matt's reaction to, among other things, a mob of kangaroos in Melbourne, boomerangs in Brisbane, and waterskiing in Sydney.

TOP Uncle Travelling Matt in France, in front of the Arc de Triomphe, for the French episode "Catch the Tail by the Tiger."

BOTTOM Michel Robin as Doc, a chef as well as inventor, with his dog, Croquette, in the French edition of *Fraggle Rock*.

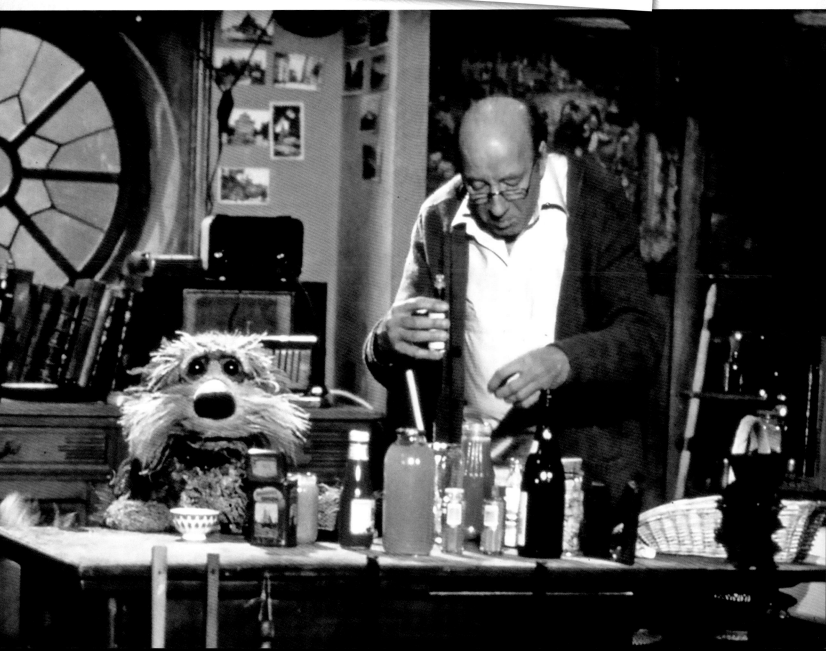

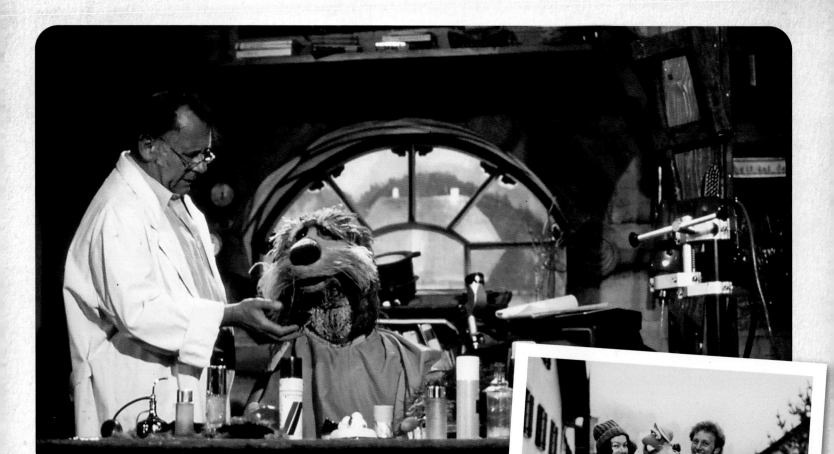

The puppet also surfed on the Gold Coast and tried a trampoline in front of the Sydney Opera House.

Five days of shooting were planned for New Zealand, where Matt would experience the inside of a rugby scrum, take part in a Maori ceremonial dance, and visit a geyser in Rotorua. "We were hoping to shoot Matt running into Maori warriors with his face painted, looking scary," remembers Dave Goelz, "but the chief of the tribe [we spoke with] was reluctant because at that time, there was a lot of discrimination against Maoris in New Zealand, so it was a sensitive subject."

Fortunately, Kenworthy was able to talk the chief into participating. "Duncan explained that the show was about harmony and getting along together, and then he asked the chief, 'Would you prefer not to be represented?'" says Goelz. "The chief thought about it and said, 'Maybe I should be a part of the thing, okay.' We shot the piece, and the chief was happy with it." In the finished segment, Matt's encounter with the Maori is enlightening rather than scary, and he concludes that the Maori people are similar to Fraggles given their decorative outfits and warm hospitality. He even wears the Maori face paint in the sequence.

During their time in Australia and New Zealand, Kenworthy and Goelz met a new colleague, Ron Mueck, a junior puppeteer who signed on as an assistant, and who taught them a little about how well their work had traveled around the world. "He was just such a fan of Dave, and this was his dream job, getting to work with, you know, Gonzo from The Muppet Show," says Kenworthy. "And he was brilliant. At the end of the two weeks, there was such a sad moment for him that we were leaving. You know, he'd done this thing he'd always wanted to do."

Kenworthy stayed in touch with Mueck, and when Jim Henson was casting his movie Labyrinth a few years later, he recommended "Ron from Australia," who was talented, easygoing, and tall enough to help operate the giant character Ludo alongside Fraggle Rock's Rob Mills. "Then he became a sculptor within the Creature Shop, and so on and so on," Kenworthy says. "Now he's a world-famous sculptor who has exhibitions all over the world. He was this kid in Melbourne. And the show came over and gave him an opportunity to travel halfway around the world and become a superstar."

TOP Doc, played by Hans-Helmut Dickow, with his dog, Sprockie, in the German version of *Fraggle Rock*.

CENTER RIGHT Uncle Travelling Matt, and puppeteers Eva and Siegfried Böhmke on location in Austria.

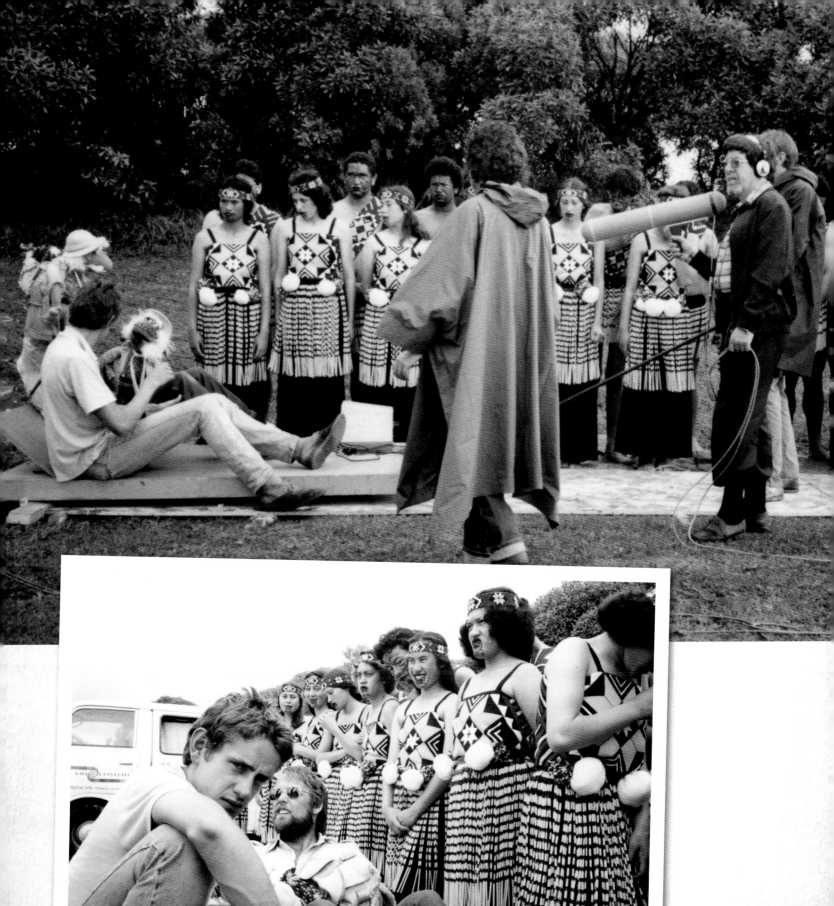

TOP Dave Goelz performs Uncle Travelling Matt as the intrepid Fraggle encounters a Maori tribe during his travels in New Zealand.

BOTTOM Ron Mueck with Dave Goelz on location in New Zealand.

WHOOPEE!

FILMING ON THE FIRST SEASON OF *Fraggle Rock* wrapped in May 1983. With all twenty-four episodes in the can, postproduction went into high gear. The final touches included adding visual effects, such as the blue-screen compositing for the Gorg-and-Fraggle scenes, locking down episode timing, and fine-tuning the sound.

Fraggle Rock debuted in the US on HBO on January 10, 1983, and in Canada on the CBC on January 23. The *Washington Post* described it as "a fresh and funny approach to mild, painless moralism; a saucy cuteness that's never merely precious or condescending; and adventures that exclude neither tots nor grandparents nor anyone in between from the target audience."[19] Said *Multichannel News*, "*Fraggle Rock* is the kind of habit-forming, extremely promotable, high-quality show programmers and operators have been talking about, wishing about, for years."[20] Critics applauded Jim Henson's ability to offer moral insights without being preachy, introduce fun characters who weren't corny, and continue his unerring

instinct to create programming that would appeal to adults as well as children. "Kids can be vastly entertained," wrote Bob Wisehart of the syndicated Newhouse News Service, "and, unless they have a heart full of unwashed socks, adults will be charmed."[21]

Fraggle Rock's ratings reflected its positive reviews. It ranked number one among HBO non-feature family programs, with a 13.2 percent rating among children, compared to the average HBO kids rating of 2.4 percent at the time. In sales material prepared by Henson Associates after the first season, it was noted that among children ages two to eleven, *Fraggle Rock* was watched more than HBO's highly touted first

RIGHT Fraggles appear on the front cover of US's *TV Guide*; Doc and Sprocket grace the cover of Canada's *TV Times*.

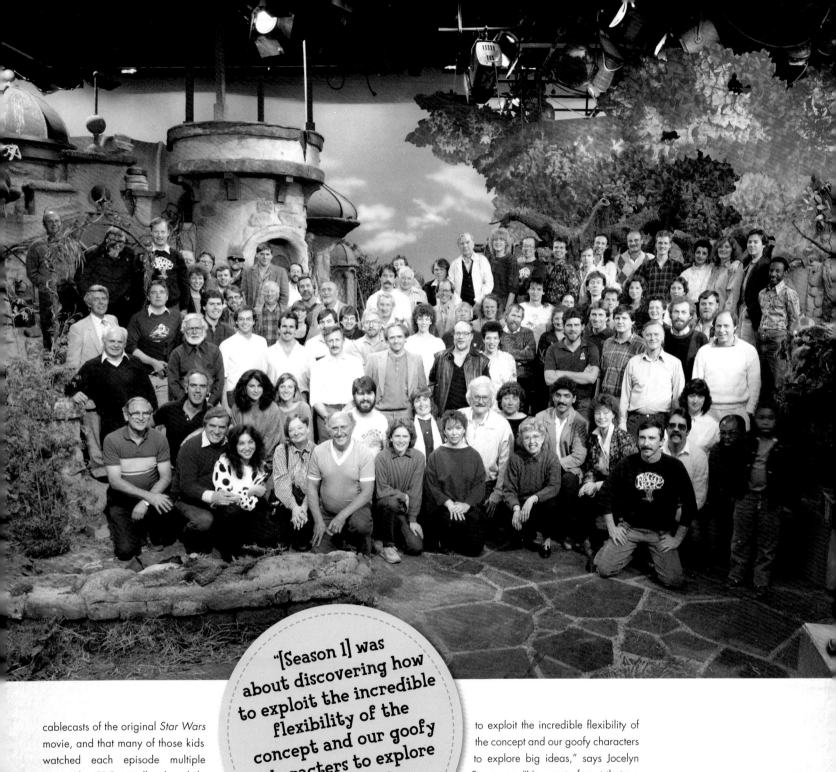

"[Season 1] was about discovering how to exploit the incredible flexibility of the concept and our goofy characters to explore big ideas."
JOCELYN STEVENSON

cablecasts of the original *Star Wars* movie, and that many of those kids watched each episode multiple times. The CBC initially placed the show in its 5:30 p.m. slot, but quickly moved it to 7 p.m., where it could reach a broader audience.

After its first season, the show won the International Emmy Award for Outstanding Children's Programming; an ACE Award from the National Cable Television Association for Best Children's or Family Series; and an ACT Award, Best Children's Program Series, from Action for Children's Television, a grassroots, nonprofit child advocacy group dedicated to improving the quality of television programming offered to children.

"The first season of *Fraggle Rock* was about discovering how

to exploit the incredible flexibility of the concept and our goofy characters to explore big ideas," says Jocelyn Stevenson. "It's easy to forget that we were all under incredible pressure, and as much as we all loved what we were doing, we didn't have a clue if it was going to work."

Considering the enthusiastic reception from viewers of all ages, critics, and broadcast networks, it was clear that Jim Henson's idea for "a show to bring world peace" was on the right track. The cast was settling in to their characters, and the writers, producers, and designers still had notebooks full of unused ideas. The *Fraggle Rock* team moved on to their second season feeling confident and ready to take more chances.

TOP A cast and crew publicity photo taken on the set of *Fraggle Rock* for *People* magazine includes Jim Henson, Jerry Nelson, Steve Whitmire, Karen Prell, Kathryn Mullen, Faz Fazakas, Richard Hunt, Jocelyn Stevenson, Jerry Juhl, Diana Birkenfield, George Bloomfield, Phil Balsam, Dennis Lee, Don Gillis, Gerry Parkes, Trish Leeper, Larry Mirkin, Dave Goelz, Jane Gootnick, Terry Angus, Tim Miller, Rob Mills, Gord Robertson, and many others.

SEASON 2: EXPANDING A WELL-ESTABLISHED WORLD

ONE OFTEN OVERLOOKED ASPECT OF *FRAGGLE ROCK'S* creative success was the decision to produce the show in Toronto. Sequestered from the bustle of New York, Los Angeles, or London, the cast, writers, and crew found that they spent more time together, on and off the set. They had regular lunches and dinners, where they learned more about each other, even finding inspiration for *Fraggle Rock* episodes through their close interactions. Jocelyn Stevenson says that by the time the show's second season began, the creative team knew one another so well that they could quickly intuit which writer would be right for which script, and which performers might play well off each other in a scene.

They all enjoyed each other's company so much that they didn't even seem to mind returning to work early. Season 2 was scheduled to begin production in September 1983. But before the official start of production, the team reconvened in Toronto, taking the time to review Season 1 and discuss ways to improve the next season of episodes.

Midway through the summer, over the weekend of July 16–17, a meeting entitled the *Fraggle Rock* Educators Seminar was held. The event was an opportunity for the show's producers and writing staff to meet with child psychologists and schoolteachers to discuss *Fraggle Rock*'s themes, characters, and language. Jim Henson led the group, prompting discussions on the relationships among the three species and approaches the writers had taken to addressing conflict resolution. The sessions also covered a wide range of other topics, including reality vs. fantasy, how the show's depictions of fear and anger might affect younger viewers, and whether the Trash Heap looked too sad.

"Many useful ideas came out of last weekend's writers' seminar with our panel of educators and psychologists," wrote Jerry Juhl in a follow-up memo, dated July 20. And indeed, within two days of the meeting, changes inspired by the seminar were being made to *Fraggle Rock*'s upcoming episodes.

It was agreed that the stories that took place within Fraggle Rock needed to parallel the Doc and Sprocket segments more clearly. The wrap-up segment at the end of the show "should illuminate or at least underline the basic point of the program," said Juhl. Doc should also be made "more real"—that is, he could still be eccentric, and should be funny, but needed to be a more competent scientist, at times showing a genuine gift for invention. This would be an abrupt change for Doc, but Juhl believed it was more important to optimize the character than worry about explaining a transition in personality.

An even bigger change was applied to Sprocket when it was decided he should be a stronger conduit between the reality of the workshop and the fantasy of Fraggle Rock. To this end, Gobo and Sprocket would strike up a friendship, a development that demonstrated the show's ability to change and evolve. "If we can show no shift in the attitudes of Sprocket toward Gobo,

BOTTOM Richard Hunt and Rob Mills with Junior Gorg.

I will certainly be experimenting with Doc and Sprocket scenes in the coming weeks, and will pass on any positive results to you at once. Meanwhile, I invite any of the writers currently at work on a script to look at his/her Doc scenes and try a hand at this new approach if you wish.

This change may make future Doc scenes seem very different from the ones in the past - indeed, we will be redrawing the character in a rather major way. There seems no way to make a transition between the two characters, but we believe it is better to make the change anyway, disregarding the break in continuity.

SPROCKET - We feel that Sprocket needs to become our transition figure between reality and fantasy much more clearly than he now is. To do this, we propose to allow a relationship - and eventually a friendship - to develop between Sprocket and Gobo.

This move is part of a larger thought which was discussed at much length during the seminar: The concept of the program should be allowed to change and evolve as it progresses. In fact, if we can show no shift in the attitudes of Sprocket towards Gobo, or the Fraggles toward the Gorgs, (to name but two examples) then it will become increasingly difficult to explore our themes of interdependence.

Unlike the change with Doc, Sprocket and Gobo's discovery of common interests makes quite a logical and an interesting idea for a story. Look for it to appear in the next set of 12 scripts, and be thinking about the potential of these two characters as they get to know and trust each other. Think of Sprocket as the pivot between fantasy and reality.

THE DOOZERS - Lots of worry here about the plastic look of the edible Doozer Constructions, in that it could encourage very young children to have their building blocks for lunch. We are thinking about a story in which some Doozer changes the formula for Doozer sticks, thus allowing for a change in the design of the things to make them more clearly gingerbread-like. They should look like food - they should **be** food.

THE TRASH HEAP - A number of changes here - We are retracing our steps. Marjory as a magical figure does not seem to be working, and we are returning again to the idea that the Trash Heap is a dotty, kindly old lady - like the great-aunt you might have had when you were four who filled you with awe.

We are also considering moving Marjory from her present position behind the Gorg's castle to a spot right near the entrance to the rock. In this way the Fraggles can have passing encounters with her as they cross into the garden, relieving us of the device of always having to go and ask the Trash Heap for advice. In this way she can sometimes offer advice when it isn't asked for. Or the Fraggles and the Heap can have conversations that do not

July 20, 1983

TO: Jocelyn Stevenson, David Young, bp Nichol, Carol Bolt, Dennis Lee, Laura Phillips, Sugith Varughese, Nika Relski, John Pattison, Susan Juhl

CC: Jim Henson, Diana Birkenfield, Larry Mirkin, Duncan Kenworthy, Martin Baker, Michael Frith, Jane Leventhal, Louse Gikow

FROM: Jerry Juhl

RE: Changes in Fraggle Rock

Many useful ideas came out of last weekend's writers' seminar with our panel of educators and psychologists. In the next few weeks we will be comparing notes among several of us and putting together a document that summarizes the discussion.

A few decisions were made during that seminar which will change the look of Fraggle Rock, and some of these changes should be reflected in the show fairly soon. The purpose of this memo is to make us all aware of these changes and how they will come about.

DOC - It was unanimously agreed that the Doc and Sprocket scenes in the show are not working in terms of illuminating the themes of shows. It was decided to make Doc much more real, that is, more believably of this world. While maintaining his eccentricities, we should also show him to be competent, and at times, genuinely gifted. Doc should not only be capable of inventing an automatic dogfood dispenser, but also of producing a toilet valve that saves a gallon a flush. And he should have an abiding interest in ecologies, interdependencies, interrelationships - the same things that the show itself is interested in. The little plots that evolve in the workshop during the show should more carefully parallel what is happening in Fraggle Rock, so that at the end of the show Doc can make a comment to Sprocket that illuminates or at least underlines the basic point of the program. I certainly hope that Doc will continue, despite all this, to be entertaining. (Carol Bolt has suggested an interesting model for Doc - one that should be known to those of you who have spent time in England - Magnus Pike. He is the BBC's science reporter. He is Doc's age. He has a total grasp of his subject matter, and a breath-taking enthusiasm. Pike believes that astro-mechanics is more fun than foreplay, and is therefore enlightening and very amusing at the same time.)

1

precisely turn on the necessity of asking for or receiving advice
at all.

This move will certainly be accomplished in terms of a story
which should be told fairly soon. And who knows what might
happen to a living Trash Heap when she is picked up and moved to
a new location. It might even change her accent.....

VOICES - We want to try to differentiate among the Gorgs,
Doozers, and Fraggles in any way that we can. Language is
obviously a common barrier between peoples, but for obvious
reasons all of our folks have to talk English. But we can modify
the English. For the Gorgs, Jim has proposed a return to that
battered, pseudo-Shakesperean syntax which he calls
"Foresoothian". And the Doozers, while on duty, should speak
TechTalk. Some interesting experimentation to be done here...

These are the changes we expect to make quite quickly - before
the first of the year. The change in the Trash Heap and the
Doozer constructions will take place in shows that will most
likely be written by Jocelyn or me. But ideas are gratefully
accepted from any source. Meanwhile, those writers who are
working on stories that use Doozers or the Trash Heap in major
ways should should check with me before continuing.

#

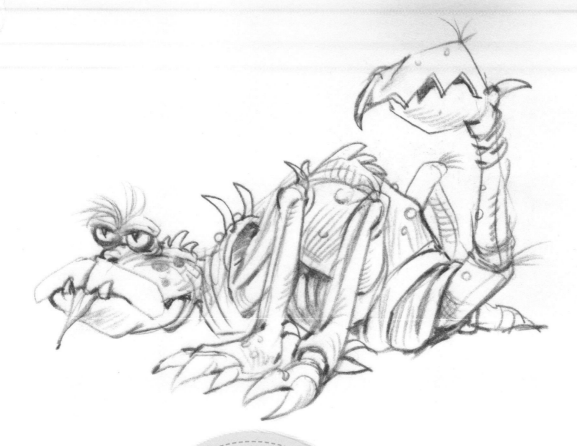

Unfortunately, Juhl was not thrilled with the pitches he received—including replacing the Doozer constructions with gingerbread houses.

or the Fraggles toward the Gorgs," wrote Juhl, "then it will become increasingly difficult to explore our themes of interrelationships." Juhl was particularly excited about the potential of stories that revolved around these characters getting to know and trust each other.

Other discussions about Season 2 were more focused on design and logistics. It was decided to move the Trash Heap, situated behind the Gorg's castle in Season 1, to a spot closer to the Rock's garden entrance. This would allow encounters with Marjory that didn't require a pilgrimage to ask her advice, and free the character up to offer unsolicited advice or just chitchat. Marjory's change of location would be explained in the third episode of the season, Juhl's "The Trash Heap Doesn't Live Here Anymore," in which Junior decides to build a gazebo in her original spot.

It was also decided there needed to be a better differentiation between the voices of the Fraggles, the Doozers, and the Gorgs. Henson felt the best approach to achieving this would be in their language. "For the Gorgs, Jim has proposed a return to that battered, pseudo-Shakespearean syntax which he calls 'Foresoothian,'" wrote Juhl. The Doozers should speak more "TechTalk."

In addition, the educators' seminar raised concerns about the Doozer constructions. Some in attendance felt that the plastic appearance of the edible Doozersticks might encourage small children to eat similar-looking pieces from their toy boxes. Juhl sought new ideas from the team on how they could alter the appearance of the Doozersticks so that they looked more like food. Unfortunately, Juhl was not thrilled with the pitches he received—including replacing the Doozer constructions with gingerbread houses or using brick-shaped slabs that resembled cake—feeling they would be "kitschy and kidsy" and clash with the established Doozer aesthetic. Juhl added that these changes would wreak "almighty havoc with the budget." Ultimately, he decided that the best fix was to just keep reinforcing the idea through the scripts that the sticks were made from radishes and therefore not something you could find in your own home.

After he had more time to digest what came from the seminar, Juhl communicated to the team that while all the suggestions by the educators and psychologists were appreciated, the production should not go overboard applying their thoughts. Juhl was worried that in trying to please everyone they might end up making the show bland and unimaginative. "I would rather err in other ways," he wrote in a follow-up memo.

TOP Michael K. Frith concept for a Poison Cackler, as seen in the season 2 episode, "The Wizard of Fraggle Rock."

INSERT Jerry Juhl's notes on the education seminar that led to a number of changes to *Fraggle Rock* going into season 2.

THE WRITE IDEAS

THE EDUCATORS' SEMINAR GAVE THE writers something to chew on, but Jocelyn Stevenson is quick to point out that the stories for Season 2 came not from an overall master plan, but simply by feel. "We didn't approach it in a 'story arc' kind of way," she says. "We did it by exploring relationships. Again, we didn't feel as if we were creating this—we still felt as though we were discovering it."

The writers wanted to add new facets to each character and give them the opportunity to grow, whether it was Boober coming to accept his need for solitude or Wembley taking steps to overcome his indecisiveness. Meanwhile, Doc acquired a part-time job doing chores for the unseen Ms. Betty Ardath, who opens the Captain's Inn bed-and-breakfast next door to the workshop. Juhl and Stevenson also wanted the stories to be guided by a growing interconnectivity between the species and the characters' physical exploration of Fraggle Rock itself.

These Season 2 changes would develop organically, particularly as the writers and performers knew the Fraggles and their world much better. "The characters really had a life of their own," says Stevenson. "It wasn't the writer or the performer, and in some ways not even a combination of the two—it was like something else! These characters had turned into beings that were just outside us all. That started to give the shows a type of momentum."

As production geared up, the writers came to Stevenson and Juhl with new story ideas. "You could go to Jerry or Jocelyn, and they would say, 'What do you want to do?'" recalls Laura Phillips. "I'd say, 'an anti-war story,' and they'd say, 'Cool, fine.' They didn't dictate. If you had a passion to do something, they got excited with you, and they let you do it."

It was necessary, however, to ensure a balance of genres and moods, and so the writers were always asked to think, *What haven't we tried?* "If we've done an emotional story, then an adventure, let's do a farce now, or a mystery," says Larry Mirkin. "We were motivated by curiosity about all sorts of things in their societies and about the characters. We didn't want to repeat ourselves, obviously. It also depended on the individual writers, and what interested them. There was no calculated plan in mind."

Producer Larry Mirkin continued to encourage the writers and puppeteers to interact, with his overall objective of having the "best idea win." "We would challenge one another to serve this bigger idea of the show," he says. "The collaboration was extraordinary." In one example of Mirkin's philosophy bearing fruit, Dave Goelz persuaded Jerry Juhl and Jocelyn Stevenson that, in Season 2, Boober should develop a cooking obsession. "It just helped to make him even more interesting and entertaining," says Goelz. "It was his way of transcending his fears. He was terribly worried about life, but then, if he could make a nice bisque, it helped him forget for a while. I think that's, in a way, how we get through life. If we thought about what was ultimately going to happen to us, we might be crippled."

Goelz was always seeking ways to bring new aspects to Boober's personality, which gave Stevenson an idea. "Jocelyn thought it would be good to see the fun side of Boober," says Goelz, "which might have had something to do with me feeling that Boober's negativism was very limiting. So she came up with this idea of 'Sidebottom,' the fun *side* of Boober that he keeps on the *bottom*."

At first, Sidebottom appears only in Boober's dreams, as a joyous and free-spirited alter ego who tells jokes, sings, and dances. "The only way for Sidebottom to exist would be in Boober's subconscious," says Stevenson, "and the most understandable access to that is through dreams. Children understand the dream world."

Because Sidebottom is disturbing his sleep, Boober consults the Trash Heap, who tells him he can either learn to live with Sidebottom or just stay awake. She advises him to bring along his friends—it's revealed that Fraggles can share dreams—and get another opinion of Sidebottom. To Boober's dismay, the other

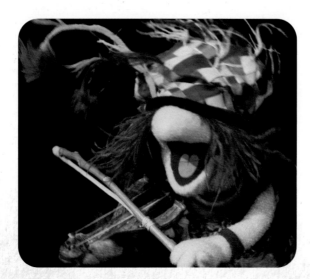

BOTTOM Sidebottom, Boober's raucous alter ego, singing "Everybody's Doin' It" in his first appearance, the season 2 episode "Boober's Dream."

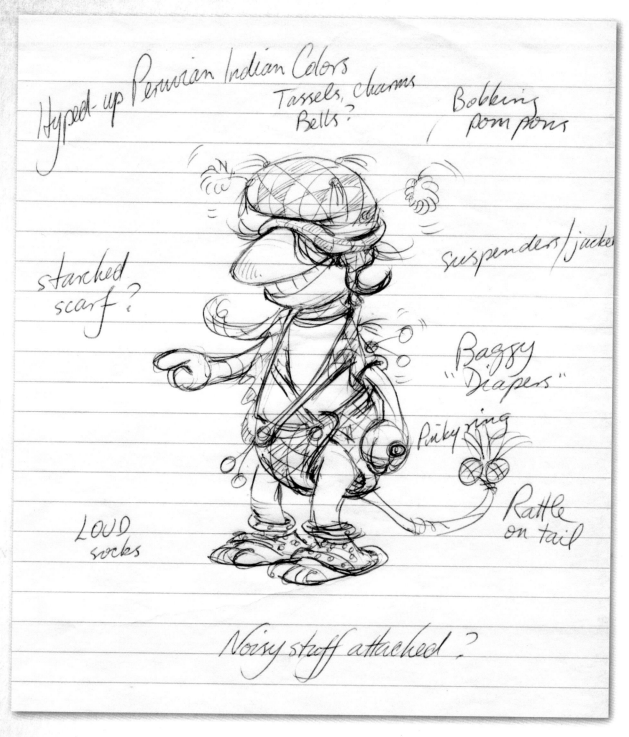

Hyped-up Peruvian Indian Colors
Tassels, charms
Bells?

Bobbing
pom pons

starched
scarf?

suspenders/jacket

Baggy
"Diapers"

Pinky ring

LOUD
socks

Rattle
on tail

Noisy stuff attached?

Fraggles are delighted to meet his fun side. But Sidebottom loves having them around so much that he doesn't want to let them leave the dream. "Eventually, we see a slightly dark side of Sidebottom," says Goelz. "Sidebottom's so anxious to have company, he goes too far and freezes Boober's friends. This compulsive nature is common to both Boober and Sidebottom." Boober gets Sidebottom to release them, realizing that he had control over this other side of himself all the time. "Sidebottom was a good way to introduce the idea that every person has different sides to him or herself," says Stevenson.

Sidebottom promises to stay out of Boober's dreams if Boober will allow him "to break loose now and then." Boober agrees, but makes Sidebottom promise not to be *too* much fun in front of his friends. "Boober is such an interesting character," says Stevenson, "and Dave is such an interesting performer. He just loved Sidebottom. It opened up who Boober was for all of us."

Goelz's favorite Sidebottom story came later in the season. "'Boober's Quiet Day' is where Sidebottom convinces Boober to act with freedom and enjoy," says Goelz. "And for a moment Boober is able to do it. He even kind of likes it.

"[Sidebottom] was a huge idea, about becoming a whole person," Goelz continues. "This is what the Muppets are. They're really representing humans, but they're cloaked in abstract costumes. You don't know what they are, but it doesn't matter because they're us. And *Fraggle* was like that. It was really all about human beings trying to get along in the world."

TOP Initial concept art for Sidebottom by Michael K. Frith.

SECOND (SEASON) CHANCES

AS THE STORIES FOR SEASON 2 STARTED to come together, Michael K. Frith designed the new characters and settings and provided his concepts to the puppet builders and set designers. Although there was a strong focus on the new elements being added to the show, at the same time each department was looking to fix anything problematic from the previous season, whether it was a costume or an electromechanical element.

The puppeteers were also focused on making improvements to their performances before cameras rolled on Season 2. In particular, Kathryn Mullen was still grappling with keeping her head out of the shots when performing Mokey and was hoping to fix the issue before the shoot. "Mokey is tall, and I have short arms," she explains. "And, as with most puppeteers, I had hesitated to ask for something that would make my life easier!"

The solution proved to be a simple change in wardrobe: Mokey's sweater/robe was redesigned to have deep raglan sleeves that continued in one piece up to the neck. "I could get my head behind the robe," says Mullen, "And that was very helpful with camouflaging so that I could actually get up into a shot." Hidden behind the big sleeves, Mullen could lift her entire head into the camera's line of sight if she needed to, and no one would ever know. "Once I had the longer sweater," she says, "life became a lot easier and I ruined a lot fewer shots."

Bigger changes, both visual and mechanical, were made to the Ma Gorg puppet.

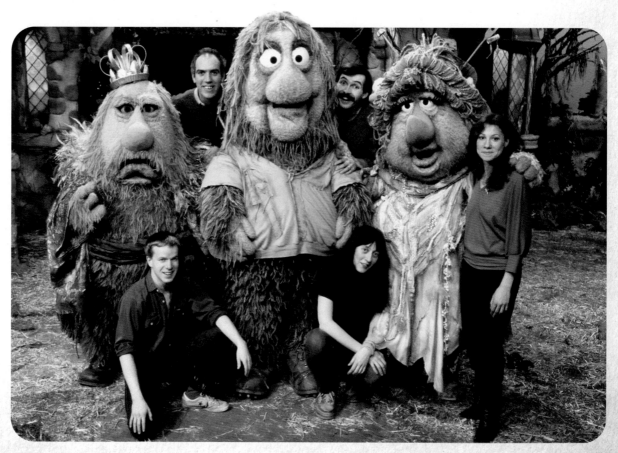

BOTTOM (Left to right) Pa Gorg, Gord Robertson, Richard Hunt, Junior Gorg, Rob Mills, Myra Fried, Ma Gorg, Trish Leeper, taken during the first season of *Fraggle Rock*.

During the first season, the radio-controlled curtain of hair over Ma's eyes and mouth had not performed as well as expected, and the creative team felt that it was limiting the character's personality. Originally Frith's idea, the curtain "was better in theory than in practice," he admits. "So I gave her a new 'do,' sweeping her hair up off her face in a nice big bird's nest on top."

Once Ma's hair was no longer obscuring her face, Tim Miller reconstructed the puppet's nose, inserting radio-controlled mechanisms that allowed it to be maneuvered in more expressive ways. He also remodeled the character's mouth with flexible latex tubing for better movement, and the puppet was given radio-controlled eyelids that could be raised and lowered with the flick of a switch. "Ma always looked so unhappy in the first season, and there was no way she could smile," says puppet builder Connie Peterson. "With the changes, she was more sympathetic, even though she was supposed to be grumpy."

In addition, costumer Polly Smith revised the puppet's outfit, dressing it in layers of lace over a lilac-colored dress and discarding her crown. "When you change the face, you change the personality," Smith explains, "and so the costume should change as well." Inspired by Frith's new design for Ma's hair, Smith also added two large wooden knitting needles, arranged to resemble the *kanzashi* worn by geishas.

"Suddenly, Ma appeared to be almost coquettish," says Jocelyn Stevenson, "and this opened up all sorts of story possibilities."

Ma Gorg was also assigned a new head/voice performer in Season 2, Cheryl Wagner, who had been performing the right hand for Cantus the Minstrel and Convincing John. When they started working together, Wagner and Ma's body performer, Trish Leeper, discussed ways to improve the character. "Ma considered the Fraggles as vermin," says Leeper, "infesting her garden and probably carrying diseases, so it was a lot of 'Ah!' 'Eek!' 'A Fraggle!' Then Pa and Junior would run after them." Leeper and Wagner began to wonder if Ma Gorg was becoming a two-dimensional character, because that was pretty much all she did.

"But, the wonderful thing about working on *Fraggle Rock* was that not only did people welcome your input, they encouraged it," Leeper continues. "I remember the three of us Gorgs talking with Jerry Juhl about physical comedy. For example, Laurel and Hardy. You have the smart guy and the not-so-smart guy. Of course they get in trouble, but what usually drives that is what's called a 'ringmaster'—the boss, the wife, the person they're responsible to." From then on, it was agreed that Ma would no longer be a scared, nagging wife, but the head of the Gorg family and a force to be reckoned with.

For Season 2, all three Gorgs received a major upgrade to the optical system that gave the puppeteers a clear view when performing inside the characters. Because the helmet-like apparatus used during Season 1 would frequently shift

while being worn by the puppeteer, displacing the eyepiece, Gorg performers Rob Mills, Gord Robertson, and Trish Leeper suggested attaching a mask to the headpiece. The mask would fit onto the face of the performer, increasing the headpiece's stability and preventing the eyepiece from shifting.

Special effects director Faz Fazakas also replaced the fiber-optic system used in Season 1 with a very small black-and-white television-type camera at the Gorgs' eye level that connected to a home video camera's viewfinder mounted onto the mask. The mechanics were informally referred to as "Gorg Vision." The image this system projected was an undistorted Gorg's-eye view of the world and enabled the puppeteers to have proper depth perception. "We could finally see!" says Mills. "Of course, it added more weight to the heads, but it was worth it."

"Suddenly, Ma appeared to be almost coquettish, and this opened up all sorts of story possibilities."
JOCELYN STEVENSON

TOP Jim Henson and Ma Gorg during shooting for the second season episode "A Friend in Need."

NEW CREATORS, NEW QUARTERS

SET DESIGNER BILL BEETON MOVED ON to new projects after the first season of *Fraggle Rock*, and another CBC veteran, Robert Hackborn, took over the role of set designer for Season 2. Hackborn had been with the CBC since the advent of television in the 1950s, working in all aspects of art direction, scenic design, and special visual effects for a wide variety of shows, including *Mister Rogers' Neighborhood*. He pioneered the use of glass-matte shots at the CBC, placing background scenes painted on glass in front of the camera to make sets look larger and more elaborate than they actually were. Hackborn's mastery of that kind of visual trickery made him a perfect fit for *Fraggle Rock*, with its intricate underground worlds.

Director Eric Till was another Canadian showbiz veteran who joined the crew in Season 2. Till had a long career directing movies, miniseries, and both adult and children's TV shows before landing at *Fraggle Rock*. Till admits that when he began directing episodes, he would give notes directly to the puppets. "But the puppeteers were very charming, and they just ignored me," he says. "The puppets would nod and respond, but it took me ages to overcome [doing] that." Till did feel there was "a wonderful humanity" to the creatures. "Before the director ever got on the set, the writers placed in the hearts and minds [of the characters] real human emotions that we

could absolutely reach out and touch. They were characters with warts, they had insecurities, all of which we all have. Theoretically, it was a children's show, but damned if I believed that it was anymore."

The new additions to the creative team weren't the only changes for Season 2. Mokey and Red became roommates in "A Cave of One's Own," by Jerry and Susan Juhl. "Let's move them in together and see what happens," says Karen Prell with a wink. "A story gold mine." Not surprisingly, their shared domesticity turns into a disaster as Red fills their new cave with her trophies, sports equipment, hair ribbons, costumes, and more, exasperating the fastidious Mokey. "They were very tight friends, even though they were polar opposites," says Frith.

Frith's design for the Red-and-Mokey cave included ample space for the puppeteers to work. Frith envisioned that Red would sleep in a hammock set beside the back wall, giving Karen Prell the option of operating her through the wall or through the hammock. "Mokey was lower, on her bed of cushions," says Frith, "where she could sit and lie and meditate on the floor quietly, with the puppeteer working Mokey from beneath." Frith gave the room an assortment of windows and other openings in the wall, to allow characters to lean through and interact with Red and Mokey. One window also allowed Mokey to catapult Red into the swimming hole, ending their biggest argument in "A Cave of One's Own"!

The episode also introduced one of Season 2's new characters: Lanford, Mokey's fanged, carnivorous plant that shows a strange hostility toward Red. Lanford was performed by Rob Mills. "Of course, when [Mokey] was dealing with Lanford, it would be all

BOTTOM Mokey and Red move into their own cave in "A Room of One's Own."

OPPOSITE TOP A tranquil moment between roommates Mokey and Red in concept art by Michael K. Frith.

OPPOSITE BOTTOM Lanford, Mokey's pet plant.

INSERT Karen Prell's sketches and notes regarding Red and Mokey's cave.

> "The writers placed in the hearts and minds [of the characters] real human emotions that we could absolutely reach out and touch."
> **ERIC TILL**

Red & Mother's Room - Exterior

Has balcony — puppets stand below and enter from underneath. Pod-shaped room wrapped in your basic quaint fairy tale roots & vines for a different look.

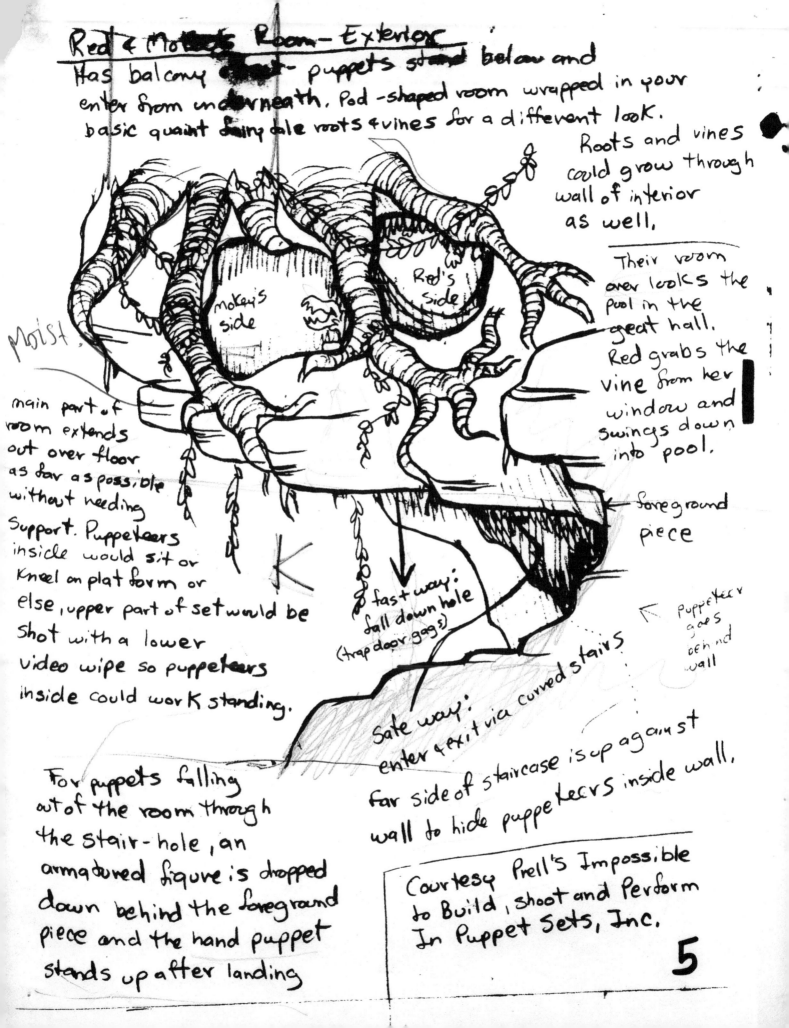

Roots and vines could grow through wall of interior as well.

Moist.

Their room overlooks the pool in the great hall. Red grabs the vine from her window and swings down into pool.

Moker's side

Red's side

main part of room extends out over floor as far as possible without needing support. Puppeteers inside would sit or kneel on platform or else, upper part of set would be shot with a lower video wipe so puppeteers inside could work standing.

foreground piece

fast way: fall down hole (trapdoor gags)

Puppeteer goes behind wall

Safe way: enter & exit via curved stairs

far side of staircase is up against wall to hide puppeteers inside wall.

For puppets falling out of the room through the stair-hole, an armatured figure is dropped down behind the foreground piece and the hand puppet stands up after landing

Courtesy Prell's Impossible to Build, Shoot and Perform In Puppet Sets, Inc.

5

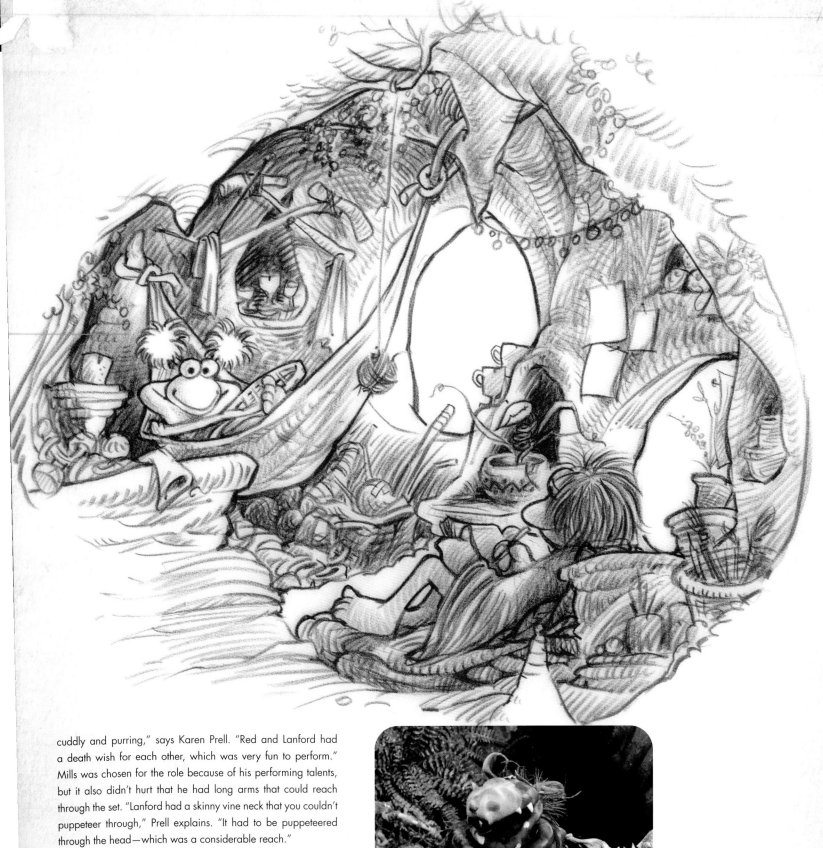

cuddly and purring," says Karen Prell. "Red and Lanford had a death wish for each other, which was very fun to perform." Mills was chosen for the role because of his performing talents, but it also didn't hurt that he had long arms that could reach through the set. "Lanford had a skinny vine neck that you couldn't puppeteer through," Prell explains. "It had to be puppeteered through the head—which was a considerable reach."

These kinds of challenges—involving everything from character dynamics to puppet choreography—awaited anybody who signed on to *Fraggle Rock*. It's also what made the show so fun to work on, because conquering those challenges could be so satisfying. Eric Till would sometimes quote the great Hollywood director Elia Kazan when asked what it took to do such a complicated job. In a word: "Patience."

DOOZERVILLE

AS SEASON 2 PROGRESSED, *FRAGGLE ROCK* paid its first visit to the Doozers' home, a development that gave some much-needed insight into the little creatures' culture. "For the second season, it was decided that we wanted to learn more about the Doozers," says Jocelyn Stevenson. "We wanted to find out who they were as characters." Doozers work in the caves and chambers of Fraggle Rock, but they live behind its walls in a place called the Doozer Dome. There, the Doozers can actually relax, discarding their tools and swapping their helmets for hats featuring colorful flowers and feathers. At the Doozer Dome, families spanning several generations can unwind on grassy lawns, or sit on benches and unwind under large shady mushrooms—they even fish in a splashing fountain in the center of town.

"I wanted to develop this sense of urban life," Frith says. When designing the Doozers' home he played with several ideas; one early concept saw the Doozers living in cliff dwellings. "Then the idea of it expanded into a whole city," he remembers. "They would live inside giant geodes. The outside walls would be rough and stony, but the interior [of the Dome] would be highly polished and gleaming." For the interior areas of the city, Frith sketched a world that mixed the luxurious style of art deco with the streamlined efficiency of modern industrial design.

Frith imagined that the inside of the Doozers' individual

dwellings would resemble the style of a house in a 1950s sitcom. "Mom is making dinner, all the kids are around the table, and Dad's putting on his work boots," he explains. "But, of course, when they go outside, Mom is equal to Dad in the workforce." Jerry Juhl liked this overall style, and extrapolated that the Doozers' homes should be little bungalows, with chrome and Formica dinettes, and courtyards for barbecues. There would be gardens filled with glass flowers to tend, and places to play. He imagined the interior of the homes would be small and cozy, befitting the diminutive, lovable Doozers.

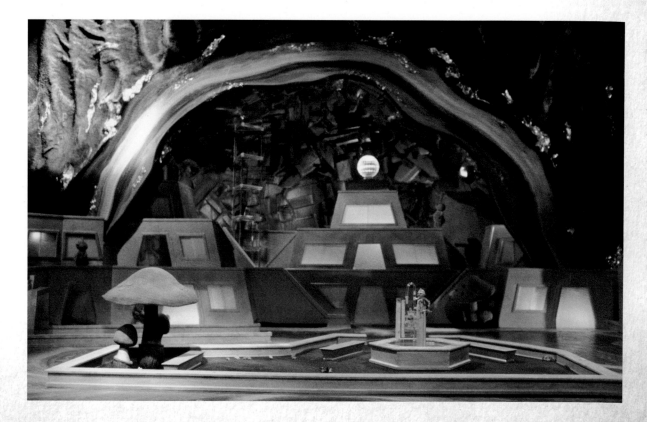

BOTTOM The Doozer Dome set.

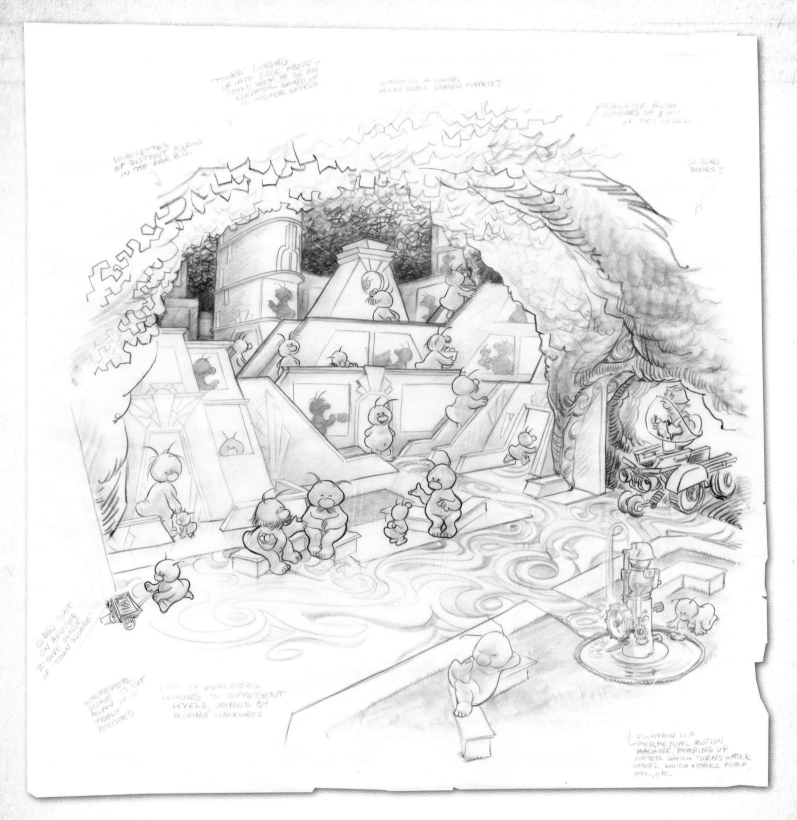

Robert Hackborn took both Frith's and Juhl's concepts for the Doozers' homes and fashioned them into the Doozer Dome set, which consisted of a city of flat-topped, four-sided pyramid structures stacked upon each other and housed within a naturally occurring geode. Ramps and escalators would transport Doozers between the different levels.

Faz Fazakas and his special effects team built the Doozer constructions for Season 1 based on Frith's concept art. As Season 2 began production, they were encouraged to add their own ideas to the Doozers' world, a task that they took to heart. Larry Mirkin was surprised to learn that the special effects crew even had names for the characters, "before *we* had names for characters. They had a whole drama going on among the Doozers in the background while we were doing a show about something completely different. I think that's why there's all that life in the background—they were highly inventive people. They all knew that they were there to serve the script and idea of *Fraggle Rock*, but within that, they wanted to give viewers the best they could."

TOP Doozer City color rendering by Michael K. Frith showcases both the Doozers and their architecture. Frith would often write his ideas for the builders or writers on his sketches, and "sometimes," he jokes, "they may have read them."

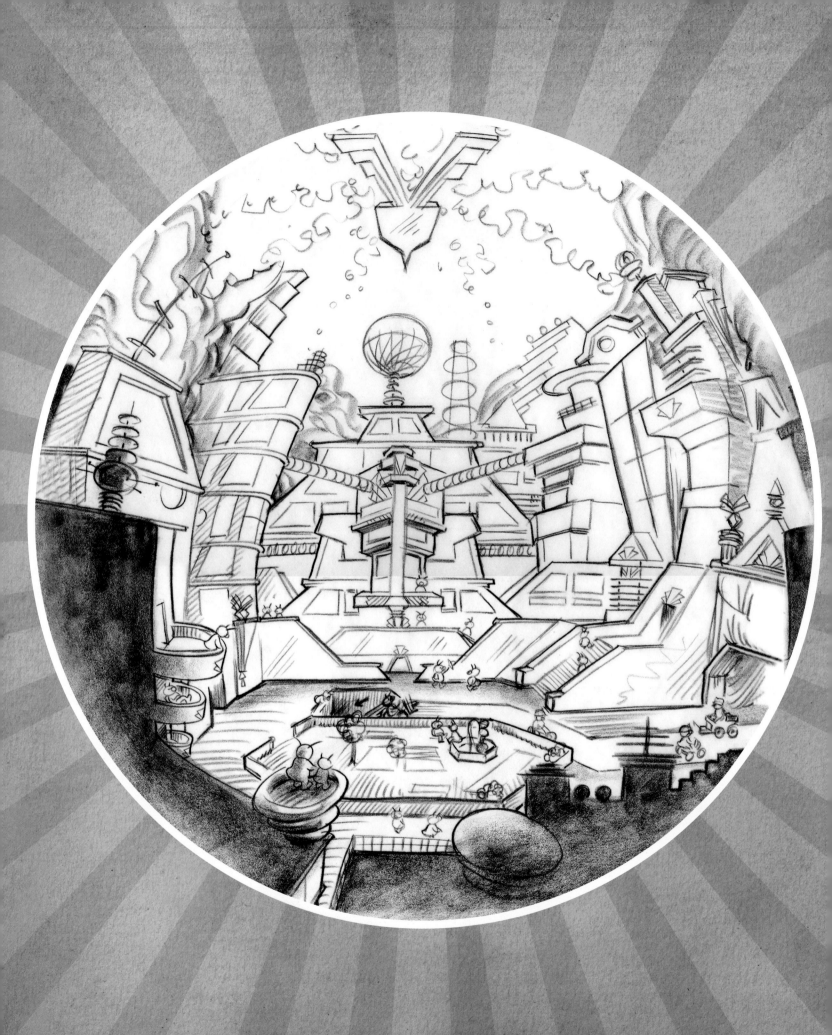

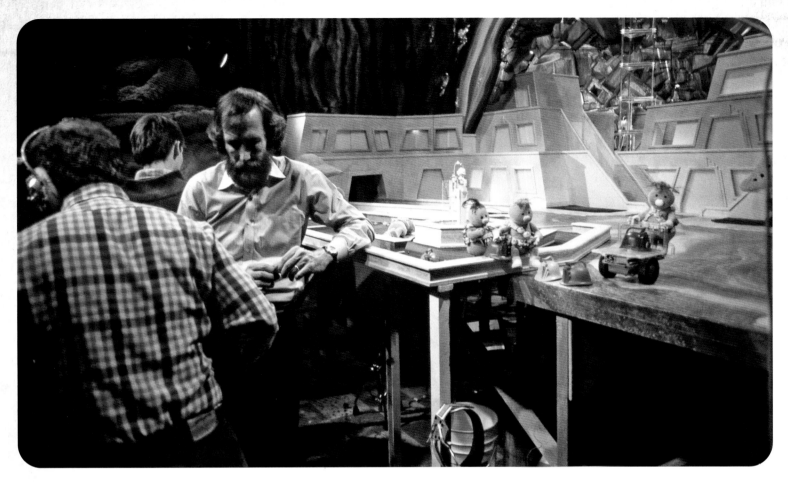

"Wembley and Gobo would be having a conversation while walking through a tunnel, and they would pass a Doozer construction," says *Fraggle Rock* electromechanical wizard Tom Newby. "The site and the work going on there would have its own storyline—this allowed us to create a sense that there was something going on that you weren't really watching in this show. The Doozers might have just finished building a bridge or a tower, and those two would casually, without thinking, smash into it on their way, because that's just what Fraggles do." If the characters were to return through the tunnel later in the episode, the special effects crew would rework the set to show the Doozers rebuilding the damaged structure.

In order to get quickly from job to job by foot or by truck, the Doozers travel spiraling highways. Faz Fazakas gave the job of assembling these to Dick Loveless, who had worked on the TV special *Rocky Mountain Holiday with John Denver and the Muppets*. "The Doozers would drive these beautifully crafted, remote-controlled cars on these elevated roads all over the set, sweeping high up into the air," remembers Karen Prell. "They looked beautiful, but they didn't have any guardrails." As the Doozer vehicles traveled along the roadway, a crew member would need to walk beneath, below camera height, ready to catch any falling cars, because "once in a while," says Prell, "one would take a dive off."

Season 2 also saw a new assistant join the Doozer build team: the then-19-year-old Brian Henson. Despite being the boss's son,

WATERWHEEL - POWER STATION AND
ELEVATOR LEADING TO DOOZER LAND

he would get his hands dirty with everyone else, fussing with tiny motors and little strings and rods to keep the puppets moving through shots. "I was pretty good with that sort of thing," he recalls, adding with a laugh, "I was real young." When working on the Doozer Dome and other elements of the tiny creatures' world, the special effects team sometimes worked long nights until they reached what they called the "Doozer dawn." "But it was worth it," Tom Newby says.

OPPOSITE Concept art of Doozer City by Michael K. Frith, described on the paper as "a gleaming, modern metropolis inside a giant, polished geode." This art was created for a Doozers animated show pitch in the early 1990s.

TOP Jim Henson next to the Doozer Dome set while filming the season 2 episode "All Work and All Play."

ABOVE A 1982 design sketch of the Doozers' home base by Tom Newby. The illustration portrays a waterwheel-driven power station and an elevator ascending to Doozer quarters.

DOOZERS AT WORK

THE DOOZERS' LARGER ROLE IN SEASON 2 extended beyond their increased background presence. A number of the new episodes would focus on specific Doozer characters, including the least Doozerish of the Doozers: Cotterpin. Up until the Season 2 episode "All Work and All Play," by Jerry Juhl, Doozers were portrayed like worker bees. Cotterpin would break the mold: Unlike her compatriots, she doesn't want to build Doozer constructions; she wants to play and sing and make art. Nevertheless, she tries to stick with tradition and participate in the ceremony where, like other young Doozers, she'll "take the helmet" and become a worker. As the ceremony concludes, Cotterpin decides that she cannot go through with it. "She wants to have her own life, she wants to do her own thing," says Kathryn Mullen. "She's supposed to be going for her helmet, which means she'll be like everybody else. So she breaks out."

The vows taken by the Doozers at the "ceremony of the helmet" are conducted by the Architect Doozer, a leader of the community. These oaths are not spoken but sung, in the infectious tune "Yes, We Can," accompanied by a Doozer pipe-organ player. The chorus repeats—endlessly—with variations on the lyric "yes, we can": *yes, we can; yes, we really, really can.* "I consider it a mark of success if a listener becomes infected with an earworm," says Phil Balsam. "Many

of the people in the show came down with this disorder while recording it, including myself. But I think the Henson Company had health insurance for that!"

Later, after a failed stint trying to be a Fraggle, Cotterpin confides in the Architect, who reveals that, historically, there have been many Doozers who've refused to take the helmet, including himself. She discovers there are Doozers who "take the drawing board," and so Cotterpin becomes the Architect's apprentice.

BOTTOM Visual development art of Cotterpin Doozer and her family around the table, created for a proposed 1990s Doozer animated series.

OPPOSITE Jim Henson on set at the Doozer Dome with the Wingnut Doozer puppet.

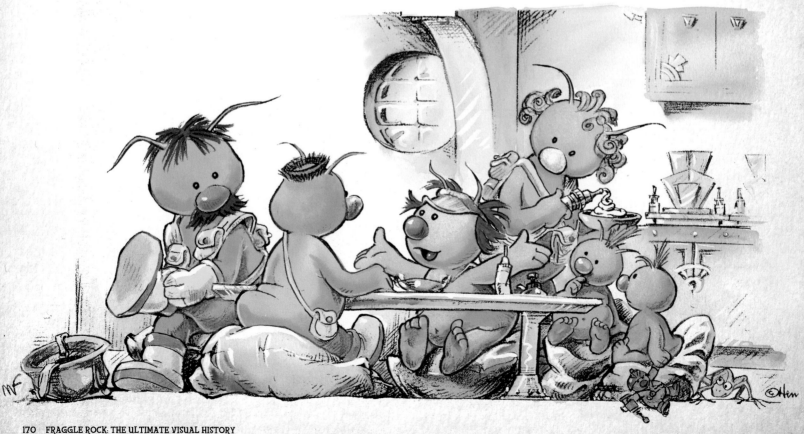

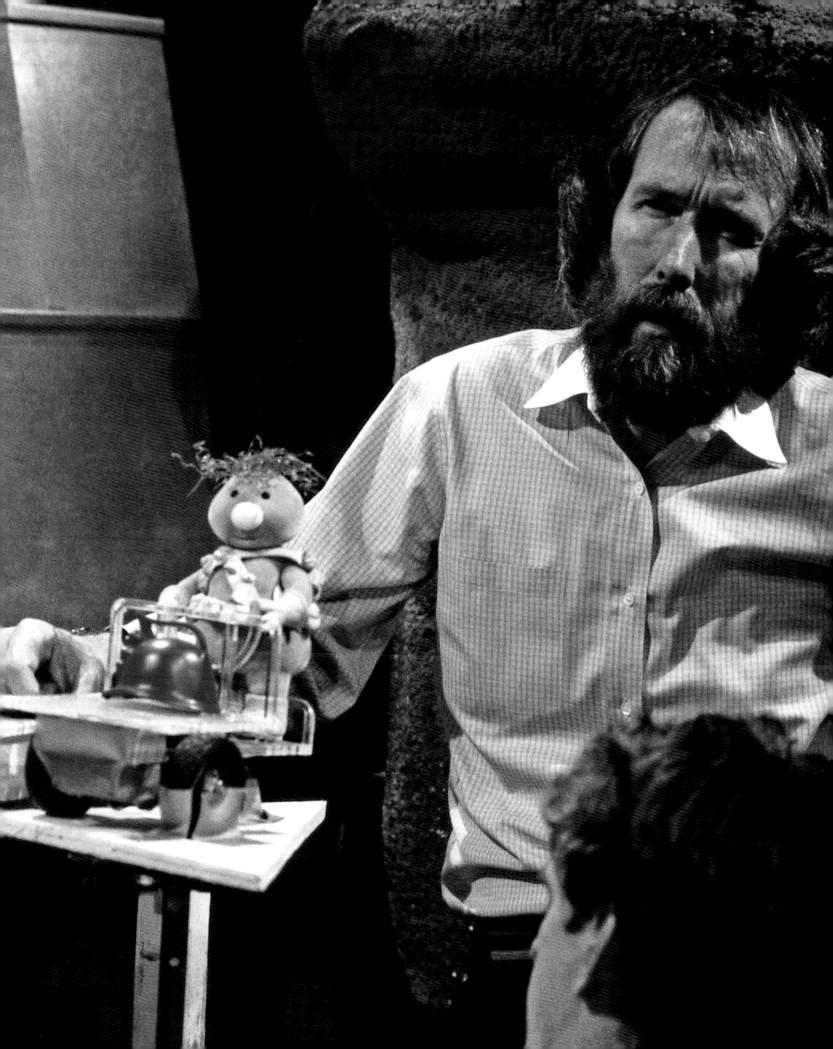

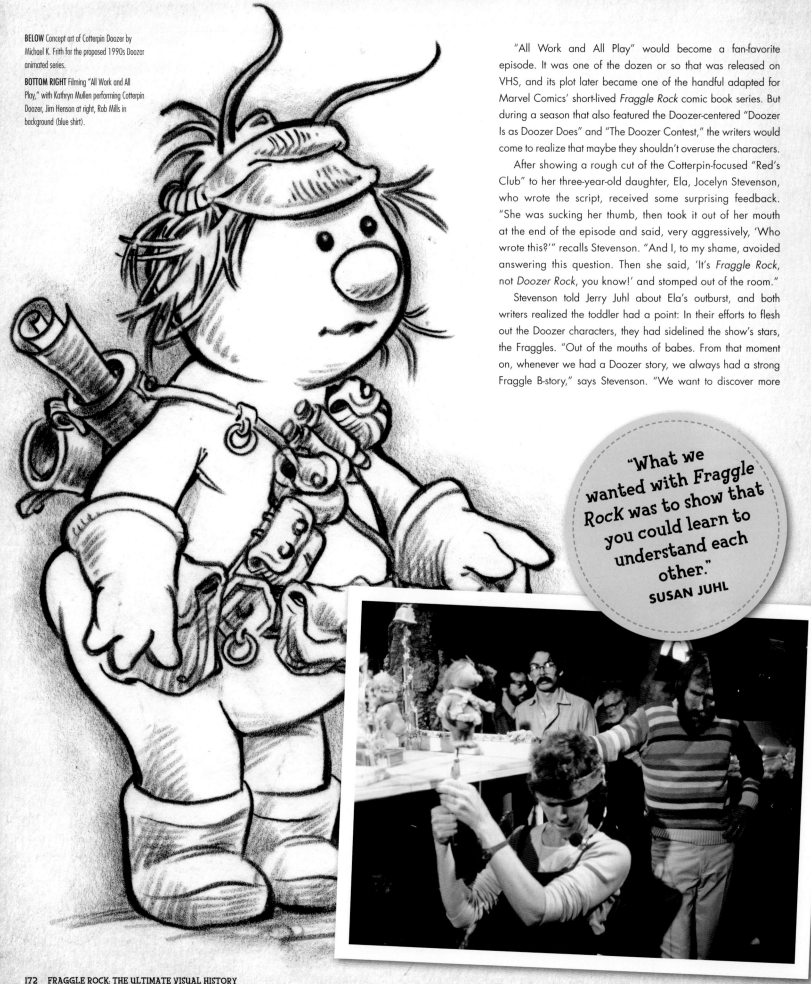

BELOW Concept art of Cotterpin Doozer by Michael K. Frith for the proposed 1990s Doozer animated series.

BOTTOM RIGHT Filming "All Work and All Play," with Kathryn Mullen performing Cotterpin Doozer, Jim Henson at right, Rob Mills in background (blue shirt).

"All Work and All Play" would become a fan-favorite episode. It was one of the dozen or so that was released on VHS, and its plot later became one of the handful adapted for Marvel Comics' short-lived *Fraggle Rock* comic book series. But during a season that also featured the Doozer-centered "Doozer Is as Doozer Does" and "The Doozer Contest," the writers would come to realize that maybe they shouldn't overuse the characters.

After showing a rough cut of the Cotterpin-focused "Red's Club" to her three-year-old daughter, Ela, Jocelyn Stevenson, who wrote the script, received some surprising feedback. "She was sucking her thumb, then took it out of her mouth at the end of the episode and said, very aggressively, 'Who wrote this?'" recalls Stevenson. "And I, to my shame, avoided answering this question. Then she said, 'It's *Fraggle Rock*, not *Doozer Rock*, you know!' and stomped out of the room."

Stevenson told Jerry Juhl about Ela's outburst, and both writers realized the toddler had a point: In their efforts to flesh out the Doozer characters, they had sidelined the show's stars, the Fraggles. "Out of the mouths of babes. From that moment on, whenever we had a Doozer story, we always had a strong Fraggle B-story," says Stevenson. "We want to discover more

> "What we wanted with Fraggle Rock was to show that you could learn to understand each other."
> **SUSAN JUHL**

about the others, but in a way so [that] we discover it via the Fraggles. So that was really good advice from a three-year-old."

The second season of Fraggle Rock was, in a lot of ways, defined by its new additions. Beyond the introductions of Sidebottom and Lanford, in Season 2 Gobo found a new tunnel into the Gorgs' castle, and while looking through Uncle Travelling Matt's old maps he discovered the Caves of Boredom (where Boober briefly moved, just to get some peace and quiet).

The writers also finally found an opportunity to introduce the Ditzies—first mentioned in the original Things We Know About lists—specks of light who are crucial to the Fraggles' existence: It's the Ditzies who light the caves and tunnels of the Rock. Though initially intended to be one of the show's main species, the microscopic Ditzies were featured in only one episode, "The Day the Music Died." Michael K. Frith, who dreamed up the characters, says that they didn't do much more with them because the little glowing specks were "really impossible to build and puppeteer." Ultimately, the team opted to bring the Ditzies to life via rudimentary video effects, superimposing the glow from a balled-up string of tiny lights into live-action scenes. Frith laughs, "Nowadays, with CGI, this would be a breeze."

Season 2's episodes premiered on HBO in January 1984 to good reviews and strong audience ratings. Looking back at those days, Susan Juhl recalls the fun everybody had: "We laughed, and we had lunches. That was very important. We saw a lot of our writers over a social situation. It wasn't just sitting there over a desk; it was something else so that they felt relaxed, and it really worked. And besides, it was fun." But more important, according to Juhl, they felt that they were

accomplishing their goal of teaching kids to be more tolerant. "What we wanted with Fraggle Rock was to show that you could learn to understand each other, and that by understanding each other you have a lot better life," she says. "Because if you help each other, then you have more fun. It's just a better way to live."

Momentum was building, and everyone was looking forward to more stories and discovering the next Thing They Would Know. After Season 2 wrapped on April 20, 1984, the production team took a short two-week break and began working on Season 3.

BOTTOM LEFT Polaroid inventory image of prototypes for the Ditzies characters made of tinsel and wire. The idea was ultimately discarded, and video effects were used instead.

BOTTOM RIGHT Photocopy of Michael K. Frith's costume design for "The Wizard of Fraggle Rock" hand-colored by builder Tim Miller during the puppet fabrication process in 1983.

SEASON 3: A CHANCE TO EXPERIMENT

BACK WHEN KAREN PRELL WAS STILL an apprentice on *The Muppet Show*, she typed up and shared with Richard Hunt a comical list of Laws of Muppeteering, modeled after the old Murphy's Law that "anything that can go wrong, will." Throughout the '80s, Prell's list would occasionally be read aloud at Henson Associates wrap parties, while her colleagues howled with laughter at wacky laws like "If the script is right, you're in the wrong studio" and "The amount of Steve or Kathy's head in the shot is proportionately equal to the excellence of a take."

ABOVE Concept art of the bass singer from the Ink Spots by Michael K. Frith for the third season episode "The Incredible Shrinking Mokey," 1985.

BOTTOM Two of the three Ink Spots, doo-wop backup singers and troublemakers.

OPPOSITE A scene from the snow-themed season 3 episode, "Blanket of Snow, Blanket of Woe."

But it's Prell's First Law of Muppeteering—"If it moves, upstage it"—that perhaps best describes the way collaboration worked on *Fraggle Rock*, especially in Season 3.

Consider the case of the Ink Spots: furry brown creatures who occasionally popped up in the background of musical numbers and other crowd shots, beginning in Season 3. The Ink Spots were introduced in part to give Gord Robertson, Rob Mills, and Trish Leeper something to do on set whenever the Gorgs weren't in a scene. While the Fraggles were singing, the Ink Spots would lip synch along to the words with such gusto that it was hard not to look past the stars and focus on the strange little creatures behind them.

This was the state of *Fraggle Rock* in its third year. Everybody was encouraged to believe they had something to contribute; and everyone was trying to squeeze all they could into every second of every episode.

Writer Jocelyn Stevenson also feels that *Fraggle Rock*'s third season was defined by the creative team's experimental approach to the new episodes. "We were comfortable with the world now," says Stevenson. "We had discovered a lot of things about it. We looked to take more risks with our ideas, really trying to see the range of stories we could tell, including stories you wouldn't be able to tell in any other series."

Producer Larry Mirkin adds that such risk-taking was possible only because of the trust shown by Jim Henson and the production's partners. "Not only did I never get any comments from Jim, I never got any comments from HBO or CBC, which nobody can believe," says Mirkin with a laugh. "We were very fortunate. There was a level of trust they gave to us that spoiled us all. We were left alone to do what we thought was right. Of course, we had a lot of internal discussions about actions or storylines, or what was the right thing to do, but it was left to us to do it."

This sense of freedom led the writers down some unusual creative avenues during the development of Season 3. "We had never done a show about illness, so we did 'Pebble Pox Blues,'" says Mirkin. "What would be the differences between humans and Fraggles when this happens?" In the story, written by Laura Phillips, Wembley catches the most contagious of Fraggle diseases and must be cared for by die-hard hypochondriac Boober. Pebble pox combines elements of measles, chicken pox, and hives, and gives Fraggles a tender tail, frizzled fur, and ticklish teeth, along with an itchy rash. "Illness seemed so very un-Fraggley," says Jocelyn Stevenson, "but we found a way to do it."

In "Red-Handed and the Invisible Thief," Red's radish bars keep disappearing, leading her to accuse her fellow Fraggles, including roommate Mokey, of the theft. "I thought, I'd like to do a mystery," says writer Robert Sandler. "But the

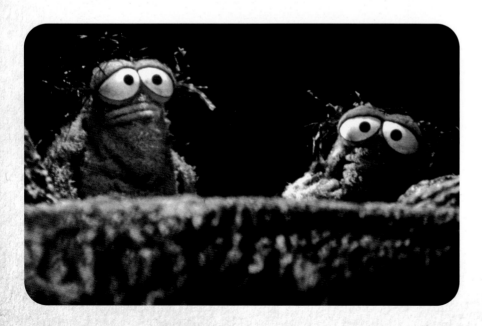

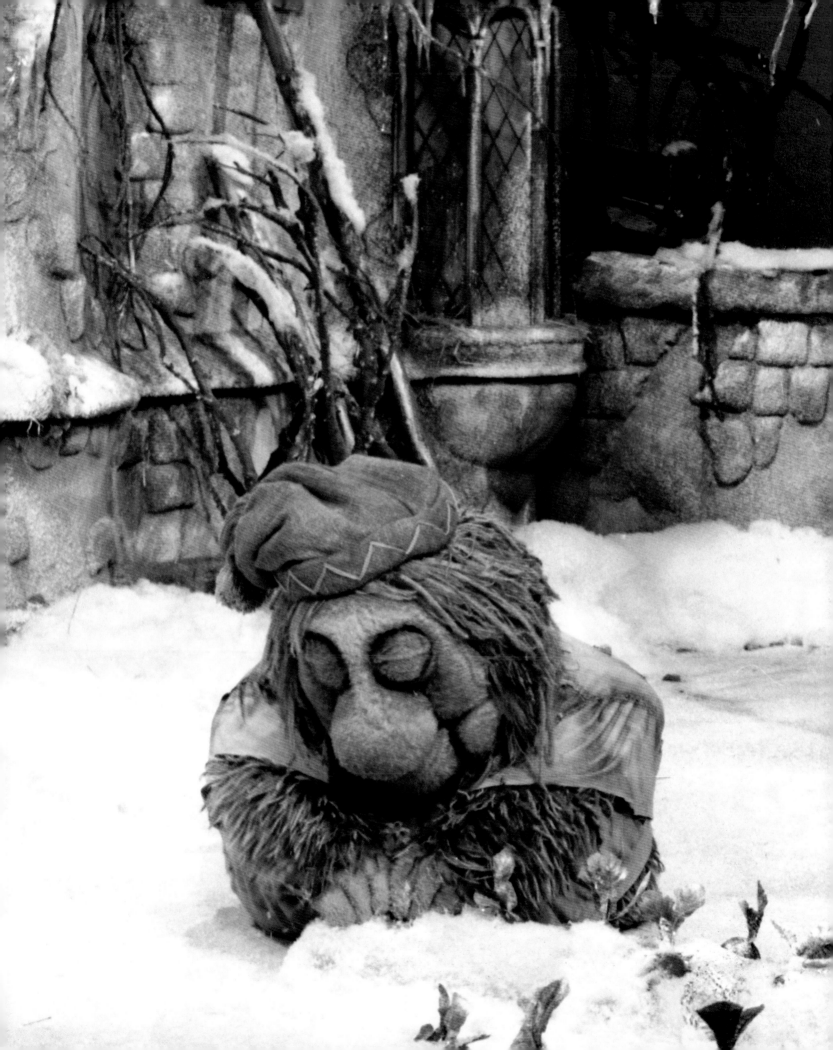

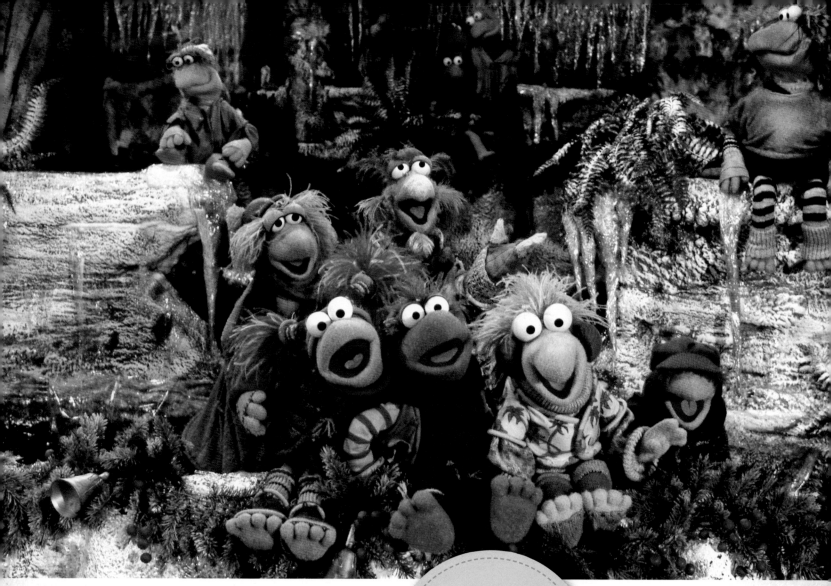

TOP The Fraggle Five and friends in winter wear for "The Bells of Fraggle Rock." After this episode, Mokey wore her scarf year-round.

ABOVE Concept for the wye wiggle creature, drawn by Michael K. Frith for a potential 1987 animated special called "Wembley and the Wye-Wiggle."

reason no one had done a real mystery [on the show] was because nobody is allowed to do bad things. It's very hard to have a mystery without someone doing something bad." Sandler needed to create a story that involved theft but sidestepped the immorality of stealing. The solution? It turns out that Red has been pilfering the radish bars in her sleep. The episode would go on to be nominated for an International Emmy.

One of the biggest creative risks taken by the writing team was to begin Season 3 with a holiday-themed episode, "The Bells of Fraggle Rock." When co-creators Jerry Juhl, Jocelyn Stevenson, and Michael K. Frith began the Things We Know About lists, they were conscious that the show needed to be designed for an international audience. The stories had to be as culturally neutral as possible and could not be aimed solely at American or British audiences. But, by Season 3, the writers were comfortable enough with the world they had created that they felt they could introduce a wintertime Fraggle holiday without jeopardizing the show's overall mission.

"Obviously, they would never celebrate Christmas, but

"The sweetness of ringing the bells and singing . . . It was really, really pretty."
KATHRYN MULLEN

Jerry and Susan Juhl and I wanted to do a Christmas-type celebration," Jocelyn Stevenson says. "We tried to stay away, as much as possible, from cultural references, but we had all decided it would be nice to have a holiday-type episode."

"The Bells of Fraggle Rock," written by Stevenson and Jerry and Susan Juhl, takes place at winter solstice, when the Fraggles celebrate the ancient Festival of the Bells. At this gathering, presided over by Cantus the Minstrel, every Fraggle must ring a bell in order to create vibrations that will rouse the mythical Great Bell at the heart of the Rock. If the Fraggles fail to ring the Great Bell, then Fraggle Rock and its inhabitants will freeze over. During the episode, Fraggles skate on a frozen pond and congregate around warming fires. Art director Diane Pollack gave the Rock a wintry makeover for the episode, with icicles dripping from the tunnel tops that, in the show, the Doozers work hard to remove. "All the sets were white," remembers Kathryn Mullen, "and [every character] wore hats and scarves, and adorable gloves."

Aside from its festive themes, "The Bells of Fraggle Rock" has

endured because of its heartwarming ending, which sees Gobo discovering that the real "heart of the Rock" is in the creatures who live there, who must make a joyful noise to spread the warmth that keeps them all alive. Mullen found the story—and the changes the craftspeople made to the usual costumes and sets—enchanting. "It was just beautiful, and it was sweet, too," she says. "The sweetness of ringing the bells and singing . . . It was really, really pretty."

Because of this episode's holiday theme—and how well the story was executed—even now "The Bells of Fraggle Rock" is replayed on TV around the world during the holiday season. Feeling empowered to take chances, the *Fraggle Rock* team produced a perennial television favorite.

Inspiration for a story can come from many sources. When writing the episode "Believe It or Not," Jocelyn Stevenson remembered a childhood game in which she would pretend there was a monster living in the basement of her family home. She extrapolated upon this idea to create the monster Skenfrith—named after a town in Wales and not Michael K. Frith—whose form is determined according to the way he is perceived by an observer. "If you thought of him as nice, he was nice," Stevenson explains. "But if you thought of him as a big monster, then he would become a big monster. It's how perception affects your beliefs."

"Believe It or Not" was not the only Stevenson story inspired by her own experiences. In "Scared Silly," Boober plays a simple prank on Wembley, who tries to retaliate by booby-trapping Boober's room. The idea came to Stevenson after Dave Goelz spotted her at a Toronto mall ATM one day, snuck up behind her, and *growled*. "We had a good laugh," Dave Goelz says. "Though she probably wanted to kill me."

Sometime later, Goelz was walking down a noisy street near the studio and stopped to look in a shop window. "I was leaning over, looking at a pair of shoes, and I suddenly saw the reflection of Jocelyn behind me, tiptoeing across the sidewalk, like a cartoon," he says with a laugh. "I waited until she got right behind me and said, 'Hello, Jocelyn.' And I don't think I've been forgiven for that either."

Stevenson describes the "Scared Silly" episode as a way of working through her "personal anguish" at being pranked by Goelz and others who worked on the show—playing tricks on cast and crew was a tradition on Henson productions. Steve Whitmire was another trickster, so it perhaps isn't surprising that his and Goelz's Fraggles—Wembley and Boober—are the lead characters in the story. "[Dave and Steve] were very good at it, and I was always scared by them, they always got me," Stevenson recalls.

"Scared Silly" also introduced the term *baloobius*, the name

BOTTOM LEFT Character design titled *Skenfrith Unadorned* by Michael K. Frith for the episode "Believe It or Not."

BELOW RIGHT The Skenfrith puppet in one of his simpler iterations, featuring only one head with three eyes, horns, and his version of Red's pigtails.

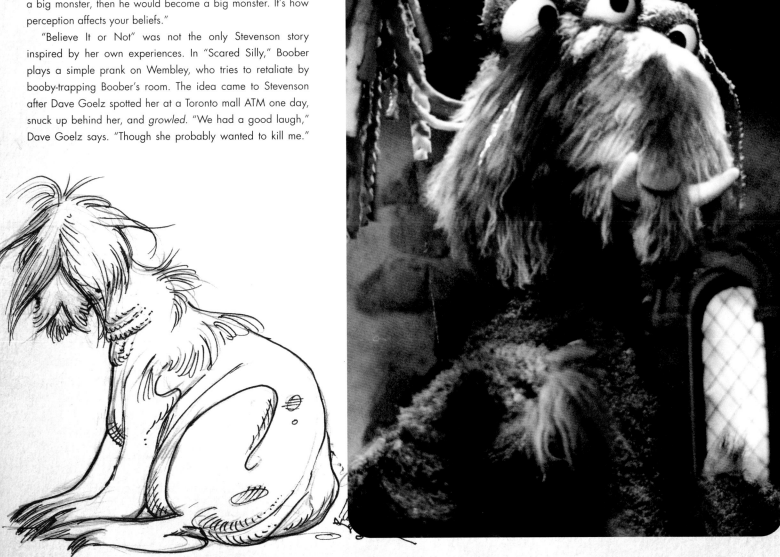

for the fringe on the end of a Fraggle's tail, which flares out when a Fraggle is scared. "The word *baloobius* just came," says Stevenson. "As I said, it's always been there and I just discovered it. That was all."

Fraggle Rock's rapid filming schedule didn't allow for much wiggle room if anything went catastrophically wrong. But because the writers, cast, and crew worked so tightly together—and welcomed each other's input—they could usually improvise a good fix in the face of any setback.

During *Fraggle Rock*'s third season, Steve Whitmire broke a bone in his right hand and couldn't perform for a short time. As Wembley now had to take a smaller role in the upcoming episodes, the writing team needed to rework some of the scripts. To help fill the Wembley gap, Karen Prell suggested a new story inspired by a period in which she couldn't perform for a week after undergoing surgery.

"While I was recovering at my parents' home in my own bedroom, they were treating me like a little girl," says Prell. "I love my parents very much, but I was a grown-up and it was driving me nuts." Echoing that predicament, the same one being faced by Whitmire at the time, Prell suggested a story in which Red suffers an injury that requires her to slow down and rest. "And Boober, who's a fanatic hypochondriac, goes nuts going into medical triage mode, trying to heal Red," Prell explains. "Red finally escapes Boober's ministrations, and then she injures herself even more."

The episode, "Playing Till It Hurts," was written by Jerry Juhl, and sees Red get injured while practicing for the big "rock hockey" tournament. Hearing that her sports idol, Rock Hockey Hannah, is going to be at the event, Red leaves her sickbed and joins the game, only to be injured again.

Whitmire returned to the show in short order, though he performed his next two episodes using his left hand while his right hand continued to heal. As for Prell, she remembers "Playing Till It Hurts" as a personal favorite because she didn't just come up with the premise—she also suggested jokes and other bits of business to Juhl, who then "blessed this pile of gags with a point." Given how much fun she and everyone else in the *Fraggle Rock* family had making that episode, Prell says, "It was really a gift Jerry gave the whole crew."

For Season 3, not only did the writers pen stories set in the present, but they also made a concerted effort to explore the history of the show's various species and the events that had shaped their respective cultures.

> "The word *baloobius* just came."
> JOCELYN STEVENSON

BOTTOM A rare view of Red at rest, as seen in the season 3 episode "Playing Till It Hurts."

OPPOSITE TOP A note and illustration of appreciation by Karen Prell following the completion of the episode "Playing Till It Hurts."

OPPOSITE BOTTOM LEFT Concept art for the present-day version of the Storyteller from season 3's "Born to Wander" by Michael K. Frith. She was originally named "Ol Nanny Fraggle."

OPPOSITE BOTTOM RIGHT The young Storyteller as seen in the flashback in "Born to Wander," featuring a young Matt Fraggle before he began to travel.

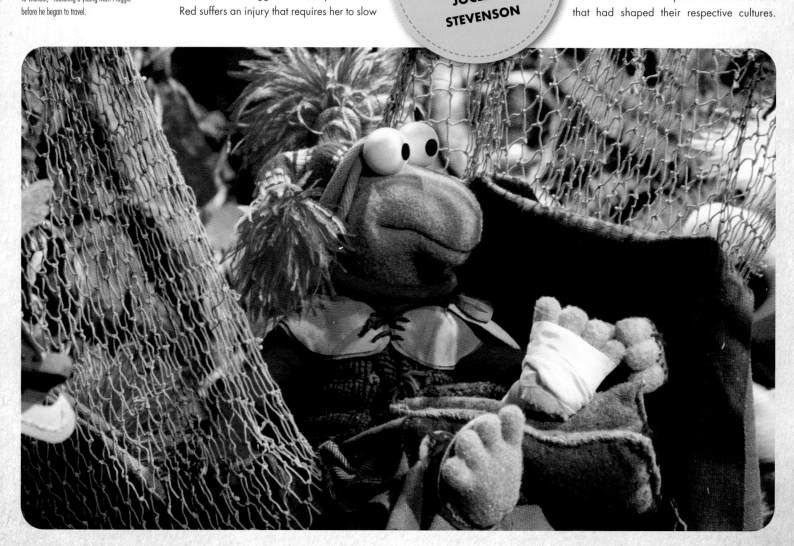

Writer bpNichol pitched an origin story for Uncle Travelling Matt. "He always wanted to show Matt as a little boy," says Dave Goelz, "and I thought it was an amazing idea." Goelz met with Nichol and Juhl to work on the story, and suggested that when Matt was young he had an Uncle Gobo who was a legitimately great explorer. "And little Matt, who's five or six years old, follows his Uncle Gobo around, because he wants to be an explorer too," says Goelz. "But his Uncle Gobo is always frustrated because Matt would wreck things, trip over something, break some beautiful thing his uncle had found."

The Uncle Gobo character who appeared in "Born to Wander" was a straight re-costuming of the Gobo puppet, augmented with a mustache and an explorer costume. To create the young Travelling Matt puppet, Rollie Krewson took the original pattern for the grown-up Matt and downsized it.

"Born to Wander" begins in Wembley and Gobo's room, where their friends have been invited for a session with Madame Storyteller, the keeper of Fraggle Rock history—a character who acts in a similar capacity to Cantus the Minstrel. As host, Gobo gets to choose the story, and wants to hear about his Uncle Matt's first big journey. Madame Storyteller reveals Matt's early history and his troubled relationship with his Uncle Gobo.

In this earlier time period, Fraggles ate only mushrooms. When their supply runs out, Uncle Gobo is sent to find more. Matt insists on going with him, to his uncle's chagrin. Early in their mission, Uncle Gobo is injured, but young Matt vows to continue his uncle's quest.

Matt's ineptitude has many consequences on the journey, but not all of them are bad. While on his search, he accidentally creates the hole that leads from Fraggle Rock to the Gorgs' garden.

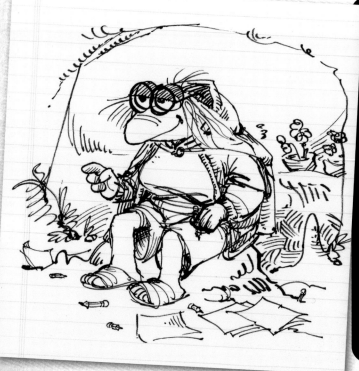

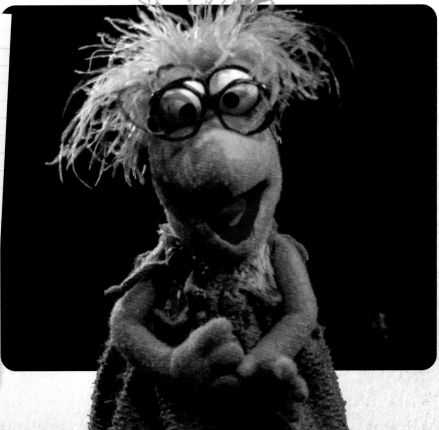

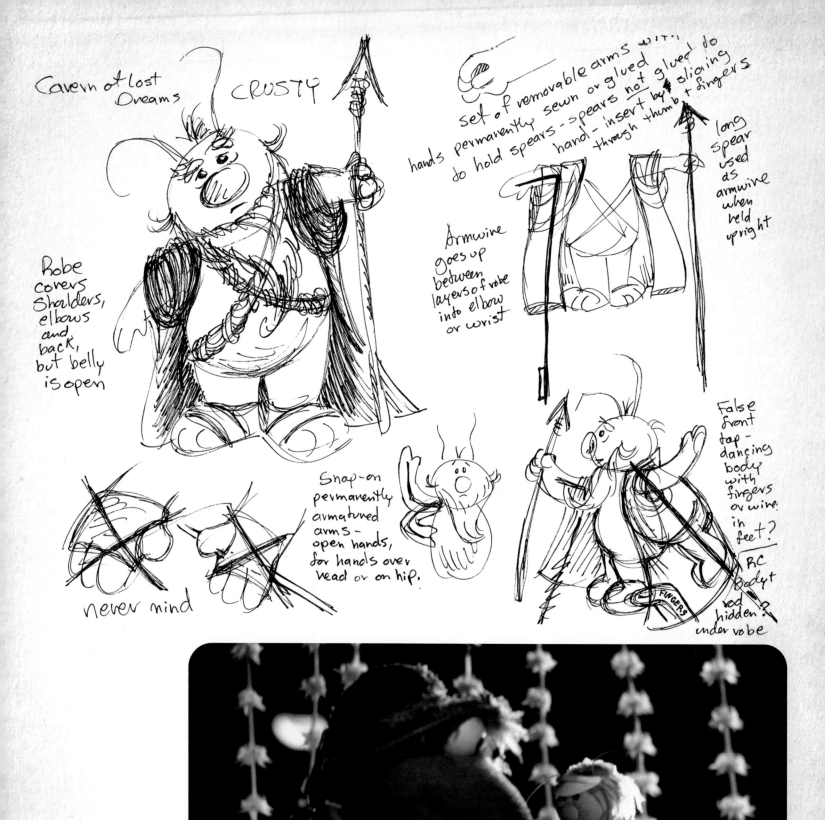

TOP Karen Prell concept art for the ancient Doozers seen in "The Cavern of Lost Dreams."

BOTTOM Gobo Fraggle and Cotterpin Doozer are imprisoned by the Doozer guardians Crusty and Yeaster in "The Cavern of Lost Dreams." The "bars" are made from itching plants — "one drop of that sap on your skin and you'll never stop itching."

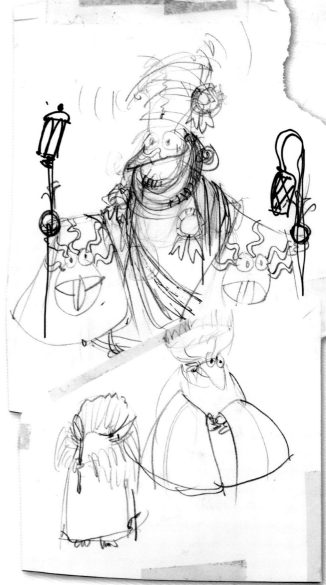

"We didn't know much about the early Doozer world, so it was time to show that."
LAWRENCE S. MIRKIN

When Matt explores the garden, Ma and Pa Gorg throw radishes at the intruder to drive him away. Matt thinks the vegetable is just a nice red rock, but when he brings one home, a hungry Fraggle bites it, and likes it. Matt is subsequently praised for discovering a new food source.

"It was so lovely that from the beginning Matt was a bumbler," says Goelz. "That he was never meant to be an explorer. He was just no good at it." Goelz adds that what he found most poignant about the character is that he couldn't see his own flaws. Just as he misinterpreted what he saw the Silly Creatures doing around the world, so he also misconstrued and embellished his own abilities. That's what made him funny—and lovable.

Besides uncovering Uncle Travelling Matt's secret history, Nichol also wanted to explore the origins of the Doozers. "We didn't know much about the early Doozer world, so it was time to show that," says Larry Mirkin. In "The Cavern of Lost Dreams," Cotterpin Doozer seeks inspiration in the legendary cavern, where the earliest Doozer constructions are rumored to still exist. She enlists the help of Gobo, mapper of the Fraggle tunnels, to find it. Not only do the pair find the cave, but they also find two ancient Doozers—Crusty and Yeaster—who are still guarding the structures. And in a reference to "Born to Wander," those early structures are made from mushrooms.

Larry Mirkin describes "The Cavern of Lost Dreams" as "something we weren't really prepared to do prior to Season 3," because first they had to establish the world of these characters, by telling stories in which the Gorgs, Fraggles, and Doozers learned more about one another. In Season 3, they started to work backward more, filling in the history and mythology of the three factions.

TOP Designs for the "The Secret Society of Poohbahs" episode from season 3, illustrated by Jim Henson. While Henson generally didn't design characters for the show, he contributed ideas and occasionally sketched out rough designs for the puppet builders.

BAD IS NOT GOOD

IN PREVIOUS SEASONS, THE CREATIVE TEAM had frequently discussed how good and evil should be addressed in the show. "It was a nagging sort of question," says Larry Mirkin. "All the different conflicts in our show were usually because of misunderstandings. They're conflicts of interest rather than one character is good and the other character is bad. We just didn't think that way about the show for many, many reasons, both philosophical and aesthetic. But because good and evil is a subject in literature, we thought we should explore it."

BOTTOM The only Fraggle "villain," Wander McMooch, performed by Bob Stutt, for the season 2 episode "Junior Sells the Farm."

In the Season 3 episode "Home Is Where the Trash Is," Philo and Gunge decide to leave the Trash Heap and search for their original home, but they have no idea where to go. "I think this is my favorite of the shows that I wrote," says Sugith Varughese, calling it the *Fraggle Rock* version of the absurdist play *Waiting for Godot*. "It was absurd, but in a very sophisticated way."

While searching for their home, Philo and Gunge check out various potential locations, including Doc's workshop. Unfortunately, this created a problem for the international partners creating their own wraparound segments. "We didn't have a Philo and Gunge to give to them," Mirkin explains. With no puppets or puppeteers to provide to the international productions, Philo and Gunge couldn't appear in whatever location those versions of *Fraggle Rock* used in lieu of Doc's workshop.

To solve the issue, director George Bloomfield came up with a workaround that would mean altering the US version of the episode. "Home Is Where the Trash Is" already included a subplot about a pileup of garbage bags in the workshop. "So, when Philo and Gunge come through the pipes close to Doc's workshop," Mirkin continues, "they 'go into' the room, but George Bloomfield shot the scene as though we were following them walking *behind* the garbage. We hear them, but all you see are the bags moving slightly before the pair get chased out by Sprocket and they're back in Fraggle Rock." Overseas, the other *Fraggle Rocks* could do the same for their wraparound segments, featuring Philo and Gunge without actually showing them.

On their travels, Philo and Gunge are taken in by Wander McMooch, a toadlike con man. McMooch was briefly seen in Season 2, cheating Junior Gorg into selling the family farm so the toad could build a housing development. In this story, McMooch's darker personality is revealed when he forces Philo and Gunge to work as his unpaid laborers.

> "I think this is my favorite of the shows that I wrote. It was absurd, but in a very sophisticated way."
> **SUGITH VARUGHESE**

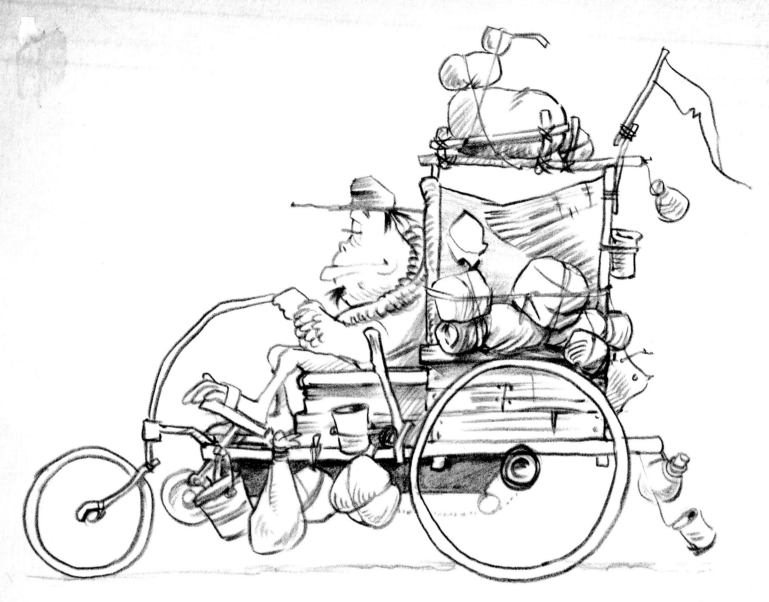

The McMooch puppet was designed by Michael K. Frith and performed by Bob Stutt, whose first job with Henson Associates was on *Fraggle Rock*. Frith made McMooch a "lizardy thing, to get away from either Gorgs or Fraggles," and gave his outfit a faded elegance. "His torn coat is unraveling, the stock around his neck is greasy, and he has a ratty, fringed belt. He's like a sleazy Mr. Toad." Art director Diane Pollack created the boggy swamp beyond the Gorg's garden where McMooch lives.

Although McMooch was a fun addition, Larry Mirkin was never comfortable with the character. "The [episode] was really well done, and I'm happy we did it," he says. "However, I just thought that McMooch didn't seem right in this world. The character really had no redeeming values. We didn't know anything about him; he just served as an antagonist and a bad guy." After "Home Is Where the Trash Is," the creative team decided not to use McMooch again. They also ruled against the use of traditional one-dimensional villain characters, believing that it was antithetical to the mission of *Fraggle Rock*.

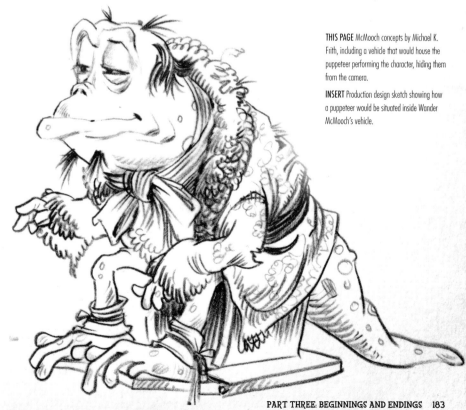

THIS PAGE McMooch concepts by Michael K. Frith, including a vehicle that would house the puppeteer performing the character, hiding them from the camera.

INSERT Production design sketch showing how a puppeteer would be situated inside Wander McMooch's vehicle.

EXPANDING MARKETS

IN 1983, THE YEAR THAT SEASON 1 premiered, Duncan Kenworthy began courting potential overseas partnerships for *Fraggle Rock* in Japan, China, and the Soviet Union. He knew from his considerable experience in foreign sales that these three territories would be a tough nut to crack. Kenworthy had luck in Japan, after shopping around a fully dubbed pilot episode in 1984. The network NHK signed on to distribute the show as the third season was being shot, and began airing episodes in 1985.

Although they'd previously bought *Sesame Street*, Kenworthy's contacts in China turned down *Fraggle Rock*. Kenworthy enjoyed his meetings there, but, as he recalls, the country was still recovering from Chairman Mao's Cultural Revolution, which made the true chain of command harder to figure out. "The [people] heading the [TV] department used to be farmers, and their assistants had been university professors," he says. In short: He faced bureaucratic gridlock, and couldn't get a green light.

The Soviet Union eventually came on board, but through a slightly circuitous route. In 1966, Jim Henson had become the

chairman of UNIMA-USA, the North American wing of UNIMA (Union Internationale de la Marionnette), the international puppetry union. UNIMA holds a World Puppetry Festival every four years, where puppeteers meet, train, promote their work, and share their experiences.[22] The festival would alternate between being held in capitalist cities in Europe and the United States, and communist cities behind what was then called the Iron Curtain."[23] "It's important to note that [my father's] interest in puppetry was always related to an international interest; he wanted to get the US puppet community connected to and involved with the

BOTTOM Sergei Obraztsov with his puppet character the Drunk and Jim Henson with Kermit the Frog during the taping of an episode of the *Jim Henson Presents The World of Puppetry* series in 1984. Their friendship led to the Fraggles' debut in the Soviet Union.

Russians go for Fraggle Rock

Soviet Television is considering buying *Fraggle Rock* for broadcast next year. The dramatic move follows the successful coproduction between Soviet TV and Henson International Television on an episode of *Jim Henson And His World Of Puppetry*.

Executives from Henson have just returned from Moscow where Soviet buyers viewed the programme and gave a very positive response. The episode of *Jim Henson And His World Of Puppetry* that prompted the move features Sergei Obraztsov, grand Russian puppeteer and head of the State Puppet Theatre in Moscow for 50 years. The programme shows Obraztsov's performance with filming backstage and an interview.

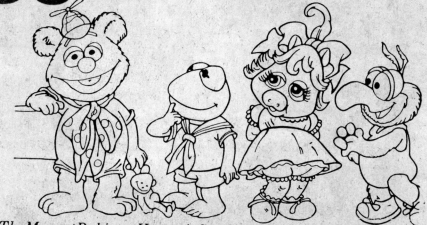

The Muppet Babies—Henson's first fully animated project.

Having done one co-production it is easier to do a second."

As with all Henson productions the programme content has been shaped around international participation: "Each country co-produces the programme featuring the puppeteer from th v

UK in between starting work on his new feature, *Labyrinths*.

Meanwhile CBS has commissioned a second children's programme to couple with Henson's new creation *The Muppet Babies*, which is Henson's first fully animated project, made in co-

international puppet community," explains Cheryl Henson. "He coproduced the UNIMA festival in 1980 in Washington, DC, with a very close friend, Nancy Staub, who was a personal friend of Sergei Obraztsov."

Henson was enamored of Obraztsov, who had almost single-handedly established puppetry as an art form in the Soviet Union. The two finally met at the DC festival, which was hosted by Henson, and struck up a partnership that would see them work together to break down cultural barriers between the Eastern and Western blocs. This friendship led to *The Dark Crystal* and *Labyrinth* being screened at the Moscow Film Festival. Through the work of Henson and Obraztsov, not to mention seismic changes in the wider political climate, Kenworthy and Orton were eventually able to sell *Fraggle Rock* to the Russians. The show premiered there January 8, 1989, the first American television series to be broadcast in the Soviet Union.

Ten months later, on November 9, 1989, Germany's reunification began, literally destroying the barrier between West Germany and communist East Germany. "By the end of the year,

as the show's lessons of tolerance and understanding wafted through the airwaves, the Berlin Wall came down," says Henson Company archivist Karen Falk. "We always joke that *Fraggle Rock* led to the end of the Cold War."

The third season debuted in the US on HBO on January 7, 1985. The Nielsen ratings for Season 3 maintained the consistent seasonal average, capturing 20 percent of the Canadian audience. The season won another ACT Award, and more and more *Fraggle Rock* toys and games and books were beginning to show up on department store shelves around the world.

"I think we started to gain steam in the second season," says Mirkin, "and then we hit our stride in the third." By the end of the third season, according to Frith, nobody asked "Can we do this?" whenever someone wanted to tackle a difficult topic or try an ambitious story. Instead, the attitude was "How *will* we do this?"

Before the season even ended, the production team and performers were looking forward with great enthusiasm to the fourth season and raising the bar even higher. What they didn't know yet was that what they hoped to be their best season yet would also be their last.

TOP News story announcing Soviet television's interest in purchasing *Fraggle Rock*.

SEASON 4: YOU CANNOT LEAVE THE MAGIC

EACH YEAR, HENSON ASSOCIATES WOULD HOLD a series of meetings to review the status of their current and future projects. During *Fraggle Rock*'s second season, the creators were asked at one of these reviews to begin brainstorming possibilities for how the franchise could continue after the current show ended. Suggestions included an hour-long 3D television special and a new series focusing on Uncle Travelling Matt's adventures with a new cast of Fraggles. During these sessions, the team began discussing how the main *Fraggle Rock* series might end.

Although nothing final was decided, in March 1985, just before the end of filming on Season 3, Jim Henson held a "Future of the Fraggles" meeting in Toronto with Jerry Juhl, Jocelyn Stevenson, and Larry Mirkin in attendance. Henson told them he had decided that *Fraggle Rock* should finish on a high note, and that the next season would be the last.

Though the ratings were still strong, and the writers felt they had ideas for several more seasons, it was time to move on from *Fraggle Rock*. "Jim said it was so much better to quit while we were ahead," says Jocelyn Stevenson, "and that made a lot of sense to us. Though as much as I wanted the thing to continue, part of me was relieved." With two very young children—and a

BOTTOM Art created by Karen Prell that was featured in the season 4 episode "Brush with Jealousy."

third on the way at the time of the March meeting—Stevenson had been flying back and forth between Scotland and Toronto throughout the production, with her kids in tow. In some cases, she had needed to leave her children at home with her husband while she was away for long periods of time. "Jerry [Juhl] and I had already been spelling each other so that we both didn't have to be in Toronto all the time," she continues. "He, too, was getting weary of spending so much time away from home."

Throughout her time on the show, Stevenson had defined each season with a single question. "The first season was *What is this and where are we going?*" she explains. "The second, *What if we try this and this and this?* For the third, I asked, *What stories can we tell with this series that you wouldn't be able to tell in any other?*" Now that *Fraggle Rock* would be coming to an end, the question Stevenson asked was *What stories do we need to tell before it's over?*

One key theme was soon agreed upon for Season 4: There would be a greater focus on miscommunication among the species and solutions that would increase understanding between the different factions. In addition, some classic *Fraggle Rock* characters would receive more attention: Doc and Sprocket would get the opportunity to go outside the workshop, the Gorgs would be imbued with personality differences that were more distinct, and Marjory, whom Stevenson says had been "accidentally not used much" in the third season, would get more screen time.

The core team of Henson, Stevenson, Mirkin, and Juhl then turned their attention on how the very last batch of episodes should be approached in order to wrap up the entire series in a satisfying manner. Conceptual designer Michael K. Frith and producer Duncan Kenworthy were also brought into the conversation.

"When the decision was made about not going forward, then two things happened," says Larry Mirkin. "One was, okay, if we have just so many stories to go, let's make sure these are top of the line. The other thing we really wanted to do was find a way to end the series with an arc that would put an end to the chapter."

THE FUTURE OF FRAGGLE ROCK

March 9, 1985

TO: Jim Larry
 Diana Jerry
 Michael Jocelyn
 Duncan Susan
 Martin Gregg

FROM: Mira

I. HOW MANY MORE?

The biggest question of the meeting was whether to continue
FRAGGLE ROCK for 96 or 120 (or more) shows. HBO, the CBC,
and the entire cast and crew have strongly urged that the
series continue beyond 96 shows. The strongest impets for
continuing is the idea that we are accomplishing positive
things with the show, and that it is an important series
to have on the air. By the end of the meeting, everyone
agreed that going to 120 (or beyond) would encourage the
exploration of new areas and would be a lot of fun. In
order to keep the show interesting and fresh, though,
people also agreed that the format needs to be loosened up
a bit and the major themes need to be stressed in new ways.

II. NEW DIRECTIONS

A. THE GOALS OF THE SHOW: The miscommunication between the
species seemed to be one of the aims of the show that
could be addressed more often in the upcoming shows.
Rather than aiming towards a utopia where the Gorgs,
Fraggles, Dozers and Doc all understand each other,
it was agreed that their understandings would be ten-
tative and temporary. And in addition to showing
their continual miscommunication, one of the valuable
things the series could do would be to model better
communication between the species.
* Show that the same work might mean different things to
 different people.
° Write a show around racist jokes. Gorgs might tell
 Fraggle jokes while Fraggles told Doozer jokes while
 Doozers told Rodentia jokes while...
° Show the links between the characters' attitudes
 more often, by cutting from a Gorg complaining or
 enthusing about something to a Fraggle
 complaining or enthusing about the same thing.

°Use the Doozers as linking devices, continuing their lives and work as the Fraggles and Gorgs carry on. These asides would help to layer the world of FRAGGLE ROCK and show how differently the three species approach life.

B. UNCLE TRAVELLING MATT: Although one suggestion was to bring him back to the Rock, the discussion centered on how to stop feeling limited by the format of the weekly postcard. Everyone agreed that perhaps we don't have to have a weekly postcard; and as long as it adds up to the same amount of UTM air time (for the sake of the inter- national adaptations) we could skip him entirely some weeks and give him three or four minutes other weeks. In order to improve the entertainment and production value of the UTM segments these suggestions were made:

°The same director that directs the show should direct that UTM segment, perhaps on the preceding Thursday and Friday.
°UTM might start interacting with people (after Gregg and Larry check the residuals deal).
°We might sneak in stock footage of demolition derbys, Wimbledon, and ships being christened (as Duncan did at Ascot) to give Matt absurd situations to address and to help compensate for the short shooting season that Toronto's weather allows.
°At some point when UTM is relating his experiences we might show how each of the Fraggle Five is interpreting what he's telling them: Gobo might see a group of Docs when Matt talks about a bunch of Silly Creatures, while Wembley might imagine a group of very tall Fraggles.

C. DOC & SPROCKET: Again it was decided that varying the segments might keep them from feeling stale, as long as it adds up to the same number of studio days for the international adaptations.
°It was agreed to look into ways of getting Doc & Sprocket out of their dark set and into some sunshine. We might try to build their front porch and garden, and they might take walks in the countryside too.
°Doc might invent a robot with personality.
°Since the lighthouse keeper works so well in the UK version it was agreed to try to place Doc somewhere on a coastline. This would allow us to spend a few days shooting Doc puttering around outside; these tape pieces could then be sprinkled throughout the season.
°Exterior scenes with Doc & Sprocket will probably require a real dog for long shots. So, at long last, it was agreed to hold the Sprocket lookalike contest, provided that we use the slogan: "You win; we get to keep the dog".

D. THE GORGS: This is another part of the show that doesn't
feel completely comfortable yet. In order to expand
the Gorgs' environment it was agreed to experiment with
models and matte painting, and possibly doing the Gorgs
as hand puppets. And although Junior is working pretty
well, both Ma & Pa Gorg's characters seem to need some
shaping.

 1. PA GORG is already fairly likable, but we might want
 to reenforce the threat he poses to other species.
 We might make him more paranoid about his Empire,
 eagerly patrolling the grounds with his musket and
 cannon. His random sitings of non-existent enemies
 could lead to devastating fusillades. Also, he might
 suddenly decide that as King, it's about time that
 he levied some taxes on every living thing.

 2. MA GORG has real problems in the Congeniality Depart-
 ment. Rather than having her aware of everything that
 Junior and Pa are planning, it was agreed that it might
 be more effective to have her a bit more unaware.
 Perhaps she could be preoccupied with her role as The
 Queen. She could take on the role of Cultural Archivist,
 fondly reminiscing upon the good old days, and making
 proclamations about what sorts of cermonies they
 should be celebration today. She could also become
 a sort of Royal Do-Gooder, destroying whatever natural
 balance exists in the garden with misguided intentions.
 She might also be a Storyteller of the Great Gorg Past,
 which could lead to their acting out the story of Jack
 and the Beanstalk from the giant's POV.

 HERD OF COWS: Overall the Gorgs should seem like peasant
 farmers with pretentions. We should give them some animals
 to herd to encourage their agraian tendencies - maybe
 cows or sheep. They can be funny in their exuberance,
 but also a little threatening and unappealing; they're
 not the cleanest sorts of creatures, and their hootenannys
 threaten to cave in The Great Hall.

E. MAJORIE: Marjorie was accidentally not used much this
season, but it was agreed to use her more in the future.
Although she's been through a number of changes, her
nuttiness is valuable and should be untilized.

III. PRODUCTION CHANGES

 A. It was agreed to re-shoot portions of the beginning
 and the ending sequences to update the characters
 that have changed and to allow more time in the ending
 for credits.

B. Putting each show's title at the top of the show seemed like a nice idea.

C. Listing each performer's characters in the credits also sounded like a good idea; this would not include ATFITW, but just the major roles from each week's episode.

IV. FRAGGLE RELATED STUFF

A. The idea of doing spin-off shows with Uncle Travelling Matt as the host of a show about different countries around the world or perhaps about different animals seemed like it was a possibility for later on.

B. GORG FAIRY TALES on Saturday Morning: there was no resolution on this topic.

C. A FRAGGLE ROCK SPECIAL: always a possibility if we can find a buyer.

D. FRAGGLE ROCK MOVIE: still a strong possibility.

V. FUTURE MEETINGS

A. DIRECTORS/PERFORMERS/WRITERS MEETING might be held next Saturday to discuss any ideas or changes people want to discuss.

B. WRITERS'THINK TANK MEETING could be held in May or June. This meeting would be held with invited guests who write about cultural and sociological issues. It might help to revitalize and focus the writers on the themes we want to address.

"We felt it was clearly important to do two or three episodes at the end of the series that would wrap the series up," said Jerry Juhl. "That would give us a sense of finality. That would end this chapter of the Rock. Maybe there would be another chapter someday, but there was a sense of finality about this that, at the same time, let the audience know that the Rock continued, the magic carried on. We felt strongly about that."

But Jim Henson was not in favor of creating a finale that would definitively wrap up the entire series. "He came from the school of 'every episode should be self-contained,'" Mirkin explains. One of Henson's main concerns was that, as with any television show that enters syndication, there was no guarantee that episodes would be shown in their original order, and so the final episodes could cause confusion if the shows were aired randomly.

Michael K. Frith shared Henson's concerns about potentially baffling future viewers with an actual finale. He also felt the whole idea diminished the show's sense of wonder. In an April 2, 1986, memo, he wrote: "On an aesthetic level I was (and am) most uncomfortable with the business of *rapprochement* between species, feeling, as I do, that this really just neutralizes our fantasy world, makes it bland, loses it its bite, its edge and its relevance to *this* world, the one about which we're supposed to be teaching our young viewers a thing or two through these little fables."

Despite Frith's concerns, the team continued to lobby Henson.

"We told him, you wouldn't have to watch these in order to enjoy them," Mirkin continues, "but if you *do* watch them in order, it'll have a really nice sense of completion. And there's possibility for the future in the way we want to do it."

The debate about the final episodes went on over a period of weeks. "I'm sure we never fully convinced Jim," said Jerry Juhl. "But he let us do it. It's that spirit of trust—Jim had taken this set of people and said, 'You guys are going to do this.' And I've always been really grateful to him that he let us wrap that show."

TOP Filming the season 4 episode "Wembley's Wonderful Whoopie Water." (Left to right) Trish Leeper with Aunt Granny Fraggle, Karen Prell with Red, Bob Stutt with Felix the Fearless.

CENTER Concept art by Karen Prell for the season 4 episode "Inspector Red," in which Red once again sets out to solve an apparent theft.

INSERT Notes from a March 9, 1985, meeting about the future of *Fraggle Rock*.

COMING CLOSER

AFTER FILMING FOR THE THIRD SEASON ended on March 25, 1985, the series went on hiatus from April to September, as a number of essential crew members decamped to London to work on the feature film *Labyrinth*, directed by Henson. The delegation included puppeteers Dave Goelz, Karen Prell, Steve Whitmire, Kathryn Mullen, and Rob Mills, plus associate producer Martin Baker and Muppet effects director Faz Fazakas. Jerry and Susan Juhl used this quiet period as a much-needed sabbatical, returning home to California to relax and work on personal projects.

Jocelyn Stevenson's son Tom was born in August, so once production resumed in fall 1985, it was decided that she would work on the scripts from home and return to Toronto at the beginning of 1986. With Stevenson contributing from afar, the writing team began their work by conceptualizing stories that would pull the Fraggles, Gorgs, Doozers—and even Doc and Sprocket—closer together. During this period, the writers exchanged potential concepts for upcoming episodes and the all-important finale arc. Susan Juhl compiled a document titled "Notes for Season Four" that included the suggestion that the hole in Doc's workshop may not be the only entrance to Fraggle Rock from Outer Space: "There are an endless number of ways to tap

into the magic, if one is aware, and willing to search," the note read. This idea would prove to be key during the development of the final episodes' themes.

The writers also discussed ways to tackle serious real-world issues in even deeper ways than they had before. In "A Tune for Two," written by Laura Phillips, the show confronts deeply ingrained bigotry when Wembley chooses to sing with Cotterpin Doozer in a musical contest known as the Duet-a-thon. "The idea that a Fraggle would sing with a Doozer breaks with tradition," says Phillips. The contest supervisor refuses to let them register, insisting that only Fraggles can sing together. Cotterpin's peers are also opposed, because of their long-held belief—passed

BOTTOM Mudwell the Mudbunny, as seen in the episode "Gone But Not Forgotten."

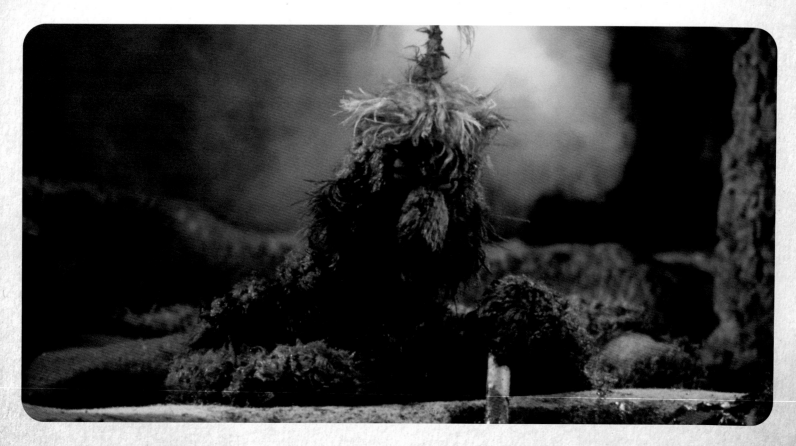

down from their parents—that Fraggles are untrustworthy, and disdainful of Doozers. The standoff is resolved after Wembley argues, "Just because it's always been doesn't make it right." Hearing this, the Fraggles take his side and refuse to participate unless the duo is allowed to sing.

"For me, this was really about tolerance and about racism," says Phillips. "The species were so often so separate. One of the main issues that Fraggles dealt with was mutual dependence, so I looked for any opportunity I could to bring them together and really deal with that. Anything you wanted to do, any story you wanted to do, and, especially, any story that mattered, could be done in *Fraggle Rock*."

Phillips tested that notion further in the episode "Gone But Not Forgotten," which saw Wembley, her favorite character, deal with the conflicting emotions evoked by death. "In 'Gone But Not Forgotten' Wembley goes on his first solo overnight hike through the tunnels, like a vision quest, and he meets a rare creature called Mudwell the Mudbunny," she explains. "The Mudbunny doesn't know why, but it spends most of its life stirring a big vat of mud, and at the right moment, which only he can feel, he sinks into it and, well . . . goodbye." Wembley struggles with the loss, and in an effort to accept that he will never see Mudwell again, he returns to the mud pit. Suddenly, a colorful lizard-type animal emerges from Mudwell's resting place, and seems to know Wembley. Could it be Mudwell?

Although there is a clear cycle-of-life theme running through "Gone But Not Forgotten," the words *death* and *reincarnation* are not used. "Reincarnation was too vague an idea," says Larry Mirkin. "It's more like a caterpillar and butterfly. It was about an experience of Wembley growing up, going out into the world alone, and when you do that, unexpected things can happen. Some of them can be very difficult and very frightening, but also very wonderful." It was also was no coincidence that the episode was preparing *Fraggle* fans for the hard fact that sometimes things come to an end.

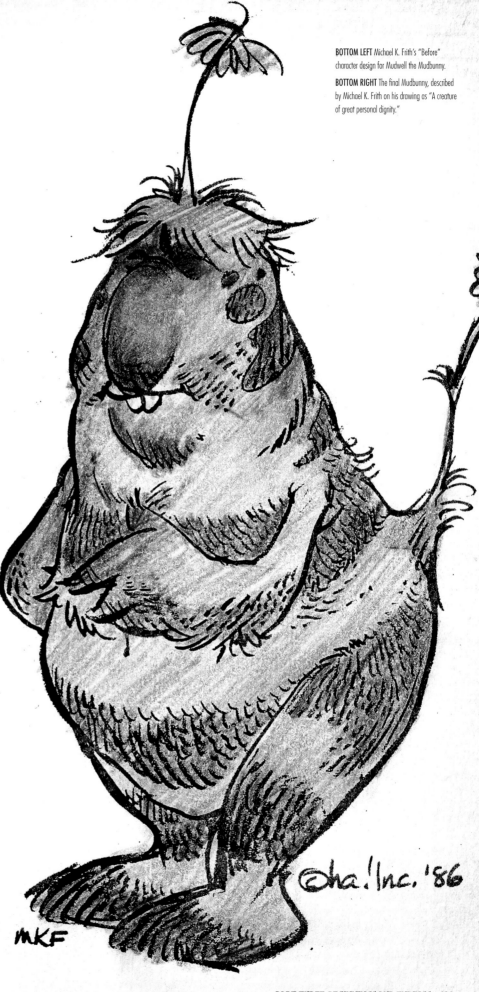

BOTTOM LEFT Michael K. Frith's "Before" character design for Mudwell the Mudbunny.
BOTTOM RIGHT The final Mudbunny, described by Michael K. Frith on his drawing as "A creature of great personal dignity."

LET THE WATER RUN (AGAIN)

ANOTHER GOAL FOR THE FINAL SEASON was to create an episode where the interconnected world of *Fraggle Rock* could teach kids about ecology. "But," Mirkin says, "could we really do an environmental show that could be fun, interesting, and somehow empowering without being preachy?"

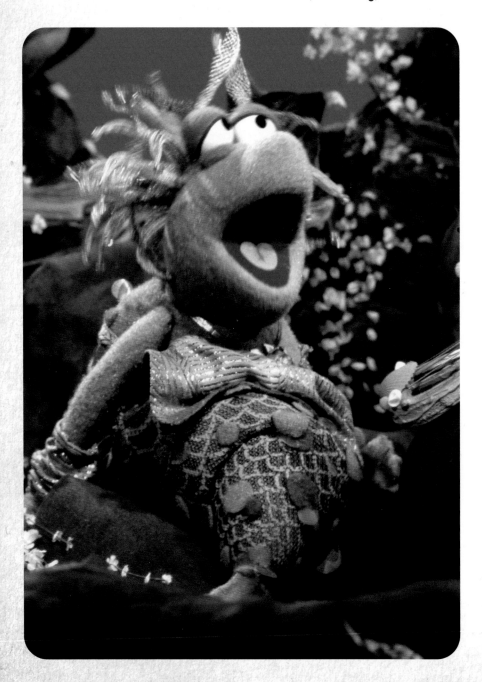

That question was answered in "The River of Life," by David Young. In the episode, Doc is offered money to use the (apparently) empty caves behind his home for waste disposal. Knowing that the Fraggles live in those caves, Sprocket needs to find a way to persuade Doc not to make the deal.

"The first thing Jerry Juhl ever told me about *Fraggle Rock* was that the show was about the interconnected nature of the world," says writer David Young. "That everything affects everything else. That nothing exists in isolation, and that there's this wonderful, interwoven, interpenetrating thing that kids need to understand."

The waste finds its way into the Fraggles' pool and pollutes it during a terrible heat wave. Boober smells the foul water, and tries to get the others not to drink it, but it's too late, and the Fraggles become sick. The bad water also affects the Gorgs' garden, where Ma and Pa Gorg fall ill after taking a dip in the nearby stream.

"[Boober] dithers and worries, but doesn't know what to do," says Young. "That's the way that we all feel now about the environment. 'Maybe I'll just hide under this rock, you know.'" For Young, Boober was the perfect character for this story because "Dave Goelz could play anxiety better than anyone else in the cast." ("All the characters are an aspect of ourselves," Goelz notes with a laugh. "Even the writers, you know. Wembley being indecisive . . . Maybe David Young could relate to that! I don't know.")

Ultimately, Boober comes to believe that in order to appease the Silly Creatures and save Fraggle Rock, he needs to return the postcards taken by Gobo from Doc's workshop. When Doc sees the postcards, it dawns on him that there just may be creatures living underneath his home, and so he calls off the waste-disposal deal.

"Doc wasn't a *bad* human being," says Jocelyn Stevenson. "He wasn't a horrible person who didn't care about anything. He was just slightly ignorant, and that's how we are. That's why the show works as well as it does."

The importance of water and the symbiotic nature of Fraggle Rock both come up again in the episode "Beyond the Pond,"

written by Jocelyn Stevenson. When Red discovers long pink vines called "knobblies" clogging the Fraggle swimming pool, she urges Boober to kill them with poison kohlrabi juice. Red then receives a psychic message—"Follow the roots"—and she swims through underground channels to Merggle Lake and finds five Merggles living there: Mervin (Jerry Nelson), Mermer (Steve Whitmire), Merboo (Kathryn Mullen), Merkey (Rob Mills), and Merple (Nikki Tilroe). The Fraggles' aquatic cousins teach Red that the knobblies she considers a nuisance are connected to the giant tree that nurtures and sustains life in their lake.

According to Susan Juhl, this kind of narrative-driven approach to big social issues was very important to her husband and the other writers: "Jerry liked to think of these kids watching the show and getting these little messages, without being hammered over the head, because that wasn't his style at all. But he knew that they would probably use these things in their real lives, and that would be very important."

The episode was also an enjoyable challenge for the builders and puppeteers who were tasked with creating believable underwater scenes. To show Red swimming in "Beyond the Pond," the team used "tabletop" puppetry, inspired by the traditional Japanese art of Bunraku. The set was covered in black material, and three puppeteers were dressed completely

in black so they blended into the background. The group then puppeteered Red using rods, their forms rendered invisible by the black-on-black camouflage. "One's doing the feet, one's doing the arms, and one's doing the head," explains Cheryl Henson. "My dad did quite a bit of that on *The Muppet Show*, and he'd done it in early stuff, so it's a technique he'd been using for years." The "swimming" Red puppet was also given loose pigtails that could be manipulated by monofilament wires to make it appear as if her hair were floating.

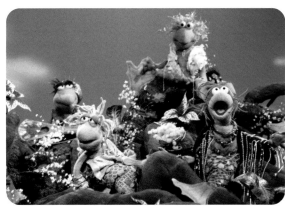

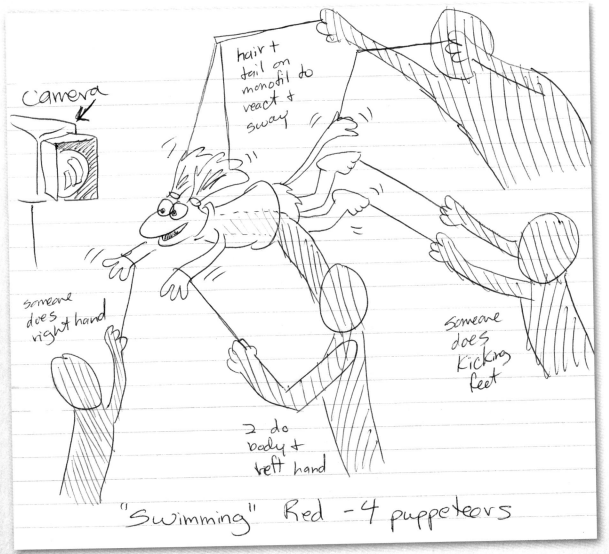

hair + tail on monofil do react + sway

camera

someone does right hand

someone does kicking feet

2 do body + left hand

"Swimming" Red - 4 puppeteers

OPPOSITE Mermer Merggle, from the episode "Beyond the Pond."

TOP RIGHT Merggle concept art by Karen Prell.

CENTER RIGHT The Merggles: Merkey, Mervin, Mermer, Merple, and Merboo.

BOTTOM A Karen Prell sketch showing the puppetry techniques used to create Red's swimming sequence in "Beyond the Pond."

COMING TO AN END

WHILE PLANNING THE FINAL SEASON, Juhl, Stevenson, and Mirkin repeatedly discussed the stories they felt they needed to tell before the show came to an end. "If you have the opportunity to watch them in order, there is a development," says Larry Mirkin. "The shows in Season 4 move in a different way than Season 3." And the entire plan for the last season culminated in the final three episodes, each of which in its own way says goodbye to some aspect of *Fraggle Rock*.

"We needed a few shows that would lead up to that last show," says Jocelyn Stevenson. "We wanted to tie up the whole Gorg story. We wanted to tie up the Fraggle story in the Rock, how everything was connected."

Jerry Juhl asked writer Laura Phillips if she would like to help wrap up the Gorgs' story. "She came in and said, 'I have an idea you might not like. I'd like to destroy the monarchy,'" says Larry Mirkin. "Could she do that? And we thought, *Yeah, that's a cool idea.*"

Phillips's episode "The Gorg Who Would Be King" reveals that, in Gorgic tradition, the current king must relinquish the throne to his heir when the last leaf on the Gorg garden's mystical Nirvana Tree falls. Neither Pa nor Junior is happy about this; in fact, in order to stop the last leaf from falling, Junior eats it. To his shock, he shrinks down to the size of a Fraggle. To avoid being captured by Pa, Junior dives into the hole that leads to the Rock. While there, he learns about the Fraggles' form of leaderless government. "No Gorg had ever been inside Fraggle Rock," says Jocelyn Stevenson. "He learned about the universe he was supposed to be ruling, and decided that it didn't need a king after all."

When Junior returns to his normal size, he is crowned king

BOTTOM Character design by Tim Miller inscribed "Singing Succulents," possibly for the season 4 episode "Wonder Mountain," in which characters known as the Singing Cactus trio hypnotize Red with their enchanted song "Do the Sashay."

OPPOSITE Junior turns his back on the monarchy in "The Gorg Who Would Be King."

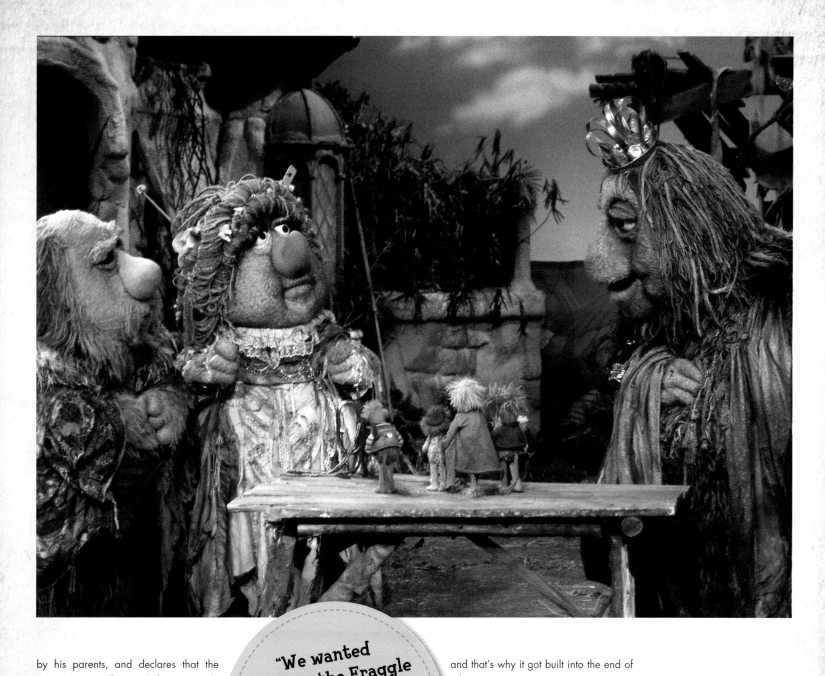

by his parents, and declares that the universe seems fine and doesn't need anyone to boss it around. He dissolves the monarchy and throws his crown away. "This was such a huge honor," says Phillips. "They let me end the kingdom, which is astounding when you think about it. It's a legend, it's a major truth of *Fraggle Rock*, and I got to determine it."

In the second-to-last episode, "The Honk of Honks," written by Jocelyn Stevenson, Gobo decides that he can no longer let the Silly Creatures stop him from exploring Outer Space. He boldly walks into the workshop and ends up face-to-face with Doc for the first time, though the human is unable to see him. "We had been creeping up to the idea that eventually we wanted the Fraggles and Doc to see one another," says Larry Mirkin. "But that had to be very special,

"We wanted to tie up the Fraggle story in the Rock, how everything was connected."
JOCELYN STEVENSON

and that's why it got built into the end of the series."

Back at the Rock, Gobo asks Cantus, who has arrived to oversee the Fraggles' Song of Songs ceremony, why Doc couldn't see him. Cantus tells him that for Gobo to become visible to the Silly Creature, the two have to touch. When Gobo goes back to the workshop, he finds Doc on the phone, talking to his best friend, Ned Shimmelfinney, whose health has gotten so bad he can no longer live by the seashore. Gobo is moved by Doc's emotional reaction to Ned's plight, so he places his hand on Doc's while offering comforting words. Suddenly, the human and Fraggle can see each other. "Finally, Doc can see the magic," says Larry Mirkin. "This scientist, this practical, rational guy, finally accepts that there is magic."

MAGIC IS WITH YOU

THE FINAL EPISODE OF *FRAGGLE ROCK*, filmed in May 1986, ensured that the story came to a satisfying end, but also signaled that the magic of *Fraggle Rock* would endure.

In "Change of Address," written by Jerry Juhl, Doc has decided to move across the country to be with Ned. Gobo is despondent over losing his new human friend and consults the Trash Heap about what to do. He's surprised to learn that Marjory thinks becoming friends with a Silly Creature is a wonderful thing, because humans need to know about the magic. "Whose magic?" asks Gobo. "Everyone is magic," she responds. "Fraggles, Gorgs, Doozers . . ." According to Marjory, even the Silly Creatures are magic, but "are sometimes too silly to remember that." She tells Gobo he must find Doc and speak the words *You cannot leave the magic*. But when Gobo gets back to the workshop, he's too late. Doc and Sprocket are gone.

The Fraggle Five join Gobo in the now-empty workshop, before they all walk through the caves, pondering Doc's absence. Then Gobo has a revelation: If you cannot leave the magic, and the Fraggles are magic, then Doc can't leave them and they can't leave him. Suddenly, a new tunnel appears before them.

"We had always, for years, thought that there are many ways to get in and out of *Fraggle Rock* and we had just never shown them," says Mirkin. "We wanted to have a sense of 'You, too, could find it.'"

As Doc and Sprocket move into their new apartment, they find a box positioned against the wall, just like the one they

BOTTOM Doc (Gerry Parkes) and Gobo face-to-face in "Change of Address."

found when they first moved into the workshop. But when they move the box, there's nothing but wall. Doc reflects on how meeting Gobo made him feel "different. Little furry creatures living behind the walls," he says to Sprocket. "That's . . . magical. And, maybe, anything is possible." All of a sudden, the box moves to the side and Gobo appears from the recently discovered tunnel that now links to Doc's new apartment. "You cannot leave the magic," he says. Doc replies that he and Sprocket just discovered that.

"This last show is just filled with wonder," says Larry Mirkin. "It is the epitome of what the show is about, but it's also the epitome of Jerry Juhl. It really is that the magic is in everybody and perhaps even things that aren't living. It transcends all of us. You cannot leave the magic."

The last day of production, May 16, 1986, was poignant and emotional. "At that point, we were resigned to the show ending," says Mirkin," but it was very sad. I remember when we actually did the last shot of the last episode, Wayne Moss, the floor manager who always called it when a show wrapped, wouldn't call it. He made me call it." The last scene shot was literally the last scene of the series, as Doc, Sprocket, and Gobo are reunited.

"I remember we all gathered [on set]," says Susan Juhl, "and when the last shots were being done we were almost all crying, because it was a very emotional moment for us all. We were family, and so we were sad, but it had to be."

The final episode's closing credits were special. Rather than the usual "scat" version of the *Fraggle Rock* theme, the credits featured every character singing a part of the lyrics to a slower-tempo version of the familiar opening theme song: the Fraggles; the Doozers, accompanied by Uncle Travelling Matt; Marjory the Trash Heap, with Philo and Gunge; and the Gorgs. The final, solo line, "Down at Fraggle Rock" was sung by Doc, punctuated with an enthusiastic "woof" from Sprocket.

That evening, after shooting finished for the last time, the cast and crew gathered for a wrap party at the Sutton Place Hotel in Toronto. "The wrap party was a blur," says Jocelyn Stevenson. "We were all incredibly sad and felt discombobulated, knowing we would no longer be seeing the people we'd basically been living with for the past five years. When *Fraggle Rock* ended, I literally felt as if I emerged, blinking, into the sunlight."

"Truth be told," adds Dave Goelz, "the wrap party was very emotional, and I can't remember many details. The tributes were

HENSON ASSOCIATES, INC.
117 EAST 69 STREET
NEW YORK, N.Y. 10021
(212) 794-2400 TELEX-420750 PRODUCERS OF THE MUPPETS

April 4, 1985

TO: Jim
 Michael
 Duncan
 Diana

CC:
 Larry
 Jocelyn

FROM: Jerry

RE: "Change of Address"

I just wanted to thank you guys for your responses to the "Change
of Address" script.

Ending this show is tough for all of us in different ways.
Certainly it is hard for you, who, to paraphrase Duncan, helped
give birth to the baby, but have not had a chance to participate
in the day-to-day activties of raising it. Quite naturally,
things have not gone entirely the way you expected or hoped.
Like kids, a television series grows and evolves through
thousands of small, daily decisions. I hope that there are
things about the show that each of you think HAVE gone well.

Anyway, here I stand, in the middle of the nursery where I've
been for the last few years, looking at the kid we have reared,
aware of his (her?) faults, but pretty damned proud nonetheless.

Now I will do away with that metaphor before it takes over this
memo and runs amok.

Jim and Diana have expressed their opinions to me by telephone.
So just for the record, let me try to summarize their responses
(if I'm not accurate here, you two will have to write your own
memos, dammit!):

Jim, never one to miss an opportunity to poke me in the ribs,
started out by reminding me that he had always been against
anything that smacked of a conclusion. Nonetheless, he said that
he liked much of what the script was about and what we were
trying to say. He seemed especially enthusiastic about what we
are saying concerning magic. And he was happy with the idea of
Doc seeing a Fraggle. What bothered him was Doc permanently
moving from the the workshop, partly because of the syndication

problems this creates. He suggested that Doc not sell the
workshop, but close it down for a trip to the desert to help Ned,
clearly meaning someday to return.

I have told Jim I will experiment with this idea, and even do a
draft to try it out. I can't go too far, or I lose all the
dramatic risk, but I'll work with it awhile.

Diana, in expressing her feelings, has been as shy and soft-
spoken as she alaways is, but I think I have detected some mild
disapproval. Actually, she feels strongly that there should be
NO ending to the show. She thinks the final episode should be
just another story, because she likes to think of Fraggle Rock as
unchanging and unchangable. So Doc would not see Gobo, Doc would
not move.

And Duncan has proposed another, very interesting, story,
different from mine, but quite eloquent and moving. And one that
has an even stronger sense of finality (at least in one sense)
than mine.

And Michael would rather we be moving in other, deeper, larger
realms altogether.

Well, I know this much: we all aren't going to be happy!

In the coming weeks, all of the ideas you've expressed WILL be
seriously discussed by us in Toronto. I promise.

Meanwhile, thanks for input and the help.

What's really wonderful about this is that we all still care so
much for these little guys.

Love,

Jerry

Pst! Y'WANTA GO TO A PARTY?

FRI'DAY, MAY 16TH 1986, 7:00 PM
SUTTON PLACE HOTEL, 955 BAY ST.
STOP 33

7:00-8:00 pm: DRINKS
8:00-9:00 pm: DINNER
FOLLOWED by
ENTERTAINMENT
&
DANCING!
DRESS: FESTIVE
RSVP
JANIS OR SAVERINA
967-6864

FRAGGLE WRAP

©ha! Inc., '86 MKF

"It really is that the magic is in everybody and perhaps even things that aren't living. It transcends all of us. You cannot leave the magic."
LAWRENCE S. MIRKIN

deeply felt and sincere. We were in the grand ballroom on the top floor of the Sutton Place Hotel, surrounded by glass walls facing east, south, and west. The lights of Toronto sparkled outside, and the reflections of dear sparkling souls danced across the glass."

At the end of the party, Jim Henson got up to give a speech. "This whole project of *Fraggle* has been a joy from the beginning," he said. "It's fun when you start out trying to do something that makes a positive statement. I think the body of work of *Fraggle Rock* is something that's going to stay around.

And I think it's something we're all going to be proud of for a long time. And I think . . . that's really nice."[24]

"Jim wanted to make a difference," said Jerry Juhl. "And he was brave enough to walk into a crowd of people and say, 'I want to do a show that brings peace to the world.' He knew the impossibility of a television show bringing peace to the world, but he wasn't so cynical as to say we can't think about it. This was a kind of idealism that could seem naive and childlike and foolish. But that didn't mean that it couldn't come true."

TOP The Michael K. Frith–designed invitation for the *Fraggle Rock* final wrap party in 1986.

INSERT A memo from Jerry Juhl regarding the final episode of *Fraggle Rock*, "Change of Address."

PART FOUR

THE MAGIC CONTINUES

EXPANDING A UNIVERSE

MICHAEL K. FRITH HAS ALWAYS INSISTED THAT the Things We Know About lists he worked up with Jocelyn Stevenson and Jerry Juhl back in 1981 were never meant to be what television producers sometimes call a "bible"—a reference document of characters, stories, themes, and designs that define what a TV series will be. That's because, according to Frith, he never thought of *Fraggle Rock* as a television show.

"My background was in children's books before I got into the TV game," Frith explains. "I have very, very strong feelings about the aims of storytelling, and about the length and the strength and the depth and the importance that stories can have." Frith recalls that when the *Fraggle Rock* brainstorming sessions began, everyone involved repeated "almost like a mantra" that they were "creating a world." He adds, "And it had to be a world that could exist in any medium: as books, as games, as toys, and even just as pure pieces of stand-alone art."

At the time, Frith was the director of creative services at Henson, which meant he had oversight on every toy, game,

book, and puzzle. The extent of Henson Associates' ambitions for the Fraggle universe is evident in the correspondence that flew back and forth between Frith and others inside Henson Associates in the project's early years. The long-range product plan circulated by the licensing department executive Betts FitzGerald in November of 1982 included playsets, pajamas, musical instruments, a dining set, and toiletries—all designed to be produced in a way that respected the integrity of the *Fraggle Rock* concept. Furthermore, in a "Marketing Principles" document that circulated internally at Henson Associates in mid-1983, the bullet points included statements like "We are here to support the characters not exploit them,"

CAVE

© ho! Inc '85

HBO
FRAGGLE
ROCK

MKF 9/6

LEDGE FOR
"WALKAROUNDS"
TO REST ON

"Money is a secondary objective," and "We will not just add a picture of the character to a commodity product that makes no sense."

Meanwhile, big-picture plans on an internal "Fraggle Wish List" included a Macy's Thanksgiving Day Parade float (a wish that was realized, in 1983 and '84), a chain of theme parks, a traveling *Fraggle Rock* van that would visit schools across the US and Canada, a syndicated advice column in family

and children's magazines, and a lavishly illustrated book offering a behind-the-scenes look at the making and meaning of *Fraggle Rock*.

Giving fans a peek behind the curtain was something Jim Henson believed in strongly. The summer after *Fraggle Rock* debuted its final episode, HBO aired *Down at Fraggle Rock*, a documentary that revealed the trade secrets and the deep passion of the craftspeople and performers who brought the

TOP In 1983, an HBO-sponsored *Fraggle Rock* float made its debut at the Macy's Thanksgiving Day Parade, based on this concept design by Michael K. Frith.

OPPOSITE BOTTOM In 1984, the float was redesigned by Michael K. Frith to include Junior Gorg, though in the final version, he stood in the middle, trying to catch "Fwaggles."

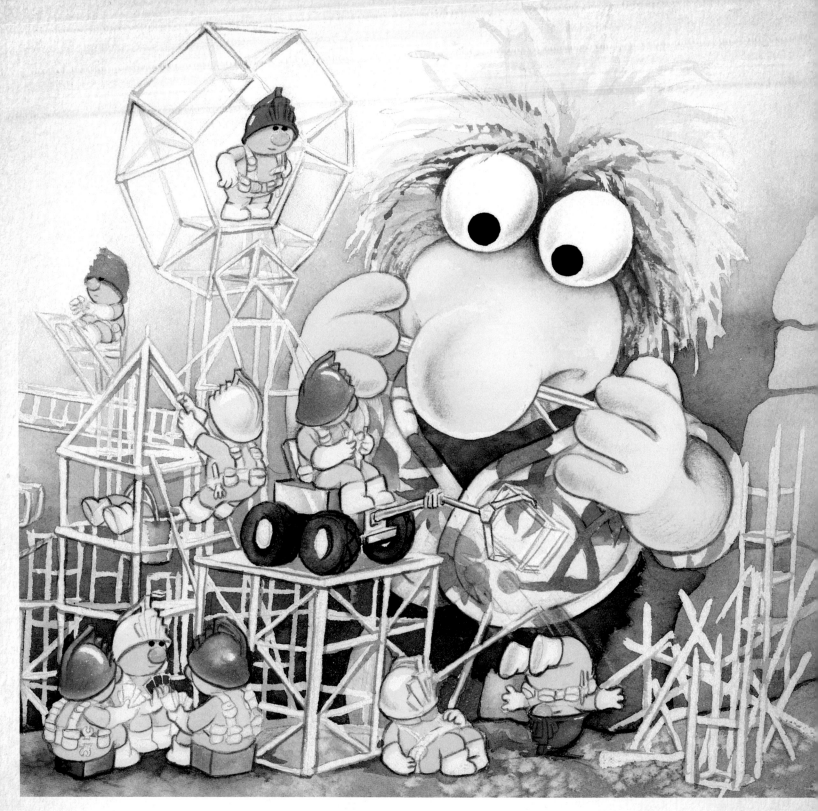

TOP Illustration by Sue Venning for the Fraggle storybook *What Do Doozers Do?*

show to life. The special aimed to inspire the audience to be creative themselves, by showing how fun and rewarding it can be to get together with a group of good people and overcome tricky technical challenges to tell a story. Originally airing July 13, 1987, *Down at Fraggle Rock* would go on to win an ACE Award and a Gemini award, and was nominated for an International Emmy.

At the core of this documentary and all the other potential *Fraggle Rock* projects was the goal of sharing with the world an idea expressed in another intracompany memo from October 1984 concerning that frequently cited *Fraggle Rock* word: *magic*. "Magic in Fraggle Rock," the memo reads, "manifests itself as music, light, water, and joy . . . It is, in fact, the same level of magic which a happy, secure child might find in the real world. The same magic that creates imaginary playmates, and animals that speak, animates Fraggle Rock."

The goal was always to spread that magic outside the confines of the HBO show. What Frith and his team would ultimately find, though, is that magic is tough to plan. It happens on its own schedule, and in its own way.

GETTING ANIMATED

FRAGGLE ROCK'S ORIGINAL RUN ON HBO ended in March 1987. Six months later, Jim Henson Productions and Marvel Productions (the movie and TV arm of Marvel Comics during this period) debuted the NBC Saturday morning cartoon *Fraggle Rock: The Animated Series*. At the time, Henson and his creative team touted the freedom of animation, and how it enabled them to continue the adventures of the Fraggles, the Gorgs, and the Doozers without having to consider whether any of their more outlandish ideas could be translated into physical constructions and puppetry. As Frith puts it, "We'd taken puppetry to places it had never been before, but it still had limitations." Conversely, with animation, if the creative team wanted to include a scene in which Junior Gorg's giant hand yanked a radish from the ground right above the Doozers and caused a mini-earthquake, they could do it, and not think twice about how to realize the moment onscreen.

Appearing on *Good Morning America* on September 7, 1987, Henson compared the new animated *Fraggle Rock* to the company's already successful Marvel coproduction *Muppet Babies*: "What we were trying to do [with *Muppet Babies*] was to do something that related to kids' imagination, and I think it worked very well with that show. And now what we're trying to do with *Fraggle Rock* is maintain the sort of philosophy that we used for the show itself, which is basically a nice philosophy about kids getting along with other kids and understanding other people's points of view."

The new show would certainly have seemed familiar to fans of the HBO version. Though nearly every story lasted less

BOTTOM Cartoon versions of Wembley, Red, and Mokey appear in "Fraggle Fool's Day," an episode of the animated *Fraggle Rock* series.

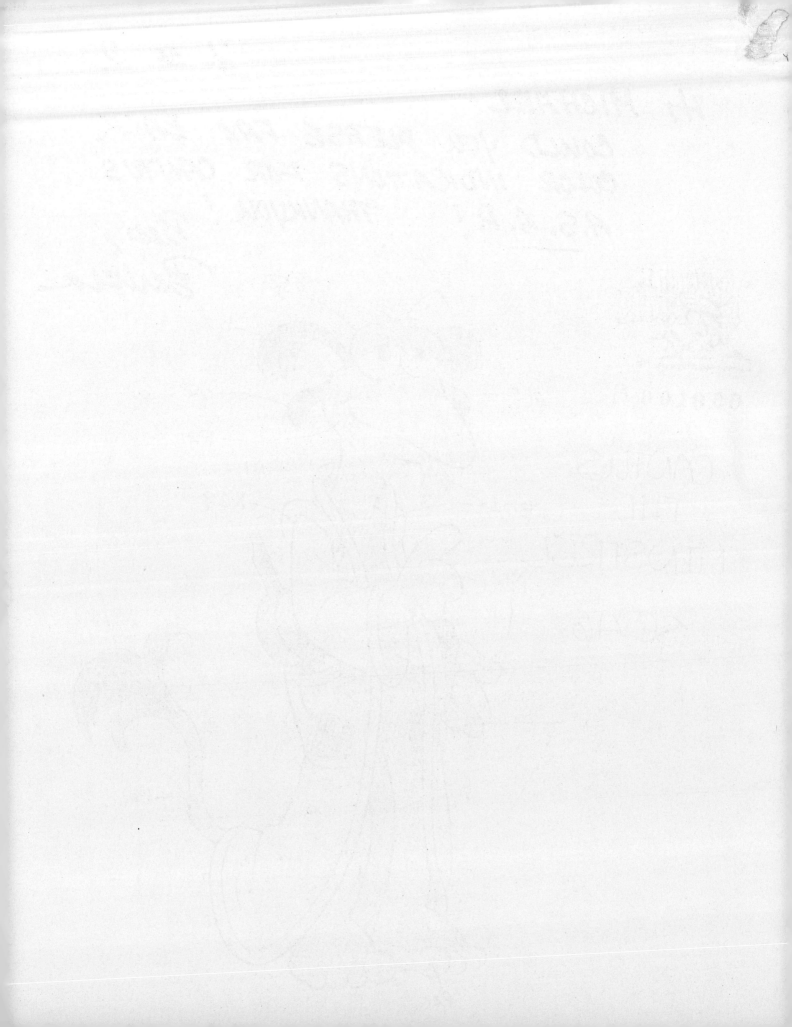

than fifteen minutes (with two stories per episode), that time was typically divided between the usual *Fraggle* factions, with Doc and Sprocket, the Gorgs, the Doozers, Uncle Travelling Matt, and Marjory the Trash Heap all represented. (Michael K. Frith is especially proud of the Travelling Matt segments, which put the cell-animated uncle into live-action footage of the real world.) The premises for the episodes wouldn't have been out of place on classic *Fraggle Rock* either: for instance, "The Great Radish Round-Up," in which the Gorgs try to rid themselves of their Fraggle pests by planting poison berries in place of radishes; or "A Fraggle for All Seasons," in which Mokey looks for a Fraggle who can fulfill an ancient prophecy.

Michael K. Frith was a producer on *Fraggle Rock: The Animated Series* and found the lengthy development process unusual, because instead of having to begin by spending time visualizing a new idea, he already had characters and a setting to work with. "When you're designing for a puppet, you can get pretty elaborate," he says. "When you move into animation, suddenly everything becomes much more simplified. What was filled with different kinds of textures really comes down to basic shapes." But Frith also recalls the pleasure of the challenge, "re-creating those characters I so loved for this new medium." As early as a year before the first animated episode aired, he was faxing drawings to Marvel Productions and getting back notes on how to refine and simplify the Fraggle look for a cartoon.

The simplifications extended to the way the characters were portrayed. Though Boober, Wembley, and the gang still had their same personality traits, they were more broadly comic, meant to appeal to the very young audience that tuned in to the Smurfs and Alvin and the Chipmunks cartoons that flanked *Fraggle Rock: The*

> "What we're trying to do . . . is maintain . . . a nice philosophy about kids getting along with other kids and understanding other people's points of view."
> **JIM HENSON**

BOTTOM Uncle Travelling Matt and Red from a model sheet for the animated *Fraggle Rock* series.

INSERT The animated version of *Cantus the Minstrel.* This image was sent to Michael Firth by Marvel Productions so that he could confirm the character's colors.

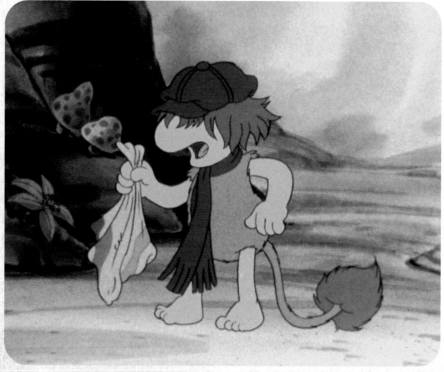

Animated Series on NBC. Frith acknowledges that adjusting to this change was also a challenge, and not always as enjoyable as working with puppets. "*Fraggle Rock* was really a very different kind of thing for Saturday morning television," he says, "and I can, in retrospect, understand why there was a bit of a learning curve for the writers." The storytelling formula for Saturday morning shows was geared more toward heroes and villains, and Frith had to emphasize that, in the Fraggle universe, "There are no villains."

Frith has nothing but praise for the storyboard artists, animators, and voice actors who worked on the show. Because the recording was done in Los Angeles—far from where the core crew of Henson puppeteers were based—the original *Fraggle Rock* actors were unable to play Gobo, Red, Mokey, and the rest. But, Frith says, "The voice actors fell in love with those characters and went deep, deep, deep into them. They worshipped our original Muppet performers and did everything they could to translate what they were doing into the animated characters . . . and did, by and large I think, a really nice job."

But Frith also admits that it took a while for his fellow writers

and producers on the animated series to become comfortable enough with the philosophy of *Fraggle Rock* "to make these shows work and make them fly." Just around the time that Frith felt the animated series was really starting to click, NBC chose not to renew it for a second season. The show debuted September 12, 1987, and on December 5 of that year NBC aired the last of the thirteen episodes.

"That was heartbreaking," Frith remembers. "Because so many people had put so much work into it. And just speaking for myself, designing and redesigning and re-re-designing those characters for animation and working with the animators, who were putting their hearts and souls into it . . . to see all of their work just suddenly gone was a heartbreaker."

He adds: "I remember sitting in our conference room in one of our executive sessions and turning to Jim. I said, 'NBC is not renewing. What am I going to tell all those people who poured themselves into this?' And Jim said, 'Well, you're going to have to use the chowderhead excuse.' I said, 'What? The chowderhead excuse? What's the chowderhead excuse?' He said, 'Oh, it's easy: "NBC! They're a bunch of chowderheads!"'"

"That was as good as anything," Frith recalls with a laugh.

OPPOSITE TOP The Fraggle Five help Uncle Matt when he loses his memory in the "Homebody Matt" episode of the animated *Fraggle Rock.*

OPPOSITE BOTTOM Boober in the animated *Fraggle Rock* series.

TOP A background created for the animated *Fraggle Rock* featuring the Gorgs' castle.

BOTTOM Concept sketch of Ma Gorg for the animated *Fraggle Rock.*

PAGE-TURNERS

BECAUSE CABLE TELEVISION—AND ESPECIALLY HBO—was still a luxury in a lot of American households in the early 1980s, some of *Fraggle Rock*'s target audience first got to know the characters through picture books. In 1983, publishing house Holt, Rinehart and Winston launched a line of Fraggle books, starting with the forty-eight-page hardcover storybook *The Radish Day Jubilee*, and eventually extending to coloring books, activity books, pop-up books, and calendars.

Though some familiar *Fraggle Rock* writers—including Jocelyn Stevenson and David Young—were credited as authors on the books, in actuality many of these children's books were adaptations of existing HBO episodes, drawing on the original scripts, with no actual new contributions by the original scriptwriters. Jane Leventhal, who oversaw the publishing program at Henson Organization Publishing (or HOP!), had a gifted staff of in-house writers and editors who also turned out original stories alongside the adaptations. One of the originals—*The Legend of the Doozer Who Didn't*, by the prolific HOP! writer-editor Louise Gikow—was even referenced in an episode of the show, the title cited by Cotterpin's parents as a cautionary tale about the importance of work in Season 2's "All Work and All Play."

By May of 1984, when Jim Henson himself appeared at the Henson Organization Publishing booth at the American Booksellers Association trade fair, more than half a dozen *Fraggle Rock* books were either available for sale or in the works, with translated versions about to be published across Europe. Karen Falk, director of the Jim Henson Company's archives, describes the success of the *Fraggle* book line: "The tremendous care that went into crafting each *Fraggle Rock* script made the transition to storybooks seamless. It was easy to take fully formed storylines with characters that translated well into artwork and make compelling reading experiences for children."[25]

Michael K. Frith, who consulted on the books, had started his career in publishing and took pride in the quality of the *Fraggle Rock* titles that the team was producing—titles that he saw as a natural extension of the original concept he had created with his Henson colleagues. He recalls that when he first started passing the Things We Know About

THIS PAGE The French-published *Fraggle Rock* versions of the storybooks *If I Were King of the Universe* and *The Tale of Travelling Matt*.

D'après les marionnettes de Jim Henson

Ah! si j'étais roi

Textes de Danny Abelson
Illustrations de Lawrence Difiori

Hachette jeunesse

D'après les marionnettes de Jim Henson

Mon oncle Matt est un globe-trotter

Textes de Michaela Muntean - Illustrations de Lisa McCue

Hachette jeunesse

"I could think of no other medium I'd rather see this new world explored in than a book."
MICHAEL K. FRITH

Un libro de Fraguel Rock M.R. con los Muppets M.R. de Jim Henson

Nadie sabe a dónde va Gobo

Mark Saltzman. Ilustraciones: Peter Elwell

PLAZA JOVEN
POJ
EDICIONES

concept booklet to potential licensees, one of them looked up at him in wonder and said, "But . . . but . . . it's so . . . *literary*!" The remark delighted Frith. "With my background as a kids' book editor, I could think of no other medium I'd rather see this new world explored in than a book," he says.

As an artist himself, Frith worked closely with the illustrators. But not *too* closely, because he wanted to avoid any kind of generic "house style" for the Fraggle drawings.

"My aim," Frith says, "was to remind the book illustrators that these were actual three-dimensional 'living' things, and to encourage these very talented artists to see them through their own eyes, bring their own stylistic strengths and quirks to their depictions. It was—back then, anyway—a novel idea. And we got some wonderful results."

They also got some wonderful sales figures. A 1985 Henson Associates newsletter notes that the forty-plus *Fraggle Rock* books they'd published over the previous two years had sold over a million copies combined.

FRAGGLARNA

Vad gör Doozar?

Text: Michaela Muntean · Illustrationer: Sue Venning

TOP Spanish edition of the storybook *No One Knows Where Gobo Goes.*

BOTTOM Swedish version of the storybook *What Do Doozers Do.*

MARVEL STARS

THROUGHOUT THE 1970S AND INTO THE '80s, major American comics publisher Marvel Comics began to introduce mature themes and content into its superhero and science-fiction/fantasy comics, and in the process began shedding some younger readers. In an effort to correct a worrying trend, Marvel created a new imprint, Star Comics, that would offer these kids some quality "gateway" comics to read. The imprint launched in 1984 with an adaptation of the movie *The Muppets Take Manhattan*.

Building on the Henson-Marvel relationship, Star Comics began publishing an ongoing *Fraggle Rock* series in 1985, written by Stan Kay and drawn by respected industry veteran Marie Severin, who'd been working as a colorist and penciller since 1949. "Marie was a terrific cartoonist and a delightful person to work with," Michael K. Frith recalls. Although Frith

> "[Marie Severin] is one of the most influential and most important female comic book creators of the last fifty years."
> STEPHEN CHRISTY

had to do some "blue-lining" occasionally, referring to his habit of using soft-lead blue pencils to suggest corrections to a piece of art, he felt that Severin's talent "was such that she was able to jump right in and deliver great stuff."

The first two *Fraggle Rock* issues featured original stories, but issues #3 through #8 adapted some of the TV show's most popular stories, like "Believe It or Not" and "The Great Radish Caper." Unlike the picture book authors, the writers of those episodes went uncredited in the comics. Kay and Severin were listed as the creators, although Frith says that the staff at HOP! made suggestions and corrections at every stage of the process.

The comic book version of *Fraggle Rock* ran for only eight monthly issues before being canceled in 1986. Marvel began reprinting the comics in 1988 (after the demise of the Star imprint) to capitalize on the arrival of the animated show. The reprint series lasted just five issues.

In 2010, Stephen Christy, editor-in-chief for the comic book publisher Archaia, forged a business relationship with The Jim Henson Company. The Henson team licensed some of its properties to Archaia for comic book adaptations, and opened up its archives to allow Christy and his team to tap the well of ideas for unmade projects, and make use of material that was sitting idle.

"There wasn't a lot in the *Fraggle Rock* archives that hadn't been produced, but the Marvel comics were just sitting there," Christy says. Because no one at Henson or Marvel could locate the original artwork, Archaia had to retouch and recolor scans of old copies of the comics. But he says it was worth it to preserve the work of Marie Severin. "She is one of the most influential and most important female comic book creators of the last fifty years," he says. "And she was a titan at Marvel during her time there."

Since 2010, Archaia (bought by Boom! Studios in 2013) has also published several original *Fraggle Rock* comics, tapping

BOTTOM *Cover of* Fraggle Rock #5 *published by Marvel Comics in December 1985*

popular kids' comics creators of today like Jeffrey Brown and Katie Cook to write and illustrate projects that have ranged from fun short stories aimed at young kids to longer multipart epics that Christy describes as "what a *Fraggle Rock* movie would look like on paper." Christy has taken the same approach to these books as Michael K. Frith did in the '80s, encouraging artists to make the Fraggles their own. "We told those folks that we didn't want them to change their style to do the Fraggles," he says. "Henson gave us the freedom to do that. They didn't have to. These characters are obviously hugely important to them. But they felt like it would be really cool for fans to see different artists interpreting the Fraggles in different ways."

The only catch? Every artist Archaia hired had to love the show. "That was our one criteria," Christy says. "You can bring your artistic sensibility to the table, but you have to be a *Fraggle Rock* fan."

THIS PAGE *Boober the Doozer* — Page 1, Volume 1 of the anthology comic book series by BOOM! Studios/Archaia, published May 1, 2010, for Free Comic Book Day.

LET THE FRAGGLES PLAY

BECAUSE MICHAEL K. FRITH HAD BEEN INVOLVED with the toy lines for *Sesame Street* and *The Muppet Show*, he had high hopes for what the *Fraggle Rock* toys could be, dreaming of a line of innovative educational devices that would extend the show's message of community and interconnectivity. He pictured musical instruments and music-themed activities, and kits that would take children through the phases of puppetry design and building. He imagined board games that would teach about the water cycle, and Doozer construction sets with elementary learning elements.

TOMY'S GONE SOFT ON JIM HENSON'S FRAGGLE ROCK PLUSH TOYS.

Heading into 1983, Henson managed to lock down licenses with the Tomy toy company for five plush dolls (Gobo, Red, Mokey, Wembley, and Boober, with Uncle Travelling Matt and Sprocket later joining the line) and four Doozer windup toys. All these products were introduced at the February 1983 Toy Fair, and were on shelves that fall. The following year, Milton Bradley released a *Fraggle Rock* board game, the object of which was to transport postcards between Doc's workshop, Marjory the Trash Heap, and the Swimming Hole. The Fraggle toy line would eventually expand to include puzzles, View-Master reels, and Colorforms sets.

But Frith admits he was disappointed with what toy-making technology was capable of at the time, and what the toy companies were interested in producing: "It was really, really hard to create dolls, puppets, and so forth that were true to the original characters. We had to go back and forth many, many times between our vendors and our people in the shop, who would have to make, remake, repattern, and so on, to get them to something that was, to my eye, acceptable." To Frith, the plush toys and windups were just "cute," and not the cutting-edge learning tools he'd hoped to produce.

For political reasons, Henson Associates had to tread a very narrow line with their merchandise circa 1983. In 1981, President Ronald Reagan's new Federal Communications Commission chairman, Mark S. Fowler, had loosened the regulations preventing American TV programs aimed at kids from directly promoting toys. What followed was a wave of cartoons like *My Little Pony*, *G.I. Joe*, and *He-Man and the Masters of the Universe*, in which each episode effectively functioned as a half-hour ad for action figures and playsets. This was soon followed by a backlash to blatant commercialism, with parents' groups in the US and regulatory commissions abroad demanding that overly commercial shows be yanked from the air.

So when Duncan Kenworthy and the Henson Associates' Product Group undertook a presentation for UK retailers in November of 1983, they had to word their remarks carefully, to make it clear that their company should be recognized primarily as a producer of TV and film, and that "the licensing of products, publishing, software, music, etc., are all support mechanisms to enhance our principal endeavor, production." In other words: They weren't making shows to sell toys; they were making toys to sell shows.

Given the company's squeamishness over skewing too commercial, it's all the more ironic that Michael K. Frith's best experience with the Fraggle toy line came from an unexpected source: McDonald's. "I've never been in a McDonald's in my life," Frith says with a laugh. And yet, in 1987, when the newly renamed Jim Henson Productions set out to promote *Fraggle Rock: The Animated Series* with a line of Happy Meal toys, Frith was amazed at how creative and conscientious the fast-food giant's product development team was.

The only snag? Frith wanted the Fraggle vehicles to be slightly off-center, so that they'd wobble a little when kids pushed them. When next he met with the McDonald's toy engineers, they gave him a solemn look and told him they'd had to put the axles in straight. When Frith asked why, they replied, "We did a focus test, and the moms thought they were faulty."

Whether or not the Happy Meal toys were as offbeat as Frith had hoped, they remain popular with *Fraggle Rock* fans, fetching impressive prices on the collectors' market. Like the other Fraggle merchandise released in the '80s, they became part of the experience of the show for a lot of kids—and part of the magic that keeps *Fraggle Rock* alive.

OPPOSITE LEFT Advertisement for the Tomy *Fraggle Rock* plush dolls released in 1983.

OPPOSITE RIGHT Boober Fraggle Tomy plush doll.

THIS PAGE The Tomy plush versions of Red (top), Gobo (left), and Wembley (right).

ROCKING IN THE NEW MILLENNIUM

BY 1990–THE YEAR JIM HENSON TRAGICALLY DIED, at the age of 53–the Fraggles had eased into semi-retirement as a pop culture phenomenon. Outside of repeats and home video releases, *Fraggle Rock* wasn't a vital and ongoing presence on television anymore, as either a cartoon or a live-action show. The Marvel Comics line had been canceled. No new Fraggle-related children's books were being published. The characters were put back on the shelf . . . but not for long, because by the time the twenty-first century arrived, the generation who'd grown up with the show was ready to return to the Rock.

In 1998, The Jim Henson Company and Hallmark Entertainment bought stakes in the cable channel Odyssey Network and started re-airing some shows from the Henson vault—*Fraggle Rock* included. Not long after that, new merchandise started appearing in stores: T-shirts, CD collections of *Fraggle* music, DVDs, and calendars.

In 2009, The Jim Henson Company partnered with the Canadian children's entertainment production company DHX Media (later to be renamed WildBrain Ltd.) to pitch *Doozers*, an animated series aimed at young children. Back around 1993 and '94, Jim Henson Productions had pitched another animated Doozers series, which would have followed Cotterpin

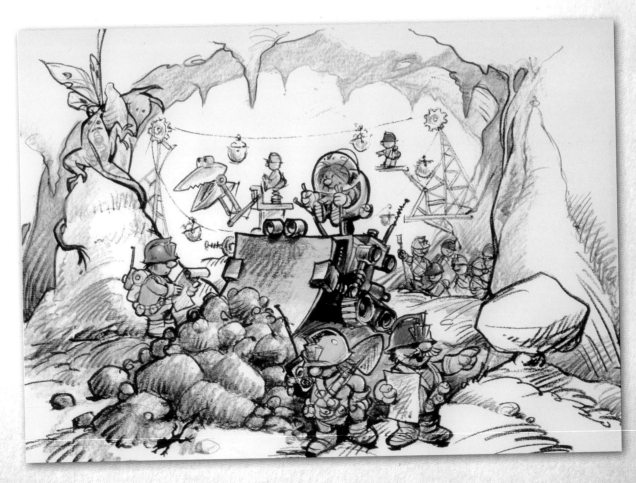

BOTTOM Michael K. Frith's *Doozers at Work* development art for a proposed but unrealized 1990s animated Doozer series featuring Cotterpin and her friends.

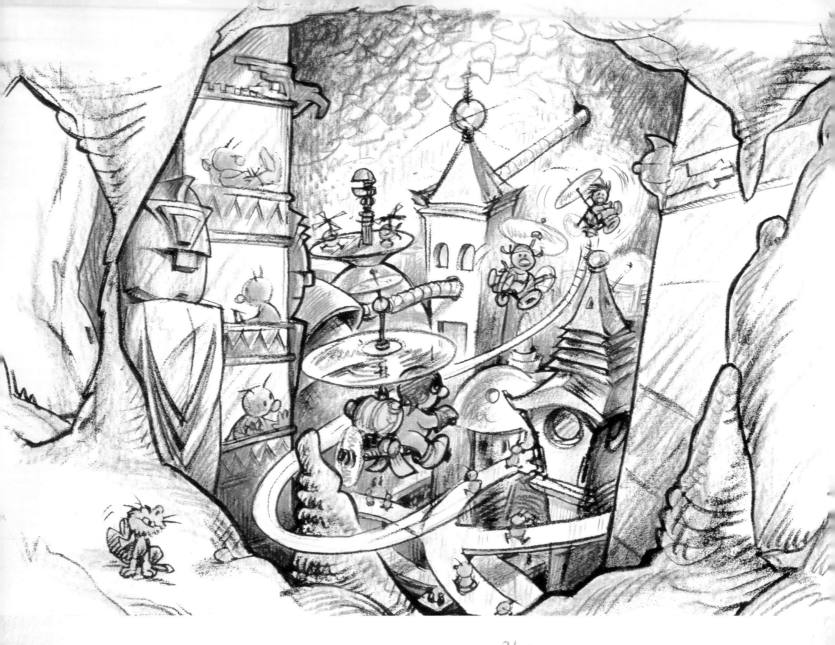

and her fellow misfits Lugnut, Patch, and Downspout, as they came up with their own offbeat solutions to Doozer problems. Unfortunately, the show never made it to the screen, although Michael K. Frith produced some visually stunning concept art for the project.

The idea of creating a stand-alone Doozers show never quite went away, though. "Even when the *Fraggle Rock* series was made, [we were] curious about the world of Doozers, and the possibility one day of giving Doozers their own show," says Lisa Henson. "They were very intriguing; they were not the stars of the show, but they had their own little world going on."[26]

The CG-animated Doozers show debuted in the US on Hulu in 2014 and was also picked up by networks and streaming services worldwide. *Doozers* follows the adventures of "the Pod Squad," four young Doozers—Spike, Molly Bolt, Flex, and Daisy Wheel—who spend their days coming up with crafting and construction projects meant to solve big and small problems around their community. They use technology, tools, nature, and thoughtful planning to help each other and their elders. The stories on *Doozers* are for preschoolers, involving simple

TOP *Doozers at Home* development art by Michael K. Frith for the 1990s animated show pitch.

BOTTOM The Architect teaches Cotterpin, Lugnut, Patch, and Downspout in development art for the 1990s animated Doozer series.

problem-solving; and the computer animation is much slicker than the old rod-and-motor puppets. But the producers have retained the original appeal of the characters, from their single-minded industriousness to the way their little mouths open and close in a charmingly mechanical way.

Speaking about *Doozers* in 2014, Lisa Henson highlighted how the show was intended to present "an innovative curriculum about creative thinking, inventing, and design thinking." She added that it was very important to the *Doozers* creative team that the heroes rarely solve their problems right away. "There's no instant success," Henson said. "In fact, in many of our episodes, they never really solve the original challenge, but come up with something else along the way, or they fail and then try something different and solve it that way. We really like some of the teamwork and creative thinking that we're modeling in the show."[27]

While the Doozers have enjoyed some time in the limelight, in recent years the Fraggles have popped up in a Taco Bell kids' meal promotion, and they've begun to have a presence on the collectibles market, with Funko Pop! figures, special-edition plush toys, and vinyl mini-figures available at comics shops and online retailers. The characters have also finally begun fulfilling some of Michael K. Frith's original dreams for Fraggle merchandise by appearing in educational apps for mobile phones and tablets. Apps like *Fraggle Friends Forever*, *Fraggle Rock Game Day*, and *Doozers Play-Along Stories* have helped preschoolers learn to read, while "Doozer Creek" and "Fraggle Rock Music Maker" have turned the world of the Rock into an interactive location where kids can build with virtual blocks or tap out tunes.

But perhaps the most surprising reappearance of the Fraggles (outside of perhaps a short parody in a 2008 episode

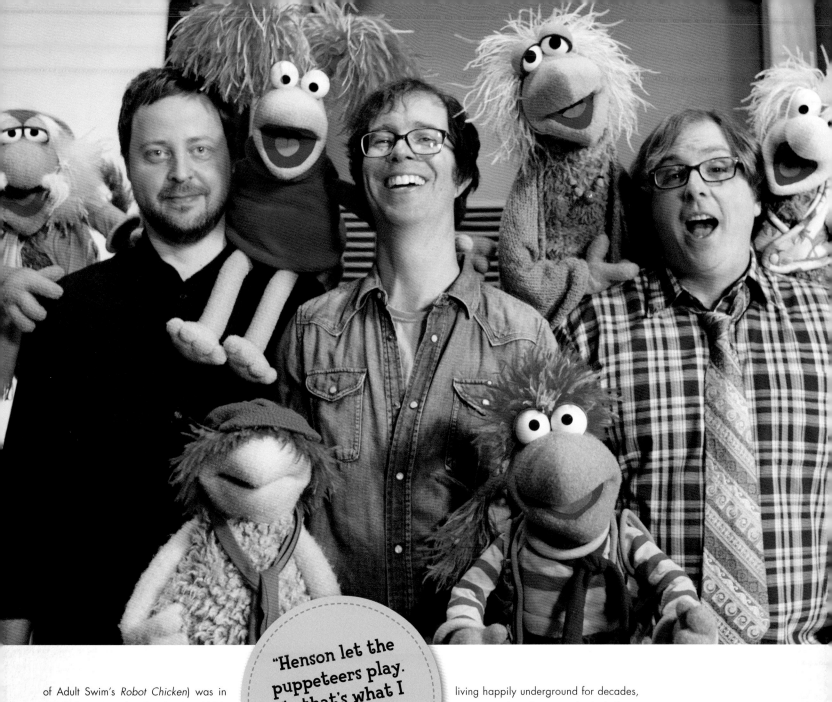

"Henson let the puppeteers play. So that's what I tried to do."
PHILIP HODGES

of Adult Swim's *Robot Chicken*) was in a 2012 music video for the Ben Folds Five song "Do It Anyway." Initiated by The Jim Henson Company, and produced in collaboration with Nerdist Industries, the video features the Fraggle Five bopping around in a recording studio with the band, as Uncle Travelling Matt roams about and presenter Chris Hardwick (founder of Nerdist), comedian Rob Corddry, and actress Anna Kendrick each join the party. At the end, the Silly Creatures and Red (performed by Karen Prell) sing the *Fraggle Rock* theme.

The video was shot on the Henson lot, in Henson Recording Studios, and directed by Philip Hodges, a filmmaker and puppetry enthusiast who considers Lisa Henson a mentor. Hodges says he worked with the Henson team on the concept of "reintroducing the Fraggles to the world" in a simple way, by creating a scenario where the Fraggles had been living happily underground for decades, unaware that humans had built a recording studio above their home. The idea of having them suddenly reemerge from their caves was "to rewind to that initial fun that you experience when you see the Fraggles for the first time."

Rather than using refurbished versions of the old puppets, Henson's New York workshop created entirely new models of the Fraggle Five. But having Prell on the set helped connect the new to the old, Hodges says. "She brought an energy and an excitement about the project that legitimized it. Just seeing her put on the puppet made everyone else rush to put their puppets on and get into character." During the shoot, Hodges encouraged everyone to be spontaneous and to bring their own personalities into their performances, just like the cast and crew used to do on *Fraggle Rock*. "Henson let the puppeteers play," Hodges says. "So that's what I tried to do."

OPPOSITE TOP Spike, Daisy Wheel, Mollybolt, and Flex from 2014's *Doozers*.

OPPOSITE BOTTOM LEFT Flex, one of the stars of *Doozers*.

OPPOSITE BOTTOM RIGHT Concept for a radish-harvesting machine created for a 1980s storybook by Sue Venning called *What Do Doozers Do?* The book celebrated all things Doozer-related and proved to be a good jumping-off point for the *Doozers* series.

ABOVE Darren Jessee, Ben Folds, and Robert Sledge of Ben Folds Five in a publicity photo with the Fraggle Five and Uncle Travelling Matt.

A FRAGGLE FUTURE

IN 2020, EIGHT YEARS AFTER THE Ben Folds Five video, the Fraggles made a triumphant return to the screen in *Fraggle Rock: Rock On!*, a series of shorts made for the Apple TV+ streaming service.

Created during the COVID-19 pandemic, the show aimed to provide hope and inspiration to families during one of the most challenging times in recent history. Karen Prell performed as Red again, with Fraggle newcomers John Tartaglia and Donna Kimball voicing and performing Gobo and Mokey, respectively. Dave Goelz returned to voice both Boober and Uncle Travelling Matt, while another new addition, Frankie Cordero, voiced Wembley. Shot during the pandemic lockdown, from the homes of each performer, the shorts delivered a huge amount of *Fraggle Rock* fun. Notably, the Fraggles in the show use a system of "Doozertubes" to communicate with people in the outside world, allowing for appearances by a range of sensational celebrities and musical guests including Common, Tiffany Haddish, Ziggy Marley, Alanis Morissette, and Jason Mraz. Also appearing in the show was lifelong Fraggle fan Neil Patrick Harris.

Building off the goodwill generated by *Rock On!*, in 2020 The Jim Henson Company and Apple TV+ also announced an official reboot of *Fraggle Rock*, with full-length episodes that embody the grander scale stories for which fans have been clamoring. One thing is certain, the new production will continue to reflect the principles of the original series and respect the values of *Fraggle Rock*, as eloquently expressed by Jerry Juhl in a 1985 memo.

BOTTOM: The Fraggles assemble virtually in a scene from *Rock On!*

OPPOSITE: Concept design of the Gorgs' castle for the new Apple TV+ *Fraggle Rock* series.

"*Fraggle Rock was always that sort of very precise little gem.*"
BRIAN HENSON

"The goals of *Fraggle Rock* as I understand them have always been just a bit more idealistic than those of many other HA projects," Juhl wrote. "In the production offices of this show we are openly and unashamedly trying to produce classic children's storytelling of the kind achieved by L. Frank Baum or A. A. Milne. We have, in other words, set ourselves goals we know are worth the striving. As Larry Mirkin says, 'We are in service of the idea.'"

Brian Henson is quick to point out that this kind of concern about protecting the brand isn't unusual for *any* Henson franchise. "I think quality is very important in everything that we do," he says. "We try to make everything the highest quality that we can. It's the most fun, frankly. When you put together a whole bunch of artists—and everything that we make takes hundreds of artists all working in concert—and really try to create a product that has a very high level of excellence, it's just far more rewarding for everyone."

That said, Henson does admit that the company might be a little more protective than usual toward the Fraggles because of the pure-hearted motives behind the original show: "*Fraggle Rock* was always that sort of very precise little gem."

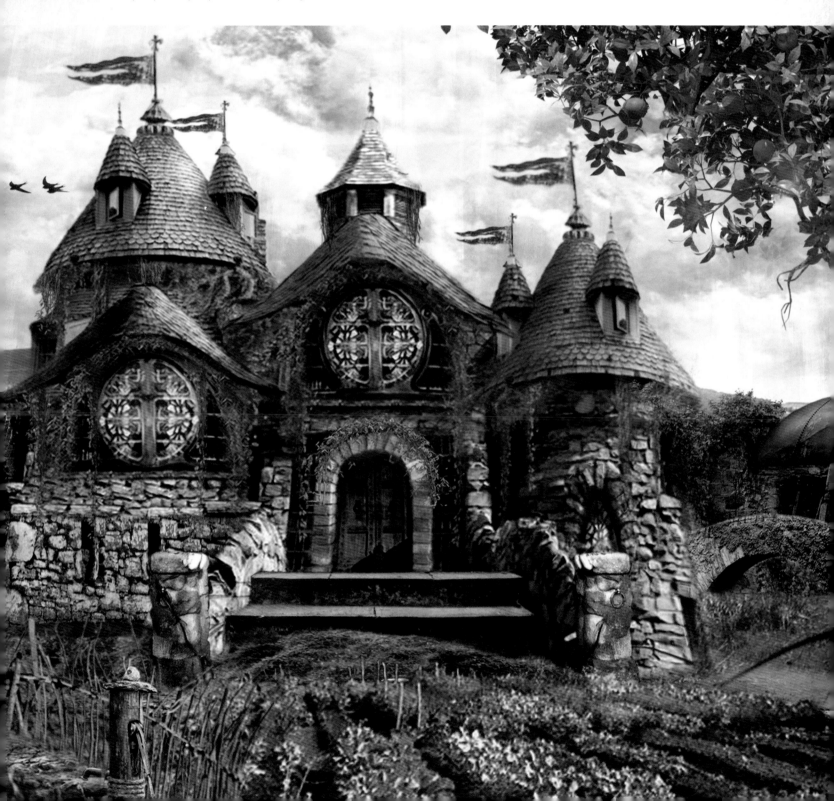

FRAGGLES FOREVER

"ALL OF US, ESPECIALLY CHILDREN, HAVE in our hearts 3,000 years of magic and fantasy. We need a place to merge or cross over where there are no limits. To leave the real world of cars, space flights, and technology and travel through the looking glass into the other real world of magic. Fraggle Rock is that very special place—intriguing and magical where human beings can freely experience the harmony of the inner spirit and the outer being."
—Michael K. Frith, November 1981

In 2013, Karen Prell, Kathryn Mullen, and Michael K. Frith attended Dragon Con in Atlanta, to celebrate the thirtieth anniversary of *Fraggle Rock*'s premiere. As Frith recalls, what moved him the most about the experience was the number of children and parents who came up to him and talked about how the show was a comforting escape from our sometimes scary world: "Within Fraggle Rock, they felt safe. They felt excited. They felt accepted."

What Frith saw with his own eyes was something that *Fraggle Rock* fanatics have known for thirty years: People don't just enjoy this show, they *cherish* it. *Fraggle Rock*—popular though it is—may not have been as widely seen as *Sesame Street* or *The Muppet Show*, but it features stories that genuinely appeal to all ages. It has a sense of mythology and a consistently idealistic worldview in which viewers want to become immersed.

"The mission of *Fraggle Rock* was, up to that point, unparalleled," says Frith. "It was an amazing accomplishment. I think it will always stand as something really exceptional. Everyone who worked on that show looks back on their time on *Fraggle Rock* as an extraordinarily special time in their lives."

Dave Goelz readily agrees. "It was creative nirvana working on the show, really," he says. "I think every single crew member who worked on it carries it with them always, because the show had an extraordinary intent and the democracy with which it was produced allowed everybody to contribute and shine. Everybody felt they were working on something that was a lot greater than a normal television program."

On what other show would the director set out a second chair for the episode's writer to sit in? On what other show would the performers hang around with the people building the sets, with both groups feeling free to make suggestions to the other? On what other show would the entire creative team engage in long, respectful debates—usually over a plate of food—about the nature of evil in an interconnected ecosystem?

"It's a show that's lasted," Duncan Kenworthy says. "It's a show that people care about, because it has values and emotions and . . . a morality, if you like. There's a spark about it that comes . . . not just from the puppeteers or the writers or Jim, but I think from everybody. That was always Jim's philosophy, wasn't it? Having fun making the show made the show enjoyable."

Phil Balsam tells the story of how he once walked into a record store and saw the Season 1 *Fraggle Rock* DVD set. When he brought it up to the counter, the clerk started raving about the music on the series, without realizing he was talking to one of the people responsible. The clerk went on to say that he was also an aspiring musician, and that *Fraggle Rock* was responsible for making him want to pursue that dream. "So yeah, there are fans," Balsam says. "Hey, *I'm* a fan."

Jocelyn Stevenson feels that *Fraggle Rock* was an extraordinary moment in pop culture history: "We were touched not only by what we created together, but by its impact. Every one of us is familiar with what we now call the 'Fraggle face.' It's the look people give you when you say you had something to do with the show. Whenever we see it, it's a moment of extraordinary connection."

Stevenson says that in the years since *Fraggle Rock* ended, she's heard commentators say it was almost too creative, too compassionate, and too *intelligent* to be a kids' show. But she disagrees. She recalls Jim Henson's original mission and how a young audience from the 1980s made the series their own, continuing to carry it with them in their hearts and minds even today. Stevenson laughs at the idea that the show was too smart for its audience. "It was," she says, "exactly as intelligent as it needed to be."

OPPOSITE A publicity photo of Jim Henson surrounded by the Fraggle Five and a crew of Doozers, taken in 1983.

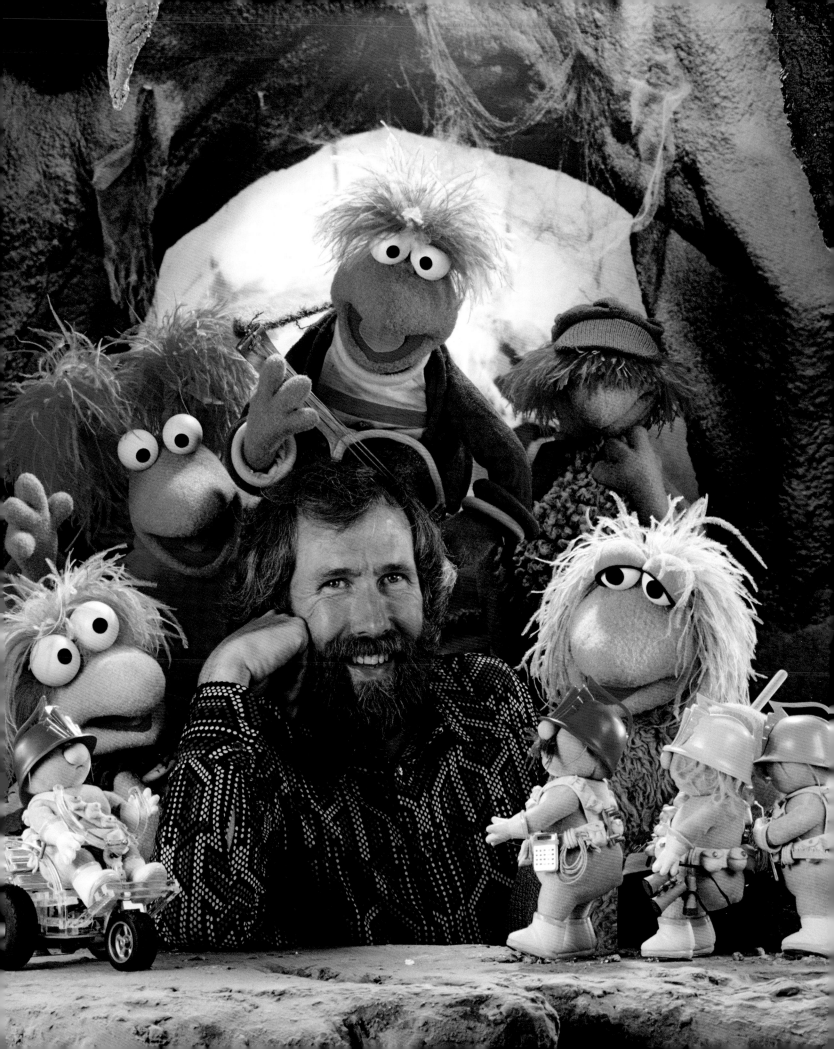

NOTES

1. Brian Jay Jones, *Jim Henson: The Biography* (New York: Ballantine Books, 2013), 24–25.

2. Jones, *The Biography*, 203.

3. "Peter Orton: Media entrepreneur who made a global success of Bob the Builder," December 12, 2007, https://www.independent.co.uk/news/obituaries/peter-orton-media-entrepreneur-who-made-a-global-success-of-bob-the-builder-764554.html.

4. Judy Harris, "Interview of Jim Henson," September 21, 1982, http://users.bestweb.net/~foosie/henson.htm.

5. Jennifer Nalewicki, "These Caves in Bermuda Inspired the '80s TV Show 'Fraggle Rock,'" *Smithsonian Magazine*, March 11, 2019, https://www.smithsonianmag.com/travel/these-caves-in-bermuda-inspired-80s-tv-show-fraggle-rock-180971647.

6. Jeff DeBell, "HBO to Increase Original Programs," *Roanoke [Virginia] Times & World News*, December 3, 1981.

7. Tom Jory, "HBO Set for New Muppets," *Associated Press*, December 1981.

8. "Muppeteer Sketches," Muppet Musings, February 25, 2011, http://muppetbalcony.blogspot.com/2011/03/muppeteer-sketches.html.

9. Kenneth Plume, "Ratting Out: An Interview with Steve Whitmire," Muppet Central Articles, July 19, 1999, https://muppetcentral.com/articles/interviews/whitmire2.shtml.

10. James Nobes, "Muppet Mondays: Wembley Fraggle," Muppet Space, http://muppetspace.simplesite.com/306124373.

BOTTOM LEFT Character design by Tim Miller for the Flutebird, seen in the season 1 episode "The Beast of Blue Rock."

BOTTOM RIGHT Design for a character called the "Odd Old Man" by Michael K. Frith from the season 4 episode "Wembley's Flight."

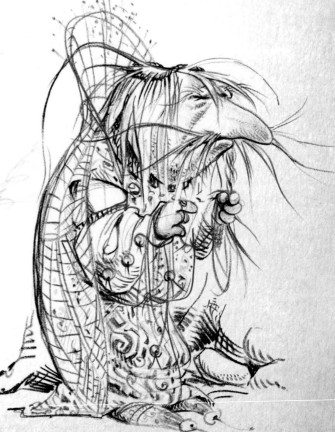

11. HBO Premiere Press Kit, "Dog's Life Not So Bad for *Fraggle Rock* Puppeteer Steve Whitmire," released December 7, 1982.

12. Jim Henson, "12/15/1979 – 'Karen Prell Comes in from Washington State.'" Jim Hensons's Red Book, https://www.henson.com/jimsredbook/2011/12/12151979.

13. Carol Wallace, "HA! Helpers Give Birth to Fraggles," *On Cable*, January 1983.

14. Wallace, "HA! Helpers."

15. Mike Petersen, "Gettin' Down at Fraggle Rock: Part 2," *Screenarchives*, October 2006.

16. Danny Horn, "Gonzo in San Francisco: Dave Goelz at the Walt Disney Family Museum," ToughPigs, August 18, 2016, http://www.toughpigs.com/dave-goelz-at-the-walt-disney-family-museum.

17. Horn, "Gonzo in San Francisco."

18. Petersen, "Gettin' Down at Fraggle Rock: Part 2."

19. Tom Shales, "The Fraggle Factor," *The Washington Post*, January 10, 1983.

20. Peggy Ziegler, "Muppet Master Henson Creates Enchanting New Series for HBO," *Multichannel News*, January 10, 1983.

21. Bob Wiseheart, "New Muppet Breed Lives Beyond Belief," *The Plain Dealer*, January 9, 1983.

22. "Mission," About Us, UNIMA, http://www.unima-usa.org/history.

23. Jim Henson, "8/19–24/1984 – 'In Dresden with Cheryl for UNIMA Puppet Festival,'" Jim Henson's Red Book, https://www.henson.com/jimsredbook/2013/08/819-241984-2.

24. Adam Bunch, "Down at Fraggle Rock In Yorkville – The Muppets Take Toronto," The Toronto Dreams Project Historical Ephemera Blog, February 13, 2014, http://torontodreamsproject.blogspot.com/2014/02/down-at-fraggle-rock-in-yorkville.html.

25. Jim Henson "5/27/1984 – 'In Wash. for ABA,'" Jim Henson's Red Book, May 25, 2013, https://www.henson.com/jimsredbook/2013/05/5271984.

26. Gary Levin, "'Fraggle Rock' Doozers Land on Hulu,' *USA Today*, February 10, 2014, https://www.usatoday.com/story/life/tv/2014/02/10/fraggle-rock-doozers-henson-hulu/5340309.

27. Laura Clark, "Lisa Henson: What I Learned from My Father," Mom.com, April 24, 2014, https://mom.com/entertainment/12092-lisa-henson-what-i-learned-my-father.

BOTTOM LEFT Concept art by Michael K. Frith for the Genie character seen in the season 3 episode "Wembley and the Mean Genie."

BOTTOM RIGHT Frith's concept art for the Begoony, a creature Mokey befriends in the season 3 episode "The Incredible Shrinking Mokey."

PAGES 222–223 Licensing art created for the UK version of *Fraggle Rock*.

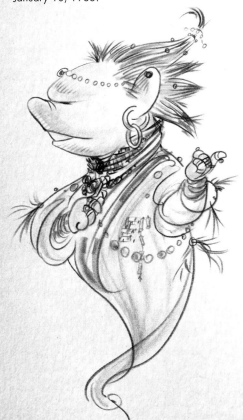

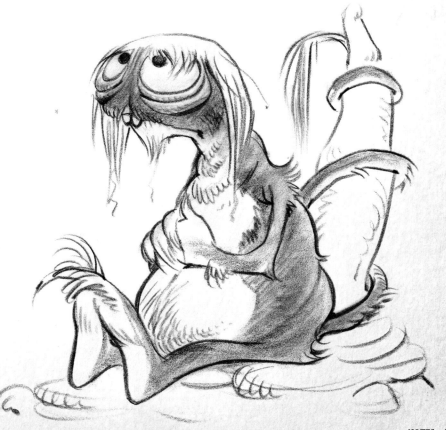

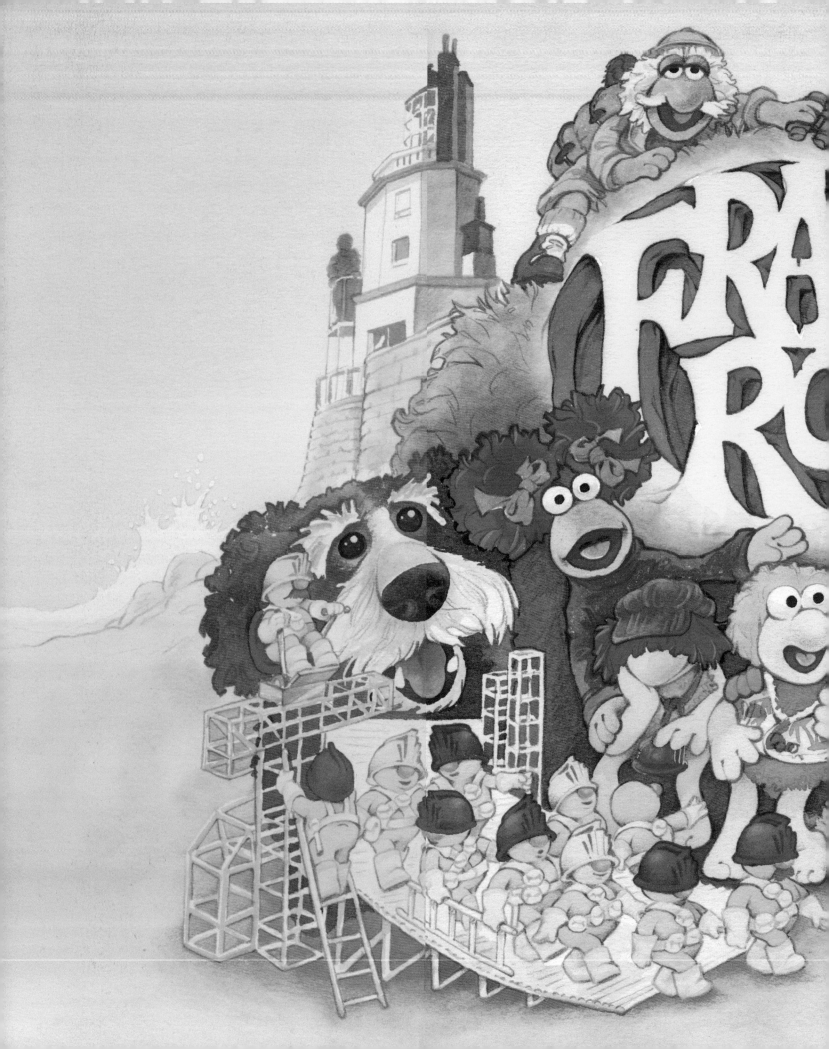

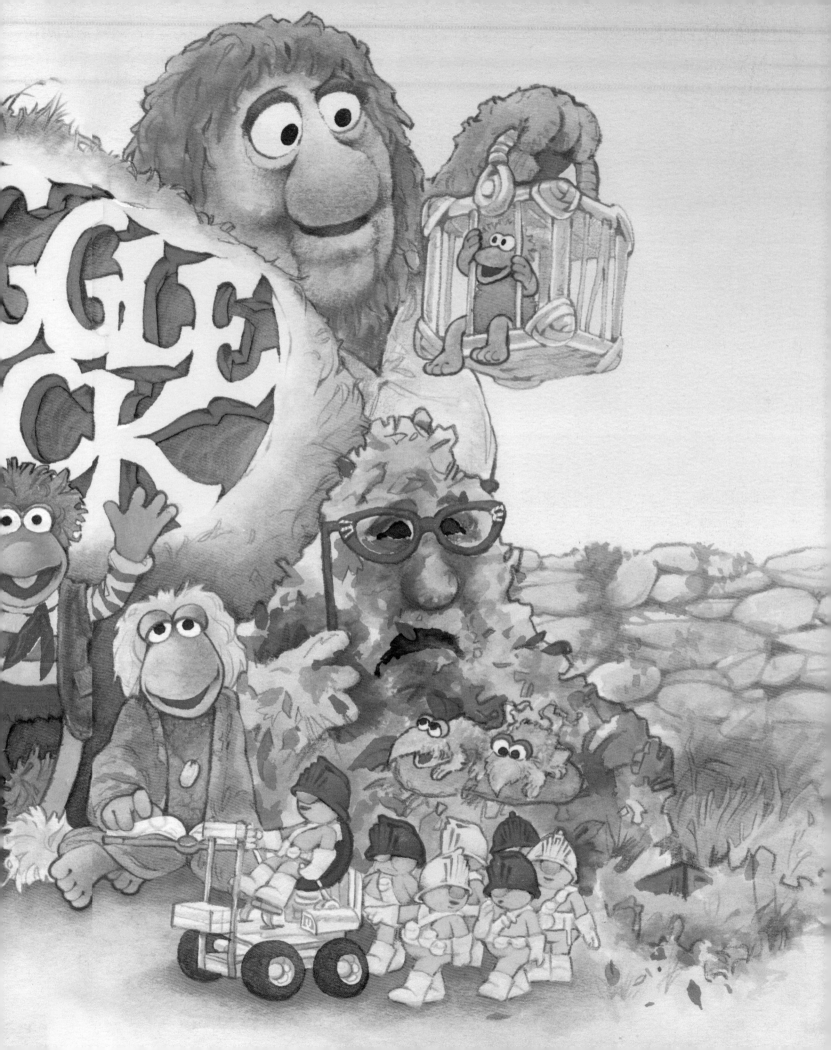

INSIGHT
EDITIONS

PO Box 3088
San Rafael, CA 94912
www.insighteditions.com

f Find us on Facebook: www.facebook.com/InsightEditions

𝕏 Follow us on Twitter: @insighteditions

© The Jim Henson Company. JIM HENSON'S mark & logo,
FRAGGLE ROCK mark & logo, characters and elements are
trademarks of The Jim Henson Company. All Rights Reserved.

All rights reserved. Published by Insight Editions, San Rafael,
California, in 2021.

No part of this book may be reproduced in any form without written
permission from the publisher.

Library of Congress Cataloging-in-Publication Data available.

ISBN: 978-1-68383-683-4

Publisher: Raoul Goff
VP of Licensing and Partnerships: Vanessa Lopez
VP of Creative: Chrissy Kwasnik
VP of Manufacturing: Alix Nicholaeff
Editorial Director: Vicki Jaeger
Designers: Amy DeGrote and Amazing15
Executive Editor: Chris Prince
Editorial Assistant: Harrison Tunggal
Managing Editor: Lauren LePera
Senior Production Editor: Elaine Ou
Senior Production Manager: Greg Steffen
Senior Production Manager, Subsidiary Rights: Lina s Palma

ROOTS of PEACE ⊛ REPLANTED PAPER

Insight Editions, in association with Roots of Peace, will plant two trees for each tree used in the manufacturing
of this book. Roots of Peace is an internationally renowned humanitarian organization dedicated to eradicating
land mines worldwide and converting war-torn lands into productive farms and wildlife habitats. Roots of Peace
will plant two million fruit and nut trees in Afghanistan and provide farmers there with the skills and support
necessary for sustainable land use.

Manufactured in China by Insight Editions

10 9 8 7 6 5 4 3 2 1

Insight Editions and the authors would like to
express their gratitude to the following for their
help with this book:

Infinite thanks to Phil Balsam, Stephen Christy,
Michael K. Frith, Dave Goelz, Brian Henson,
Cheryl Henson, Lisa Henson, Duncan Kenworthy,
Rollie Krewson, Tim McElchera, Rob Mills,
Lawrence Mirkin, Kathryn Mullen, Connie
Peterson, Karen Prell, Gord Robertson, Polly Smith,
and Jocelyn Stevenson for their time, insight,
and knowledge.

Endless appreciation is extended to Karen Falk,
director of The Jim Henson Company Archives;
and archivists Carla DellaVedova, Shannon
Robles, and Susie Tofte. Thanks also to Jim
Formanek, director of Branding and Publishing,
Consumer Products; Nicole Goldman, Executive
Vice President of Branding; and Halle Stanford,
President of Television for The Jim Henson
Company. Additional material was gleaned from
interviews conducted by Lawrence Mirkin in 2005
and 2007 with the writers, performers, puppet
creators, artists, producers, directors, composers,
and production and technical crew.

In memory of the many talented individuals who
helped bring Fraggle Rock to the world, including
bpNichol, Bill Beeton, Diana Birkenfield, George
Bloomfield, Carol Bolt, Faz Fazakas, Stephen
Finnie, Don Gillis, Jim Henson, Jane Henson,
Richard Hunt, Jerry Juhl, Gordon Luker, Tim Miller,
Jerry Nelson, Peter Orton, and Caroly Wilcox.

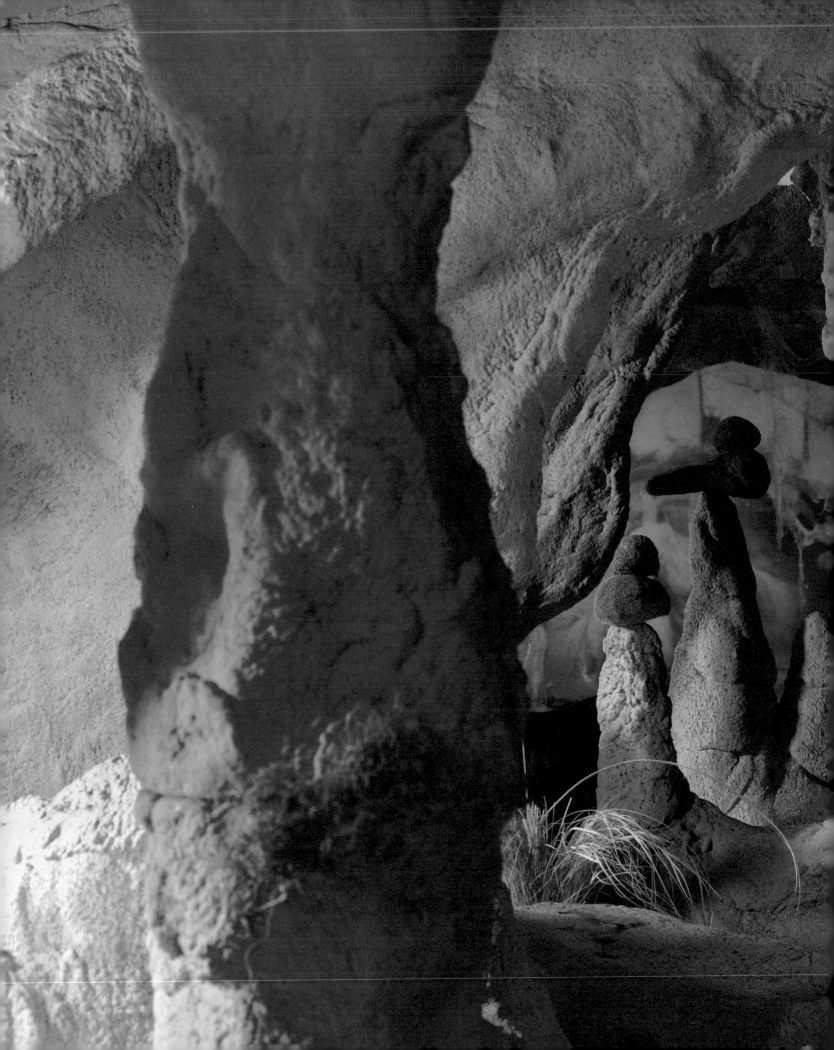